Richard Kostelanetz

# The Theatre of Mixed Means

an introduction to happenings
kinetic environments and other
mixed-means performances

PITMAN PUBLISHING

First published in Great Britain 1970

SIR ISAAC PITMAN AND SONS LTD.
Pitman House, Parker Street, Kingsway, London, WC2B 5PB
P.O. Box 6038, Portal Street, Nairobi, Kenya

SIR ISAAC PITMAN (AUST.) PTY. LTD.
Pitman House, Bouverie Street, Carlton, Victoria 3053, Australia

PITMAN PUBLISHING COMPANY S.A. LTD.
P.O. Box 9898, Johannesburg, S. Africa

Copyright © 1968 by La Monte Young
Copyright © 1967, 1968 by Richard Kostelanetz

ISBN: 0 273 31474 2

Printed in The United States of America
G0—(G.3505)

Coventry University

For Boris and Ethel Kostelanetz,
who expressed the necessity
of invention.

Supple and turbulent, a ring of men
Shall chant in orgy on a summer morn
Their boisterous devotion to the sun,
Not as a god, but as a god might be,
Naked among them, like a savage source.
Their chant shall be a chant of paradise,
Out of their blood, returning to the sky;
And in their chant shall enter, voice by voice,
The windy lake wherein their lord delights,
Their trees, like serafim, and echoing hills,
That choir among themselves long afterward.
They shall know well the heavenly fellowship
Of men that perish and of summer morn.
And whence they came and whither they shall go
The dew upon their feet shall manifest.
— Wallace Stevens, "Sunday Morning" (1923)

There are signs today that we are approaching an age of symbolism, and that a prolonged phase of naturalism is giving way to a new conception of reality, one of multiple dimensions and renewed significances.—Sigfried Giedion, "Symbolic Expression . . . ." (1966)

The theatre doesn't interest the working class because there is nothing exciting in it. They can get excitement on the television. . . . There is nothing in theatre which will excite the intellectual. Looking at the theatre, he sees adolescent ideas of problems of a miner's hut in Wales, which literature covered a long, long time ago and so did painting.—Sean Kenny, Theatre Designer (1964)

Reality is a construct of our senses, a chart which slowly emerges as we take soundings of our feelings, trace the contours of our sensations, measure distances and altitudes of experience. The chart changes as our knowledge increases, as our recording instruments improve in precision.—Herbert Read, *Icon and Idea* (1955)

If you do not change your mind about something when you confront a picture you have not seen before, you are either a stubborn fool or the painting is not very good.—Robert Rauschenberg (1966)

By the unification of architecture, sculpture, and painting, a new plastic reality will be created. Painting and sculpture will not manifest themselves as separate objects, nor as "mural art" which destroys architecture itself, nor as "applied art," but *being purely constructive* will aid the creation of an environment not merely utilitarian or rational but also pure and complete in its beauty.—Piet Mondrian, *Plastic Art and Pure Plastic Art* (1945)

Not satisfied with the *suggestion* through paint of our other senses, we shall utilize the specific substances of sight, sound, movement, people, odors, touch. Objects of every sort are materials for the new art: paint, chairs, food, electric and neon lights, smoke, water, old socks, a dog, movies, a thousand other things which will be discovered by the present generation of artists. Not only will these bold creators show us, as if for the first time, the world we have always had about us but ignored, but they will disclose entirely unheard of happenings. . . . —Allan Kaprow, "The Legacy of Jackson Pollock" (1958)

The further out one moves, the simpler becomes one's understanding of what theatre is. I now would accept only that theatre is a situation in which people gather to articulate something of common concern. —Ken Dewey, "X-ings" (1965)

Happenings remove people from the illusory world which, swathed in abstractions, is their everyday life, and put people into the actual world through devices which freshen perception.—Lee Baxandall, "Beyond Brecht: The Happenings" (1966)

**viii**

The poet of the future will surmount the depressing notion of the irreparable divorce of action and dream.—André Breton, *Les Vases Communicants* (1932)

The world of events can be described by a static picture thrown into a background of the four dimensional time-space continuum. In the past, science described motion as happenings in time; general theory of relativity interprets events existing in space-time.—Albert Einstein, quoted by Gyorgy Kepes, *The Language of Vision* (1944)

Space-time stands for many things: relativity of motion and its measurement, integration, simultaneous grasp of the inside and the outside, revelation of the structure instead of the facade. It also stands for a new vision concerning materials, energies, tensions, and their social implication.—Laszlo Moholy-Nagy, *Vision in Motion* (1947)

The major artistic inventions . . . resemble modern mathematical systems in the freedom with which their creators discarded certain conventional assumptions, and replaced them with others.—George Kubler, *The Shape of Time* (1962)

Education is the continuous process of the adjustment of the individual to his environment; and if the individual ever claims to be completely educated, it merely indicates that he is in need of a change of scene. —Herbert Read, *The Grass Roots of Art* (1946)

In an age when the quest for and response to the "new" moves artists everywhere, what particularly characterizes the American's explorations is his willingness to pursue aesthetic ideas literally, wholeheartedly and unselfconsciously to ultimate and unprecedented ends. In a culture where politics at its best is very much the art of the possible, the best art exemplifies the politics of the impossible.—Richard Kostelanetz, *The New American Arts* (1965)

The limits of this new theatre are only those of science and imagination.—Michael Kirby, "Films in the New Theatre" (1966)

# Foreword

The most interesting recent development in American theatre represents such a great departure from traditional practice that it has acquired a plethora of new names: "happenings," "the new theatre," "events," "activities," "painter's theatre," "kinetic theatre" or "action theatre." A designation such as *happening* is a totally inadequate description of a movement that includes totally planned, precisely executed, repeatable staged performances; *events* is too vague and general, *theatre without words* too negative, and *the art of radical juxtaposition* too clumsy and platitudinous. I prefer to christen the entire movement "the Theatre of Mixed Means," a term that encompasses various strains of activity and yet makes the crucial distinction between this theatre and traditional, predominantly literary mono-mean practice, and the following introductory essay defines my conception of the new theatrical form. Whereas a tendency toward generalities characterizes this introduction (and, incidentally, most previous writing on new theatre), the remainder of this book emphasizes differences — be-

tween one genre of new theatre and another, between one creator and another, and between a certain practitioner's recent works and his past achievements. I find the new theatre artistically more various than certain critics have led their readers to believe.

The Theatre of Mixed Means has been nothing but controversial, enlisting both vociferous supporters and vehement detractors, passionate claims that it represents the only viable "way out," and equally strong assertions that it is a "dead end." Indeed, nothing in the theatre at the present time inspires such sharp arguments as the new movement. To my shame, I must admit contributing to the lump-and-toss tendency myself, recording the opinion, in a book I edited and partially wrote, *The New American Arts* (Horizon, 1965), that the happening was very much an expired corpse. My opinion, to continue my confession, was based upon inadequate research, some unfortunate experience, and a bias toward the theatre of literature I had learned about in college. Since then, I have seen many more examples of mixed-means performances, most of which pleased and excited me considerably, several of which I would rate among the most exciting theatrical presentations I have seen (and often re-seen) in recent years — Claes Oldenburg's *Moviehouse* (1965), Robert Whitman's *Prune. Flat.* (1965), John Cage's *Variations VII* (1966), La Monte Young's *The Tortoise, His Dreams and Journeys* (1964 —), Ken Dewey and Terry Riley's *Sames* (1965), Robert Rauschenberg's *Open Score* (1966), and Meredith Monk's *16 Millimeter Earrings* (1966). Indeed, I would say, in general, that during the past two years (1965–67), I have personally had as a theatrical spectator far more satisfying experiences with mixed-means pieces than with traditional presentations, whether on Broadway or off or off-off. For no greater reason, may I offer this book as a token of remission.

Where, two years ago, I had hoped that *The New American Arts* offered a definitive statement on avant-garde activity in America today, I have since discovered that advanced art, as it always does, continues to upset the expectations of even its closest observers and most loyal devotees. A major problem of that earlier book, I now recognize, lay precisely in my decision, as editor, to split the critical work into categories—cinema, fiction, dance, poetry, painting, theatre, and music. I was then only dimly aware that so much that is currently artistically advanced today straddles, if not transcends, these tradi-

tional divisions; in fact, a few of my fellow contributors stretched into areas outside their assigned scope. If I did the book today, I should probably take a more radical step: Choose several younger critics, perhaps trained in various fields, and then ask them to write on everything in new art that interested them, regardless of traditional forms of classification. We are indeed approaching that unprecedented condition where not only are all the arts blending together into one, but also where all the environment that man creates is revealing his artistic bent.

As a critic, I believe that one either approaches the truly contemporary movements as they develop, or one retires to the academy to lecture on the past. My first impulse was to write a book-length study of the new movement; but as I am, alas, a latecomer to the scene, it would be irresponsible of me to write critically of performances I missed. In the new theatre, unlike the old, descriptions by other observers and/or manuscripts of the performances are insufficient guides to critical judgment. Then, too, one problem that new theatre poses, a predicament yet to be solved, is the creation of a viable critical vocabulary. The Theatre of Mixed Means insists that its competent critic at once describe precisely the movements of individual players and the entire ensemble, evoke the character and quality of the images, define the projected personalities of the performers, deal with the sounds the piece makes and the rhythms it achieves, explain the integration of the elements, identify the shape and degrees of coherence, and cope with themes and meanings suggested by the whole. Since the critic must now respond to dance, film, theatre, and music all at once, criticism of the new work has been sparse and, when in print, meager in perception. Another problem stems from the fact that the Theatre of Mixed Means is still in embryo as a movement, slightly more than a half-dozen years old. By contrast, the Theatre of the Absurd had existed for over a decade when Martin Esslin's fine book appeared.

I feel that, at this time, the most viable introduction to the Theatre of Mixed Means should contain the following elements: 1.) An essay that characterizes the new art form, identifies its various genres, traces the diverse strains of its artistic ancestry, ascertains its significances, and discerns its ultimate purposes; 2.) A critic's conversations with the leading practitioners, who explain their own intentions and describe how they conceive and execute their own pieces; 3.) A conclu-

sion in which the critical questions the new movement raises are broached — what kind of criteria can we posit and what judgments can we make? 4.) A four-part bibliography listing statements and scripts by the practitioners, critical essays about the new movement, reviews of individual performers, and background materials that have enormously influenced both the practitioners and their critics; in this last part are the sources of many facts and quotations used throughout the book. Every "introduction," I believe, has an obligation to direct its reader elsewhere.

In general, I think of interviews as a lesser form of critical knowledge, too often a feeble substitute for work the editor-interviewer should do himself. However, I have discovered that most practitioners of the new theatre have that multi-aware sensibility I mentioned before, and, for this reason alone, they can usually provide a richer, more comprehensive description of their own pieces than a critic; they also invariably have a stronger memory for other practitioners' work. Since this book emphasizes differences in the new theatre and since most of these people are unashamedly articulate, I decided that conversations, extensively planned and heavily edited, would make more effective chapters than expository criticism. Such a process turned out to be considerably less than a short cut; for the work of transcribing, revising, editing, copyreading, recopying, introducing, and proofreading was just as arduous as writing out of my own head an equal number of pages. Consequently, this book is the major product of the past year's labor.

Finally, whereas one book on the new theatre can emphasize its history and provide a list of authors, pieces, and dates of performances, another can describe important pieces and reprint their authors' manuscripts, and a third can tell a story largely through pictures, my own contribution to the critical task deals primarily with ideas — the purposes of the Theatre of Mixed Means, the various conceptions that several major practitioners have, and their analyses of the processes shaping their own theatrical pieces. This book by no means exhausts the possible critical approaches to the new theatre.

I might have joined so many other "theatre critics" who bemoan the American theatre while ignoring the new movement completely, had not several friends insisted upon stretching my education; and for this expansion of my intellectual consciousness, I should like to thank

Lee Baxandall, John Brockman, S. Foster Damon, Harris Dienstfrey, Richard and Amy Foreman, Jill Johnston, Michael Kirby, Lawrence Kornfeld, Marshall McLuhan, Eric Mottram, Albert L. Murray, and the Advisory Board on the Pulitzer Prizes which granted me, in 1965, the Pulitzer Fellowship in Critical Writing. Throughout the text, as well as the bibliography, I credit those books and essays that shaped my understanding of the new theatre. Without Susanna Opper's amazing competence in unfamiliar situations, the interviews would have lacked an essential answer or two; and if not for Julianne Stephenson's sharp critical sense, much unessential patter and many foggy phrases would have remained. To E. L. Doctorow and Richard Baron I am grateful for their faith in a project without precedent; to Robin Morgan Pitchford, for preparing the manuscript for the printer; and to Anne M. Barry and Joyce Johnson too, for their labor on a task seemingly without an end.

I am thankful to the artists for granting me interviews with them. All were good enough to check and revise their contributions, and several have since become good friends. Were more space available, I should have liked to include my conversations with the film-maker Stanley VanDerBeek, the composers Dick Higgins and Terry Riley, the directors Lawrence Kornfeld and Michael Kirby, the designer George Maciunas (founder of American FLUXUS), the painters Carolee Schneemann and Jim Dine, the dancers Meredith Monk, Steve Paxton, Elaine Summers, and Kenneth King, and the various artists associated with ONCE (Michigan)—all of whom have created works I have enjoyed and admired.

Those to whom I dedicate this book exposed me to life; and no thanks I could give them would be great enough.

# Acknowledgments

*Acknowledgment is made to the following for permission to quote excerpts used in this book:*

*Art News:* for "The Legacy of Jackson Pollack" by Allan Kaprow, October 1958.

Bantam Books, Inc.: for *The Medium Is the Massage,* Copyright © 1967 by Marshall McLuhan, Quentin Fiore, and Jerome Agel.

Faber and Faber Ltd.: for "Sunday Morning" by Wallace Stevens from *The Collected Poems of Wallace Stevens.*

Alfred A. Knopf, Inc.: for "Sunday Morning" by Wallace Stevens from *The Collected Poems of Wallace Stevens.*

George Wittenborn, Inc.: for *The Dada Painters and Poets,* Documents of Modern Art, Volume 8. New York, N.Y. 10021.

# Contents

**xix**

part 1

the
mixed-means
medium

Many of us have departed from the old canons
and obsolete conventions, to a new space
articulation, to satisfy more adequately the
specific need of our time for a vision in motion.
—Laszlo Moholy-Nagy, *The New Vision* (1938)

In one sense, a theatre that mixes its means is not new, for the fusing of the arts is as old as Art itself. Indeed, as primitive ceremonies integrated dance and drama, song and sculpture, the separation of these arts probably followed in the development of human consciousness from the recognition of Art as distinct from life; and once these several kinds of artistic expression were recognized as distinctly different, individuals could specialize in one or another field and, in the Renaissance, sign their names to personal work. "Civilization," writes Herbert Read, "insisted on a specialization of artistic functions." Only then, historically, could specialists in one art join with veterans of another to produce such modern theatrical combinations of song-drama-dance as operas or, more recently, musical comedies.

What differentiates the new Theatre of Mixed Means from both primitive ceremony and the musical stage are, first, the components the new mixtures use and, second, the radically different relationships that these elements have to each other. That is, whereas both opera and musical comedy emphasize poetic language to an accompaniment of song, setting, and dance, the new theatre generally eschews the

language of words and includes the means (or media) of music and dance, light and odor (both natural and chemical), sculpture and painting, as well as the new technologies of film, recorded tape, amplification systems, radio and closed-circuit television.

In the old theatre, even in Diaghilev's ballets, the elements complemented each other—the music clearly accompanied the singer or dancer, each coinciding with the other's beat—but in the new theatre, the components generally function nonsynchronously, or independently of each other, and each medium is used for its own possibilities. Moreover, some practitioners of mixed-means theatre, such as Allan Kaprow, intentionally exclude any signs of the conventional arts, particularly such traditional contexts as art galleries and performance halls. Instead, the new theatre defines its presence not by the environment in which it occurs but by the purposes of its participants; as Ken Dewey puts it, "People gather together to articulate something of mutual concern." These departures make the new theatre crucially different from traditional practice, and although its ancestry can be traced, its novelty remains unquestioned.

The new movement has generally been called "Happenings," which is hardly appropriate, for not only do all examples of the new theatre have some kind of script, but very few use chance procedures, either in composition or performance, and even fewer depend upon improvisation, or entice an audience to participate. As this is a new theatrical form, it deserves a new name; and I prefer "the Theatre of Mixed Means," because that phrase isolates the major characteristic and yet encompasses the entire movement. Within this new art, I discern four distinctly different genres of mixed-means events: pure happenings, kinetic environments, staged happenings, and staged performances. Although most pieces fit clearly into one particular category or another, sometimes a piece will shift from one style to another as well as overlap stylistic boundaries.

In pure happenings, the script is vague enough to allow unexpected events to occur in an unpredictable succession. The movements and identity of the official participants are only sketchily outlined, and a participant may improvise details of his activity, although its general purpose has usually been decreed in advance. The resulting actions are, as Michael Kirby notes, *indeterminate* rather than improvised. A pure happening insists upon an unfettered exploration of space and

time — both are open rather than closed. A pure happening provides neither a focus for one's attention nor a sense of duration; and the performance envelops the audience, who generally do not intend to be spectators, by allowing them to feel that they too are participants in a significant process. Although Kaprow (who originated the word "happening" and scrupulously pursues his ideal conception) first established himself as a painter, the shape his pieces take actually has less to do with how we see than how we hear:

Auditory space has no favored focus. It's a sphere without fixed boundaries, space made by the thing itself, not space containing the thing. It is not pictorial space, boxed-in, but dynamic, always in flux, creating its own dimensions moment by moment. It has no fixed boundaries; it is indifferent to background. The eye focuses, pinpoints, abstracts, locating each object in physical space, against a background; the ear, however, favors sound from any direction. [Edmund S. Carpenter, *Eskimo* (1959)]

The author of a pure happening is, as Kaprow notes, closer to a basketball coach than a theatre director or choreographer; for he gives his players only general instructions before the event. Thus, one of Kaprow's recent pieces, *Household* (1964), opens in "a lonesome dump out in the country" with the following activities:

11 A.M. Men build wooden tower on a trash mound.
Poles topped with tarpaper clusters are stuck around it.

Women build nest of saplings and strings on another mound.
Around the nest on a clothesline they hang old shirts.

The entire script for Dick Higgins' *Gångsång* is: "One foot forward. Transfer weight to this foot. Repeat as often as desired." In the summer of 1966, Ann and Lawrence Halprin, respectively a dancer and an architect, gathered a group of people on a driftwood beach and asked them to build shelters; the resulting process, which actually created a driftwood village, was a pure happening. So is a massive gathering of people, a "Be-In"—whose author is not individual but collective. Pure happenings are generally not performed in conventional theatrical situations which, by their nature, close off the space and impose focus on the activity. Some have exploited natural surroundings, such as a forest or a swimming pool or Grand Central Station or an entire city. Some can be performed anywhere, at any

time, before either an intentional audience, a random gathering of miscellaneous people, or even nobody at all.

Kinetic environments differ from pure happenings in that they are more closely planned, their space is more specifically defined and constricted, and the behavior of the participants (or components) is more precisely programed. However, they are, like happenings, structurally open in time and, as forms, capable of encouraging participational attention. USCO, or Us Company, an artists' collective, has created kinetic environments of music, taped noise (such as a constant heartbeat), paintings, sculpture, machines, electronic instruments (for example, a television or an oscilloscope), and projected images both on slides and film. A kinetic environment of fewer elements is La Monte Young's Theatre of Eternal Music, in which Young, along with three other musicians, creates within a closed space a precisely constructed chord of constant harmonic sound which is electronically amplified to the pitch of aural pain and projected through several speakers; usually the sound can entirely envelop both the room and the spectator's consciousness. A recording of Young's theatre piece, however, is not a kinetic environment but a piece of sound-music, unless, of course, the listener recreates the original performance situation — the environment — of a darkened room, several loudspeakers, slides of oriental calligraphy, and an odor of incense.

Staged happenings differ from pure happenings primarily in occurring within a defined space, mostly on a theatrical stage. Otherwise, the actions of the participants are variable or indeterminate from performance to performance; either chance operations or a flexible script ensure that events cannot be duplicated. Because the space is fixed, the audience is usually separated from the performers; thus, its role is more observational than participational. John Cage's concerts are generally staged happenings; so are most of Ann Halprin's and some of Merce Cunningham's pieces. "A Happening with only an empathic response on the part of a seated audience," Kaprow writes, "is not a Happening but stage theatre." For instance, a football game is a staged happening to a spectator; a pure one to a participant.

In the staged performance, which is as pre-planned in conception and as precisely executed as the kinetic environment, the major actions are defined in advance, the audience's role is observational, and the dimensions of space and time are usually predetermined. Indeed, in

all these respects, the staged performance is similar to traditional theatre; but where drama emphasizes speech, new theatre thoroughly mixes the media of communication and most pieces have no words at all. When language is employed, the words generally function as isolated, minimally syntactical fragments of "found" sound. For example, in Ken Dewey and Terry Riley's *Sames* (1965), short phrases — "I," "That's not me" — are repeated over and over again and one voice multiplies into a chorus of itself, while six stationary ladies in bridal dress grace the stage and film is projected upon the theatre's ceiling and walls. Staged performances offer a perceptual experience akin to a lively dance act or an engrossing mime.

The following chart * graphically represents the differences between one genre and another:

| GENRE | SPACE | TIME | ACTION |
| --- | --- | --- | --- |
| Pure Happening | Open | Variable | Variable |
| Staged Happening | Closed | Variable | Variable |
| Staged performance | Closed | Fixed | Fixed |
| Kinetic environment | Closed | Variable | Fixed |

What all the various forms of the Theatre of Mixed Means have in common, then, is a distinct distance from Renaissance theatre — a distance that includes a rejection not only of the theatre of explicit statement and objectified plot but also the visual clichés produced by unison movement, synchronous accompaniment, and complementary setting. Intrinsic in the mixed-means theatre is the most liberal definition possible of theatrical activity: any situation where some people

* As "open" is the equivalent of variable, and "closed" equals fixed, then three aspects—space, time, action—distributed two ways produce the possibility of $2^3$ or eight, and the following are, by implication, the four unborn genres of new theatre, which I shall refrain from christening with individual names:
1.) Open-Fixed-Variable would be, for example: Move anywhere, in any manner, for thirty minutes.
2.) Open-Fixed-Fixed would be, for instance: Move ten barrels from Spot X to Spot Y by any route that you wish in exactly five minutes.
3.) Closed-Fixed-Variable would be: Do anything you wish within a circumscribed area for one-half hour; an example might be a truly improvised jazz performance with an exact time set for its end.
4.) Open-Variable-Fixed would be: A cross-country race over a terrain that lacked a marked path.

perform for others, regardless of whether or not the spectators intend to be an audience.

In mixed-means theatre, the performers usually do not enact roles but carry out prescribed tasks. Since these gestures and movements are, to varying degrees, less precisely programed than actors' activities in theatrical drama, mixed-means performers, unlike actors, do not assume other personalities, but merely display their own. As synchronization is abandoned, so the relations between all activities, whether at any particular moment or over the duration of the piece, tend to be discontinuous in structure and devoid of an obvious focus. As the ways of presenting material are nearly as various as the number of mixed-means practitioners, each piece demands of the spectator an actively engaged and highly personal perception. These symptoms of apparent disorder, often leaving the eye unsure of where it should look and the ear unsure of what it should hear, challenge the audience to perceive order in chaos.

The process of understanding any unfamiliar form of communication appears to involve three separate recognitions, which Edward T. Hall in *The Silent Language* (1959) defines as "*sets, isolates,* and *patterns.* The sets (words) are what you perceive first, the isolates (sounds) are the components that make up the sets, while the patterns (syntax) are the way in which sets are strung together in order to give them meaning." However, in drawing upon several kinds of communication, a mixed-means piece speaks in several languages at once, insisting that its audience be as artistically polylingual as its creator. A realized event should exemplify Richard Southern's dictum: "All good theatre should be comprehensible to a deaf man." Furthermore, as each piece of new theatre tends to create an amorphous definition of space, an imprecise conception of time, an unconventional stage rhythms, the audience often has difficulty discerning when a particular piece has ended.

In the Theatre of Mixed Means, a piece usually opens by announcing a sound-image complex which is immediately communicated; and rather than employ the musical techniques of variation and development or the dramatic forms of linear development, mixed-means pieces generally pursue one of three patterns — an unmodulated development that sustains or fills in the opening outline; a thoroughly discontinuous collage of several sections; or an associational succes-

sion of sequences that relate to each other in several ways.* The first form is more often than not characteristic of environments, the second of both kinds of happenings, and the last of staged performances; but there exists no necessary correlation between genre and structure. Narrative, when it exists, functions more as a convention than a revelatory structure or primary component, for the themes of a piece are more likely to emerge from the repetition of certain actions or the coherence of imagery. The comprehension of a mixed-means piece, then, more closely resembles looking at a street or overhearing a strange conversation than deducing the theme of a drama: The longer and more deeply the spectator dissects and assimilates its sound-image complex and associates the diverse elements, the more familiar he becomes with the work.

Like many of the most important tendencies in contemporary art, the Theatre of Mixed Means emphasizes the processes of creation, rather than the final product, and this links it with primitive pre-verbal communal rituals. "Drama may be the *thing done*," writes Richard Southern, "but theatre is *doing*." More important, it employs various media of communication to create a field of activity that appeals to the total sensorium. Historically, the new theatre represents that radical departure from nineteenth-century forms that the modern theatrical medium, unlike the other arts, has yet to undergo. "The theatre is always twenty or thirty years behind poetry," Eugene Ionesco once wrote, "and even the cinema is in advance of the theatre." As the revolt in poetry was away from the Renaissance notions of perception and connection, so the new theatre embodies a rejection of linear form and explanatory truth. Like the new cinema of Jean-Luc Godard and Alain Resnais, it explores the representation of time; like the new architecture, the potential shapes of space.

* Flat form:
Discontinuous form:
Associational form:

# 2

Obviously the causes of Happenings
have been "in the air"
for at least fifty years,
probably longer.
—Ken Dewey, "X-ings" (1965)

The Theatre of Mixed Means did not spring out of ether; indeed, not only do its precedents exist in the four great avant-garde movements of early modern art — Futurism, Dada, the Bauhaus, and Surrealism — but the new theatre also extends from recognizably modern tendencies in all the arts it encompasses: painting, sculpture, music, dance, film, and theatre. Art ultimately comes out of art, because the artist is influenced more by the conceptual models he observes in art and retains in his head than by non-artistic experience; and what data he finds outside of art generally falls into patterns that were shaped by those prior conceptual models. "Every style aims at a faithful rendering of nature and nothing else, but each has its own conception of Nature," the German art historian Alois Riegl argued around the turn of the century, and his intellectual disciple, the contemporary art historian E. H. Gombrich, formulates this dictum: "We can never neatly separate what we see from what we know." Therefore, the confluence of these tendencies and the influence of the mixed-means precedents, along with the dialogues one art persistently holds with another, is probably the most immediately conclusive explanation of

why the Theatre of Mixed Means should have emerged at this time, as well as why, despite variations in individual background and purpose, the new theatre as a whole achieves a highly definite character.

Futurism, Dada, the Bauhaus, and Surrealism all represent the banding together of artists in various fields—writers, musicians, sculptors, painters, and architects—who first either produced manifestos announcing a collective purpose or, in one case, founded an institution and then created works of art both individually and corporately; and what these movements also have in common is a rejection of archaic conceptions of aesthetic form as well as the barriers that traditionally separated one art from another. "You may paint with whatever you please," wrote Guillaume Apollinaire in 1913, "with pipes, postage stamps, postcards or playing cards, candelabra, pieces of oil cloth, collars, printed paper, newspapers." From then on, all arts could emulate painting by extending into other arts, and traditional ideas of artistic propriety were consigned to the ashcan of art history.

Futurism was historically the first of these multi-media movements, originating in Italy with the poet-politician Filippo Tommaso Marinetti's *Futurist Manifesto* of 1909. Once organized, the movement intended to create art representing qualities and activities as various as speed, simultaneity, kinetic continuity, interaction of visible and invisible forces, changes in the environment, leaps in point of view, etc. Futurist paintings, out of an admiration for the machine, seem on the verge of motion, initiating what Gyorgy Kepes defines as the "simultaneous representation of the numerous visible aspects composing an event," and Futurist poets recorded in print the abstract sounds of everyday life. Where Marinetti exploited various sizes of typography to create picture-poems that expressed, wrote Laszlo Moholy-Nagy, "movement, space, time, visual and audible sensations," so the composer-painter Luigi Russolo envisioned in 1913 that music would "break out of this narrow circle of pure musical sounds and conquer the infinite variety of noise-sounds," and he subsequently constructed *Intonarumori* (Noise-Organs) to produce sounds mechanically in a theatrical context. Soon after, Marinetti himself posited a mixed-means theatre (which he never built) that would simultaneously exploit "the new twentieth-century devices of electricity and the cinema" as well as poetry, scenery, and props.

Where Futurism discovered that the new technologies would be-

come propitious instruments for mixed-media art, Dada exposed all subsequent modern artists to unfamiliar material, as well as introduced unfamiliar material to art. When a poet signed his name to a page in the telephone directory and Marcel Duchamp affixed the pseudonym of "R. Mutt" to a porcelain urinal, Dada proclaimed that ready-made "found objects" were as much the stuff of art as hand-made ones. Upon such an assertion of absolute aesthetic freedom, Dada artists constructed, in both space and time, mixed-media conglomerations which, writes William Seitz, "awakened the senses and sensibilities to the immense multiple collision of values, forms, and effects among which we live." The Cologne Dadaists transformed a 1920 exhibition into what we would now recognize as a mixed-means environment. "In order to enter the gallery," David Gascoyne writes, "one had to pass through a public lavatory. Inside the public was provided with hatchets with which, if they wanted to, they could attack the objects and paintings exhibited." Kurt Schwitters, perhaps the most versatile of the Dadaists, once transformed his own home into a multi-roomed environment; and he later performed an *Ursonata* (1924) which Moholy-Nagy in retrospect describes as "a poem of thirty-five minutes' duration containing four movements, a prelude, and a cadenza in the fourth movement. The words do not exist, rather they might exist in any language; they have no logical only an emotional context; they affect the ear with their phonetic vibrations like music."

Indeed, in the 1920 Schwitters conception of the "Merz composite work of art," we can recognize an extraordinary prophecy of the new theatre of the 1960's, even though his speculative image never grew beyond the printed page:

In contrast to the drama or the opera, all parts of the Merz stage-work are inseparably bound up together; it cannot be written, read or listened to, it can only be produced in the theatre. Up until now, a distinction was made between stage-set, text, and score in theatrical performances. Each factor was separately prepared and could also be separately enjoyed. The Merz stage knows only the fusing of all factors into a composite work. Materials for the stage-set are all solid, liquid and gaseous bodies, such as white wall, man, barbed wire entanglement, blue distance, light cone. . . . Materials for the score are all tones and noises capable of being produced by violin, drum, trombone, sewing machine, grandfather clock, stream of water, etc. Mate-

rials for the text are all experiences that provoke the intelligence and emotions. The materials are not to be used logically in their objective relationships, but only within the logic of the work of art. The more intensively the work of art destroys rational objective logic, the greater become the possibilities of artistic building. . . . Take in short everything from the hairnet of the high class lady to the propeller of the *S. S. Leviathan*, always bearing in mind the dimensions required by the work.

So precisely prophetic of contemporary work was this description that, indicatively, early pieces were regarded, by some historical critics, as a species of neo-Dada; but that classification, like certain other early rubrics, was too limited a description for the variousness of the Theatre of Mixed Means.

Unlike Futurism, Dada, and Surrealism, informal conglomerations of like-minded artists, the Bauhaus was an educational institution possessed of clearly articulated purposes, particularly the fusions of art with craft, the artist with technology, and artistic design with daily life. The architect Walter Gropius, its founder in 1919, drew the Bauhaus faculty from several arts—among its members were established architects, painters, sculptors, stage designers, photographers, typographers, industrial designers, and writers, and upon such diverse resources, the Bauhaus initiated what Herbert Read considers "the greatest experiment in aesthetic education yet undertaken." While teaching its preliminary course in the middle twenties, Laszlo Moholy-Nagy, a jack of nearly all artistic trades, conceived of an elaborately mechanized mixed-means theatre—a "Mechanized Eccentric," which could project a "synthesis of form, motion, sound, light (color) and odor," onto three simultaneously active stages; the result would be a "Theatre of Totality," which, he wrote, "with its multifarious complexities of light, space, plane, form, motion, sound, man—and with all the possibilities for varying and combining these elements—must be an organism." At the same time, Gropius himself devised a "Total Theatre," unfortunately never built, in which the entire interior could be changed to suit the form of the theatrical event. A picture-frame proscenium stage could be transformed into a protruding platform surrounded on its forward sides by a semicircular orchestra, or the completely circular seating of a sports event or circus. "The contemporary theatre architect," Gropius wrote, "should set himself the aim to create a great keyboard for light and space, so objective and adaptable

in character that it could respond to any imaginable vision of a stage director." Such a building would still be an ideal structure for contemporary mixed-means theatre, which generally insists upon creating a space suitable for a particular piece, or a piece appropriate for an existing space.

Surrealism, in its original purpose, is markedly different from Futurism and Dada; for where its predecessors wanted to incorporate the realities of modern life into art, Surrealists attempted to expose subterranean forces in the individual—to represent a personal reality beyond appearances—in order to create a new consciousness. To this purpose, Surrealists intended to suppress the desires of the individual ego, as well as break down the conventions of linear organization. Often several collaborated on poems and drawings, each doing his share independently of the others; the painter Max Ernst, a Dadaist before he became a Surrealist, developed "frottage" by putting a sheet of paper over randomly chosen material and rubbing a pencil across the sheet. "The drawings made in this way," writes Calvin Tomkins, "lost the character of the material employed and assumed a wholly new aspect." Certain strains of mixed-means theatre, like frottage, use similarly aleatoric techniques to discover an originality that the author's conscious intentions could not possibly create. Paradoxically, although Ernst's purposes were anti-intention and anti-art, his technique contributed to the storehouse of strategies from which subsequent artists could intentionally draw.

In its preference for alogical and nonsynchronous activity, the new theatre also draws upon the Surrealistic interest in collage. Although this compositional technique was actually invented by Pablo Picasso and Georges Braque several years before Surrealism took shape, the Surrealist poets and painters became more thoroughly committed to exploring the possibilities of non-logical juxtapositions. The result was an aesthetic syntax distinctly new—what the critic Jill Johnston christens "the logic of simultaneous vision." Indeed, after exploring such a compositional "logic" within various media—whether poetry, prose, painting, or music—the Surrealists began, with the Paris exhibition of 1938, to create three-dimensional environments. Marcel Duchamp designed what Michael Kirby describes as "a great central hall with a pool surrounded by real grass. Four large comfortable beds stood among the greenery. Twelve hundred sacks of coal hung from

the ceiling. In order to illuminate the paintings which hung on the walls, Duchamp planned to use electric eyes that would switch on lights for the individual works when a beam was broken." At a later Surrealist exhibition, Duchamp wove twine all over the exhibition hall. Like the Dadaists before them, not only did the Surrealists announce themselves as "anti-art," but they also produced (and sold!) works we now admire as masterpieces; and the examples they set had a great influence upon subsequent art.

The mixed-means theatre also extends from another primary tendency in modern painting—the development, starting in the late nineteenth century with Paul Cézanne, away from fixed perspective to a simultaneously multiple point of view. Cézanne's great revolution consisted of integrating into a single two-dimensional field several objects as they could only be seen from different viewpoints—for example, a table is represented as seen from above, a bottle as seen from its side. This technique influenced more thorough Cubists such as Picasso and Braque and, later, Willem de Kooning, whose *Woman I* (1952) displays a figure seen simultaneously from many different angles, in numerous moods, from various lights, and in diverse dress. "Cubism," writes Sigfried Giedion, "breaks with Renaissance perspective. It views objects relatively; that is, from several points of view, no one of which has exclusive authority." In other words, a multiplicity of moments-in-time and perspectives are superimposed upon one still rectangle; and certain examples of mixed-means theatre attain a similarly Cubist fusion of temporal and perspective diversity within a single frame.

Nonetheless, in painting such a development implies a converse action, which is actually a movement out from the painting's frame into the third dimension of space and eventually the fourth of time, no longer suggesting depth and duration through illusory means but actually achieving them as physical qualities. In the history of painting, collage leads into assemblage, which extends the collage principle into space and various media. Picasso initiated this modern device by pasting a fragment of oil cloth onto a Cubist composition, *Still Life with Chair Caning* (1912), and then wrapping a piece of hemp around it in lieu of a frame. Such an act represents, writes William Seitz, "the absorption of assembling objects into the method, as well as the subject matter, of painting." Out of Picasso's artistic precedent,

write Harriet Janis and Rudi Blesh, came "the movement of the picture out into space and its eventual merging into action and/or forms in the space-time continuum." In the middle fifties, Allan Kaprow, originally a painter, extended the collage principle into time when he escalated an exhibition of his assemblages into an all-over environment with moving parts, *Penny Arcade* (1956). "Not satisfied with the *suggestion* through paint of our other senses," he wrote at that time, "we shall utilize the specific substances of sight, sound, movement, people, odors, touch. Objects of every sort are materials for the new art." Subsequently, he pushed the collage technique one step further to pure happenings which, he writes, "in structure and content are a logical extension of 'environments.'" Where space was once static and the spectator a passive observer, now it becomes kinetic and he a participant. If Jackson Pollock regarded the canvas as an area within which the painter acts and represents his actions, Kaprow in pure happenings removed the canvas, so to speak, and made the action itself into an artistic event. "Space is no longer pictorial," Kaprow wrote in 1960, "but actual (and sometimes both); and sound, odors, artificial light, movement and time are now utilized." Also in the middle fifties, Robert Rauschenberg incorporated a stuffed goat into his collage entitled *Monogram* (1955–59), thereby creating "a combine" or stand-up painting. In 1959, he initiated fourth-dimensional painting (a phrase which incidentally could also define certain strains of new theatre), by incorporating an actual radio into the field of *Broadcast*. To the curator-critic Henry Geldzahler, the historical significance of painters' mixed-means theatre lies in "an attempt on the part of painters to reintroduce recognizable human content into our artistic life."

From sculpture, two contemporary tendencies—one extrinsic, the other intrinsic—flow into the new theatre. The first aims to get sculpture off its heavy pedestal and out of the museum into an informal setting and, parallelly, brings informal materials, such as crushed car parts and other junk, into sculpture, all to make sculpture more intimate and accessible to the spectator. In his *Mobile* (1913), Marcel Duchamp put a bicycle wheel on a stand, initiating not only "ready-mades," but kinetic sculpture; and by the end of that decade, the Russian sculptor Vladimir Tatlin founded the modern practice of constructing an abstract object out of miscellaneous materials, as well

as designed a sculptural *Monument to the Third International* (1919–20) that would have been over one thousand feet high. The late David Smith, probably the greatest modern American sculptor, preferred to "house" his metallic pieces on his own front lawn; and Simon Rodia, whose intentions may not have been as classically artistic as Smith's, actually constructed his masterful Watts Towers in his backyard, right in a Los Angeles slum. His works are so large that attempts to move and house them are likely to be thwarted. Similarly, Claes Oldenburg always transforms an exhibition of his sculpture into an integral environment, to create the illusion that the setting is not a gallery or a museum but an artistically articulated space, and he generally allows the art-viewer to *touch* his works. Moving sculpture outside is at once a physical reality and a metaphor for extending sculptural designs into theatrical settings; for as the life-size sculptures of George Segal, a close friend of Kaprow's, create the impression, Lucy Lippard notes, of "quick-frozen happenings," so Oldenburg's theatrical pieces, particularly those in *The Store* (Spring, 1962), are designed to offer experience as tactual as his sculpture.

The second major evolution of contemporary sculpture has been away from a material concept of space to virtual and kinetic volume. That is, in contrast to a piece of classic sculpture which defines its presence by its mass, the Constructivist works present a skeletal frame which encloses the space (or body) of the work. "We deny volume as a spatial form of expression," wrote the brothers Naum Gabo and Antoine Pevsner. "In sculpture we eliminate (physical) mass as a plastic element." The "volume" of a Constructivist sculpture is virtual (enclosed and imposed) and yet constant, even though it becomes redefined as the spectator moves around the piece. "From each new viewpoint," writes Carola Giedion-Weckler, "it seems to be a different composition." Mobiles and other forms of kinetic sculpture, however, continually rearticulate both their virtual volume and definition, "by the [constant] motions of points (smallest bodies)," Moholy-Nagy writes, "or by the motion of linear elements or larger bodies." In this respect, Alexander Calder's mobiles exist in time as, Moholy-Nagy continues, "a weightless posing of volume relationships and interpenetrations" (which explains why film reproduces them more effectively than photographs). Indeed, Moholy-Nagy himself designed plastic and mechanical "light sculptures" which expressively

transform and reproject the illumination around them. "By the mere fact of devoting fresh attention to the problem of light," he wrote to Giedion-Weckler in 1937, "we enter into a new feeling . . . which can be summed up in one word—floating." Therefore, kinetic sculptures presage those strains of new theatre in which people and objects are less sculptural volumes in a fixed space, as in literary theatre, than kinetic forces in a continually rearticulated space.

If the new theatre grows out of the desire of painters and sculptors to stretch their art into time, so it also extends from the concern of certain composers with the space their pieces fill; and this tendency, in turn, complements the musical tendency to exploit in a theatrical context all possible materials, regardless of their medium, previous familiarity, or artistic status. Richard Wagner was probably the first important modern composer to favor an integrally mixed-means work; and certain recent happenings seem an ironic comment on his conception of "the artwork of the future." Years after him, the Russian composer Alexander Scriabin incorporated a light-projector into his *Prometheus—The Poem of Fire* (1910) and later envisaged a *Mysterium* which he wanted to perform, Faubion Bowers writes, from a mountain top in India before an audience that could also observe images on a screen and inhale various kinds of incense, as well as pursue certain activities to Scriabin's instruction.

Where Wagner and Scriabin wanted to assault the senses with a variety of stimuli, the American composer Charles Ives, like Gabrieli and Mozart before him, desired to make the performance space contribute to his compositional intention; and in his *The Unanswered Question*, written in 1908 but not performed until many years later, two groups of musicians are, by design, separated from each other, while a soloist is assigned to a third position in the hall. "There is complete contrast between the three elements," writes the composer Henry Brant, "in tone quality, tempo (which includes speedups, retards and rebato), meter, range; harmonic, melodic and contrapuntal material. No rhythmic co-ordination exists between the three constituents, except an approximate one at points of entrance." As the sound literally moves from one place to another, the piece attains choreographic qualities and its space becomes kinetic; and by granting his three sound-sources a relative degree of autonomy, Ives literally created what we would now define as a staged happening. More

recently, Brant himself has pursued the possibilities of sounds in space, distributing his musicians all over (and sometimes under) the performance situation; and most wholly electronic pieces exploit the technological capability of distributing a sound over one or several of many loudspeakers.

In America, among the greatest influences shaping the Theatre of Mixed Means are the ideas and examples of John Cage, who in the early fifties made the intellectual leap that connected all performed music with theatre. In 4'33" (1952), perhaps the most crucially influential of Cage's artistic illustrations, the pianist David Tudor comes to the bench and sits—just sits still—for the prescribed duration. The "music" is composed of all the sounds that happen to arise in the performance during 4'33" and the "theatre" consists of all the miscellaneous visual-aural activities that happen within that time span. Pursuing the implications of his example, Cage takes the radical step to say that any and all sounds, arranged in any way, whether intentional or accidental, are "music" and that all activities, both visible to the eye and audible to the ear, constitute "theatre." In a 1954 lecture entitled "45' for Speaker," he wrote, "Theatre takes place all the time, wherever one is. And art simply facilitates persuading one this is the case." While admiring the freedom implicit in his position, most creators of the new theatre take a slightly more conservative position, which holds that any and all sounds and images, as well as any juxtapositions of these elements, are viable components of a theatrical situation which the artist *designs* to a certain coherence and conception— what Schwitters meant when he described "the dimensions required by the work." Only practitioners of pure happenings take the final leap with Cage and regard unintentional elements as intrinsic to the piece.

"Cage is currently less concerned with musical structure than with theatre," as Milton Babbitt so concisely put it; and many a spectator has found Cage's comic demeanor and David Tudor's swift and expansive movements all over and under the piano as engaging as the sounds they produce. Indeed, Cage himself has stated that he often finds the orchestral performers' machinations more interesting than the music they play, particularly when their movements are not in unison; in *Theatre Piece* (1960), which like all his recent works is indeterminate in performance, he intentionally substituted directions

for visual activities (which, of course, inadvertently make sounds) for his usual prescription for aural experience. His most recent mixed-means performance pieces create a situation which offers, to quote him, "the autonomous behavior of simultaneous events," both visual and aural; and a thoroughly hybrid event, such as his spectacular *Variations V* (1965), in which his music joins Merce Cunningham's dance, Stan VanDerBeek's films and several sorts of complicated electronic technology, is probably the most original and interesting form of opera America has today.

The Theatre of Mixed Means also descends from tendencies in contemporary dance. Historically, the first great development in modern dance, as John Martin has observed, was away from an emphasis upon classic poses (the framing of pictures) and choreographic conventions (stylization) to a concentration upon more original patterns of movement and personalized expression. With this shift from stasis to kinesis and from the telling of stories (and the creation of consistent characters) to the making of suggestively indefinite activities, the new dance of Isadora Duncan and Mary Wigman initiated a more fluid and dynamic conception of space, which was both non-rectangular and continually rearticulated. The work of Ann Halprin and Merce Cunningham culminates the second revolution of modern dance. Developing her ideas in San Francisco quite independently of Cunningham, who has lived in New York, Halprin allows in her work only natural movement which arises in the course of accomplishing a particular task; therefore, although people move in her pieces, often quite beautifully, the beauty that is created is more "found" than intentional. Moreover, her pieces exhibit a clearly unfettered use of space and material—an attitude characteristic of the entire mixed-means movement; and several of her more recent activities pursue this predilection into pure happenings in which an event, out of its own processes, develops organizing principles that define the piece. An example is the creation, mentioned before, of the driftwood city.

In their long professional association with each other, Cage and Cunningham have evolved similar aesthetic principles; and if Cage suggests that all sounds can be considered music, so Cunningham believes that all kinds of movement, in any combination, whether intentionally choreographic or not, can be considered viable compo-

nents of "dance." To demonstrate this bias, in *Collage I* (1952) he instructed his company to perform onstage such everyday activities as combing their hair, brushing their teeth, and washing their hands. In addition to exposing dance to all available movements, Cunningham has achieved four great changes in dance structure. First, he separated dance from its enslavement to the rhythms of the accompanying music. Not only does Cunningham generally compose his dances without musical background, but when he does use music (which he usually chooses after he composes the dance), the dancers do not follow its sounds—it functions as an equally discontinuous aesthetic parallel to their movements. His definition of "music" is, of course, as liberal as Cage's, and in his *How to Pass, Kick, Fall and Run* (1965) the "score" consists entirely of John Cage reading a series of funny stories. Jill Johnston writes that Cunningham's work was "the first example in dance of putting things together, or letting things go together that are not logically thought to have any business being together." Second, not only do Cunningham's dancers move independently of each other, but the parts of their bodies also function within a similarly discontinuous syntax. Third, he discards the traditional rule that a particular dance should have a single fixed order; sometimes he tosses coins to determine the sequence of its parts. Finally, his pieces depart from traditional dance by exploding the focus out from a particular dancer to the entire stage (as Pollock's all-over paintings animate an entire canvas), as well as by abandoning the traditional reliance upon climaxes and resolutions. In these principles, the authors of the new theatre have much in common with Cunningham; and like Cunningham and Cage, nearly all of them reject the notions that art should express the author's emotion or direct attention to a particular extrinsic reference. Their art affects us primarily, but not entirely, as arrangements of sensory forms.

Traditionally, film has been, in Marshall McLuhan's dichotomy, a hot medium. That is, primarily because it occupies so few degrees of man's entire viewing range, film fosters detachment in the audience. However, recent years have witnessed numerous attempts to make the film experience more intimate and involving—more primarily tactual than visual. Alain Resnais's *Last Year at Marienbad* (1962), with its blurred outlines and undefined action, has a cooler, more involving quality than standard fare; and like the mixed-means

theatre, so much of the best cinema since 1960—in the age of Godard —is more elliptical from sequence to sequence, or less dependent upon telling a patently coherent story, as well as more demanding of the sensory faculties; and these formal changes make film a more involving medium, to those segments of the audience willing or prepared to become involved.

Moreover, the experiments in multiple projection, ranging from Cinerama to 3–D, attempt to encompass more of human attention than conventional screening—an effect similar to that produced by sitting very close to the screen. For instance, when the philosopher Ludwig Wittgenstein finished a seminar or lecture, his pupil Norman Malcolm remembers, he would immediately rush off to the cinema, where he would insist upon sitting in the front row. There the screen "would occupy his entire field of vision, and his mind would be turned away from the thoughts of the lecture and his feelings of revulsion." Cinerama can achieve a similarly total absorption, as evidenced by a toboggan ride, in an early example, which invariably induced frantic screams, and in many of the 3–D films, a fad that passed too quickly, several events exploited the semblance of depth to shock the audience. A primary current ambition, expressed by artists as various as Milton J. Cohen and Stan VanDerBeek, consists of systems of movies and slides, as well as lenses and mirrors, that would project images onto all the available space above the floor, often in combination with live performers, music, and other sensory input; the aesthetic model is the classic planetarium. "The lesson," Howard Junker writes, "is that creating perfect illusion entails encasing the audience with images." Also, by surrounding the eyes with visual data, such experiments more accurately duplicate the quality of real life than "neo-realism" or the most factual documentary.

In most strains of mixed-means theatre, however, film becomes another means for filling the space. Sometimes filmed images are projected upon a wall or a screen, as well as a mobile prop and/or person. Film also functions as a commentary on the medium itself—a major theme of Robert Whitman's *Prune. Flat.* (1965) is film's illusionistic capacity; for not only is a certain action on film quite different from the same action repeated live on the stage, but projecting a filmed image upon a live performer produces strange effects upon both the film and the person. In that kind of situation, a mixed-means artist

is taking a fixed product—a print of film—and putting it in an un-fixed process-situation; and that produces not only singular patterns of integration but also a greater diversity of response.

In *The New Vision*, Moholy-Nagy offers a strikingly comprehen-sive insight into the unprecedented character of all contemporary culture, when he noted that as the emphasis in poetry has shifted "from syntax and grammar to relations of single words," so painting has changed "from colored pigment to light (display of colored light)," which is to say film; so modern sculpture has evolved "from mass to motion" and so architecture has developed "from restricted closed space to free fluctuation of forces." In the old architecture, as well as in the old styles of theatre and sculpture, space was a static volume which could be best observed from one place; Fontainebleau, near Versailles, for instance, asks to be viewed from the front. In the new architecture, as well as the new theatre, when we move around the building its space becomes kinetic, as our perception of it is continually changing. Contrasting Renaissance space with present conceived today is its many-sidedness, the infinite potentiality for awareness, Sigfried Giedion writes, "The essence of space as it is relations within it. The eye can not sum up this complex at one view; it is necessary to go around it on all sides, to see it from above as well as from below." The new theatre resembles the new architecture in denying the traditionally clear boundary between inside and out, between what belongs to the structure and what does not. Therefore, the revolution in space implicit in the tradition that runs from Frank Lloyd Wright's Robie House (1906), with its indeterminate spatial flow between the living areas, through Walter Gropius' Fagus Factory (1911) with its glass walls, Le Corbusier's Chapel at Ronchamps (1955), and Mies van der Rohe and Philip Johnson's glass-walled Seagram Building (1958), demands of the spectator the same kind of perceptual readjustment as kinetic sculpture and mixed-means theatre. All these tendencies, writes Moholy-Nagy, "lead to the rec-ognition of a space condition which is not the result of the position of static volumes, but consists of visible and invisible forces."

The dominant forces shaping the new theatre, particularly in Amer-ica, come from outside theatrical circles; yet these recent developments still represent extensions of modern theatrical ideas regarding the ma-terials available to the director, the space a performance creates, and

the performance's relationship to its audience. Ever since the debut of Alfred Jarry's *Ubu Roi* (1896), which represented the overthrow of nineteenth-century conventions and the ideal of similitude as well, everything has become possible in the theatre, although, one hastens to add, certain propitious possibilities became more acceptable earlier than others. Intrinsic in this assertion of absolute freedom was the unfettered use of additional media. Where Sergei Eisenstein, a theatrical director before he turned to movies, incorporated film clips into his early twenties' stage productions of Jack London's *The Mexican* and Alexander Ostrovsky's *Enough Simplicity in Every Sage* (and in 1923 actually staged *Gas Masks* in a gas factory), his former teacher Vsevolod Meyerhold suggested in his 1930 lecture on "Reconstruction of the Theatre" that the director, "using every technical means at its [theatre's] disposal, will work with film, so that scenes played by the actor on the stage can alternate with scenes he has played on screen." Erwin Piscator, working in Berlin around the same time (with Moholy-Nagy as his stage designer) also adopted this innovation, which has since become so respectable that film clips are now frequently incorporated into Broadway productions.

Where the proscenium stage, which historically emerged in Italy in the seventeenth century, was tied to Renaissance ideas about visual perspective and the arched banquet halls of Italian palaces, many contemporary directors favor a more open stage, where at least three and sometimes four sides face the audience. Some productions today extend out into the auditorium itself, not only through the rampways we associate with burlesque but also by actually planting actors in the seats. As the audience becomes a part of the performance's active space, it feels more viscerally involved with what transpires. "This sense of physical participation, in conjunction with the pre-established atmosphere of intimacy between actor and audience, [extends the] immediate theatre reality over the whole of the auditorium," Earle Ernst writes of the Kabuki Theatre, "so that the focal center of the performance is created in the midst of the audience." Indicatively, as Western theatre moves out of the proscenium mold, the melodramatic forms that were once the common theatrical staple become more appropriate to the rectangular performance fields of conventional movies and television.

Greater audience involvement is a motive we nowadays associate

with Antonin Artaud, who argued in *The Theatre and Its Double* (1938) that as the Western tradition of literary theatre had reached a dead end, theatre should abandon the Word and return to more primitive or Eastern conceptions of a ritualistic spectacle and an intimate performer-audience relationship. Artaud's ideas have since filtered into the contemporary literary theatre. In Ionesco's *The Chairs*, for instance, the most significant scenes, as well as the climax, are entirely wordless (or filled by sounds that might be interpreted as ersatz), and the characters function, their author writes, as "the pivots of some mobile construction." The Artaud influence extends to Roger Blin's direction of Jean Genet's plays, Judith Malina's productions at New York's Living Theatre, and the extraordinary work of Jerzy Grotowski, who transforms his entire theatre in Wroclaw, Poland, into a functioning stage. In a prison play, for example, he places the audience in one cell while the action takes place in another; in Christopher Marlowe's *Dr. Faustus*, the audience sits among the actors at a long medieval dining table. Enticing the audience to become participants in a theatrical process is, as Artaud would have recognized, precisely the same strategy that informed primitive ritual theatre.

However, all these achievements differ from the Theatre of Mixed Means in several crucial respects. Blin, Malina, and Grotowski use professional actors who play roles; the new theatre usually draws performers trained in the other arts or even people of no particular competence, all of whom execute prescribed tasks. Also, where these three directors usually adapt the scripts of others, in the new theatre the director—the man who "fields" the performance—is usually also the scripter of the plan; having assumed responsibility for both creation and execution, he becomes the total author of the production. As a result, since each performance piece is so closely attached to its author, it is generally impossible for one man to duplicate another creator's piece as closely as, say, productions of *Hamlet* duplicate each other. True, he may adapt another man's format or even pilfer an image or a sequence, but then what is stolen probably becomes the crook's possession.

A first-rate mixed-means work generally represents a more integral fusion of various media than the blatant combination exemplified, for example, by most musical comedies. Sergei Eisenstein perceived the crucial difference when he contrasted the Japanese Kabuki en-

semble with the Moscow Art Theatre. In a *"monastic ensemble* [italics his]," he wrote, "sound-movement-space-voice here *do not accompany* (or even parallel) each other, but function as *elements of equal significance."* Perhaps the mixed-means theatre will someday evolve, as Kabuki has, a coherent, purely theatrical language composed of all the artistic languages that theatrical situations include, and Western audiences will understand everything they perceive as definitively as Japanese spectators comprehend Kabuki performances.

The new theatre extends Bertolt Brecht's idea of theatrical alienation, as the playwright and critic Lee Baxandall has noted, not only in making "words, music and setting . . . become more independent of one another" and rejecting the clichés of commercialized theatre, but also in espousing the objective creation of a spectacle which produces responses that are at once subjective and personal and yet detached and critical. "The A-effect," writes Brecht, "consists of turning the object . . . to which one's attention is to be drawn, from something ordinary, familiar, immediately accessible, into something peculiar, striking and unexpected. What is obvious is in a certain sense made incomprehensible, but this is only in order that it may then be made all the easier to comprehend." That second sentence inadvertently indicates a primary strategy of mixed-means theatre—to present common materials in arrangements so original that each member of the audience will be forced to a perception, if not a definition, wholly his own.

The new movement in American theatre connects with the great (but sometimes hidden) tradition of non-literary performance which, I would argue, has been the dominant and propitious tradition of the American stage. From pre-Revolutionary times to the present, the best American theatre has eschewed literary moorings for an emphasis upon performance values, where the performer himself was the author of whatever words he spoke—a tendency that artistically owed more to the European example of *commedia dell' Arte* than Elizabethan theatre. As Constance Rourke showed in *American Humor* (1931), much of the best American theatre in the nineteenth century existed in the minstrel shows; and had she lived into the 1960's, Miss Rourke undoubtedly would have rewritten her posthumously published *The Roots of American Culture* (1942) to identify the Boston Tea Party as an early semblance of pure happenings. "It may well be a ques-

tion," she wrote, "whether the participants enjoyed more dumping the tea in the harbor or masquerading in warpaint and feathers with brandished tomahawks."

Early in the current century, the most satisfying theatre was found in vaudeville—a hybrid, mixed-means format that could encompass nearly every known kind of entertainment. Like vaudeville, the Theatre of Mixed Means is not exclusive but inclusive, exploiting everything it can potentially encompass, rather than putting down some feasible possibilities as beneath its dignity; vaudeville and the new theatre are also distinctly similar in formal strategy. "Not the happy ending but the happy moment," writes Albert F. McLean. "Not the fulfillment at the end of some career rainbow but a sensory, psychically satisfying here-and-now were the results of a vaudeville show."

At the same time that Eugene O'Neill's plays became the masterworks of the American stage, the great performers entered the movies, creating a cinema where the Marx Brothers, Charlie Chaplin, Buster Keaton, and Orson Welles either dominated the director's efforts or became their own directors, if not scriptwriters and, in Chaplin's case, the composer too. Some observers have argued that the great performance tradition expired in the early thirties when the cinema and radio killed vaudeville, but I would reply that it continued in certain dramatic productions whose form and tradition often went unrecognized. In 1924, the stage designer Norman Bel Geddes transformed an entire Broadway theatre into the semblance of a cathedral (an environment) for Max Reinhardt's pantomime production of *The Miracle*. "The stage contained a facade of Gothic architecture pierced by windows of stained glass," writes Mordecai Gorelik. "Religious processions moved down the aisles of the theatre."

The greatest theatre of the thirties, I understand, came not from the script-oriented Group Theatre, whose history several memoirs have transformed into myth, but from Orson Welles's Mercury Theatre, which was more concerned with creating a spectacular performance than with scrupulously rendering the text. (He was, so to speak, more the disciple of Meyerhold than Stanislavsky.) In 1947, Stark Young wrote that the dancer Martha Graham was "the most important lesson for our own theatre that we now have," and two years later Eric Bentley judged José Limon's *The Moor's Pavanne*

the best theatre then current in New York. The performance tradition was sustained into the late fifties by Judith Malina's production of *The Connection* (1959), where the necessities of effective performance transcended Jack Gelber's script, and her extraordinary direction made Kenneth H. Brown's *The Brig* (1963) into a singularly spectacular production. Moreover, most live jazz concerts, which achieve a structure similar to that of the minstrel show, represent some of the best performance theatre around. In short, what theatrical genius we have had in America would seem to express itself primarily not in playwriting but performance—our writers excel, instead, at the arts privately created and privately consumed, such as fiction, poetry, and the essay. Perhaps by now we should recognize once and for all that the European tradition of a theatre of literature, like the European opera or the novel of manners, will not thrive as well on these shores.

The new theatre is characteristically American in its frequent references to sub-artistic or "popular" culture, if not in its use of the actual objects themselves—automobiles in Claes Oldenburg's *Autobodys* (1962), the most common of American historical myths in his *Injun* (1962), the radio and other mundane sources of sound in John Cage's pieces, bridal costumes in Ken Dewey and Terry Riley's *Sames* (1965), a corny travelogue in Robert Whitman's *Two Holes of Water* (1966). In practice, the pop reference is either the subject of the piece, an element within a larger frame, or a distortion that evokes ironic meanings; the popular element can even become the actual setting for the performance—as Oldenburg has exploited the seats of a moviehouse, so segments of Kaprow's *Gas* (1966) used such "found objects" as a summer beach on a Saturday afternoon and a garbage dump. What is important is that the new theatre, like pop art, views popular materials as a feasible subject for artistic purposes; and in this respect its artists connect with an American tradition that includes Charles Ives's *The Concord Sonata* (1915), which mixes snatches of hymn tunes with references to Beethoven's *Fifth Symphony*; and Herman Melville's *Moby-Dick* (1851), which integrates common whaling lore with allusions to Shakespeare. (An implication of this tradition, I suggest, is that the American artist finds both high and popular culture equally immediate to his existence and perhaps

equally important, though in different ways. This attitude had wide currency here long before either pop art or mixed-means theatre was born.) Furthermore, not only does the new theatre display a rough surface texture and hybrid quality that is so unlike the smooth prettiness typical of European art, but formally it recreates all the visual diversity and discontinuity of our culture—a disordered order that invariably strikes the European organicist mentality as "chaos."

Indicatively, as the Theatre of Mixed Means extends from all the arts it encompasses, so its creators trace their own artistic origins to a diversity of conventional arts. Ann Halprin worked in a Broadway troupe before she gave her first dance recital. Before he turned to dance, Merce Cunningham aspired to be an actor; in recent years, he has both conducted John Cage's music and directed short plays. Robert Whitman, Robert Rauschenberg, Allan Kaprow, and Steve Durkee (of USCO) were all originally painters; Claes Oldenburg, Robert Morris, and Carolee Schneemann do sculpture; and Rauschenberg has designed costumes and decor for the Merce Cunningham Dance Company. Ken Dewey, Michael Kirby, Meredith Monk, and Lawrence Kornfeld served apprenticeships in the theatre; Gerd Stern (of USCO) was once a poet and a journalist, and his associate Michael Callahan learned electrical work from his father and psychology in school. John Cage has written two books of essays, and the composer Dick Higgins also runs a publishing house. Stan VanDerBeek, once a painter, first became known for his films. All of these artists developed modernist ideas in their respective fields, and out of the convergence of these ideas comes the new kind of theatre we know.

Indeed, the prime movers of the new movement in America have had little experience with conventional theatre. Although Allan Kaprow is often credited as the originator of "happenings," what was in fact probably the first such premeditated event in America stemmed from a cooperative performance at Black Mountain College, North Carolina, in the summer of 1952. As John Cage remembers it, in his foreword to *Silence* (1961), the evening "involved the paintings of Bob Rauschenberg, the dancing of Merce Cunningham, films, slides, phonograph records, radios, the poetries of Charles Olson and M. C. Richards recited from the tops of ladders, and the pianism of David Tudor, together with my Juilliard lecture, which ends: 'A piece of

string, a sunset, each acts.' The audience was seated in the center of all this activity." Indicatively, none of these participants has had any connection with professional theatrical circles; and Kaprow's involvement ran no further than composing in 1960 an electronic score for an off-Broadway production of Eugene Ionesco's *The Killers*.

The Theatre of Mixed Means has developed outside the professional theatrical community, which has less opposed the new work than remained unaware of it. Kaprow's performances in the late fifties were held in art galleries or outdoors on private farms; now he uses spaces that know no limits, such as cities and counties. Some early events were performed in the gymnasium and gallery of Judson Memorial Church; Claes Oldenburg rented a narrow Lower East Side store to house his pieces. La Monte Young has performed in encased settings as various as a friend's loft, a small off-Broadway theatre, and a tent on Long Island. Some of the best recent performances used the New York Film-Makers' Cinematheque; and where Dick Higgins rented Sunnyside Gardens, a boxing ring, for Easter morning (1965), the Theatre and Engineering Festival (1966) used the same New York armory that had housed the notorious Armory Show more than fifty years before. Of the major practitioners of mixed-means theatre, only Robert Whitman and Carolee Schneemann have accepted formal contracts that require them to repeat a piece in the same theatre and at certain times.

The following list of American authors, several important pieces, places, and dates provides a more effective history than a padded narrative:

John Cage, Untitled staged happening, Black Mountain College, N. C. (Summer, 1952)

Allan Kaprow, *18 Happenings in 6 Parts*, Reuben Gallery, N. Y. (October, 1959)

Ann Halprin, *Birds of America or Gardens Without Walls*, University of British Columbia (December, 1959)

Red Grooms, *The Burning Building*, Delancey Street Museum, N. Y. (December, 1959)

Claes Oldenburg, *Snapshots from the City*, Judson Gallery, N. Y. (March, 1960)

Robert Whitman, *The American Moon*, Reuben Gallery, N. Y. (November, 1960)

Claes Oldenburg, *Injun,* Museum for Contemporary Arts, Dallas, Texas (April, 1962)

Allan Kaprow, *The Courtyard,* The Greenwich Hotel, N. Y. (November, 1962)

Robert Rauschenberg, *Pelican,* Kalla/Rama, Washington, D. C. (May, 1963)

Ken Dewey, *et al., In Memory of Big Ed,* International Writers' Conference, Edinburgh, Scotland (September, 1963)

Ann Halprin, *Parades and Changes*—Version I, San Francisco State College (February, 1964)

La Monte Young, *The Tortoise, His Dreams and Journeys,* Pocket Theatre, N. Y. (October, 1964)

Carolee Schneemann, *Meat Joy,* Judson Memorial Church, N. Y. (October, 1964)

Robert Morris, *Waterman Switch,* Judson Memorial Church, N. Y. (January, 1965)

Dick Higgins, *The Tart,* Sunnyside Gardens, N. Y. (April, 1965)

John Cage, *Variations V,* Philharmonic Hall, N. Y. (July, 1965)

Allan Kaprow, *Calling,* New York City and New Jersey woods (August, 1965)

Ken Dewey and Terry Riley, *Sames,* Film-Makers' Cinematheque, N. Y. (November, 1965)

Claes Oldenburg, *Moviehouse;* Robert Rauschenberg, *Map Room II;* and Robert Whitman, *Prune. Flat.,* Film-Makers' Cinematheque, N. Y. (December, 1965)

Kenneth King, *Blow-Out,* Judson Memorial Church, N. Y. (April, 1966)

Robert Rauschenberg, Robert Whitman, John Cage, *et al., Theatre and Engineering Festival,* 69th Regiment Armory, N. Y. (October, 1966)

Meredith Monk, *16 Millimeter Earrings,* Judson Memorial Church, N. Y. (December, 1966)

Although the impetus of the mixed-means theatrical movement seems to reside in America, the works here resemble parallel activities all over the world. The Gutai Group of Japanese painters were doing similar events in the middle fifties, although they have since abandoned the theatrical medium which has recently attracted a subsequent group of Japanese artists. There exist constellations of mixed-means practitioners in Germany, France, Holland, Scandinavia, and Czechoslovakia, all of whom interact with each other as well as learn about American phenomena. Nonetheless, discriminating observers who

travel more than I find that national boundaries separate distinctively different styles. As Edward T. Hall points out in *The Hidden Dimension* (1966), "No matter how hard man tries it is impossible for him to divest himself of his own culture, for it has penetrated to the roots of his nervous system and determines how he perceives the world."

# 3

Man takes cognizance of the emptiness which
girds round him and gives it psychic form and
expression. The effect of this transformation,
which lifts space into the realm of the emotions,
is space conception. It is the portrayal
of man's inner relation to his environment:
man's psychic record of the realities
which confront him, which lie about him
and become transformed.
—Sigfried Giedion,
*The Eternal Present: The Beginnings of Art*
(1962)

Just as the new theatre extends from so many distinctly modern tend-
encies in the arts, so has it much in common with certain impulses
which we recognize to be truly contemporary in recent thought. In one
respect, the new theatre contributes to the contemporary cultural re-
volt against the predominance of the Word; for it is definitely a
theatre for a post-literate (which is not the same as illiterate) age, in
which print will interact and compete with other media of communica-
tion. As twentieth-century art and music were liberated from the
nineteenth century's dependence upon literary themes and concep-

tions, so has the new theatre emancipated itself from the need to make sense with words. The Word, it seems to say, separates man from an instinctive relationship with natural life; for as Marshall McLuhan notes, it was the ideographic alphabet, in contrast to the Eastern calligraphic, that initiated Western man's alienation from his environment. "By surpassing writing, we have regained our wholeness, not on a national or cultural, but cosmic, plane. We have evoked a super-civilized sub-primitive man." Paradoxically, the new theatre which is so deeply an extension of modern culture eschews the primary material that created that culture—expository prose.

By cultivating the total sensorium, the new mixed-means art seems designed to help man develop a more immediate relationship with his surroundings; for not only does the Theatre of Mixed Means return the performer-audience situation back to its original, primitive form as a ceremony encompassing various arts, but it also endeavors to speak internationally—to employ the universal media of sounds and movements, as contemporary painting speaks universally in shapes and colors, in an age when the old spoken languages contribute to archaic national boundaries. Similarly, the Theatre of Mixed Means denies the myth that formal education is necessary for the appreciation of art and, therefore, the tradition that theatrical arts are solely for the educated, even though many pieces demand an experienced perception for which the mixed-means theatre is often its own best teacher.

The new theatre also links with another contemporary notion which holds that art and life, instead of being wholly distinct realms, are continuous, if not identical; therefore, the old conservative cliché of "It's not art" is today more amusing for its archaism than valid for its relevance. Some recent artists have even espoused a naturalistic aesthetic whose primary tenet is that art must emulate the disorder of natural life—what the conservative critic Yvor Winters christens "the fallacy of imitative form." "I think daily life is excellent and that art introduces us to it and its excellence the more it begins to be like it," John Cage once said, using a syntax whose ambiguity must be intentional. The new theatre, however, is not an extension of literary naturalism; for although it employs natural materials and movements, its purposes are more formal than representational—it is more interested in the structural patterns life presents than in offering a literally detailed "slice of life." That is, lifelikeness as a positive value refers

more to form than detail or, as Cage might say, "As life is complex and lacks a steady beat, so I prefer complex theatrical pieces of irregular rhythm." This bias toward formal similitude also becomes a method. When Rauschenberg designed sets for the Merce Cunningham Dance Company, he would often, just before a performance of a certain dance, *Story* (1963), draw upon scrap materials that happened to be lying about; and in the same piece, the performers at regular intervals would go offstage and pick additions to their costumes from a scrap-heap of diverse clothes.

The method they used resembles that of the Eskimo who instead of planning to carve a particular figure literally "finds" the figure in the slab at hand or the Indian sarodist Ali Akbar Khân who says of how he starts a piece, "I have to listen to the drone and check my instrument, and then I begin to see the full character of what I am going to play. It opens up like a book." The rationale of this method was expressed by a Balinese sculptor who said, "We don't create art. We just do as well as we can." The analogy with Eastern and primitive activity has two other dimensions of relevance. "Where European art naturally depicts a moment of time, an arrested action or an effect of light," writes Ananda K. Coomaraswamy, "Oriental art represents a continuous condition." Second, as Margaret Mead points out:

The art of primitive culture seen now as a whole ritual, the symbolic expression of the meaning of life, appeals to all the senses, through the eyes and ears, to the smell of incense, the kinaesthesia of genuflection and kneeling or swaying to the passing procession to the cool touch of holy water on the forehead. For Art to be Reality, the whole sensuous being must be caught up in the experience.

This attitude presumes that some of the best art stems from fortuitous accidents. Although Versailles is impressive, writes the architectural historian Jacqueline Thywhitt, "inwardly we find it rather boring. Main Street at night . . . is a chaotic mess, but inwardly we find it rather exhilarating."

Thus it is implied that ordinary life is filled with artistic movements and objects. The architectural professors Appleyard, Lynch, and Myer have, in *The View from the Road* (1964), written sensitively about the aesthetic experience of driving on the highway, and both the dance critic Edwin Denby and the anthropologist Edward T. Hall have

shown how much learned and developed "art" there is in such a normal activity as walking—how Americans, say, have assimilated and developed distinct forms of walking (and, thus, contrasting kinetic-space conceptions) different from Italians. Furthermore, because of the impact of contemporary design, most of us experience more consciously designed art per day than our historical predecessors. As I write this essay, for instance, I look at a streamlined typewriter keyboard that is considerably more artistic than keyboards of fifty years ago. Today, art is everywhere, impressing our sensibilities all the time.

It is indicative, therefore, that in mundane activities we find the aesthetic precedents and parallels for all genres of new theatre—as both battles and Easter egg hunts resemble pure happenings, so churches and discotheques are kinetic environments; as rodeos (and bullfights) and spectator sports are staged happenings, so circuses and burlesque routines are equivalents for staged performances. As our responses to these phenomena are not unlike our responses to the new theatre, our memories of these events tell us how each strain of new theatre offers us a different kind of perceptual experience. After all, as Herbert Read writes, "to give coherence and direction to play is to convert it into art," and recreation is a kind of re-creation.

Just as the radical aestheticians like Read, Gyorgy Kepes, George Kubler, and Marshall McLuhan would dismiss as insignificant the distinction between fine and applied art and elevate all modern life to the status of an aesthetic experience, so the new theatre, among its more radical implications, would remove art from its perch above experience—where it is held to be greater than experience—because it distinctly enhances it. This depreciation, in turn, implies a dethronement of the artist from his chair high above the mass. The new aestheticians define the artist as the man who makes things that his peers admire:

In primitive societies [writes Margaret Mead] the artist, instead, is a person who does best something that other people, many other people, do less well. His products, whether he be choreographer or dancer, flutist or potmaker, or carver of the temple gate, are seen as differing in degree but not in kind from the achievements of the less gifted among his fellow citizens.

At most, the artist is a seer who perceives more of the actualities

and/or possibilities of the environment—particularly the ways its multiplicity and discontinuity impinge upon the sensibility—and then recreates his sensory experience to communicate it to others. That is, he creates works or activities that make us more conscious of our common existence.

This readjustment of the artist's status also relates to the new art's critique of the traditional hierarchies that related the choice of subject to artistic value. Whereas the female nude was once regarded as the highest or ideal form, it now has, as an image for art, a rank equal to miscellaneous junk; and where a heroic protagonist was once considered the pinnacle in the hierarchy of a play—he was indeed its *star*—so in the new theatre, in general, all performers have a status equal to each other and, sometimes, to nonhuman elements. Indicatively, those notorious nude or semi-nude figures that do appear in mixed-means theatre generally do not, in the context of a piece, function to elevate the text or focus the audience's interest.

Not only do mixed-means authors employ new electronic machinery to produce effects wholly impossible in the nineteenth century, but the new theatre joins the electronic media in contributing to the cultural revolution of the twentieth century: a revolt first against classical conceptions of mental concentration, second against traditional ways of organizing experience, and third against a predominantly visual existence. Just as the front page of a modern newspaper (itself a product of *wire* services) differs from a page of prose by offering a conglomeration of miscellaneous forms and data, so the new theatre insists that we concentrate not upon one place, as before, but everywhere at once. Some pieces are so rich in diverse and often distant activity that they effectively discourage the most recalcitrant habits of narrow focus. Second, the form of the mixed-means theatre corresponds to that of the new media; for whereas the old theatre, as well as the old music and the old film, imitated the formal character of print by offering a line of development, the new theatre presents a discontinuous succession of images and events, which must be pieced together in the observer's mind if the piece is to be fully understood. Finally, the Theatre of Mixed Means resembles the new media in appealing to more than one sense of human attention. The new theatre joins television in initiating, if not demanding, a revision of the sensibilities, inculcating in the young sensory ratios quite different from those of

their elders, as well as a decided preference for experiences which are more participational than observational. Indeed, this difference probably explains, first, why the young are able to do their homework while listening to the radio or watching television and, second, why they find the new theatre and the new multi-media discotheques more congenial than their parents do. In the discrepancy of response to the new theatre lies a symptom of the widening gap of generational difference.

Likewise, the new theatre has much in common with the formal revolutions implied by the new physics—Quantum Mechanics and the Theory of Relativity. According to the Quantum, energy flows not in a continuous stream, as Newtonian physics describes it, but in an uneven arrangement of discontinuous batches whose path of movement cannot be precisely predetermined. Not only is the form of mixed-means theatre more discontinuous than the theatre of Newtonian ages, but the activities in the new theatre are also less precisely programed than those of traditional performance. Moreover, "Space in modern physics," writes Giedion, "is conceived of as relative to a moving point of reference, not as the absolute and static unity of the baroque system of Newton." Similarly, in most strains of the new theatre, one seat is not necessarily more advantageous than another; indeed, if one sits at all, he should change his seat from time to time to observe the same activity from different angles, in the same way that he should move around the best examples of contemporary architecture. A purpose intrinsic in art, Herbert Read writes, is "mankind's effort to achieve integration with the basic forms of the physical universe and the organic rhythms of life;" and the Theatre of Mixed Means contributes to a contemporary effort to make the structures of art emulate the hidden forms of nature (micro-physics rather than macro-physics), not only to bring life and art into harmony but also to make, as art has always done, more of the invisible environment visible.

The new theatre also contributes to that contemporary impulse to obliterate traditional categories of artistic creation and apprehension. "The differences which were once so clear," Kaprow writes, "between graphic art and painting have been practically eliminated; similarly, the distinctions between painting and collage, between collage and construction, between construction and sculpture, and between some

large construction and quasi-architecture." As *Finnegans Wake* is at once poetry, fiction, and essay, so it implicitly challenges such traditional distinctions; and much that is relevant and influential in contemporary thought—the ideas, say, of Marshall McLuhan, Buckminster Fuller, Kenneth Boulding—displace as irrelevant such traditional categories as criticism and social thought, science and humanities, precisely because they encompass all these dimensions. Likewise, contemporary science has undergone so much cross-fertilizing that those hybrid terms like bio-physics and physical chemistry seem to be excessively feeble attempts to draw jagged lines across overlapping territories. "A kind of interchange is occurring," Kaprow continues, "which, besides blurring traditional outlines, is producing a new set of forms that in turn are reconditioning our experience." Thus, a mixed-means theatrical performance can be at once music, dance, drama, and kinetic sculpture, as well as an entirely new form that eschews references to any of those arts. Just as all sciences are becoming Science, and all thinking is becoming Thought, so all the arts are becoming Art.

# 4

Vision in motion is a synonym for simultaneity and space-time; a means to comprehend the new dimension.
—Laszlo Moholy-Nagy, *Vision in Motion* (1947)

For audiences developing today, a sense of media forms and leisure forms is as important as a sense of content.
—Reuel Denney, *The Astonished Muse* (1957)

Many a literary mind has criticized the Theatre of Mixed Means as being "empty of meaning"; yet people trained in the arts know that it is chock full of artistic significances. Certain mixed-means events express a theme that can be defined in the same kind of denotative words we use for talking about literature. Carolee Schneemann's *Water Light/Water Needle* (1966), for example, portrays the high pleasure of physical movement and contact; indeed, it can be considered a realized image of the utopia Norman O. Brown posits in *Life Against Death* (1959). One of the major implications of Claes Oldenburg's *Moviehouse* is that the audience of a moviehouse can be more interesting than the film. Robert Whitman's *Prune. Flat.* expresses meanings of another kind—the differences between kinetic images and static ones, between filmed experience and live

activity. Still, the importance of the mixed-means theatre lies less in its themes and more in its contribution to forms. Not only has the new movement transcended theatrical formulas, whether commercial or anti-commercial, without yet sinking into its own ruts; but it has also reawakened our sense of the possibilities of theatrical situations.

Therefore, the ultimate "meaning" of an event can be nothing more than the forms it offers—the medium of multiple means can be the entire message—just as the complete effect of a piece may be the enhancement of the audience's sensory perception. "The lesson the theatre has to teach," Ionesco once wrote, "extends far beyond the giving of lessons." Without calling attention to its tutelage, the Theatre of Mixed Means teaches us, first of all, to be omni-attentive— to awaken and jostle the perceptive capacities of our eyes, ears, nose, and skin, both to fuse and separate this sensory information. It preaches at us to be fully aware as we, for example, cross the street, not only of the cars speeding from the right but also of the kinetic patterns and transforming images that natural activity continually shapes. In this respect, the Theatre of Mixed Means is an art for the age of informational overload, as well as the era of polymorphously libidinal leisure that is superseding the era of phallic concentration, whether at orgasmic pleasure or productive work.

Culturally, the Theatre of Mixed Means implies the abolition of archaic forms, whether artistic or social; the importance of truly individual responses in all kinds of situations; generalized perception (polyliteracy) in an age increasingly populated by specialized (mono-literate) machines; a profoundly liberal attitude toward the eccentric and unusual; the breaking-up of the mass audience into smaller communities; the creation of more intimate social experiences; and the importance of play, which is, Johan Huizinga writes, "that it is free, is in fact freedom." Significantly, producing mixed-means theatre involves a less complicated process than literary drama; and its equipment, if there is any, is generally more portable. Likewise, as a formal theatrical set-up is unnecessary, certain hazardous and time-consuming contractual negotiations are disposed of; because it has assimilated modern technology's virtue of cutting costs within the process of production, mixed-means theatre usually charges its audience less, if anything at all, than conventional fare; as a more accessible form of theatre, it therefore links with the contemporary desire to make na-

ture's abundance more accessible to everyone. Indeed, the new art's critique of the old parallels in several respects the new radical thought's critique (i.e., Kenneth Boulding's and Robert Theobald's) of both capitalism and socialism; for although we should honor the achievements of old ways, mankind must explore and exploit the radically new possibilities his environment creates if human life is fully to achieve its potential. "Tyranny and dictatorship, manifestoes and decrees will not recast the mentality of people. The unconscious but direct influence of art," Moholy-Nagy writes, "represents a better means of persuasion for conditioning people to a new society, either by its projective or its satiric-destructive means." Unlike orthodox Marxists, the new artists, as well as the new radical thinkers, presume that a change in consciousness *precedes* a change in social organization; and the new art is thoroughly implicated in this political purpose.

The spectator who most thoroughly (rather than "correctly") understands a mixed-means theatrical presentation becomes involved with the various dimensions of a piece, assimilating all the stimuli it has to offer (as well as integrating his own interpretative responses); for the new theatre demands a perceptual attitude closer to that instigated by the experience of paintings than of books. The most profound purpose of the new theatre, then, is initiating a multiply attentive perception that enables us better to perceive not isolated events in space and time, but the structure and order of events in space-time—to comprehend what Giedion defines as "a principle which is ultimately bound up with modern life—simultaneity," as posed by our multiply transforming, discontinuous environment. As art offers sensory delight as well as, in Kenneth Burke's phrase, "equipment for living," no medium I know is more effective in this education than the Theatre of Mixed Means; for through its pleasurable pedagogy, the new theatre enhances, at once, our perceptions of art and our enjoyment of life.

conversations

# 1

## author's note

*Quot homines, tot sententiae.* (So many
men, so many minds.)—Terence, *Phormio*

**A true historical criticism discerns, first,
the similarities in the diverse and, then,
the diversities within the similar.**

If nothing else, the following conversations should signify that gone
are the days when an American artist would deflect or evade questions
about his purposes and processes, as well as pretend innocence and
ignorance when sophistication was clearly evident. Most of the cre-
ators of mixed-means theatre are, like professional quarterbacks on
the pre-game television shows, extremely willing to tell a curious
interviewer exactly what is on their minds; and if perhaps the in-
quisitor fails to understand the first time, they will gladly repeat their
ideas in a different or simpler form. Most of the artists have partici-
pated in public symposia on the new art and the new theatre; a few
have even committed their ideas or their scripts to prose. Most of
them strike me as admirably conscious of the sources of their inspira-
tion, the symptoms of their personal style, the ways they integrate
their perceptions and ideas, the deficiencies of their own works, and
the possible meanings their performance pieces have. Most have
closely followed the theatrical work of their peers, and were quite

willing to evaluate frankly the pieces they had seen. Usually, however, they later requested that such remarks be deleted from the published text; for better or worse, people involved in the new theatre would sooner be generous in public than nasty.

Most of the contributors have college degrees (Allan Kaprow has an M.A.), but more important is the fact that all together they exhibit an attractive kind of polyliteracy defined by their capacity to appreciate sensitively and knowledgeably books, periodicals, films, painting, sculpture, music, dance, and life; in turn, they create an art particularly suited for a polyliterate audience (and invariably mysterious to a monoliterate, which is to say illiterate, one).

With the exceptions of Claes Oldenburg, and Gerd Stern of USCO, all of the practitioners were born in the United States; all were raised here. Not only do they draw upon peculiarly American phenomena for both their content and form and refer often to particularly American experiences, but nearly in unison they also exhibit a kind of cultural patriotism that is perhaps typical of their generation.

One of the dominant themes emerging from these interviews is that the major creators of mixed-means theatre descend from various artistic traditions; and this probably explains why each of them describes a distinctly individual way of composing a piece and why each possesses concerns, as well as a conceptual language, derived from his original artistic background. Where Robert Rauschenberg describes pieces that are very painterly in their heightened preoccupation with the character and texture of visual images, Robert Whitman's works tend to extend from kinetic sculpture—containing a profusion of elements which seem at first haphazardly chosen but are later discerned to be tastefully arranged. Claes Oldenburg's pieces can be characterized as live pop sculpture, and he continually describes parallel concerns and strategies in his sculpture and theatre. John Cage's extravagant pieces clearly descend from his ideas about music, Ken Dewey is constantly preoccupied with definitions and possibilities of theatre in our time, and the origins of Ann Halprin's ideas, curiously, can be traced as much to architecture as to dance. Even beyond the differences in aesthetic ancestry, the artists display varying conceptions of ultimate value. Where Robert Rauschenberg wants his pieces to be "involving," John Cage attempts a lifelike formalism; La Monte Young favors creating an overwhelming sensory experi-

ence while Allan Kaprow puts the emphasis upon committed participation, and USCO designs pieces to reveal, if not instill, a certain philosophical outlook. Robert Whitman's and Ann Halprin's performances aim to inspire a kind of plastic empathy; Claes Oldenburg's are tactual and metamorphic spectacles. Moreover, where Whitman and Oldenburg create out of a generally expressionist ambience, Cage, USCO, Young, Rauschenberg, regard their creations as integral structures which have minimal relevance to their authors' emotional makeup. Whatever their differences, each is a mature artist who has moved through various styles to the unique one he presently holds; and I would expect each one to develop in directions that he or we cannot yet foresee.

From time to time, one hears rumors that the Theatre of Mixed Means is both faddish and highly lucrative. One charge has as little truth as the other. Where fads in America rarely last more than three years, most of the creators of the new theatre have been working considerably longer, and its most loyal admirers have evinced an equally extended commitment. In fact, the regular audience for this kind of theatre is actually quite small—in New York City, it probably numbers not more than one thousand people, most of whom I would describe as more likely to visit an art gallery than to see a show off-Broadway. Far more people, I am sure, have heard about "happenings" and other genres of mixed-means theatre than have seen a single example. When Robert Whitman's *Prune. Flat.*, one of the most admired and most discussed pieces, had a commercial run for several weeks off-Broadway in New York City, it played only on weekends to audiences which were usually far less than capacity and invariably less than enthusiastic. Most of the practitioners do not get enough performances, and most of the regular audience does not get to see as much as they should like. As I write these words, on a Saturday afternoon in mid-winter, there are no mixed-means performances playing in New York this evening.

Mixed-means theatre is by no means lucrative for anyone concerned. All the practitioners live modestly, largely off income gleaned from other sources. USCO builds machines and does silk-screens, Ann Halprin teaches dance, Alan Kaprow lectures on art history. Robert Whitman, Claes Oldenburg, and Robert Rauschenberg have sold paintings and sculpture. John Cage is probably the only one who can

live off his performance fees, and most of these come from institutions that believe he is presenting "music" or "a lecture" rather than "theatre." Allan Kaprow says that he someday hopes to live off the fees he earns from sponsors who commission him to do happenings; and La Monte Young, presently a Guggenheim fellow (1966–67), recently raised the price for his ensemble's performances to what he believes is a reasonable fee, although the figure has yet to be matched. In fact, most of the people interviewed in this book invariably lose money on their time-consuming theatrical work.

Although conversations are, as I explained before, the most satisfactory form for the chapters of this book, I must also admit that they create their own kinds of problems. In the following transcripts, I have, at times, cut and revised to make the commentary more effective. As a result, the following texts are generally more coherent and more formal than our actual talks. On the other hand, I have at times intentionally preserved many idiosyncrasies of syntax, vocabulary, and capitalization. The major deficiency of these transcripts is that they do not reproduce the variety of tones with which phrases were spoken, so that a statement that was patently ironic in conversation may appear leadenly declarative in print (and vice versa). As I write this criticism, I realize that one solution to this problem would be an alphabet of symbols introducing each sentence, where each character would define the particular tone of what succeeds it. That idea, alas, I will save for another book.

Most of the conversations took place in mid-summer, 1966; and after I typed up the preliminary transcripts, they were returned to the artists for correction. Later in the year, some supplementary conversation occurred; and that new material was integrated into the previous text. For each session I used a portable tape-recorder with a voice-activated microphone, whose hidden talents nearly everyone admired.

"One who forms his opinion from the reading of any record alone is prone to err," warns the professor of law Edmund M. Morgan, "because the printed page fails to produce the impression or convey the idea which the spoken word produced and conveyed." Taking his admonition one step further, may I warn that any reader who announces a judgment of the new theatre based solely upon reading this book is irresponsible to both himself and his listeners, and any re-

viewer who critically pounces on a stray line without reproducing the entire context is betraying our mutual sense of the real nature of conversation. As some of Marshall McLuhan's less discerning critics have as yet to comprehend, conversation creates not expository prose but its own genre of language; and a construction that might seem clumsy in one medium is liable to be perfectly acceptable and effective in another. Finally, I hope that all this serious talk about the new theatre will lead readers to experience, perhaps with greater joy and comprehension, the mixed-means medium itself.

# 2

**We must get ourselves into a situation
where we can use our experience
no matter what it is.**

## —John Cage

For various reasons, John Cage may be considered by historians the
putative father of the mixed-means theatre. For over twenty years his
ideas have permeated the consciousness of New York's artistic com-
munity. It was Cage who put together the first truly mixed-means
performance in America—an untitled piece performed at Black
Mountain College in 1952. In the mid-fifties participants in his com-
position classes at The New School included Allan Kaprow, Dick
Higgins, George Brecht, Jackson MacLow, and Al Hansen, all of
whom later became creators of theatrical works. Since 1943, Cage has
also been Musical Director of the Merce Cunningham Dance Com-
pany. However, the tracing of influence must not be pushed too far,
for many of the creators of new theatre had been developing their
ideas in a mixed-means direction before they encountered Cage.

Cage himself was born in 1912 in Los Angeles, the son of an
imaginative and versatile inventor. He grew up on the West Coast
and attended Pomona College, but quit before graduation to travel
through Europe. After returning to Los Angeles in the early thirties,
he studied music with Arnold Schoenberg, Adolph Weiss, and Henry

Cowell. His first revolutionary act as a composer was the invention of a specially prepared piano that introduced strange noises into a musical situation, a stylistic technique he was to continue to explore. In *4' 33"*, his famous silent piece of 1952, Cage implied that all sounds in the performance situation during the prescribed duration, whether intentionally produced or not, were music; and since then, he has used methods of composition that further reduce the influence of his taste and intention. His recent pieces offer situations designed to make unplanned, "chance" sounds arise, although Cage selects in advance the elements involved, as well as determining how they shall interact. Since his choices are ingenious, such works as *Rozart Mix* (1965), *Variations V* (1965), and *Variations VII* (1966) are immensely intricate theatrical spectacles, full of interesting aural and, usually, visual activity.

A slender man who looks much younger than his years, Cage lives in a small three-room cottage in Stony Point, New York, about forty minutes north of Manhattan in Rockland County. The conversation took place in his bedroom-study; the time was Saturday evening. Cage had finished the work of the day, as well as a dinner he had cooked himself. Aside from occasional touchiness, he was completely charming.

KOSTELANETZ — Would you consider this—now, here—a theatrical situation?

CAGE — Certainly. There are things to hear and things to see, and that's what theatre is.

KOSTELANETZ — If you were blind, would it still be a theatrical situation for you?

CAGE — I imagine so, because I would visualize from what I hear.

KOSTELANETZ — Therefore, the radio is not theatrical.

CAGE — How are you going to separate it from the environment that it's in? That's really the way to get interested in recording—to include the environment. You'll find more and more in one of these situations that nobody closes his eyes as much as he used to.

KOSTELANETZ — Where did you remark that a tuba player looked more interesting than what he played?

CAGE — I said something like that about a horn player. I think it may be in the article on Communication in my book, *Silence* [1961].

KOSTELANETZ — Would you say then that all life is theatre? That all theatre is life?

CAGE — It could be seen as such, if we change our minds.

KOSTELANETZ — When did this occur to you?

CAGE — I don't know when I gave conscious expression to it. The year 1952 begins to be very . . . if you look in my catalogue, you'll be amazed at the number of things that happened in 1952. The *Water Music*, for instance, begins then, and then I had already given that happening at Black Mountain College. All these things began to be apparent, and I began to relate them to things that I had observed in my life. This testing of art against life was the result of my attending the lectures of [D. T.] Suzuki for three years. I think it was from 1949 to 1951.

KOSTELANETZ — Did you feel uncomfortable, as an eminent man in his late thirties, taking courses at Columbia?

CAGE — No, I wasn't registered. I still am a student. I'm studying chess now with Marcel Duchamp.

KOSTELANETZ — Is chess theatre?

CAGE — Well, you have to ask yourself "What is theatre?" I would answer that theatre is seeing and hearing.

Here's a very good statement by Joe Byrd, a composer now on the West Coast: "What should we expect of these arts? Shouldn't we expect dance today to concern itself with movement in all forms including the kinetic quality of football or stock-car races; music to explore the psycho-physiological potentials of sound, the peculiar rhetoric of machines, the anxieties produced by low-frequency vibrations in sync with one's own nervous system; poetry, to fulfill [Gertrude] Stein's semantic implications to reawaken the sound and sight of a word and their relation to its meaning, to gloriously destroy the context, adjectival, and syntactical inhibitions that make all poetry verbiage; and theatre (!) we might expect to become a catholic, experimental aesthetic extended to functional existence. Here the psychedelic experience is an example, but ultimately, because of its artificiality, a crutch. More, the obligation—the morality, if you wish —of all the arts today is to intensify, alter perceptual awareness and, hence, consciousness. Awareness and consciousness of what? Of the real material world. Of the things we see and hear and taste and touch."

KOSTELANETZ — Do you regard that as the purpose of theatre—to increase our perceptual awareness of the world?

CAGE — Yes.

KOSTELANETZ — Before you came to that recognition about life as theatre, what kind of theatre did you appreciate?

CAGE — I was among those dissatisfied with the arts as they were, and as Europe had given them to us. I infuriated Paul Goodman at Black Mountain by speaking against Beethoven. Paul Goodman, bright in other respects, swallowed European thinking hook, line, and sinker. I just looked at my experience in the theatre, realized I bought a ticket, walked in, and saw this marvelous curtain go up with the possibility of something happening behind it and then nothing happened of any interest whatsoever. The theatre was a great disappointment to anybody interested in the arts. I can count on one hand the performances that struck me as being interesting in my life. They were *Much Ado About Nothing*, when I was in college; it was done by the Stratford-upon-Avon players. Nazimova in *Ghosts*. Laurette Taylor in *Glass Menagerie*. The Habima Theatre's *Oedipus Rex* in 1950 or thereabouts. [Pause] I run out. . . .

KOSTELANETZ — What qualities animated these performances?

CAGE — That isn't an interesting question. The situation is complex. I was four different people, for those performances were widely spaced in time. It just happened—what can we say? We don't any longer know who I was. They somehow struck me so that I was, as we say, bowled over—really amazed.

I'll show you what I mean. In the forties at some point—'43, '44, '45—I heard those short string quartet pieces by Webern. I was sitting on the edge of my seat. I couldn't have been more excited. Play the same music for me now, and I won't even listen to it. If you oblige me to do so, I'll walk out of the hall in fact.

KOSTELANETZ — Do you see any theatre at all now?

CAGE — Never. Well, I go to happenings. That strikes me as the only theatre worth its salt. We aren't having art just to enjoy it. We are having art in order to use it. Those things we once used have been consumed. We have to have fresh food now. You wouldn't ask me, in the case of a steak I ate ten years ago, somehow to regurgitate it and eat it over again, would you?

This concern with the consumption of art and the consumption of

ideas is very close to Norman Brown. He sees art as food going right through the body and so forth, and then you can see that you use it up and you need something new. He insists on this in his new book, *Love's Body* [1966]. I was so glad to see this insistence upon freshness and newness and change in him, because over and over again recently we've had people attacking the avant-garde on the very notion that the new was something we should not want. But it is a necessity now.

KOSTELANETZ — In what sense? Intellectual? Physical? Moral?

CAGE — Consumptual. We must have something else to consume.

We have now, we've agreed, the new techniques. We have a grand power that we're just becoming aware of in our minds.

KOSTELANETZ — Technology—

CAGE — Not only technology, but our minds themselves, which we dimly know are in advance of the technology. And our education has kept our minds stunted, and we are going to change that situation. Our minds are going to be stretched. We are going to stretch ourselves to the breaking point.

Still, a lot of people are going to go on being caretakers of the past. The past has no trouble, no lack of people who are going to make love to it.

KOSTELANETZ — History is on your side, though, because technology is on your side.

CAGE — Bucky Fuller doesn't want Times Square destroyed. He says we should keep it. We should keep everything so that we know what it used to be like.

KOSTELANETZ — Then one of the things you like about happenings, as opposed to old theatre, is that they are so lifelike. Now, is a happening more successful to you if it is lifelike?

CAGE — Not that it should be lifelike but that we should be able to consume it in relation to our lives. So that it would introduce us to the other things in our lives which we consume.

KOSTELANETZ — I assume you agree this is the ultimate educational purpose of the movement.

CAGE — Yes, yes.

KOSTELANETZ — Constance Rourke has the thesis that a prime characteristic of American arts is indefinite identity—they don't particularly fit forms we know, like novel or epic.

CAGE — That could be like breaking down the boundaries, certainly taking away the center of interest, emphasizing the field.

KOSTELANETZ — These are all American characteristics. This would make Charles Ives your ancestor.

CAGE — I'm flattered to say, yes. But I'm inclined to point out that your question is a linear one, which is a Renaissance question, which is a European question, which is a non-electronic question.

KOSTELANETZ — Let me deal, if I may, with the critical questions the new form poses. I saw you at the Cinematheque one Friday night in December [1965]. There were three events—Robert Whitman's, Robert Rauschenberg's, and Claes Oldenburg's. May I ask you to evaluate them?

CAGE — You mean that you want me to criticize them—to say which one I liked the most and so on, or what.

KOSTELANETZ — As you prefer.

CAGE — Well, I liked the Whitman best [*Prune. Flat.*], because it was the most complex. Even though he has an idea and was doing something he intended to do—this is true of all three of them—I liked it. They were not doing something I would do, because I am interested in non-intention, and I think that life is essentially non-intentional. Let me put it this way: You can only approach it effectively when you see it as non-intentional. In a sense then, I criticize all three of them, but of the three, the Whitman strikes me as most useful simply because it was the most complex. This connects it with life which is also complex.

KOSTELANETZ — It also struck me as the one which filled its space and time most interestingly.

CAGE — Right. That goes along with it.

KOSTELANETZ — In other words, it was almost as good as life.

Would you say, then, that a basic critical comment about a happening stems from whether or not you wish to stay and look at it? If life outside the situation is more interesting than the happening, then the happening has not at all succeeded. This would be a purely subjective criterion.

CAGE — For one thing, I would like the happenings to be arranged in such a way that I could at least see through the happening to something that wasn't it. We'd be out of the La Monte Young fixation

ideal. We'd be in the Duchamp-Fuller-Mies van der Rohe business of seeing through.

KOSTELANETZ — Didn't Claes Oldenburg's piece, *Moviehouse*, impress you in this sense?

CAGE — Yes. But it was a police situation. It was politically bad—telling people not to sit down. I refused, so I sat down and so did Duchamp.

KOSTELANETZ — Were you uncomfortable standing up?

CAGE — No. I refuse to be told what to do.

KOSTELANETZ — When you go to a conventional concert, do you sit in the seat?

CAGE — No one tells me that I can't get up and walk around. They do give me a ticket for a seat, and if I use it that's my own business. That was my objection to the Kaprow [the original *18 Happenings in 6 Parts*]—being told to move from one room to the other.

KOSTELANETZ — Are you at all proud of your influence upon Kaprow and other people?

CAGE — I'd rather agree with Kaprow that I haven't so much influenced these people. They do what they do; I do what I do.

KOSTELANETZ — But they took your courses and probably learned things from you.

CAGE — And I probably learned things from them.

KOSTELANETZ — Have you learned from the new theatre?

CAGE — I think certainly.

KOSTELANETZ — Let me go back to the Black Mountain piece. Could you remember what was in your mind when you did that?

CAGE — It was the making of theatre—to bring all these things together that people could hear and see.

KOSTELANETZ — What kind of intention were you dealing with at that time?

CAGE — Non-intention.

KOSTELANETZ — Once you chose the element everything was improvisatory?

CAGE — No, there were time brackets during which these people were free to do what they were going to do.

KOSTELANETZ — Thus, at minute four someone was instructed to do something.

CAGE — Not at minute four, but between minute four and minute

eight, say, someone or a group of people had that time bracket free. What they were going to do I didn't know. I knew roughly, but not specifically. I knew that Merce would be dancing, but I didn't know what he'd be dancing.

KOSTELANETZ — How long did that piece last?

CAGE — Forty-five minutes.

KOSTELANETZ — Did the audience receive it well?

CAGE — Yes, that was a very good situation at Black Mountain College. The cups were introduced [placed upon each seat] so that the audience had something to do. That is, when they encountered cups on their seats, what could that mean? It meant, of course, that they would be served coffee toward the end of the piece.

KOSTELANETZ — Did you give this piece any name?

CAGE — No.

KOSTELANETZ — Why didn't you develop anything in this area yourself?

CAGE — I have been doing nothing else since.

KOSTELANETZ — So all your work since has been theatre in your mind.

CAGE — Surely.

KOSTELANETZ — Are some pieces better theatre than others?

CAGE — Why do you waste your time and mine by trying to get value judgments? Don't you see that when you get a value judgment, that's all you have.

KOSTELANETZ — You don't think that value judgments are particularly relevant in working in this area.

CAGE — They are destructive to our proper business which is curiosity and awareness.

KOSTELANETZ — Yet you can answer the basic question of whether you liked this or didn't like this.

CAGE — You asked me, and I got involved in making critical remarks about that Cinematheque performance. While I'm making them, I'm annoyed that I'm doing so. In playing chess, there's an expression of "losing tempo." If you put your opponent in such a position that he's obliged to move back from where he was, then he loses time. We waste time by focusing upon these questions of value and criticism and so forth and by making negative statements. We must exercise our time positively. When I make these criticisms of other people, I'm not

doing my own work, the people and their work may be changing. The big thing to do actually is to get yourself into a situation that you use your experience in, no matter where you are, even if you are at a performance of a work of art which, if you were asked to criticize it, you would criticize out of existence.

KOSTELANETZ — But does that alter the fact that you might have preferred going to a different happening?

CAGE — That's not an interesting question; for you are actually at this one where you are. How are you going to use this situation if you are there? This is the big question. What are you going to do with your time? If you use it negatively, you really are not consuming. You're doing some other kind of thing which, as I've explained just now, loses tempo. You have somehow to use it positively. We have illustrations of how to get at this, and it would be part and parcel of the new ethic or new morality or new aesthetic.

Kierkegaard, for instance, in *Either/Or*, speaking of conversing with a bore, pointed out that he finally noticed that perspiration was dripping off the fellow's nose and that he could enjoy that. By focusing his attention there, he could ignore all the rest of the business.

I've noticed that I can pick up anything in the way of a periodical or a newspaper—anything—and use it, not in the [William] Burroughs sense but in its content sense—in terms of its relevance to positive action now.

KOSTELANETZ — Are there some happenings you can use better than others?

CAGE — Let's say that that's true. Now let's ask this kind of question: Which is more valuable—to read *The New York Times* which is a week old or to read Norman Brown's *Love's Body*? If we face this issue squarely, we'll see that there's no difference.

KOSTELANETZ — Because you can get something out of both.

CAGE — Right. Now a really difficult problem for you, which now brings us back to the question of discipline, would be this: Listen, if you can, to Beethoven and get something out of it that's not what he put in it.

KOSTELANETZ — Is that relevant?

CAGE — We must get ourselves into a situation where we can use our experience no matter what it is. We must take intentional material, like Beethoven, and turn it to non-intention.

KOSTELANETZ — Is it a better way to apportion one's time? Aren't some things a more profitable way to spend one's time than other things?

CAGE — Look what you did. Accepting the notion of non-intention, you then said, "Can you intend to be non-intentional?" That would mean you would go around choosing.

KOSTELANETZ — What you are saying, then, is that any happening is acceptable. I could have two people sit and stare at each other for three hours; but I don't think I could do that and still hold an audience. Do you?

CAGE — Why do you speak of holding an audience? I think that these notions imply dropping the idea of controlling the audience, for one thing. We have spoken of wanting to turn each person into an artist, have we not? We've spoken of individual anarchy, etc. So, in the case of a performance, we would think of it, wouldn't we, as a celebration of some kind; and we certainly would not think of holding those people to us. If somehow they weren't enjoying the situation or consuming it, then wouldn't we be more pleased if they left? Not that we want them to go, but we don't want them to stay either. We have a certain freedom at the same time that we question the notion of freedom; this is very curious.

KOSTELANETZ — If you can't say bad and good about theatrical pieces, then there is no basis for criticism at all.

CAGE — The best criticism will be, you see, the doing of your own work. Rather than using your time to denounce what someone else has done you should rather, if your feelings are critical, reply with a work of your own.

KOSTELANETZ — Let's say I'm not a critic and I merely attend a happening and decide that I simply don't like it.

CAGE — Well, use that fact by doing something of your own.

KOSTELANETZ — Criticism, then, must turn into creation.

CAGE — Formerly, we had boundaries between the arts, and you could say then, if you are saying what I am saying now, that the best criticism of a poem is a poem. Now, we have such a marvelous loss of boundaries that your criticism of a happening could be a piece of music or a scientific experiment or a trip to Japan or a trip to your local shopping market.

KOSTELANETZ — So then my criticism is an expression of myself and my milieu.

CAGE — Not an expression of yourself. This is something that is gone too.

KOSTELANETZ — My criticism, then, is to take something I got out of a happening and then do something else.

CAGE — I think it should be. Do you know, for instance, any criticism now which you can use? I find myself more and more questioning the professional function of the critic. I don't find what they have to say is interesting. What they do doesn't seem to change what I do. What I do changes what I do. What artists do changes what I do. I don't know of any instance where what a critic has done has changed what I do.

KOSTELANETZ — You don't, then, consider Marshall McLuhan a critic?

CAGE — If you do, then I'd have to change my mind because I find him very illuminating.

KOSTELANETZ — He used to be a critic. As a younger man, he contributed to literary quarterlies essays that looked and read like criticism.

CAGE — Well, let's say he is a critic. Then he gives us the notion of what a critic really should be. Say that Norman O. Brown is a critic; then, we'll have to say that Fuller is a critic.

KOSTELANETZ — Let me deal with a particular piece, for the moment. May I ask how you composed *Rozart Mix* [1965] for thirteen tape-machines and six live performers?

CAGE — Did you ever see the score? It's just my correspondence with Alvin Lucier, a composer who teaches at Brandeis University. He wanted a concert of music in the Rose Art Museum. Because of engagements here and there, I had very little time to work on it, and he had purposefully separated me from the pianist David Tudor by engaging him to give a concert the previous month, so that this time I had to go without the usual assistance. I thought to make a tape piece, which I described in my letters to him. It would consist of loops, and we would have at least as many loops as there are keys on the piano—eighty-eight, which would be made by anybody, since I didn't have the time to do it. They could use any materials. We would have at least a dozen machines, and the loops would vary from the

shortest viable length to something like forty-five feet long. I had been told that the Museum had a pool of water and a stairway, that it had an interesting architecture. So we would put the machines all over the building. Then the loops would get tangled up with themselves, and that would be part of the performance. Now if the loop broke at any point, it would be first priority to fix it; and once it was fixed, it was to be put back in the reservoir of loops, and another one would be put on that machine. The piece was also to begin without the audience knowing it had begun, and it was to conclude when the last member of the audience had left. When only twelve people were left, we had arranged to serve refreshments; all those people had a party.

KOSTELANETZ — Wasn't there another party the night before?

CAGE — Well, I went up there ahead of time thinking that they might not have made all the loops, which turned out to be the case. They only had about thirty, I think; so I worked like a devil and made the rest of them. What you want, you see, is to get a physically confused situation.

KOSTELANETZ — Why eighty-eight as a minimum?

CAGE — The reason for that multiplicity is that you would not then be able to exercise choice. If you're making eighty-eight loops, you very quickly get uninterested in what it is you are doing.

KOSTELANETZ — What sound was on the loops?

CAGE — It doesn't really matter. That's part of the piece. I don't know what was on those loops.

KOSTELANETZ — If there was nothing on those tapes, would the piece be valid?

CAGE — Well, that would not be the piece that I wrote. In this case I specifically said there should be something on the tape.

KOSTELANETZ — Could you run a tape-recorder for twenty-four hours somewhere, say in the middle of New York City, and then cut it up and make the segments into loops? Would that discount the situation?

CAGE — I don't suppose so. That time, I mostly used material I had around; materials I had made years ago for the library of the *Williams Mix* [1952].

KOSTELANETZ — How have you and Merce Cunningham worked together?

CAGE — We collaborate in various ways. He chooses an existing piece

of music and makes a choreography, or he makes a dance and I either compose for it or choose an existing piece or invite some other composer to write for it. Our collaboration has been such that neither one of us is at a fixed point. We started at a time when dancers were very proud. They made the dance first, and then a musician came in like a tailor. With us, from about 1952 on, the music was no longer fitted to the dance. The music could go on for any length of time, so there no longer needed to be rehearsals of the dance and music together.

KOSTELANETZ — Can someone else perform your role in the concerts or do you have to go on all the tours?

CAGE — I'm not always present.

KOSTELANETZ — Who is the author of *Variations V* [1965]?

CAGE — It is published under my name.

KOSTELANETZ — Did you conceive all the parts or were they written independently?

CAGE — You haven't seen the score?

KOSTELANETZ — No.

CAGE — Well, the score is *a posteriori*—written after the piece. Do you see the implications of this?

KOSTELANETZ — But then that's not the score.

CAGE — Nonsense, that changes our idea of what a score is. We always thought that it was *a priori* and that the performance was the performance of a score. I switched it completely around so that the score is a report on a performance. These are remarks that would enable one to perform *Variations V*.

KOSTELANETZ — That would make the score a surrogate for a critical review.

CAGE — No, these are not critical remarks. They are explanatory remarks. Critics never are explanatory. These are remarks that would enable one to perform *Variations V*.

KOSTELANETZ — Well, how did you produce the score?

CAGE — Well, I tossed coins again, setting as the limit then sixty-four remarks to be written. I got, I think, the number thirty-five—I forget. Then I tossed coins again to see how many words would be in each remark. I got five. Then I was faced with the problem of writing five words on *Variations V* that would be helpful for someone else if he wished to perform it. It then became what you might call a poetic problem—to think of something in five words that would be useful to

another person if he were going to perform *Variations V*. Then I wrote them down. Then I did each of thirty-five things like that, and that's the score.

KOSTELANETZ — Did you also choose the media involved—dance, film, sounds?

CAGE — Oh, one of the remarks is that there shall be dancers involved. And then there's a remark saying that at the first performance it was Merce Cunningham. It could be someone else.

KOSTELANETZ — So the selection of the basic elements—sound, dance, and film—is fixed.

CAGE — If you want to say that, yes. There could be other films, though, than those particular ones. Would you say that our talking here this evening is fixed or unfixed?

KOSTELANETZ — It might be fixed because of the notes I have before me here.

CAGE — No, the fact that we're sitting here. It's an extremely realistic situation, terribly fixed. Really, in space, in time, you'll never be able to repeat it. We don't know precisely what we're going to say, but the moment we've said it you've even got it fixed on your tape. So can we say then that *Variations V* is fixed, and the score of it is these remarks about these things that happened, which envisage that somebody else might also do this.

KOSTELANETZ — Has anyone else done it?

CAGE — Yes, a group organized by Robert Moran in San Francisco.

KOSTELANETZ — Did you see it?

CAGE — No.

KOSTELANETZ — Did you hear reports? Was it different?

CAGE — Of course, it was different. How could it not be? Greatly different.

Say we wrote a score where two people come and want to interview a composer and they bring a transistorized tape-recorder. They meet at seven o'clock, etc. We could give lots of remarks about it. Then they could do this, say, in Ann Arbor, and you know it would be different.

KOSTELANETZ — Would you consider this—now, here—a theatrical situation?

CAGE — Certainly. There are things to hear and things to see, and that's what theatre is.

# 3

**What I'm for is a collective statement based on the need for audience and performers to be assembled; so that what occurs is a process that evolves out of both the moment and all the people there.**

## —Ann Halprin

Ann Halprin has long been acknowledged among the leading exponents of a contemporary dance that is stylistically post-Martha Graham, for she has eschewed all traditional syntaxes of the dance language for movements wholly natural to the human physique. Instead of choreographing dances of distinct character and repeatable pattern, she has constructed a series of fluidly formed mixed-means theatrical pieces faithful to her attitude toward human activity, and yet sensitive to theatrical demands. Her Dancers' Workshop Company, based in San Francisco, has toured across the United States and Canada, and has also performed at contemporary and avant-garde festivals in Venice, Rome, Zagreb, Stockholm, Helsinki, and Warsaw. In the spring of 1967, the group gave its first public recital in New York City.

Ann Halprin grew up in Winnetka, Illinois, where she was born in 1921. She attended the University of Wisconsin, taking her B.A. in dance and studying with Margaret H'Doubler, whom she regards

as her greatest influence. She also assimilated Bauhaus architectural ideas during the years her husband Lawrence studied with Walter Gropius and Marcel Breuer at the Harvard School of Design. After leaving Cambridge, Massachusetts, the Halprins spent two years in New York, where Ann gave a dance recital and worked in the Broadway production of *Sing Out Sweet Land* (choreographed by Doris Humphrey and Charles Weidman).

The Halprins moved to San Francisco in 1945 and have lived on the West Coast ever since. They have two teen-aged daughters, Daria Lurie and Rana Schuman. Mrs. Halprin is a close collaborator in her husband's work as landscape architect and city planner, as he is in hers; and in the following interview her use of the word "block" has architectural overtones.

Ann Halprin's theatrical pieces are largely developed in classroom situations or in improvisation sessions with her company. Each work is, so to speak, the continually evolving result of a lengthy process, and even after a first performance, continues to change, shedding decaying elements and developing new ones. *Birds of America or Gardens Without Walls* (1959), Ann Halprin's first major piece, is based upon her commitment to exploring the choreographic possibilities inherent in natural activity, and this bias informs her subsequent theatrical works: *The Flowerburger* (1960), *Rites of Women* (1961), *Five-Legged Stool* (1962), *Esposizione* (1963), *Visage* (1963), *Parades & Changes* (1964), *Apartment Six* (1965), *The Bath* (1966).

She generally works with artists originally trained in other fields, and her structures allow these collaborators to improvise in performance within a system of choice outlined in advance. John Graham, an actor, and A. A. Leath, a dancer, have been her closest working partners for ten years, while Patric Hickey, a lighting designer, and Jo Landor, a painter, have also collaborated in all her major works. Other associates have included the theatre director Ken Dewey; the composers La Monte Young, Terry Riley, Morton Subotnick, Folke Rabe, Pauline Oliveros, and Luciano Berio; the sculptors and painters Charles Ross, Anthony Martin, and Jerry Walters; the poets James Broughton and Richard Brautigan; and her architect husband.

Her pieces are densely filled and grandly conceived spectacles, rich in props, people, and activities, sometimes containing absurdly funny

incongruities. They generally assume an organic cast, as one activity usually relates to another and the segments flow into each other smoothly. Although each sequence, as well as each scene, asks to be perceived as a coherent whole, Ann Halprin resists such obvious strategies for achieving unity as unison movement. Occasionally, she will repeat a certain activity, such as bringing a box on the stage many times beyond normal tolerance—an exercise that induces both terror and comedy; and although she is personally highly articulate, her pieces use words not so much for their meanings as for their distinctive sounds. As theatrical constructions, her pieces are extremely impressive, achieving both a distinctly individual style and an effective kinetic communication.

The Halprins live in Kentfield, California, at the foot of Mount Tamalpais, in a compound of their own design. Their five-acre wooded area includes their house, an outdoor platform-theatre, and an enclosed studio. In downtown San Francisco, the Dancers' Workshop occupies a modest building which contains a small hall and a studio. Members of Mrs. Halprin's current performing company are people from her classes; and, although several prominent younger dancers were once her pupils, her classes attract scores of non-dancers, particularly artists from related fields who want to learn about movement.

Ann Halprin is a slender, blue-eyed, handsome woman with high cheekbones, who looks like a neatly dressed suburban matron (which she also is). She speaks with a sure authority, an animated manner, and considerable charismatic charm. The following interview took place in New York City, just after she and her husband returned from a European trip.

KOSTELANETZ — As most of the important activity in mixed-means theatre takes place in New York, do you feel at all cut off working in California?

HALPRIN — No. However, I'm aware of the concentration in numbers of artists and activities that continually takes place in New York, but we have been doing multi-media theatre for many years, too. There's much talk about the nature-oriented West Coast art; this could make sense, just because we are closer to our natural environment, rather than the man-made environment.

I've been able to see many spontaneous mixed-means performances in the most unexpected places. In a small village outside Seville I participated in the most glorious fiesta which was the finest theatre event I've seen in years. I found similar excitement in Venice's San Marco Square during Easter, Tivoli Gardens in Copenhagen, Guadalupe in Mexico. Actually, it isn't necessary to travel to be stimulated by such dramatic experiences. There is something going on all the time all around. It's just a matter of being aware—of looking and hearing and putting things together. Something is always happening.

KOSTELANETZ — When did you become a choreographer?

HALPRIN — Since my early youth I've been acutely aware of and fascinated by movement. I started making up dances when I was a child.

KOSTELANETZ — Would you say that you started off in traditional modern dance?

HALPRIN — Yes.

KOSTELANETZ — Where does the piece *Birds of America or Gardens Without Walls* [1959] stand in your own career?

HALPRIN — It was my first full-length work, and this was the first work that made a specific break with what I had been doing previously as a traditional modern dancer.

KOSTELANETZ — How was *Birds of America* different?

HALPRIN — The concern in this work was for non-representational aspects of dance, whereby movement, unrestricted by music or interpretive ideas, could develop according to its own inherent principles. The compositional approach allowed for group collaboration and improvisation. The music by La Monte Young was a series of single sounds, each surrounded by silence and produced independently of movement. Words spoken by a child performer, who was first Daria Lurie and then Rana Schuman, added another independent element; and, after the piece was composed, long bamboo poles were superimposed on the situation. Dancers were required to hold them as they moved, thus creating an ever changing visual environment as the poles made their own mobile in space.

I had been inspired to work on this piece as a result of a personal experience. One day as I was sitting for a long time outdoors in our wooded dance-deck, I became aware of light on a tree, a red berry that fell at my side, a fog horn in the distance, and children shouting; and

I wondered if they were really in trouble or just playing. These chance relationships, each independent of the other, seemed beautiful to me. I composed *Birds of America or Gardens Without Walls* according to that experience. Each thing was meant to take a long time, so stillness was an essential ingredient. It was intended for the audience to become so relaxed, if you will, that they could just see and hear and not have to interpret and intellectualize. They could let each thing be what it is as pure physical, sensory experience. Also, inherent in this personal experience was the possibility of discovering in chance relationships some new ways of releasing the mind from preconceived ideas and the body from conditioned or habitual responses. In *Birds of America or Gardens Without Walls*, each ingredient (light, sound, words, people, objects, etc.) was developed independently, according to its own intrinsic sensory nature, and allowed to relate to other elements in unpredictable ways. There was a deliberate avoidance of any beginning, middle, or end, and of fixed time. Instead, we used intervals of action followed by intervals of stillness. Hopefully, everyone in the audience would be able to perceive each element individually and yet discover relationships and events meaningful to his personal experience, just as I was able to do that day on the deck.

KOSTELANETZ — Didn't you conceive of *Five-Legged Stool* [1962] as a series of tasks?

HALPRIN — Yes, introducing the idea of tasks liberated the dancers even further from clichéd dance movement. Orienting to tasks, however, was related to a broader concern. A concern for super-reality or, to use a phrase coined by the German critic H. H. Stuckenschmidt in reviewing *Five-Legged Stool*, "sur-naturalism." *Five-Legged Stool* was a piece built out of ordinary life—of simple occurrences, physical images, and relationships between people. This realism or blown-up naturalism, which grew out of the use of tasks, was not simply a literal translation of life. In *Five-Legged Stool* a method of juxtaposing ordinary actions was employed in an attempt to break up conventional mental associations and predictions. What I mean is that each of us has an automatic stream of associating particular responses with certain actions seen or heard. For example, if you were to hear laughter, you would by nature expect to see a smiling face or whatever action would ordinarily be associated with laughter. *Five-Legged*

*Stool* took tasks that were based on ordinary life situations but juxtaposed them in illogical or unexpected relationships. By blowing the lid on logical or habitual mental habits of responses, feelings of multiple dimensions became possible. For instance, in *Five-Legged Stool*, Morton Subotnick recorded the audience's natural laughing and talking, coughing, shuffling in the lobby before they came into the theatre to take their seats. This same sound track of the collected material with subtle electronic manipulation was played back to the audience while simultaneously two performers, a man and a woman, were standing on the stage apron in static motion, staring at the audience, at one another, changing their facial expressions in such a way that the audience's sounds and the stage action were completely illogical and yet the mixture could evoke multiple responses on a purely emotional and sensorial level; or at the end of *Five-Legged Stool*, two performers are running toward each other and hitting their bodies in mid-air, falling and crashing to the floor. This violent, irregularly rhythmic series of collisions and falls is intensified by an enormously loud chaotic tape sound, and juxtaposed against all this is a chorus in the audience singing, in a steady volume and even rhythm, the familiar hymn, "A Mighty Fortress Is Our God." This is quickly extinguished, without any logical resolution, and as the scene shifts suddenly into absolute silence, one by one tiny feathers cascade down from a single concentrated spot on the ceiling. In the meantime a large window onstage that opens directly to the street brings into the feather event the sound of fog horns from the bay, of clanging cable cars on the streets, and of pedestrians' clicking steps walking on the sidewalk. Breezes flow into the stage, moving the feathers, and beams from cars passing by and street lamps form a light through which the feathers pass. All of these elements from the realistic life outside are juxtaposed against the simple act taking place inside, of falling feathers. The feather episode makes no logical sense following the violence of the previous event; yet on a deeply ritualistic level and as pure theatrical dynamics, it makes all the emotional sense in the world.

Here was a direct attempt to prepare the audience for their own departure from the theatre to the outside—to have opened up their senses and attitudes and made them able to go outside into the streets with a sharpened awareness of the pure drama all around. Thus, bringing into the theatre itself the everyday real life, merging it with

the make-believe or fantasy of theatre, was meant to be a direct invitation to the audience to experience the drama inherent in the "outside real world." As *Five-Legged Stool* was meant to have no formal ending, the audience took the theatre over, hopefully, in their own lives. A theme, as well as an intention, then, was non-separation of art and life. The use of tasks was taken to its furthest development.

In *Esposizione* [1963, Venice], an evening-length work, each performer was given one task to do throughout the entire piece: to transport an enormous load of litter from one point to another. Along the way, from point to point, were placed the most outrageous obstacles. Three starting points were chosen for six different performers, and they all eventually moved toward one goal. The starting points were the Piazza Venetta outside the LaVenezia Opera House, the prompter's pit under the stage, and the top of a cargo net forty feet in the air, where Rana Schuman, then nine years old, began her line of action by edging her way to a rope and swinging precariously in a large arch, spanning the space over the orchestra pit and back into the depth of the backstage spaces. Everyone's final goal was exiting off the stage.

Among the obstacles were the five tiers of balconies in the auditorium, the orchestra pit, the large imposing cargo net that formed a screen over the whole proscenium arch, and a ramp which slanted to the floor. The performers, and in some cases the musicians, were simply instructed to go from point to point, transporting their clumsy litter as they traveled, or playing their instruments. A space restriction was then established and Luciano Berio created a time score which determined the speed and thus also the quality of the event. For example, if five minutes were allotted to traveling up and over the steep cargo net lugging the litter with you, the event would be frantic and hysterical. If twenty minutes were allotted in that area, the task would slow down and become laborious. In this way Berio's decisions controlled many aspects of the piece, just as the selection of pathways shaped the use of environment. Jerry Walters' use of ramps and cargo nets controlled the scale of movement, as Jo Landor's selection of litter determined how each performer actually moved, and Patric Hickey's use of light, which he was free to select at will, very often controlled not only what the audience could choose to see but at times the spots to which the performers had to go. As you can see, *Esposi-*

*zione* allowed each collaborator the use of his skills to actually determine and shape the piece, and each performer the freedom to invent his own unique manner of accomplishing his task within the physical obstacles and time limits.

KOSTELANETZ — Didn't you extend this idea into *Parades and Changes* [1964] ?

HALPRIN — Yes. *Parades and Changes* stresses the collaborative aspects of working together with artists of different media. This has allowed a new development. In *Parades and Changes*, the influences from the collaborative artists have been stronger than before. The result is really a collective theatre piece.

KOSTELANETZ — What other categories of artists are involved?

HALPRIN — Two musicians, a lighting person, a sculptor, a painter, myself, and, of course, each individual performer plays a creative role too. Right now we are trying to incorporate a film-maker.

KOSTELANETZ — How, for instance, do you work with a sculptor?

HALPRIN — Charles Ross has been a collaborative sculptor. He, like all the others, is in on all the planning from start to finish. He will define the over-all structural qualities of the theatre; i.e., when we went to Hunter College to look at two theatres, he looked at one and said "This is an open meadow"; the other, "This is mountains." Chuck would continue to analyze the total space and set for all of us a visual image which is based upon the essence of the spatial statement of the theatre. He may go further and envision ways of creating a large-scale environment for an independent event that would engage himself and other performers. For instance, one time Chuck directed the performers to bring all the separate parts of a scaffold plus horrendous sheets of plastic and several extension ladders through the aisles, up onto the open stage area; and he then began to construct a mammoth object out of these materials. The performers were directed to move up and into the materials as he continued to build. Every performance would be different depending on the theatre and the materials and also how far the management would let us go. In Stockholm we were able to mount the battens and be lifted as we moved on them all the way up and out of sight. We haven't had permission to do that anywhere else. In Europe we have more freedom to use the theatres in ways we choose. Here, we have been terribly restricted.

KOSTELANETZ — If the sculptor sets the stage, how, say, does the painter fit?

HALPRIN — In different ways. Jo Landor very often will function as a general coordinator. She has a good eye, and her ideas, like Patric Hickey's, extend into every area of the production.

KOSTELANETZ — Who did the music for *Parades and Changes*?

HALPRIN — Morton Subotnick. Also, Folke Rabe composed pieces for the Swedish performances. Morton had a lot to do with evolving systems of scoring that gave us freedom to mix our media in many different ways. The scoring systems are highly technical and too difficult to describe briefly. The important thing is that group collaboration plus the openness of the over-all formal structure creates a marvelous complexity and diversity produced by many different attitudes interacting together. The results are often new forms not one of us alone would have found.

KOSTELANETZ — How is *Apartment Six* [1965] different from this?

HALPRIN — *Apartment Six* is a piece developed by A. A. Leath, John Graham, and myself as performers; Patric Hickey on lights and Charles Ross, who shapes the element of time by beginning, in view of the audience, to build a papier-mâché animal and finishing it at the end. We used a domestic setting familiar to anyone. We listened to the radio, cooked food and ate it, read the newspaper, and carried on conversation. Inevitably, because we are ourselves, something happened between us. We may have laughed or argued, cajoled or teased; and, because we are dancers by training, we moved considerably. *Apartment Six* is a fiction; but all the while, the fiction was real. The whole piece was a curious use of the element of realism. In rehearsals, John Graham, A. A. Leath, and myself had to devise a special signal to indicate that we really had stopped. The distinction between what was real in life and what was part of the play was completely broken down. We improvised entirely for the whole evening, eventually giving sixteen performances of the piece. However, it took ten years of training together, developing specific skills in use of movement and voice, as well as an understanding of an entire system of aesthetics before we were able to do this piece. *Parades and Changes* depends on more external process than *Apartment Six*, which is unstructured and depends on an internal process. The intention of the work was to

remove any separation from life and art in a very personal and individual way. The project had echoes of psychodrama in it, and I'm still involved in learning how to integrate these elements into an art process.

KOSTELANETZ — How many people are in your entire group for, say, *Parades and Changes?*

HALPRIN — Originally we had a small, unchanging company of people ranging in age from eight years old to forty-four years old with five to eight people performing. The nucleus of performers was John Graham, A. A. Leath, Daria Lurie, Rana Schuman, and myself. Simone Whitman performed in several of our major works. Now the performing company consists entirely of young people between eighteen and twenty-five. Being young, the group is forever changing and this forces me to find new ways to work. However, the Dancers' Workshop Company is constantly drawing upon new people in music and the visual arts. Change happens so fast that what I'm describing now about the group may change again by the time this interview is printed. This seems a reflection of a period we're in; and adjusting to such rapid changes in the group will lead to changes in the kinds of things that will begin to happen.

KOSTELANETZ — In what directions will the mixed-means theatre go?

HALPRIN — Two fantastically important phenomena have burst upon the scene within a few months of each other, and these most clearly and colorfully indicate an answer to this question. One took place in San Francisco and the other in New York City. I'd like to tell you first about the one event in San Francisco's Golden Gate Park [January, 1967] by quoting lines from an article, "The Tribes Gather for a Yea-Saying" by Ralph Gleason, which appeared in the *San Francisco Chronicle* the next day.

There they were. At least 20,000 and maybe more, in the greatest non-specific mass meeting in years, perhaps ever.

The costumes were a designer's dream, a wild polyglot mixture of Mod, Palladin, Ringling Brothers, Cochise and Hells Angels' Formal.

No one was selling anything. The lone refreshment wagon was 'way down in the underpass at mid-field. There were no drunks. That's right. No drunks.

As the sun set and the bands played and the people glowed, Buddha's

voice came over the sound system, asking everyone to stand up and turn towards the sun and watch the sunset. Later, he asked everyone to help clean up the debris and they did.

And so it ended, the first of the great gatherings. No fights. No drunks. No trouble. Two policemen on horseback and 20,000 people.

I am aware of similar happenings that have taken place in New York City, such as in September [1966], the attempt in Central Park. The difference was that, where the event just didn't come off in Central Park, something really happened in the Golden Gate. Here the scene is *it*. No one has to put on a performance or *make* it happen. It happens of its own accord. Here in San Francisco people aren't afraid to let go, have fun, and show their feelings even if it is naive.

The other important event I'm thinking about was the nine evenings in theatre and engineering that began October 13, 1966 in New York City at the 69th Regiment Armory. As the brochure points out, "One of the problems of the contemporary artist is that everyone knows what art is." To experiment in the meshing of art and technology is, like the "Human Be-In Happening" in San Francisco, to me a direction of enormous potential. It appears to me that artists and *audience* are at a threshold of a most exciting period. James Broughton, a poet friend of mine who has known my work for the past ten years, said to me after the recent happening at the Golden Gate, "They've caught up with you. Now how do you define your task?"

KOSTELANETZ — Which is what?

HALPRIN — I feel like I'm taking a risk to talk about what hasn't happened yet. Therefore, I can only speak in very general terms. For the past few years I've been more and more concerned about redefining the role of the audience. Ideally, each individual person in an audience should be deeply affected by what takes place in the theatre. I've spent a lot of time and energy exploring the internal processes of a work that deeply affect the performers; now I'd like to find more ways and means of defining processes that affect the audience. What I'm against is a personal statement that remains so introspective, private, esoteric, and abstract that it leaves an audience playing guessing games. What I'm for is a collective statement based on the need for audience and performers to be assembled; so that what occurs is a process that evolves out of both the moment and all the people there.

KOSTELANETZ — Do you want more direct reactions from your audience?

HALPRIN — Yes, I do. But I don't mean that a performance should flip someone out and send him charging onto the stage, crashing into the performers, snatching a lantern and nearly setting us afire. This actually happened when we performed recently at the University of California in Berkeley. I once attended a midnight performance in Zagreb given by John Cage. I hardly heard anything that Cage presented because the audience heckled him with such noise. This kind of hostility is not what I consider desirable, either as a performer or an audience member.

An experiment that I once did with an audience of fifty people explored a way of using direct reactions from an audience. A. A. Leath, John Graham, Patric Hickey, Daria Lurie, and I selected some ideas and materials and interacted in a spontaneous manner, evolving a performance as we went along. The audience was given paper and pencil and asked to write whatever was going on in their minds as a direct reaction to what we as performers were doing. At the end of the performance we collected their responses and invited any of them to a subsequent session where their responses would be read aloud and organized into a script. We selected responses, put them on separate cards, indicated time intervals; then we decided that at the next performance we would select a person from the audience, costume him, place him on a platform, and have him read from these cards. The performers would in turn respond to what the cards contained as their directions for selecting whatever was to be performed. The person from the audience was called "The Mouth." If a card contained a direction like "Make me cry," this would cut into whatever was going on and force the performers to use that direction in some way. In essence, this experiment was an attempt to allow the internal process of creation to be shared by the audience. Audience and performer mutually evolved their own production. This worked fine with an audience of fifty people. Other ways and means need to be found for audiences of 1,000 and in formal theatres. I'm still searching. The larger the audience, the more I think we are forced to cope more specifically with external processes.

KOSTELANETZ — Throughout this piece the audience retained its spectator's position?

HALPRIN — Yes, they did. However, their seating was arranged in groupings that permitted the performers to use a multiplicity of areas scattered like islands throughout the space.

KOSTELANETZ — This raises the question of where and how your art ultimately relates to life.

HALPRIN — I wouldn't dare attempt to give an absolute answer to that question. I can describe a project my husband and I did with our respective summer-school groups, that touches upon this question. About fifty of us were at a driftwood beach on the seacoast. My husband planted a stick in the sand and gave a simple direction. "Use only driftwood as your material and build a structure for yourself to use. Stay within a 150-foot radius of this center." Some people chose to work by themselves, some in teams, or couples. In each instance a unique statement evolved—a personal and imaginative driftwood structure. As the momentum and energy of the work process built up, more and more connections between structures were made. Finally, in only three hours, a city was built. What I got out of this process was that while each individual was working with maximum freedom to build his own individual structure, all these diverse individual parts came together into a total structure on its own accord, without any formalized planning. The city that took form evolved as a natural flow of the process, and the result was a configuration, a structure by itself independent of the many independent individual parts within. Like Nature in its inner operation, this process from start to finish gave to every moment its own validity, excitement, involvement, and interest. There was constant discovery, change and flux; performers and audience were the same. The main idea which impressed me was that the working process was both a life process and an art process, the two being interchangeable.

KOSTELANETZ — Do you regard one of your works as being better than another?

HALPRIN — No, I don't. That question resembles evaluating a human being's growth—is it better at eighteen than five, or better at forty or twenty? For me it isn't better or worse—just different.

KOSTELANETZ — How do you evaluate other people's works?

HALPRIN — I don't evaluate other people's work. I'm not a critic. But I do analyze my own work all the time. I have my own criteria for selection and decision-making which is based on my attitude

toward the evolving schemes that allow process to become form. Process must include the possibilities of change, flexibility, diversity, growth, interaction, and a lot of other notions yet to be identified. To me, anything, anything at all, is beautiful if it generates process or is useful in some way. Of course, all of this hinges on what your intentions are to begin with.

KOSTELANETZ — Do you consider your pieces dance or theatre?

HALPRIN — I prefer not to categorize at all. Certainly, in the traditional sense, however, my work is not considered "dance."

KOSTELANETZ — Are most of your pieces, in my categories, staged happenings?

HALPRIN — Many of the pieces, like the one I described we did this summer, are not staged at all. They are events that take place usually out-of-doors, like the fifty automobiles on the Embarcadero, Union Square at noon, a day of silence for fifty people, a walk through the woods, the slope, Hyde Street, the bus terminal, McClure's Beach, driftwood city, bathing, etc., etc. It's only when I perform in an actual theatre building that I do staged happenings. One critic in Stockholm called the performance presented there "a disciplined happening."

KOSTELANETZ — Are your pieces preordained? Can they be repeated in more or less precise patterns?

HALPRIN — None can ever be repeated in a precise pattern, but different pieces have different degrees of unpredictability. *Apartment Six* is completely unpredictable and changes enormously each time performed. *Parades and Changes* can be fairly well preordained once a sequence has been agreed upon, but it will, in turn, completely change each time it is done in a different theatre.

4

**It's almost as if art,
in painting and music and stuff,
is the leftovers of some activity.
The activity is the thing that I'm most
interested in. Nearly everything
that I've done was to see what would happen
if I did this instead of that.**

# —Robert Rauschenberg

Although Robert Rauschenberg participated in John Cage's prehistoric mixed-means performance at Black Mountain College in the summer of 1952, he did not become the author of his own theatre pieces until a decade later. Instead, it was as a painter that he originally attracted critical notice and, eventually, international fame. Rauschenberg's objects have been displayed all over the Western world; and as the recipient of the First Prize in Painting at the 1964 Venice Biennale, he is generally considered among the most important painters of the post-World-War-II period. His best-known early works were collages that exhibited a preference for sub-elegant "found" materials and an ability to integrate disparate elements. Toward the end of the 1950's, he created his first combines—three-dimensional collages or "paintings" that stand up away from the wall. In the early

sixties, he adapted silk-screening processes to his compositions and worked with plexiglass; but in 1965 he abandoned that kind of work to concentrate upon finishing *Oracle*—a five-part sculpture, each part of which contains a radio loudspeaker.

Although painting was his dominant interest during the fifties and early sixties, throughout his career he has maintained some connection with theatre. From 1955 to 1965, he designed sets, costumes, and controlled the lighting, for the Merce Cunningham Dance Company, and also collaborated in theatre pieces by Yvonne Rainer and Kenneth Koch. In *Pelican* (1963) he authored his own piece for the first time; and after he all but abandoned painting in 1965, he created a series of theatrical works—*Spring Training* (1965), *Map Room I* (1965), *Map Room II* (1965), *Linoleum* (1966), and *Open Score* (1966, for the New York Theatre and Engineering Festival). These theatre pieces, like his painting, reveal a particularly acute genius for stunningly original images and interesting visual composition as well as for the exploration of the possibilities of unusual materials and particular spaces.

Born in 1925, in Port Arthur, Texas, Rauschenberg looks considerably younger than his years. He talks willingly, though rather slowly, frequently pausing to find the most accurate word. His modesty causes him to speak about his work and his artistic purposes rather obliquely. As he has never taught and resists the invitation to lecture, his comments are somewhat disorganized and plagued by a tendency to wander; yet flashes of high insight and almost aphoristic articulateness inform whatever he says. Perhaps because his formal education was meager and, as he remembers it, uncongenial, he exhibits an unusual intelligence that is at once innocent and sophisticated, extremely imaginative and yet passionately pragmatic, highly original yet insistently empirical.

The initial interview took place in the kitchen on the third floor of his new multi-storied house, a converted orphanage, on New York's Lower East Side, just after a dinner of lamb chops and salad he had cooked for his guests. Later sessions took place in the adjacent workroom. Each time we met, he exhibited extraordinarily tenacious powers of concentration amid a plethora of distractions.

KOSTELANETZ — How did you become involved with theatre?

RAUSCHENBERG — I've always been interested, even back in high school. I like the liveness of it—that awful feeling of being on the spot, having to assume the responsibility for that moment, for those actions that happen at that particular time.

KOSTELANETZ — Was your first professional involvement with Merce Cunningham and his Dance Company?

RAUSCHENBERG — With him, and with Paul Taylor. At first I did just costumes and props. Then, at a certain point, it became clear that the lighting and the whole staging were just as essential to the way a piece looked as what the dancers were wearing. Merce lost his lighting man, and although I didn't know anything about lighting, John Cage and Merce convinced me that I could learn it for the next concert, which would be, like, in two weeks. There were three new pieces, and I didn't know one thing from another. I thought personally, "I know I can't, but I certainly do like it that they think I can. I'll try to do it their way."

At the same time I was getting interested in what the dancers at Judson Church were doing. Before I did any real theatre of my own, Jean Tinguely and Jasper Johns and myself collaborated with David Tudor to do a concert in Paris in 1961, and we also worked on Kenneth Koch's *The Construction of Boston* [1962]. I don't find theatre that different from painting, and it's not that I think of painting as theatre or vice versa. I tend to think of working as a kind of involvement with materials, as well as a rather focused interest which changes.

KOSTELANETZ — Even though your involvement with theatre may not be too different from your involvement with painting, surely painting is different from theatre on the outside.

RAUSCHENBERG — Well, in my paintings, almost from the very beginning, I observed that painting changed from one kind of light to another. Then I started incorporating lights into my painting, and theatre is a continuation of that. I wasn't proving that a light bulb was paint or that paintings ought to have light bulbs. It was an organic evolution of the use of those materials.

KOSTELANETZ — How did you become the author of your own theatre pieces?

RAUSCHENBERG — That skating piece, *Pelican* [1963], was my first piece. The more I was around Merce's group and that kind of activity,

I realized that painting didn't put me on the spot as much or not in the same way, so at a certain point I had to do theatre myself.

When I did the lights, my lighting cues were not programed. I played the lightboard. From performance to performance, things were different. In a work of Merce's called *Story*, I never repeated the set. A new one was made for each performance from materials gathered from different places. The costumes, actually, stayed more or less the same; but from time to time, stuff was thrown out and anything you could cover yourself with was brought in. The dancers could decide which, or any of these things, or none, they were going to wear when. I never knew where anyone was going to be; the space was not defined. The set had to be made out of what you could find, given the amount of time that you had in a particular locale, out of stuff that was there.

KOSTELANETZ — In the auditorium itself?

RAUSCHENBERG — No, out in the alley or any place you could get it. We didn't travel with a set.

KOSTELANETZ — What you had then was a set of ground rules for how this game should be played, rather than a piece with a closely composed score, and the game started as soon as you came into town.

RAUSCHENBERG — That was an exciting thing to do. In some places, like London, where [in 1964] we did the piece three or four times a week for six to eight weeks, it was very difficult to do a completely different thing every night. A couple of times we were in such sterile situations that Alex Hay, my assistant, and I would actually have to be part of the set. The first time it happened was in Dartington, the school in Devon. That place was inhabited by people with a very familiar look—that Black Mountain beatnik kind of look—but they occupied the most fantastic and beautiful old English building, all of whose shrubs were trimmed. There was nothing rural or rustic or unfinished anywhere. For the first time, there was absolutely nothing to use. There was a track at the very back of the stage that had lights in it, so the dancers couldn't use that space. About an hour before the performance, I asked Alex whether he had any shirts that needed ironing, which was a nice question to ask Alex because he always did and he always ironed his own shirts. So we got two ironing boards and put them up over some blue lights that were back there. When the curtain opened, there were the dancers and these two people ironing

shirts. It must have looked quite beautiful, but we can't be sure absolutely. But from what I could feel about the way it looked and the lights coming up through the shirts, it was like a live passive set, like live decor. It didn't occur to me then but it does now that it might have been difficult to tell whether we were choreography or set. I knew and I assumed it would be perfectly clear. Knowing that my job was to do decor, it might have been in bad taste, but I did it in all innocence.

KOSTELANETZ — Would you do it again?

RAUSCHENBERG — I won't do that. You see, there is little difference between the action of paint and the action of people, except that paint is a nuisance because it keeps drying and setting.

KOSTELANETZ — However, there is, I think, a great difference between doing decor and being the author of an entire piece.

RAUSCHENBERG — Well, you do a bit more. When you make sure that all the cables are taped down and that the curtains are working and that the stage is locked, you've already done everything except get up the nerve to go out there . . .

KOSTELANETZ — . . . and put your name on it.

RAUSCHENBERG — It wasn't so hard to put your name on it as it was to actually be there on the stage yourself. The first piece I did, *Pelican*, I had no intention of being in; but since I didn't know much about actually making a dance, I used roller skates as a means to freedom from any kind of inhibitions that I would have. That already gives you limitations—puts you in a certain area that you must deal with.

KOSTELANETZ — This is an example of how your choice of physical ideas determines your possibilities.

RAUSCHENBERG — It was a using of the limitations of the material as a freedom that would eventually establish the form. I auditioned dancers for the piece; and to my surprise, I found that dancers who had skated when they were children, and some of them quite well, couldn't roller skate now because of their dance training. They froze, and it was very awkward. They needed a kind of abandon to actually do it. You see, in their thinking, dancers have a going dialogue between themselves and the floor, and I had put wheels between them and the floor. They couldn't hear the floor any more, and their muscles didn't know where they were.

KOSTELANETZ — Did roller-skating movement become the syntax of the piece or a unifying image?

RAUSCHENBERG — No, it was just a form of locomotion. There were other wheels in the dance too. It was just that once I established the fact that I was going to call the piece a dance and didn't want it to be a skating act, then somehow the other ingredients had to adjust to that; so that Carolyn Brown, who was not on skates, was dancing on points, which is just as arbitrary a way of moving. It would not have occurred to me—well, once I say it, it occurs to me and I think it could be done—that someone could have possibly *walked* in that piece. Like when you do a black-and-white painting, you just give up the idea of different colors, even though you could put colors in. But if your focus is on the black and white, then that's where you are.

KOSTELANETZ — Would you describe in detail, from start to finish, the piece I saw several times and am, therefore, most familiar with, *Map Room II* [1965].

RAUSCHENBERG — I began that piece by getting some materials to work with—again we have that business of limitations and possibilities. I just got a bunch of tires, not because I'm crazy about tires but because they are so available around here in New York, even on the street. I could be back here in fifteen minutes with five tires. If I were working in Europe, that wouldn't be the material. Very often people ask me about certain repeated images in both my painting and theatre. Now I may be fooling myself, but I think it can be traced to their availability. Take the umbrella . . .

KOSTELANETZ — . . . which appeared in your painting *Charlene* [1954] and elsewhere.

RAUSCHENBERG — After any rainy day, it is hard to walk by a garbage can that doesn't have a broken umbrella in it, and they are quite interesting. I found some springs around the corner. I was just putting stuff together—that's the way I work—to see what I could get out of it. I don't start off with any preconceived notion about content of the piece. If there is any thinking, it is more along the line of something happening which suggests something else. If I'm lucky, then the piece builds its own integrity.

KOSTELANETZ — Once you collect the stuff, what happens?

RAUSCHENBERG — You just mess around. The springs, for example, made an interesting noise, so I decided to amplify that.

KOSTELANETZ — And the tires?

RAUSCHENBERG — They can be walked in, they can be rolled in, you can roll over them, you can crawl through them. All these things are perfectly obvious. Perhaps tires even have uses that you haven't seen before. What I'm trying to avoid is the academic way of making a dance of theme and variation. I'm interested in exploring all the possibilities inherent in any particular object. If you don't have any preconceptions about moving, you've got to start somewhere. This is my way.

The reason that the piece is called *Map Room II* is because there was a *Map Room I* [1965] which was done at Goddard College. There was an old sofa on the stage there. I think I make theatre pieces very much the way I make a painting, which is that I simply have to put something into the space. The sofa already occupying part of the space gets to be a member of the cast.

KOSTELANETZ — What about the shaping of the other major theatrical element, which is time? How do you fill that?

RAUSCHENBERG — Most often my pieces are as long as they just naturally get to be from having worked on them that long. It's a funny thing, but I almost know my size right now and I really ought to do something about it. My pieces are about a half an hour, no matter what my attitude is. I should do a very long piece and a very short piece.

I tend to think of time, as we traditionally know it, as my weakest point, because I've had the least experience in considering it.

KOSTELANETZ — Certainly the most frequently heard criticism of *Map Room II* was that it was too slow.

RAUSCHENBERG — I don't mind that. I don't mind something being boring, because there are certain activities that can be interesting if they are done only so much. Take that business with the tires in *Map Room*, which I find interesting if it is done for about five minutes. But something else happens if it goes on for ten more minutes. It's a little like La Monte Young's thing [*The Tortoise, His Dreams and Journeys*]. At some point, you admit that it isn't interesting any more, but you're still confronted by it. So what are you going to make out of it?

KOSTELANETZ — However, there is a difference between intentional boredom and inadvertent boredom. The first, if an artist does it, reveals that he knows precisely what kind of effect the boredom he creates will have upon people. La Monte is intentionally boring, because by playing the same chord at that amplitude he wants you to hear certain previously inaudible gradations.

RAUSCHENBERG — I'd like it if, even at the risk of being boring, there were an area of uninteresting activity where the spectator might behave uniquely. You see, I'm against the prepared consistent entertainment. Theatre does not have to be entertaining, just as pictures don't have to be beautiful.

KOSTELANETZ — Must theatre be interesting?

RAUSCHENBERG — Involving. Now, boredom is restlessness; your audience is not a familiar thing. It is made up of individual people who have all led different lives.

KOSTELANETZ — If I were to sit here and talk at, say, one-quarter of my normal speed, it would be inadvertently boring.

RAUSCHENBERG — Not necessarily.

KOSTELANETZ — Would you find it interesting?

RAUSCHENBERG — I might. I'd have to hear it. I've been with people who have speech problems. At first it made me quite nervous, later I found myself listening to it and being quite interested in just the physical contact; it can be a very dramatic thing. I've never deliberately thought about boring anyone; but I'm also interested in that kind of theatre activity that provides a minimum of guarantees. I have often been more interested in works I have found very boring than in other works that seem to be brilliantly done.

Some of Bob Morris' theatre pieces have had very little activity that goes on for a very long time. They were usually presented in mixed concerts; and I would find myself at the end of the evening being more moved by Bob's inactivity than I was by things that I was at the time more in awe of—skillful executions of extremely difficult movements.

KOSTELANETZ — What was it that made Morris' piece more memorable to you?

RAUSCHENBERG — I don't like the traditional idea of the audience—that they shouldn't assume as much responsibility as the entertainer does for making the evening interesting. I'm really quite unfriendly

about the artist having to assume the total responsibility for the function of the evening. I would like people to come home from work, wash up, and go to the theatre as an evening of taking their chances. I think it is more interesting for them. What I was doing at Morris' thing was just that.

KOSTELANETZ — I'm bothered about this juxtaposition of interesting and boring.

RAUSCHENBERG — Does it help you to think about a painting that isn't beautiful?

KOSTELANETZ — No, because that isn't necessarily contradictory. What you're doing, I think, is setting up an opposition to entertainment.

RAUSCHENBERG — I think that's it. I used the word *bored* to refer to someone who might look at a Barney Newman and say there ought to be more image there than a single vertical or two single verticals. If someone said that that was a boring picture, he was using the word in relation to a preconceived idea of what interesting might be. What I am saying is that I suspect there is a lot of work right now in theatre described as boring which is simply the awkward reorientation of the function of theatre and even the purpose of the audience. Just in the last few years we have made some drastic changes. Continuity in the works that I am talking about has been completely eliminated. It is usually different from performance to performance. There is no real dramatic continuity; the interaction tends to be a coincidence or an innovation for that particular moment.

KOSTELANETZ — What else is characteristic of mixed-means theatre?

RAUSCHENBERG — An absence of hierarchy—the fact that in a single piece by Yvonne Rainer you can hear both Rachmaninoff and sticks being pitched from the balcony without those two things making a comment on each other. In my pieces, for instance, there is nothing that everything is subservient to. I am trusting each element to sustain a work in time.

KOSTELANETZ — What meanings do these changes imply?

RAUSCHENBERG — All these ideas tend to point up the thought that it would be better for theatre if on the second night you went you found a different work there, even though it might be in the same place and have the same performers and deal with the same material.

I think all this is creating an extraordinary situation that is very

new in theatre; so both the audience and the artist are still quite self-conscious about the state of things.

KOSTELANETZ — How do these attitudes relate to the composition of *Map Room II*?

RAUSCHENBERG — In beginning a theatre piece, the first information I need is where it is to be done and when. Where it is to be done has a lot to do with the shape it takes, with the kinds of activity. *Pelican* was done in a skating rink; if it were not to have been performed in a skating rink, I'm sure that it would not have been done on skates.

KOSTELANETZ — Once you heard it would be in a rink, you said, "Why not use roller skates?" That's the kind of association you make.

RAUSCHENBERG — Exactly. Then I will often use isolated things I just happen to think of, like putting flashlights on the back of a turtle in *Spring Training* [1965]—liking that for the idea of light being controlled by something literally live and the incongruity of having an animal actually assume that responsibility. That's a separate idea, and that is one way of working.

KOSTELANETZ — Wasn't there a piece that involved a dog coming out on the stage for a similar possibility of uncontrolled activity?

RAUSCHENBERG — Yes, I used a dog in a piece of Paul Taylor's. The presence of any kind of animal other than people draws one's attention to the fact that people are simply a different kind of creature.

KOSTELANETZ — Or the fact that a theatrical situation could contain other creatures aside from people. Hasn't Lassie always been heroic?

RAUSCHENBERG — That's because of Lassie's people-quality. I wouldn't be interested in using an animal that communicated with human beings on the level that human beings have taught them to communicate. Lassie is actually a human hero. She puts out fires, saves children, does her work on the farm. That's not my interest in using other kinds of animals. It is very hard to empathize with a turtle. Once you accept it as a turtle, it doesn't become a surrogate human being.

Separate kinds of images like the turtle with the flashlights more or less occur to me divorced from any particular program or piece, like the shoes in *Map Room II* that are cast in twelve inches of plastic. That was a completely separate image that came to me apparently out of the blue. I had Arman build those shoes, because he works in plastic. I simply told him what the idea was, and he made them for

me. That sort of involvement can happen at any time and then can simply be used in the next piece.

KOSTELANETZ — If it occurred before you had to do the piece, it would be an image in your storehouse.

RAUSCHENBERG — The neon that I used in *Map Room II* came from a desire to use neon. I tend to work on such a short deadline that I can't do anything special, as I can when I'm working just for myself. Availability and expediency get to be determining elements in my theatre work.

KOSTELANETZ — Let me go back for a moment. A piece starts in your mind, once you are asked to do it. . . .

RAUSCHENBERG — What I want to know first is where. I carefully check all the architecture of the space. What permissions are granted physically because of where the audience sits, how many doors there are, where the doors are, if there are any windows. In *Map Room I*, there was a window on one side of the audience; I used it as a small stage. The piece, instead of beginning on the stage, began outside that window. It actually turned out quite beautifully, because it was pouring rain. A God-sent activity was actually working for the piece. It was a simple activity that was happening outside—a girl braiding her hair; by the time she finished, she was soaking wet. Then the rain picked up the light very beautifully, so that she was illuminated and it also put a particular stain on an otherwise perfectly natural and obvious activity.

KOSTELANETZ — Although you weren't in full control of the situation, you didn't mind the accident.

RAUSCHENBERG — I don't want to be in full control. In fact, a lot of the obstacles I bring in function to make sure that I'm not in full control. I very rarely tell my people exactly what to do. What my pieces tend to be are vehicles for events of a particular nature that can embody and use the personalities and abilities of the performers. Still, I have never been particularly interested in improvisation, because trusted to improvise, people very rarely move out of their own particular clichés and habits. Or, if they do, they are using their own pre-manufactured disguises of those habits.

KOSTELANETZ — Then what you are doing is writing a program, almost, for your materials, which include your props, your people, and your space. How specific is your program?

RAUSCHENBERG — In *Map Room II*, the first thing I thought of was the use of a confined small stage within a traditional stage. I broke it down and used the area in front of the curtain as something different from behind the curtain, so that I created two different architectural space situations within one piece, although the entire stage was small. Also, the space of the piece went out into the audience; for while we were onstage with the words making sentences at random, Trisha Brown was down below passing out large white cards to the audience for them to put on their backs. Part of the audience would later become a movie screen.

KOSTELANETZ — How carefully did you program Trisha Brown's activity—that she would come before the audience and pass out cards?

RAUSCHENBERG — My instructions to her didn't go any further than telling her exactly what her job was. I gave her a task and an attitude.

KOSTELANETZ — Did you give her a time?

RAUSCHENBERG — No, however long she needed. I said that she should wait until the lights came up on us and we were settled. Any time after that she felt ready to go, she should just start, trusting her own sense of timing to accomplish the most natural organic relationship to "time." She actually cued us, for when she was through we were through.

KOSTELANETZ — So she improvised the dimension of time . . .

RAUSCHENBERG — . . . using only practical considerations, rather than aesthetic ones. It would have been out of the question for her to prolong her scene. Somehow her activity had to relate to accomplishing a particular job. I gave her an attitude, asking her to be gracious but not patronizing, possibly using the attitude of, say, a nurse's aide or an airline hostess.

KOSTELANETZ — How specific was your programing of the sequences?

RAUSCHENBERG — The sequences were determined by a very practical consideration. I had only five people to work with; if I had picked three, say, then it would have been different. But it turned out I had five. The people in the front passing cards had to get offstage, and there was a costume change involved for Deborah Hay. There had to be an activity there to allow Deborah to get into the costume that had the live birds. I didn't have to change clothes as quickly; so I would

have to be the one to bridge that time lapse there. So I figured out the activity I would do—that would be the wiping of the mirror-screen that had images projected on it. Since the screen was dirty, it at first seemed to have no image, but as I wiped it one began to appear—Mount Rushmore tilted vertically. I liked the paradox that the more you wiped, the clearer the image got; whereas in painting the reverse tends to be true. That was for my own personal entertainment. I continued my activity until Deborah was ready.

KOSTELANETZ — Which then became the cue for you to stop. Why did you tilt that image of Mount Rushmore sideways?

RAUSCHENBERG — That's the way it fit on the mirror. Also it postponed the legibility a few moments longer. If that had been a totem pole it would have been right side up.

KOSTELANETZ — So then your script consists of tasks and cues. That's the way you outline your sequences, so to speak.

RAUSCHENBERG — My main problem in constructing a program of a piece is how to get something started and how to get it stopped without drawing particular attention to one event over another.

KOSTELANETZ — However, isn't this an aesthetic bias, as is your preference that the piece should have no climax?

RAUSCHENBERG — The shape that it takes should simply be one of duration.

KOSTELANETZ — And space.

RAUSCHENBERG — Space is a necessary consideration and one of the contributing factors to actually determining the content. If I took any one of my pieces and did it again someplace else, then I'd have to decide what to adjust to the new environment and what to build.

KOSTELANETZ — If presented in a new environment, does a theatre piece of yours radically change?

RAUSCHENBERG — It can be. New elements come in. In *Map Room I*, there was a trap door on the stage, and it was a very small stage. The space was filled horizontally very quickly; so I started working vertically. I defined another space, from the trapdoor to the roof. Now, when I re-did the piece, there was no trapdoor on the new stage, so that whole area of activity had to be eliminated from *Map Room II*.

KOSTELANETZ — Did the piece lose or gain?

RAUSCHENBERG — It changed only. Gaining or losing is a critical evaluation, and I stay out of that area.

KOSTELANETZ — Was its old form recognizable in the new setting?

RAUSCHENBERG — It might have looked more like a different piece than the same piece. Probably the tone of the piece would still be there; but from *Map Room I* to *Map Room II*, which are the same piece, there was such change that I thought the latter warranted being called number two—only two elements out of, say, ten were in both.

KOSTELANETZ — In *Map Room II*, your activity of wiping the mirror ended once Deborah Hay had her costume on; then she came onstage with a cage around her waist, almost like a tire. In that cage were three doves.

RAUSCHENBERG — I used doves not for any symbolic reason but because that's about the biggest bird that the amount of space would permit. It was going to be pigeons, but pigeons are bigger than doves. I was toying with a whole other kind of image that turned up in *Linoleum*, a piece I made after that, where I used chickens, which are big available birds.

In each case, I wanted the actual object of the bird, rather than just bird-like activity. I liked the combination of two independent elements being forced to operate as a single image. Actually, in *Map Room II*, the first idea was that Deborah's costume should be something edible for the birds, such as corn or bread, but that turned out to be an impractical way to think, since birds that are put temporarily into a new environment aren't going to eat.

KOSTELANETZ — Was the idea to combine two images in one figure so that neither one could dominate the other?

RAUSCHENBERG — Yes. It was a kind of combined coexistence to make a single image.

The new element became Trisha moving across the stage inside the tire with her bottom side showing. In fact, her body was as abstract a form as the tire. She was actually sitting in the tire and protruding, so that her outside shape remained the tire (or a black circle) obscured by some enormous tongue. The tire actually shielded her method of moving. I have photographs of it, and I find it hard to recognize it as a human body. Her method of moving was actually determined by her position—how you can move and what sorts of things you can do. I didn't want the audience to be involved with who it was that was in

the tire and what the person looked like. What I wanted was the most abstract image at that particular moment.

That was followed by the two men with their feet in the tires, Steve Paxton and Alex Hay, who were somehow moving with the attitude that feet had the ability to roll.

KOSTELANETZ — However, at first they walked in a more or less normal fashion, as though they had on shoes with curved bottoms.

RAUSCHENBERG — But later they did actual forward rolls, letting the tire be their major contact with the ground as they rolled forward. Then they put both feet in the hole of the same tire and walked, turning the tire as they went.

KOSTELANETZ — Then they put four tires in a row, slid into the casket perpendicular to the tires, and rolled like a truck axle across the floor. Were these images intended as a series of variations on the theme of man and his tires?

RAUSCHENBERG — Not necessarily. They are variations in the sense that different uses are put to the same material, but not variations in the sense of establishing a theme. Tires were not the theme. Actually, movement was the theme, with the restriction of tires.

At the same time that this was going on, a flesh-colored sofa was moved onstage. It had its own light which made it an independent entity. Deborah Hay, dressed in a flesh-colored leotard, had the following simple direction: Move from position to position on the couch, always considering the couch as part of your image. Never once did she just stand up and be a person standing on a couch.

KOSTELANETZ — She always blended into the lines of the couch.

RAUSCHENBERG — The image wasn't couch and wasn't person.

It is very difficult for me to describe these things this way and to describe the working process, because I just try things. I actually work by eye.

KOSTELANETZ — You do have a method, though, and you are conscious of it, although you may not be conscious of it at the time you are working.

RAUSCHENBERG — Actually, anything I tell you about it you could probably get out of the work, if you had seen a number of pieces.

KOSTELANETZ — I think you will find, as I have, that the creators of mixed-means theatre are better able to talk about their work than the people who see it, regardless of how experienced they are, because

the authors are more precisely aware of the new language of the new theatre. Take the sequence you have just described to me—Deborah Hay on the couch. I have seen it several times, and I could not have described it as satisfactorily as you did. Now that I've heard your interpretation I do not think I would want to describe it any other way. This may stem from my own inability to perceive your kind of preoccupations, and I doubt if I'm alone in this respect. We all lack an education in the new theatre. If you asked a drama critic what happened here, he might say it was a boring scene in which a girl did a series of headstands on a couch, because that is all his intellectual and perceptual equipment prepared him to see.

RAUSCHENBERG — His secondary interest might be whether she was a pretty girl or not and how much or how little she was wearing. My interest was that she was costumed in a color that most closely matched the couch so that integration would happen as easily as possible—so that there would be as little separation as possible between her activity and the natural construction of the couch.

KOSTELANETZ — While she was performing on the couch, the film came on, a travelogue which was projected upon the large white cards which Trisha Brown had asked the audience to hang from the back of their necks . . .

RAUSCHENBERG — . . . using the audience as a screen so that at that point it was divided. The audience had two functions: Part of it had an active role in the production, as opposed to being separated from the activity we had on the stage, while the rest were the observers of the movie.

KOSTELANETZ — It also further split our focus, because we weren't quite sure where we were supposed to look.

RAUSCHENBERG — In most cases, my interest is in acknowledging the fact that man is able to function on many different levels simultaneously. I think our minds are designed for that, and our senses certainly are. We can be sitting here, and our noses can tell us that something is burning in the kitchen; yet intellectually for hundreds of years the idea of uninterrupted concentration has been considered the most serious attitude to have in order to use our intelligence.

I think when we are relaxed, all these things happen naturally. But there's a prejudice that has been built up around the ideas of seriousness and specialization. That's why I'm no more interested in giving

up painting than continuing painting or vice versa. I don't find these things in competition with each other. If we are to get the most out of any given time, it is because we have applied ourselves as broadly as possible, I think, not because we have applied ourselves as single-mindedly as possible.

KOSTELANETZ — Do you have a moral objection, then, to those dimensions of life that force us to be more specialized than we should be?

RAUSCHENBERG — Probably. If we can observe the way things happen in nature, we see that nearly nothing in our lives turns out the way that, if it were up to us to plan it, it should. There is always the business, for instance, that if you're going on a picnic, it is just as apt to rain as not. Or the weather turns cold when you want to go swimming.

KOSTELANETZ — So then you find a direct formal equation between your theatre and your life?

RAUSCHENBERG — I hope so, between working and living, because those are our media.

KOSTELANETZ — You would believe, then, that if we became accustomed to this chancier kind of theatre, we would become accustomed to the chancier nature of our own life.

RAUSCHENBERG — I think we are most accustomed to it in life. Why should art be the exception to this? You asked if I had a moral objection. I do, because I think we have this capacity I'm talking about. You find, for example, that an extremely squeamish person can perform fantastic deeds in an emergency. If the laws have a positive function, if they could have, it might be just that—to force someone to behave in a way they have not behaved before, using the faculties he was actually born with. Growing up in a world where multiple distractions are the only constant, he would be able to cope with new situations. But, what I found happening to people in the Navy was that once they were out of service and out of these extraordinary situations, they reverted to the same kind of thinking as before. I think it is an exceptional person who uses that experience. That's because, in most cases, the service is not a chosen environment; it is somebody else's life that they're functioning in, instead of recognizing the fact that it is still just them and the things they are surrounded by. The Navy is a continuation of extraordinary situations. We begin by not

having any say over who our parents are; our parents have no control over the particular peculiar mixture of the genes.

KOSTELANETZ — Let us return to the scenes of the piece. The film is going, and Deborah Hay is visually fused to the couch. . . .

RAUSCHENBERG — Then there is the neon. When I went to get several pieces of neon, I discovered a Tessler Coil that is used to make sure there is no leakage in a neon tube and that it is the right color. When you touch the coil to any place on the tube, it activates the gases inside. I asked what would happen if instead of touching the coil directly to the tube I used my body as a conductor, by holding the coil in one hand, the tube in the other. I was told that I could if I grabbed it very quickly, but it would knock the hell out of me if I hesitated. It took a little doing always to grab it firmly, because one has fear in control of his muscles too. It's like being on a high diving board, you know—though you want to dive off so much, you don't do it. It's that kind of thing.

KOSTELANETZ — It was easier when we were younger.

RAUSCHENBERG — Because we didn't have so much fear; we hadn't heard so many stories about what could happen. It's like the caution that happened to the trained dancer's body on the roller skates. Skating is the most natural thing a child can do; but to do it seriously as an adult is very hard.

KOSTELANETZ — At this point, you took the plastic glass shoes out of your storehouse.

RAUSCHENBERG — I had them anyway, knowing that I would use them someplace in a piece. The clear plastic with the neon showing through it must have been interesting because you could see between the foot and floor, even though I was just walking.

KOSTELANETZ — It was a very beautiful image; and because of its beauty and originality, it tended to dominate—to be the most memorable image or the pinnacle of the hierarchy. Was its dominance a defect?

RAUSCHENBERG — It was more a defect to have that activity happen at the end of the piece; but before that point in the piece, I had been very busy. If I did that piece again, the order would be rearranged. At the time the audience first saw it, that piece had never been performed in its entirety, not even in a rehearsal. We had some idea of what to do. I'm not against a rehearsal, but I have a tendency to keep making

changes up to the last minute and I tend to work with people I can trust enough. We all knew that evening that we were making this thing for the first time; I like that psychologically.

KOSTELANETZ — Were all subsequent performances exactly the same?

RAUSCHENBERG — The first evening it felt just a little too rough. Everyone had trouble getting in and getting out—functional problems. Even then I had a slip of paper with me; and I would go offstage to see what happened next. As I'm the author, you could imagine how the cast felt. That second evening I sensed that the whole thing just sort of died right in front of everybody. So, the third evening I said let's speed the whole thing up; I don't care if we finish in fifteen minutes. Let's get on, do what we have to do, and get out. That would, I thought, tighten things up. My idea of the sequential arrangement is not just to string some activities along, like you're making beads or taking a trip; but when you have three things happen, you should convey the individuality of each of these events separately plus the interaction which happens because of their coexistence. What had happened was that everything had been stretched so that it became a linear piece as opposed to . . .

KOSTELANETZ — . . . an overlapping line, like a "Slinky" or a chain with interlocking loops.

RAUSCHENBERG — Right.

KOSTELANETZ — Looking back over your involvement with theatre, do you see any kind of development, aside from the obvious development that you have now become the author of your own theatre pieces, rather than a contributor to somebody else's? Also, do you see any development in your company of more or less regular performers?

RAUSCHENBERG — Well, that last is mostly a social thing of people with a common interest, and we have tended to make ourselves available as material to each other. It is in no way an organized company, and it changes from time to time—people move in and out. However, where a play could be cast with different actors and you would still get the same play, if I was not in constant touch with these people, I could not do these pieces. The whole concept would have to be changed if I had new performers—if I let Doris Day take Mary Martin's part in a musical or used the Cincinnati Philharmonic rather than the New York Philharmonic.

KOSTELANETZ — You write for these performers, and they have learned to respond to the particular language of your instructions.

RAUSCHENBERG — It goes beyond interpretation or following directions. From the outset, their responsibility, in the sense of collaboration, is part of the actual form and content and appearance of the piece. It makes them stockholders in the event itself, rather than simply performers.

KOSTELANETZ — This company includes, roughly, Alex and Deborah Hay, respectively a painter and a dancer; Lucinda Childs, a dancer; Steve Paxton, a dancer. . . .

RAUSCHENBERG — We have worked a lot with Yvonne Rainer and Bob Morris and Trisha Brown. In my new piece [*Linoleum*] I used Bob Breer's sculptures. At the time that I premiered the piece in Washington, I used the son and daughter of the people I was staying with. When I did the piece for Educational Television, Bob Breer delivered the sculptures to the studio; and since I needed another person, Bob Breer immediately became part of the performing group. It's not a company or a group in the sense of the dancers who work with Martha Graham, Merce Cunningham, or José Limon; it's informal.

KOSTELANETZ — Let's return to that question of development.

RAUSCHENBERG — In *Map Room II*, a couple of the people involved said that they had now gotten some kind of feeling about what I was after. Because this is my fourth or fifth piece and these people, if they weren't in them, had seen them all, then I think there is a body of work. If someone is working with an unfamiliar kind of image and if you see only one piece, it looks like a lot of things that it isn't and a lot of things that it is; but you don't really understand the direction. If you see five of his pieces you're more apt to see what he's doing. It's like signposts: You need a few to know that you are really on the right road.

KOSTELANETZ — Do you feel stronger and more confident now in approaching a theatre piece?

RAUSCHENBERG — Confidence is something that I don't feel very often, because I tend to eliminate the things I was sure about. I cannot help but wonder what would happen if you didn't do that and if you did this. You recognize the weaknesses in *Map Room II*, for instance, that weakness of the neon thing coming last. *Linoleum* is probably

one of the most tedious works I've ever done, the most unclimactic. If you're in the audience, you simply move into it with your attention and live through it. At a certain point it's over.

KOSTELANETZ — One of the myths of modern culture—I associate it particularly with Lewis Mumford's *Art and Technics* [1952]— is that art and technology are eternally opposed to each other and that one succeeds only at the decline of the other.

RAUSCHENBERG — I think that's a dated concept. We now are living in a culture that won't operate and grow that way. Science and art— these things do clearly exist at the same time, and both are very valuable. We are just realizing that we have lost a lot of energy in always insisting on the conflict—in posing one of these things against the other.

KOSTELANETZ — It seems to me that technology has had a huge impact upon modern art—the creation of new paints, the impact of media—all of which has never been fully explored.

RAUSCHENBERG — You can't move without encountering technology. Just think of what it would be like to go out into the field and pick your supper; now we have it deep-frozen in our kitchen after it was gathered from all over the world. It is only habits in thinking that have tended to make us callous to our actual surroundings.

KOSTELANETZ — How do you look upon working with technicians— as a division of labor, as a division of mentality?

RAUSCHENBERG — I've never questioned paints, since I've never ground my own pigments or mined for the chemicals that made them. I assume a certain amount of information in a tube of red paint. I think that one works with information as though it were a material. I think that somehow it is richer if you are in a live collaboration with the material; that's our relationship to the engineers.

KOSTELANETZ — In contrast to nearly all contemporary artists, you did not need to find your own style by first painting through several established styles—by taking them as your transient models. From the start, you were, as we say, an original.

RAUSCHENBERG — I always had enormous respect for other people's work, but I deliberately avoided using other people's styles, even though I know that no one owns any particular technique or attitude. It seemed to me that it was more valuable to think that the world was big enough so that everyone doesn't have to be on everyone else's feet.

When you go to make something, nothing should be clearer than the fact that not only do you not have to make it but that it could look like anything, and then it starts getting interesting and then you get involved with your own limitations.

KOSTELANETZ — As an artist, do you feel in any sense alienated from America today or do you feel that you are part of a whole world in which you are living.

RAUSCHENBERG — I feel a conscious attempt to be more and more related to society. That's what's important to me as a person. I'm not going to let other people make all the changes; and if you do that, you can't cut yourself off.

This very quickly gets to sound patriotic and pompous and pious; but I really mean it very personally. I'm only against the most obvious things, like wars and stuff like that. I don't have any particular concept about a utopian way things should be. If I have a prejudice or a bias, it is that there shouldn't be any particular way. Being a complex human organ, we are capable of many different things; we can do so much. The big fear is that we don't do enough with our senses, with our activities, with our areas of consideration; and these have got to get bigger year after year.

KOSTELANETZ — Could that be what the new theatre is about? Is there a kind of educational purpose now—to make us more responsive to our environment?

RAUSCHENBERG — I can only speak for myself. Today there may be eleven artists; yesterday there were ten; two days ago there were nine. Everybody has their own reason for being involved in it, but I must say that this is one of the things that interests me the most. I think that one of my chief struggles now is to make something that can be as changeable and varied and alive as the audience. I don't want to do works where one has to impose liveliness or plastic flexibility or change, but a work where change would be dealt with literally. It's very possible that my interest in theatre, which now is so consuming, may be the most primitive way of accomplishing this, and I may just be working already with what I would like to make.

KOSTELANETZ — How will our lives—our ideas and our responses—be different after continued exposure to the new theatre?

RAUSCHENBERG — What's exciting is that we don't know. There is no anticipated result; but we will be changed.

**ROBERT RAUSCHENBERG — 99**

# 5

**In the freest of these works, the field,
therefore, is created
as one goes along, rather than being there *a priori*,
as in the case of a canvas of certain dimensions.
It is a process, and one that works from the
inside out, though this should be considered
merely metaphorical rather than descriptive,
since there actually exists no inside.**
*Assemblage, Environments,
& Happenings* **(1966)**

# —Allan Kaprow

Allan Kaprow is among the most articulate of the creators of the new theatre, and this ease with words reflects the fact that since 1953 he has been by trade a teacher, first at Rutgers and now at the Stony Brook (Long Island) campus of the State University of New York, where he is Professor of Art History. Considerably older and slighter than his brown thick hair and neatly trimmed full beard make him appear, Kaprow lives with his wife Vaughan and their three children in a large old house, an oasis of antiquity in a sea of newer and smaller houses, in Glen Head, Long Island, about halfway between Stony Brook and New York City. Paradoxically, this most radical of artists

is, by environment, a suburban family man with an especial love for shopping in the supermarket and playing with his children.

Born in Atlantic City, New Jersey, on August 23, 1927, Kaprow grew up primarily in Tucson, Arizona. He returned to New York City to attend the High School of Music and Art, and then went on to New York University for his B.A. (1949). After a year of graduate school in philosophy at N.Y.U., he entered Columbia, obtaining his M.A. in Art History in 1952. In the late forties, he studied painting with Hans Hofmann, and in the middle fifties attended John Cage's classes in musical composition at the New School. As a painter, he had nine one-man exhibitions; and in the middle fifties, he created the first kinetic environments in America. In the late fifties, he also composed electronic tape for dance and theatre productions.

In 1959, pursuing some revolutionary ideas he had developed in Cage's classes, Kaprow contributed to *The Anthologist*, a literary review published at Rutgers, an article entitled "The Demiurge," in which he described "Something to take place: a happening"; and that autumn he presented *18 Happenings in 6 Parts* at the Reuben Gallery in New York. Since that time he has abandoned painting to concentrate on performance pieces which he has presented in places as various as Paris, Stockholm, Miami, and Edinburgh, Kaprow's recent works include *Calling* (1965), a two-day event in New York City and woods in New Jersey; *Self-Service* (1966), which took place in three cities over a four-month period; and *Gas* (1966), a three-day, six-part event on eastern Long Island.

As an art historian and critic, Kaprow has published numerous essays on artists of the past, as well as on his own work and that of his contemporaries, in art journals and exhibition catalogues. His essay on "The Legacy of Jackson Pollock," first published in *Art News* (October, 1958), was among the most influential articles of the past decade. His manuscript on the new art, first circulated among friends in 1960, was recently incorporated into a huge illustrated volume which he also designed, entitled *Assemblage, Environments, & Happenings* (Abrams, 1966).

Kaprow speaks firmly and distinctly, with an accent that has tinges of both Arizona and New York, and the following text hardly indicates how shrewdly he exploits variations in both vocabulary and tone. As a teacher, he wants to make everything clear, even when his mes-

sage is that matters are ambiguous and confusing; and he so rarely searches for words and ideas that he creates the impression that he has carefully and extensively contemplated all the problems his new art raises. Among his contemporaries he has an influence that is nearly as great as John Cage's, and over the years he has come to seem less a young polemicist than an elder wise man. He exhibits an intellectual's devotion to espoused principles that makes him unwilling to compromise his artistic ambitions. At one point, he attempted vainly to stop all vulgar usage of the word "Happenings," and his rather specific conception of his present work forbids him from participating in festivals where, by reputation, his work would otherwise belong.

The interview took place in the dining room of his house, a room dominated by windows, some of his early paintings, and a floor-to-ceiling bookshelf. Kaprow wore dungarees, a denim shirt, and moccasins, and from time to time served his guests soft-ice-cream sundaes topped with freshly picked fruit. He patently loves to explain and explore his ideas; and even at the conversation's end, at two in the morning, he gave the impression that he could have talked several hours more.

[The conversation opens with Kaprow speaking of Marcel Duchamp's discovery of art in common materials—"ready-mades."]

KAPROW — When he saw all these tools lying around, he suddenly realized that at that moment he had enough material for endless one-man shows. He said in a radio interview that to do that would of course be to defeat the purpose. He really wanted to be very selective and hold his punches for where they would be most effective. His purpose in creating ready-mades in that case was obviously editorial.

KOSTELANETZ — You mean that Duchamp was more interested in the ideas than in the objects.

KAPROW — I think so. He feared the objects would be considered works of art venerated for their supposed beauty. He was aware of how easily anything can become aestheticized.

Is this tape-machine automatic?

KOSTELANETZ — Yes, its microphone is voice-operated.

KAPROW — Beautiful.

KOSTELANETZ — Let me first ask what you learned in studying with Hans Hofmann?

KAPROW — I learned a great deal. I learned about modern European art, and that was quite important as a foundation. It gave me a sense of the difference between the environment I was living in and the environment I admired—the European one.

KOSTELANETZ — Why did you admire Europe?

KAPROW — It was something taught me. There was nothing better around at the time, except the just-beginning Action Painting movement in this country, which I knew too little about; and although Hofmann was a major figure in the movement, he rarely showed us his work. Even if he had, it would have essentially seemed an outgrowth of his European ideas.

KOSTELANETZ — If you were being educated now, would you have the same feeling?

KAPROW — No, of course not. Now, I'd cut my eyeteeth on abstract expressionism or, perhaps, even more recent work.

KOSTELANETZ — Do you feel any handicaps living in America now?

KAPROW — No. It's probably the most fertile atmosphere in the world for new ideas, experiences, discoveries, cataclysms.

KOSTELANETZ — What was the subject of your M.A. thesis?

KAPROW — Mondrian. I was examining, at a time when there was practically no literature on the man, what I considered his essential point to be. I conceived of him as a philosophical artist—a painter who used painting to destroy painting, in order to arrive at an essentially mystical state of awareness.

KOSTELANETZ — Mystical through the experience of rectangular shapes?

KAPROW — No, through the destruction of all visible marks on the canvas, a purpose which his rectangular shapes served; and if you sight Mondrian as I think it is necessary to do—with a fixed eye, unblinkingly, for long periods of time, where you begin to see the pictorial cancellations operating, then you arrive at a point where finally the whole canvas seems to eliminate itself and become an oscillating cypher. You become just another relation to its ever-changing proportions, a "function." I think this is what he was after; and as I've interpreted his writing, it seems pretty clear to him too. The paradox was—it's not a contradiction—that he had to use painting to do it.

Like so many artists, he was obviously interested in the work as a

form of investigation of reality and a testing of reality at the same time. For him, painting was a kind of ontological tool; it wasn't mere aesthetics. He clarified the difference between French aesthetics, which was more sensual—embodied in the work as work and as a good meal to be enjoyed for itself—and northern European thinking, which was always more philosophical.

KOSTELANETZ — Also, where the French imply that through subjective creation the painter creates subjective experience, Mondrian offers an objective creation to induce a subjective experience.

KAPROW — Yes, he was different from German expressionism in that respect. However, Mondrian was actually opposed to subjective states; he regarded his mysticism as objectively universal.

KOSTELANETZ — Doesn't this link up with tendencies in contemporary American art?

KAPROW — Very much so. If you wish to follow that thread, you can see why he was one of the most influential Europeans on our thinking —right through de Kooning and Kline and indirectly to the work of Barney Newman and Ad Reinhardt and other purists of our period.

I also see it in a man like Pollock, who used a body gesture to destroy that detached measuring stance which almost all good painters are supposed to cultivate. By being inundated in his swirls of paint and by an enormous format which he could not assess in any one glance, he finally put the whole affair on the floor and stood in the middle of it. He created a quasi-environment in which reiterated pulsations of flung and dragged paint seemed to cause a trance-like, almost ritual loss of self, first in himself and, later, in the observer. This is not painting any more.

KOSTELANETZ — But isn't this a contrary tendency—through the most subjective mechanisms he creates a highly objective field.

KAPROW — It was a frenzied counterpart to the cooler Mondrian, but it ended up with the same kind of idea—a non-aesthetical point of view, which is essentially self-transforming, rather than pictorial.

KOSTELANETZ — Is the serious, perceptive viewer supposed to be removed from himself?

KAPROW — Presumably so. The difference between Mondrian and Pollock is only apparent in this respect, merely two temperamentally alternative ways of arriving at a loss of self, or an enlargement of self, or self-transformation.

KOSTELANETZ — Do Happenings accomplish a similar purpose?

KAPROW — Well, some Happenings, not all Happenings. I would say that some of mine do that, not all. They serve different functions, some are commentaries.

KOSTELANETZ — In this respect, Cage resembles Mondrian.

KAPROW — Yes, very much, I think that is why I was attracted to him.

KOSTELANETZ — Do you consider yourself a "philosophical artist"?

KAPROW — I am vitally interested in those artists who are essentially philosophical, such as Mondrian and Duchamp; but in the end I prefer a more directly experienced sort of activity—one which only later may be examined in metaphysical terms, if one wants to do so. However, with my work, such an approach isn't necessary, while it is, I believe, essential for Mondrian and Duchamp.

KOSTELANETZ — Why did you join Cage's class?

KAPROW — It was purely accidental. Although I had known Cage's work and met him once or twice in the years before that, and although I was very interested in what he was doing, I wasn't especially interested in studying music. I was working on Environments in the mid-fifties. I was using, along with odors, many sounds. However, I wanted a richer source of sounds than gimmicked-up mechanical toys could give me. I had no background in sound whatsoever, and I didn't want to use or make music. I wanted *noise*, which had always interested me more.

KOSTELANETZ — What kinds of toys did you use?

KAPROW — Oh, buzzers, and these little Japanese toys where gorillas growl, and rattles—things like that, which were hidden off behind lights and behind barriers and so on. Nevertheless, the noises they produced were pretty much all of the same quality. So, I went to Cage to find out how to use tape-machines. It was a natural translation from being a visual collagist to being a noise-collagist. I wanted to know how to get a richer source of noise out of those tapes than I was able to do, and he explained this in a few short minutes, as I remember, and I was so intrigued by his class that I stayed. Shortly afterward, I found taped noise too abstract and needlessly detached from action; and so I returned to toys and then moved on to other sound-making activities. It was at that class that I actually did my first Happenings.

KOSTELANETZ — What did you learn there?

KAPROW — I think a point of view: to be free, to be liberated.

KOSTELANETZ — In effect, then, you felt that your background in painting—in abstract expressionism and Mondrian—still did not leave you free.

KAPROW — Oh, I dare say I would have gone to the same point without Cage, but it might have taken much longer. He was more encouraging than all of my painter friends. They began disowning me at that point, just before I went to the class. I was doing these Assemblages [pronounced the American way, with the accent on the second syllable] with noises and lights blinking.

KOSTELANETZ — Were they opposed to noise *per se*?

KAPROW — No, they just thought it was impure painting, which indeed it was.

KOSTELANETZ — What were you teaching throughout this period?

KAPROW — Primarily art history, but occasional painting courses, as well. I gave a course in medieval art, in which I had done some graduate work, and I have regularly taught modern art, nineteenth-century art, some eighteenth-century art, some contemporary American, a course in art criticism, one in aesthetics, and the usual humanities-type course which is soup to nuts. The studio courses, however, have never been quite comfortable since I left off painting.

KOSTELANETZ — Is your other activity—Happenings and the like— extra-curricular or part of your academic credits?

KAPROW — No, my position is largely academic, in the best sense of the word. Although I wasn't hired because I was an artist, the fact that I could combine the scholarly and the creative gave me something of a special advantage.

KOSTELANETZ — How come, then, you don't have a Ph.D.?

KAPROW — I was planning to get a doctorate, as a matter of fact; but on the advice of my principal teacher, Meyer Schapiro, I chucked it all. I was going to continue the Mondrian thesis—amplify it.

KOSTELANETZ — As you have developed your way out of painting, do you also feel uncomfortable teaching the history of art?

KAPROW — No, I enjoy that. What we do today does not discount what's been done.

KOSTELANETZ — In what style were your earliest paintings?

KAPROW — The ones I did in 1946 and 1947 were very Matissean,

very deliberately so. In general, I veered between an intimate Bonnard style and a more constructivist Matissean one, at the same time that I was doing all sorts of Mondrianesque drawings and so forth. Later, I became an Action Painter.

KOSTELANETZ — Then, these paintings in your dining room here represent your more fully developed style.

KAPROW — Those are action collages from the last years of my painting. That one you're looking at is called *Hysteria*, which seems an apt title insofar as all the marks are made up of the words "Ah" and "Ha" or the same letters backwards and forwards, with a few exceptions like "Ho" and "He." They occur as a rapid dark-light pattern on pieces of loosely pasted cloth, against a very dark ground; so that the letters stand out rather starkly against the muslin. I saw them as a whole town laughing at night. When I finally finished—I had no idea at first that it was landscape—I imagined myself coming in on a plane over a town, and everybody in the town was laughing and the buildings became ha-ha-ha.

KOSTELANETZ — Did you do this quickly?

KAPROW — Very fast.

KOSTELANETZ — Because you were still working with these notions from Action Painting?

KAPROW — That's right.

KOSTELANETZ — As a painter then, you emerged out of two stylistic traditions—collage and abstract expressionism.

KAPROW — From a French and sometimes northern European art basis, which was of course what Hofmann taught; but after a while, I became completely involved in abstract expressionist thinking.

KOSTELANETZ — I saw, on your porch, here, your last "painting," which is a field of apples, pears, lemons, oranges, and peaches—a fruit bowl—all of which are individually pasted on a board, about eight feet high and two feet wide.

KAPROW — That was, more accurately, an Assemblage.

KOSTELANETZ — Why did you go from this abstract expressionist field to this three-dimensional Assemblage field?

KAPROW — Three reasons, really. I wanted more tangible reality than it was possible to suggest through painting alone. I wanted above all to be literally part of the work. I further desired something of my

social world to be part of whatever art I did. Painting is far too abstract an art, even when it depicts recognizable images.

KOSTELANETZ — In other words then, your paintings acquired dimensions—a third and then a fourth; and in acquiring dimensions, they also filled in an area around the spectator—they surround you—which is very much like Pollock in the middle of his painting.

KAPROW — Exactly. His practice of being "in" his work was a metaphor, however, once the painting was finished. I wanted to keep that relationship real and constant.

KOSTELANETZ — Do you think that if Pollock had lived into the sixties, he would have gone this way himself?

KAPROW — I doubt it, I doubt it very much. He was matured at that point, and he had formed a crystal style. There was some sense, as we can see from the evidence, that he wasn't sure how to go on, after he achieved that. He was floundering around, trying to go back and forward, and so I think that had he lived he probably would have continued in some synthetic way, as most of the other artists of that generation have.

KOSTELANETZ — After several showings of your own paintings, when did you create a work that distinctly moved into greater dimensionality?

KAPROW — In 1957. This Environment consisted of overlapped sheets of plastic material, on which I had sewn and pasted all kinds of things; so that, as people moved amongst these rows, you would partly see them. These people became, of course, diaphanous parts of the Environment.

KOSTELANETZ — So it was, metaphorically, a kind of painting that looked hugely different from one point than it did from another. In that respect, it attained a kind of kinetic quality, as the images were constantly developing and disintegrating.

KAPROW — Yes, you had to brush through the curtains—sheets loosely hung from wires overhead, although it was in no sense a changeable painting.

KOSTELANETZ — Did you introduce sound here too?

KAPROW — Yes, but the trouble with the sound was that it had to be performed at prescribed times. I was using a tape-machine, although I wasn't satisfied with what I could produce on it. So, I arranged in the announcement to have a performance twice a day where visitors

could come and move about these sheets of plastic film and listen to the noise; but this disturbed me, because it was a performance—a concert, in effect—and it wasn't as constant as the physical parts of the Environment. After that, I tried a random distribution of mechanical noise and taped sounds, which went on all the time and drove the gallery dealer batty.

KOSTELANETZ — Was that last effect a part of the intention?

KAPROW — No. However, I saw no reason why there should have been a dealer at that point; he should have come in when he wanted like everyone else. I wanted the door left open, but there were other artists in the gallery who wanted their pictures protected; so it was an awkward situation. Thereafter, I left the gallery scene.

KOSTELANETZ — Where would you put an Environment nowadays?

KAPROW — In the garage or in the woods, in the middle of the highway somewhere. To be honest, I'm really not interested in Environments any more. The reason is that they tend to be, however large, set pieces. I'm really more interested in a continually active field, whose outlines are very, very uncertain so that they blend in and out of daily life.

Back then, the next step was, almost instantaneously, recognizing that the people within that situation were part of it, whether they considered it or not. Some of them didn't like it, which was an observation that made me uncomfortable at first. Cage was very useful in making me feel happy with it. At first, I thought, "How can I keep these people still? If one of them has a red coat and that doesn't work in the composition, can I get rid of it? If during the sound performance someone says something that I don't like, should I shut him up?"

KOSTELANETZ — Didn't you object to some audience sounds during the original performance of 18 *Happenings in 6 Parts* [1959]?

KAPROW — Those were not so much sounds but the attitude of the person that I didn't like. It was aggressive.

KOSTELANETZ — This is a moral, rather than an artistic judgment?

KAPROW — Yeah, it had nothing to do with whether the sound worked. It was, in fact, an aggression against me; that's what I didn't like. The sound sounded fine, as I look back at it. I was just unprepared to accept it then. I now recognize that work as having a strict nature, where the freedoms were carefully limited to certain

parameters of time and space. Random sound of any kind, even well-intentioned, wasn't really appropriate.

KOSTELANETZ — That is, the *18 Happenings in 6 Parts* existed within the space of the gallery, which you had subdivided into compartments; and every sequence of events occurred at a specific moment. Not only did the performers have precise directions, but you even gave the audience instructions too.

KAPROW — Right, everything was very tightly imposed.

KOSTELANETZ — It was a staged performance, in that respect— within a fixed time and a fixed space, everyone was doing things on cue.

KAPROW — There was no stage as such; it was a three-ring circus. I had that analogy very clearly in my mind because I had three separate rooms in which things were going on simultaneously.

The reason that the performance worked in one sense was that it was very controlled. A reason that it did not work, in another sense, was that it was *too* controlled, and people do not like to be controlled in that way. I had no idea how to make people happy with the situation at that time; so I floundered about for a number of years trying to find out.

KOSTELANETZ — So, one development in your own work has been the involving of the audience.

KAPROW — The way I tried it in Cage's class, in the pieces just after at Douglass College, and then in *18 Happenings* was to break up the audience into asymmetrical groups and then have them move about at prescribed times so that their size and composition would change. That is to say, group A would not just move to another spot, but it would get mixed up with segments of group B and C and so on. Members of the audience would be invited to do certain things at certain times, because of a card given to them, which also contained the information that at a certain time they should change their seats, as in musical chairs. However, this kind of moving about of people was only a physical affair, done without their comprehension of the reasons.

KOSTELANETZ — At your direction, rather than their own inspiration.

KAPROW — It was more without their willingness. It is not inspiration that counts here; for if you agree to play my game, you agree to play by my rules, just as I would by yours. It's a question of com-

mitment. If you slice a person into merely two parts—his body and his mind—and you neglect one for the other, then you're missing human potentials. In other words, if you have given somebody an order and crack a whip over his head, saying that he should do what I say or else, then he might do it, if he is masochistic enough, but he might resent it. He might not do it very willingly, or inspiredly, or happily. So, I did this sort of thing a half-dozen times, but I could see that the audience's reaction was always a standard one, a cliché; and they hit back in one fashion or another. So, I gave it up.

KOSTELANETZ — In another sense, then, you objected to the fact that people were viewing your pieces only with their eyes, which is to say only with their minds. You wanted their bodies to participate also, because, do you think, no experience is a full experience unless it affects both mind and body?

KAPROW — Unless, finally, those two words don't exist. We have a verbal hang-up all the time. . . . This is where I'm very sympathetic to Cage's apparent contradictions. He will use words; and if the words imply contradictions, he doesn't mean that. Rather, he doesn't know how else to say it, because the vocabulary he wants doesn't exist.

KOSTELANETZ — How did the word "Happening" come to you, and why did you use it?

KAPROW — The word came to me as just an accidental occurrence. I wrote it unconsciously and without italics or anything in an article on Jackson Pollock, where I described the ingredients of the Happenings before they took place. This was written in 1956, the year of Pollock's death, and published in 1958. Then I used it in the title of the *18 Happenings in 6 Parts* because it was a neutral word that avoided reference to art. Then the press and some of the artists took up the word, and it became the name of a kind of work. Then, I tried, along with other artists like Bob Whitman and Claes Oldenburg, to get rid of the word. They didn't want to be associated with it, and I didn't blame them. We failed, and now everything under the sun is called a "Happening." For instance, I saw in *The Reporter* a big title on the cover, "Bobby Kennedy Is a Happening." I read the whole thing. It was an analysis of his political motives.

KOSTELANETZ — How did you solve the problem of involving people in a satisfactory way?

KAPROW — It has since become very, very clear to me how to do this:

You invite people to play a game, in which the rules are explained and the expressive nature is clear. If they want to play, they will respond. Once they've made that commitment, you can play your game to your heart's content. That's why I gave up the audience.

KOSTELANETZ — Let's say I'm a friend of yours, and you are planning to have an Event. What do you tell me?

KAPROW — I spend my time thinking of the game. Let's call it a game, although the analogy should not be pushed too far. I simply write down the nature of the game and send you a copy of it. If you are interested, you will come to my meeting, where we will discuss this game.

KOSTELANETZ — For example?

KAPROW — Hop-scotch, kick-the-can, stealing cars. Or it might say we'll do the following things: draw some lines on the ground, and we're going to jump in the following way. Then we'll kick the can across the street and hide while somebody tries to find it and find us in turn. After this, we'll steal cars on such and such a street. If you're interested in playing my game, then come and talk it over, and we'll decide who's going to do what at that time. After that, we'll do it.

KOSTELANETZ — When, historically, did you formulate this conception of a Happening?

KAPROW — By November, 1962, just after I did *Courtyard,* the piece that signs off my section of Michael Kirby's book on *Happenings* [1965].

KOSTELANETZ — I think of *Courtyard* as a "staged performance" because you had a fairly fixed script, that was closely adhered to, and a fixed space. In your pieces nowadays, the actions of the primary participants may be planned well in advance, but they involve so many other people, often passers-by who don't know what's going on, that the secondary actions remain unfixed. Who is to predict, as in your *Calling* [1965], how people inadvertently in the vicinity will respond?

KAPROW — That's because of the elimination of fixed space. When you have an outline around your space, in which all of your activity takes place, then you are responsible for everything that happens within it. The minute you break your space, a lot of dimensions become unpredictable.

KOSTELANETZ — How did you conceive a more recent work such as

*Self-Service* [1966] which took place in three cities—Los Angeles, Boston, New York—over a period of four months?

KAPROW — I generally work pretty much off the top of my head, as things come to me. In *Self-Service*, I had three ways of building up the material. One source was simply things that came to my mind, which I jotted down in a notebook over a period of eight months.

KOSTELANETZ — By "things," what do you mean?

KAPROW — Images, situations, activities.

The second source of material was things observed over the course of that eight months, such as some little kid putting flowers that she had picked outside in between the canned goods in a supermarket. They were daisies; and since I thought her action was very beautiful, I used that image, in connection with a number of others, in the piece.

The third source I very often use when my mind doesn't pour out sufficiently is the Yellow Pages of the phone book. I've used them for many, many years. I go about it this way: Either I'll flip the book open to some arbitrary point and point my finger down rapidly, and I'll write down what I find—it might say Vacuum Cleaners or something like that. Or else I'll use a chance method of some kind, such as pieces of paper with numbers on them, which in turn tell me what pages to go to. One way or another it makes no difference actually. I fill up page after page with these services and products, and they in turn may completely suggest the activity. Or I may start thinking about what I could do with one item on the list, such as vacuum cleaners.

KOSTELANETZ — At this point, however, you exercise some choice, which is to say some taste. You go to the Yellow Pages to find possibilities; then, you choose from the examples you pick up.

KAPROW — Either I choose or I subject these to chance choices, which I do not select but simply accept.

KOSTELANETZ — Do you use the *I Ching*, as Cage does?

KAPROW — No, that's too complicated. Now, I used to be an Action Painter; I can't waste time. I find the *I Ching* a beautiful book, but it is not a fast enough method for me, whereas Cage is inordinately bound up with careful procedures. I have seen his preparations for a very short piece that were just exquisitely done—descriptions of how he worked, the time he spent, the operations necessary to draw all the graphs. It was to me more of a Happening than the music itself. This is his most comfortable way of working; but it's not mine.

In any case, I use as quick a bunch of methods as I can, to pull the choices out of my head; and some of these are, indeed, chosen by chance at the end. The thirty-one activities of *Self-Service* were chosen from several hundreds in my notebooks by chance methods. I threw a lot of numbers into a sack, enumerated the events in my book, and pulled out numbers one after the other; it was fast that way. These, in turn, were subjected to one further consideration; that was practicality. Those three cities were chosen simply because sponsorship was available in those places; they could have been any others. A wintertime event, for instance, was scotched, because those cities lack snow in the summer. I wanted to use laser beams in one thing; but after checking out the possibilities, I had to scratch that.

In composing lately, I freely combine my own ideas with suggestions made by somebody else or by certain chance methods. These are usually mixed up in some fashion so that the result turns out to be a give-and-take between my preference and what's given to me by my environment. I don't mean to be pure in these things; if I suddenly decide I don't like something, I'll chuck the whole chance method; if I feel chance is working for me, I'll follow it all the way.

KOSTELANETZ — Are the days on which events can occur chosen in advance?

KAPROW — They are chosen by the participants to suit their convenience.

KOSTELANETZ — Why do you want a Happening to take place in three cities at once?

KAPROW — If I could have, I would have liked more. It's a way of feeling in touch.

KOSTELANETZ — Why have a Happening in which each set of participants cannot see all the others?

KAPROW — Well, they all know the whole scheme. There's no need for them to watch each other.

KOSTELANETZ — Do the people in Boston know what the New York people are doing?

KAPROW — Sure.

KOSTELANETZ — Because they are doing the same thing.

KAPROW — About one-fourth of the total activities overlap in all cities, but everyone knows from the over-all scheme what's available to each city.

KOSTELANETZ — Let me put it this way: How is the participant's response in this piece different from that, say, instilled by *Calling*, particularly because the new event takes place in several cities?

KAPROW — *Calling* was a sequential affair, involving a fixed group. It was relatively closed therefore, at least in its events, if not in its physical nature, whereas this is conceived as a vacation-time Happening. Like many summertime events, which are often interrupted by other events—as a picnic is interrupted by rain—the activities in *Self-Service* are sometimes scotched, postponed, substituted for; so this is a relatively free and easy work. You notice that I made only the requirement, quite unlike *Calling*, that to participate in this work it was necessary to be involved in only one activity, although more are preferable. If it turned out that despite your best intentions your family needed you on the day you arranged for that activity and you couldn't make it, you would still have served your purpose well. I think that the openness and flexibility here, as well as the permissiveness of it, really are clarified by the title, *Self-Service*.

KOSTELANETZ — These Happenings, then, are solely for their participants. They have no large effect upon their innocently bystanding observers.

KAPROW — They may, although the observers may not know what they've gotten into.

KOSTELANETZ — Given my awareness of the development of your art, this would strike me as a distinct step beyond, say, *Calling*, which took place in the city and in the country on two successive days. You once wrote, "I try to plan for different degrees of flexibility within parameters," which is a musical term you use as an analogy for aspects "of otherwise strictly controlled imagery." This haunts me, so I wonder if you could please explain it with reference to, say, *Calling*.

KAPROW — It's clearer, since I was referring to earlier works, if you go to such a thing as *18 Happenings*; there, for example, I gave each performer a certain number of steps to do, while certain tape-machines were making noise, and while, in other rooms, other activities such as squeezing an orange or the showing of slides were going on.

KOSTELANETZ — Weren't these strictly controlled images?

KAPROW — Right, but I did not say that these steps should be done rapidly or slowly; rather, they should be done flexibly within the time

allotted. I did not say that you should squeeze oranges rapidly within so many seconds, but that when a bell rang you stopped. Flexibility was already built into my pieces, but looking back on it I can see it was a very slight flexibility.

KOSTELANETZ — The sequence had a beginning and an end, for one thing.

KAPROW — Yes, it was terminated by an external signal, even though the nature of the activity had no beginning and end.

In *Calling*, there was roughly the same kind of idea—that certain things have to meet up with certain things, that certain connections must be made, because certain sequences are necessary. However, here I allowed so much time between events to make sure there would be no hang-ups if, for example, there was a lot of traffic. In fact, I learned afterwards, some people had a soda between Events, and others went around the block five times to take up time and saw lots of amused passers-by reacting to the packages of wrapped-up people. This kind of freedom, therefore, I would like to amplify, and I think I'm beginning to do more of that now.

KOSTELANETZ — Speaking of that piece, I've always wondered why you had a sequence take place in Grand Central Station's information plaza.

KAPROW — Because that's a place that everybody calls for information. There was calling throughout the whole thing. My titles, you see, tend to be pretty descriptive; they are not abstract or arbitrary at all. They usually hinge upon a central point of the thing, and they are usually chosen after the composition.

KOSTELANETZ — The activity of calling, then, united all the events. In *Self-Service*, all the activities involve . . .

KAPROW — . . . not only self-service in the shops and the super-market, but one serves oneself throughout. It is a *self* service, and also the word *service* is double in meaning, both in its ritual implication, as a church service, and the physical implication of serving oneself.

KOSTELANETZ — Do you still consider your pieces part of theatre?

KAPROW — No.

KOSTELANETZ — Do you object to my title of *The Theatre of Mixed Means*?

KAPROW — I shouldn't object to it, but I don't consider myself part of any art. I'm really interested in a unique art; that's why I fight

like hell to eliminate all conventional resemblances, when I can observe them.

KOSTELANETZ — Do you mind your interview being included in a book with the word "theatre" in the title?

KAPROW — Ordinarily, I would have said no. I agreed because you said you have a liberal conception of "theatre."

KOSTELANETZ — I prefer the most general definition of theatre I can devise—it involves people who are doing and people who are observing, whether intentional or not. On the other hand, I don't object to Cage's definition of anything that strikes the eye and the ear.

KAPROW — Well, for example, a Pentagon meeting is theatre. A guy digging a great tunnel underneath the river is a form of theatre. If we go into it that way, then of course my own pieces are theatre.

KOSTELANETZ — Didn't you write somewhere that you would attempt to excise from your own pieces anything that had to do with art in the museums?

KAPROW — I would try to; I can't succeed all the time. References to culture tend to set up a contrast, and often a conflict, with the other elements of the work which are not artistic; and rather than being at war with our cultural past, I'm more interested in something quite distant from the conventional arts.

KOSTELANETZ — Do you prefer the connection with games because you object to the categories of art?

KAPROW — Except that nobody wins in my pieces.

KOSTELANETZ — I mean Easter egg hunts, where everybody who participates has a good time.

KAPROW — Yes, with that post-ritual type of game. It is not that I object to painting or theatre or music or dance or anything like that. It is that I do not wish to be compared with them, because it sets up all kinds of unnecessary discussions. People say that you're not doing this right, that you're not doing that right.

KOSTELANETZ — What distinctly separates your present work from theatrical situations is precisely that you have no intentional audience.

KAPROW — Incidentally, in what I call the normal environment, there are audiences all the time. If we get out and dig up a manhole cover in the street somewhere, as I gather some practical jokers do all the time, and if some people stand around and watch, as they do normally when people are working or something unusual is going on, then that

group is a part of the normal environment. They are not audiences coming to watch a performance; they may just pass on very shortly to whatever they have to do. Whereas if we go to the theatre or the rodeo or the circus, we are sitting there not just to watch a show but to judge it with a whole battery of standards.

KOSTELANETZ — Still, you and I have encountered people who saw certain events that happened in the streets, which they reported were great. "Let me tell you what I saw on Forty-second Street; there were these guys digging up the road." Those guys have, in effect, created an audience.

KAPROW — After the fact and unintentionally. Playwrights begin with this fact as a necessary condition.

KOSTELANETZ — In *Calling*, for instance, you created a theatre out of the main hall of Grand Central Station and an audience out of all the innocent bystanders.

KAPROW — There's a difference—they were *innocent* of the fact that it could be considered theatre. However, their *recounting* of what happened there is the theatre. . . .

KOSTELANETZ — Maybe a theatre at second remove from the work —a theatre that arises whenever one person dramatically tells a story to another.

KAPROW — That's what I call the myth-making aspect of a work—the gossip-mongering that goes on. If you hear about a Happening but weren't actually involved, it takes on a reality composed of what you imagine, what you brought from your own experience, and what you've heard. If it moves you or if enough people engage in this kind of reportage or gossiping, be they stimulated by *Vogue* and these other magazines or just a friend's report, it is always the sort of thing that can begin to spread. If it catches on—if for some strange reason it has its finger on the pulse of everybody's needs—then there is some kind of magic attached to that. It's a temper that vibrates through the daytimes of everybody and perhaps the nighttimes.

KOSTELANETZ — It becomes an event which cannot be repeated but which can be retold.

KAPROW — It is like the story of the ten men who sat around the campfire, and one of them said, "George, tell us a story," and George said, "Ten men were seated around the campfire, and one of them spoke up and said, 'Mike, tell us a story.' And so Mike began . . ."

It goes on like that; as it is retold, there is a kind of hallucination that takes place that gives it a sense of suspension, a sense of magnitude, an aura of mystery that initially it did not have.

KOSTELANETZ — So, what you are creating is a situation opposite that of a book. If the function of a book is to take hearsay and make it permanent and duplicable, as we are doing now or as the thousand and one tales of the *Arabian Nights* are now fixed for eternity, what you want to do is create an entity that will in turn stimulate a variety of stories.

KAPROW — To push that idea further, it is a much more direct and participational art than the sort of indirect experience literature permits.

KOSTELANETZ — What do you mean by "direct"? A page of prose is certainly direct to me.

KAPROW — It is a direct visual experience, but the ideational side of it is not. It has to go through your head, and you have to translate the words back into felt experience; however quickly that may take place, it is still indirect.

KOSTELANETZ — If I see a body wrapped in tin foil being taken through Grand Central Station, isn't that a visual experience too?

KAPROW — It's more immediately felt, though. In other words, I'm listening to you tell me about those bodies wrapped in tin foil. Let's carry it one step further: You're reading about it on a page, and then you look at the photograph that happens to be near it and then you think to yourself, "Gee, I could have seen that myself, perhaps, if I had been there at that time."

However, right now, I remember wrapping that figure myself and putting it in one of those cars. I also remember passing by a group of construction workers on a street, who were trying to back a great big cement truck into position to drop a load of cement down underneath the street there. The driver couldn't see much at that point; so one of the guys was standing out in the middle of the street, directing traffic in order to permit this truck to back in. He took one look at us and forgot to gesture; since he froze, the truck kept coming on until it almost fell into the hole.

KOSTELANETZ — So you created another myth—through your own actions, you created another extraordinary event. That fellow must have gone home and said, "Look. . . ."

KAPROW — I'm sure he did. His face was absolutely aghast.

KOSTELANETZ — All that you say implies that the more people that are involved, the more pleased you are.

KAPROW — If you mean inadvertently—on the gossip side—yes, of course; but in terms of a really conscious, willing participation, it doesn't make any difference to me whether it's a small or large number.

KOSTELANETZ — May I return to an earlier concern? What is the difference between the original situation of the little girl who picks flowers and brings them into a supermarket and the same event as it happens in your piece?

KAPROW — There's a big difference—the context. This is one event amidst thirty others, which constitute its ground; and the thirty-one events all together have been designated a Happening. A selecting and focusing process has taken place, and that fact gives that single action a different meaning. I observed the event and willfully made it part of the mesh of my experience, and then I used it in another context.

For example, Matisse was accused of doing things any child could do, and he answered, very cheerfully, "Yes, but not what you could do." Of course, the difference is that he is doing things that might be called childlike but not childish, in the sense that he has forty or fifty years of experience and knowledge. A vertical mark, you see, made by one man and a vertical mark made by another exactly the same might have a whole host of different meanings; and we are, unfortunately or fortunately, given to attaching meanings to things; therefore, when I ask or suggest that people put flowers into supermarkets and surround that gesture with a whole host of others to follow or precede it, the meaning cluster becomes very different.

KOSTELANETZ — In that case, how lifelike are your Happenings? Would you accept McLuhan's or Cage's implication that a good Happening is just like life?

KAPROW — No, I don't. If they were, then I wouldn't do them. I'd be terribly thrilled with life just as it is and would, as they used to say in the old hipster days, simply "dig the scene" and that would be it.

There are things which occur that I could never possibly imagine doing or succeed in doing so well. For example, that great Alaska

earthquake was fabulous, and the other day on a color TV I watched the launching of a rocket. It was a fabulous thing. Now here you have a nature-made and a man-made event, both of which are extraordinary to me. Yet they are not things that happen every day—they aren't "just like life"—and even if they did, I would still feel I had to do something myself just to shake hands with reality—just to respond. Here is where McLuhan and Cage present a different argument. Theirs is a more passive position, presuming a greater and greater acuity of response; while I feel I've got to say, "Gee, that was pretty good. Now, watch my trick," not so much to put it down but to join in the dance. The context, in this case, is life rather than art; and so we come back to the conclusion that it is lifelike but no substitute for life.

KOSTELANETZ — Then, what is it?

KAPROW — It's a more attentive participation.

KOSTELANETZ — It's a heightened game-like participational activity.

KAPROW — As lifelike as it may be, it is also primitive, simple, uncomplicated.

KOSTELANETZ — In the sense that in the primitive man's life, the ritual in which he participates at night to bring down the rain tomorrow was quite different from his daily activities but was still very much an intimate part; and the telling of the event—the oral gossip dimension—is also a primitive thing, a kind of building up of oral folklore.

Why are all the painters involved in the new theatre so articulate?

KAPROW — They went to school.

KOSTELANETZ — Where their predecessors didn't.

KAPROW — Not as much. It is a fact that though the older artists were often quite intelligent and privately well-read, the style of the time was to suppress that. It was a time of silent alienation and a growing resentment against the environment and against the glibness that seemed to bring success to everyone else. Muteness was seen as proof of one's determination to find another solution to the problem of self-realization. My generation, which is post-war, had the G. I. Bill, where everyone went to school for free. To get through it, you had to learn how to speak up.

KOSTELANETZ — Would you say that the new art and the new theatre demand conceptions that are characteristic of more articulate people?

KAPROW — This may be a cause, but I would say that the most simple

explanation is that art is now part of a booming economy. Rather than being alienated, the artist is welcomed; even if for dubious reasons, he is still welcomed. His public presence is an ingredient of the times.

KOSTELANETZ — Do you feel at all alienated yourself?

KAPROW — No, of course not. I pay taxes. I own a house.

KOSTELANETZ — Do you mind living in what the sociologists would call a suburban environment?

KAPROW — No. I might have some reservations about living on this particular corner, because it is noisy. I might not like all my neighbors, but if I changed at all, it would only be to another place pretty similar, merely better in details.

KOSTELANETZ — Why, in addition to teaching and creating Happenings, do you write—articles and your book?

KAPROW — Because I like to live on more than one level. I enjoy writing.

KOSTELANETZ — Do you consider these elements in conflict?

KAPROW — No, not at all.

KOSTELANETZ — To return to your work, may I ask why you do not allow spectators—I mean, official, ticket-carrying spectators—into your pieces, and why you don't allow cameramen to film them?

KAPROW — I do break my rules, always, for no other reason than to find out how to do something—how to allow those who have a capacity other than participation to be part of a piece, and I haven't yet licked that problem. For example, with the CBS piece [Gas, performed August, 1966] I'm trying to make the cameramen a functioning part.

KOSTELANETZ — So that the man who is carrying the camera becomes a performer while he is carrying the camera.

KAPROW — In other words, being watched becomes an element in the work. This still isn't satisfactory, real enough. It is kind of a rationalization so far. I'll beat it; it's a matter of time. The solution will be a natural one; it won't be artificial.

KOSTELANETZ — This broaches the question of how you record one of your Events for history.

KAPROW — Well, I've given that up. How you create gossip for history is the question.

KOSTELANETZ — Then gossip, in other words, is the way you wish to be recorded. But, what's the cameraman doing in Gas?

KAPROW — Creating a perfectly arbitrary image that he alone can make.

KOSTELANETZ — His arbitrariness lies in the fact that he sees the event only from one point of view and with a rather narrow, somewhat clumsy focus, while at the same time actively participating in the Happening. Isn't it also impossible for him to do both at once?

KAPROW — Of course, the time that he is in one place and the time that something else is in another place, even if you have crews all over, will not allow the final editing to do more than approximate the memory of the event.

KOSTELANETZ — Why not split the screen, as when, recently, they showed a space shot and an important football game simultaneously.

KAPROW — They did something like that at Bob Rauschenberg's performance in Washington recently. They zig-zagged the screen with saw-teeth, superimposing continuously; but I've seen enough of his works, although not that particular one, to know that the sense of space that separates his 'events was probably destroyed by this technique. In fact, a film hardly resembles the thing photographed, to come back to what we said before. I don't believe it is a record of reality. It is another thing, a picture.

KOSTELANETZ — Also, the person who is watching the film is not participating in the Happening. He is watching the film.

KAPROW — He is participating in images which are on a silver screen, a frame, by the way, which doesn't exist out there in the street; and although it might look very good, it would still be a kind of gossip . . .

KOSTELANETZ — . . . as seen by only one of the participants, rather than someone who observed the total field.

KAPROW — And who can? Even I can't, although I might plan the whole Happening.

KOSTELANETZ — What attracts you, here, then, is that no observer can grasp the whole thing and that your piece is impermanent. The first theme is in contrast to the Western tradition of art, which presumes that I should be able to contemplate a painting that doesn't move.

KAPROW — Well, I've always been impressed by the fact that I wasn't able to experience anything completely, only indirectly or in part. For example, I might be walking down the street one day, looking in the shops; and out of the side of my eye, I see a pretty girl and

I get distracted. Now I've stopped concentrating on the shops so that my mind at least is split in its attractions, and then I hear, two or three streets away, the whistle of the fire engine. Then I imagine to myself, "Boy, what a fire that is. If I could get over there fast, I might see it." But I can't. Maybe, too, because it is a hot day, I have a desire for an ice cream cone. All these things have suddenly separated my attention, and the girl meanwhile has passed and I've walked beyond the window of the store that interested me before. So I have in mind now only the ice cream and the fleeting desire to go run after the fire. This sense of multiple choices has always intrigued me, partly because it is mysterious, partly because I know I cannot satisfy everything at once.

KOSTELANETZ — As a matter of personal taste, sooner than look at one thing for a long time you would rather look at many things for a short time.

KAPROW — Yes, and have the choice of where to concentrate my attention, knowing that I'll never get everything out of it.

KOSTELANETZ — And also knowing that you cannot concentrate your attention on one thing.

KAPROW — Yes, because I get fatigued.

KOSTELANETZ — Isn't there a close resemblance between what happens in a Happening and what you have just described as life?

KAPROW — Of course, that's the way the world is, as I see it.

KOSTELANETZ — So, the art of Happenings does bring us closer to life, even if it is not duplicating it.

KAPROW — Yes, its model is life; but as a painting is not a model, so a Happening is not life.

KOSTELANETZ — Its formal model—the pattern of life—rather than its content model.

KAPROW — Right.

KOSTELANETZ — May I ask why you are so predisposed to impermanent art?

KAPROW — That's America. It's what is called "planned obsolescence," an extension of the economy.

KOSTELANETZ — Are not most of us opposed to planned obsolescence? I would prefer more permanent cars. Is it bad for me to want things that would last longer?

KAPROW — I suggest that this is a myth of the wrong kind—that you

really don't want a permanent car; for if you and the public did you wouldn't buy cars that are made impermanently. Planned obsolescence may have its bad sides; and I'm sympathetic to the quarrel with it. It also is a very clear indication of America's springtime philosophy— make it new is *renew*; and that's why we have a cult of youth in this country. Just like we can't have an old car, we can't have an old person; and it all has a great deal to do with that economy, or vice versa. I don't think that one is separate from the other, as cause and effect.

KOSTELANETZ — Do you then react against permanent art, even though you teach courses in it?

KAPROW — No, I simply react by making the kind of art which is more alive in my time. I can't make permanent art, because it is false to me to make permanent art. It's not real.

I'm not talking about the medium of painting. I'm talking about the fact that even in pop art—in, say, a painting by Roy Lichtenstein— you have an ironic reference to a moment in the forties by the style used. It represents a kind of half-humorous nostalgia for the Boston Pops Orchestra era or the snap-crackle-pop era, the whole time of soda pop that was the childhood of Lichtenstein and almost every other pop artist. At the same moment, you have an indulgence in a holocaust of commercial attention and publicity that is bound to enervate everybody very shortly, so pop art acquires a built-in obsolescence from this very faddist attraction. I don't mean that it was generated for fad reasons, but the way that it has been caught up in everybody's sensibility is bound to bring on its end.

KOSTELANETZ — America uses up its favorites very quickly.

KAPROW — So, since everybody participates willy-nilly in this kind of rat race, let's enjoy the rat race. Let's take it right by the tail and play it to the full.

KOSTELANETZ — Therefore, create a work of art that will make news today and be dead tomorrow . . .

KAPROW — . . . so that it can make more news in another form. As gossip, it is continually renewable by virtue of its unseizability.

KOSTELANETZ — Do you look upon the new theatre as something that will grow and eventually affect the whole course of America's cultural existence, if not the world's?

KAPROW — Not an individual work, but the idea of it may.

KOSTELANETZ — Would you want it to do so?

KAPROW — I suppose I would be flattered; on the other hand, I would feel less free, if I saw something liberating become ingrained.

KOSTELANETZ — That's a personal feeling. As an artist and critic, do you feel this is a good direction for art to take?

KAPROW — That's too difficult to answer. I don't know. Let's put it this way: Everyone else is trying to make monuments, whether they are succeeding or not; and there are very few, like myself, who, just as a contrast to it—to keep a balance—toss their stuff into the drink, come what may.

KOSTELANETZ — Do you get paid for doing a Happening?

KAPROW — Sure—not always, but usually.

KOSTELANETZ — Could you make a living from your performances?

KAPROW — I could, perhaps in a few years.

KOSTELANETZ — Would you like to do so?

KAPROW — Yes, but at the moment I can't.

KOSTELANETZ — How many Happenings do you do in a year?

KAPROW — I usually will do nothing unless I am either commissioned, or I have the time to do it on my own. The average number of works that I have been doing for the past seven or eight years is perhaps three to five a year. One year was very busy; I did about ten.

KOSTELANETZ — Could you do twenty a year?

KAPROW — I doubt it, because it takes me two to three months just to work out the circumstances.

KOSTELANETZ — I know you won't do any of your pieces more than once, but will you let someone else do it?

KAPROW — I wouldn't stop a person, if he wanted to try it; but I prefer not. The plan is available.

KOSTELANETZ — Have any of your pieces been done by other people?

KAPROW — Once, yes; and I found it discouraging. It was cheaply done, in my estimation.

KOSTELANETZ — Aesthetically or economically?

KAPROW — Humanly. It resulted in a near-riot, which has never happened to me, although some of my events are pretty dangerous both emotionally and physically; and I thought the way it was conducted was full of clichés, self-consciousness, and cutie-pie-ing; and these were the reasons for the riotous reaction.

KOSTELANETZ — In the audience or among the performers?

KAPROW — Everybody participated. It was done in a theatrical situa-

tion, and perhaps that was also one of the reasons for the trouble. If my work is interpreted in a traditional context, it always seems to conflict with that setting.

KOSTELANETZ — Are Happenings necessarily the most propitious art of our time?

KAPROW — Not necessarily.

KOSTELANETZ — Why did they arise at this point in history?

KAPROW — The current media are too full of information now for us to be stuck with one way of doing things. We're deluged by information—not merely daily information but cultural information, past and present, through our schooling and in magazines and television. These constitute such an abundance of possibilities that to stick to any one thing or any one discipline or any one developmental idea would be very hard to do; it reveals almost an obsessive discipline. That's why those who paint in certain obsessive ways are so interesting, because it is not merely painting; it is a philosophical holding on —a desperation, a concentration against all odds. An example is these four weeks at a time.

artists who paint one dot in the center of the picture for three or

KOSTELANETZ — You find them interesting because they are so contrary to current preoccupation. Also, therefore, you see a formal sympathy between Happenings and the current environment in that both force upon us such various and disparate experience within a single frame or thread.

KAPROW — Well, Happenings are a medium, let's face it; they've become an art form. Fundamentally, what a Happening does, which the other historic arts don't do, is permit you a number of moves through different media and, moreover, through times and places that you would have to filter through another medium in the other arts. Even the movies, which are an analogue to Happenings in that the camera can swing from place to place and from past to present in one pan or just a cut, are confined to a screen. Now, we can actually do it and say, "Okay, this Happening is going to last three years." In that sense, it achieves a liberation that no other art form has yet been able to do. I'm not saying that it is a better art form. However, I believe that because of all the complex needs of our time, this is more appropriate for many of us, where it wasn't fifty years ago.

KOSTELANETZ — The new electronic media—movies and television

—have made you aware of leaps through space whose structure or form you would like to emulate.

KAPROW — Yes. You can see a movie and empathize, as you can read a book and empathize; but you can't actually do it—jump out of your seat and into the Vista-Vision screen and fight with the guys in the O. K. Corral.

KOSTELANETZ — Are you attracted by the notion that anybody can do a Happening?

KAPROW — Anybody *may* do a Happening. The difference is whether they want to and whether they are willing to devote themselves to working at it, whether they're willing to flop. I believe in things called talents; but I'm not sure that I can recognize them all the time.

KOSTELANETZ — Do you know any unintentional creators of Happenings, whose works you find excellent?

KAPROW — Yes, I see them all the time. For example, there is the man who manages the Shop-Rite up there on Route 25A. He, along with many others, studies how to be a good manager of a supermarket; but by the ways he has them arrange the products, the displays, the check-out counters, and the particular lighting effects, he promotes, in fact, an unconscious ritual every Thursday night—a ritual of buying and exchanging. I think these are perhaps magnificent quasi-Happenings. The only difference is his lack of attention to the fact that it might be something other than a means for making a lot of money.

KOSTELANETZ — Why is it a "quasi-Happening"; because it is different from the ordinary run of things?

KAPROW — The difference lies in the kind and amount of attention given to it. I can look at it more poetically than economically, and they look at it more economically than poetically. When I'm there, I not only have a shopping list and a certain amount of money, beyond which I may not go; but also I have a sense of the spectacle, which arises partly from a detachment at the same moment that I am involved in it.

KOSTELANETZ — Here, however, you are seeing things that other people might not see.

KAPROW — Right. So, if the artist has a special function, I'm not at all sure that it is better than the manager's or the car salesman's. . . . It is simply that, yes, there are differences between us human beings—

between men and women, between artists and physicists and poets and ditch-diggers and all—but each of us does the best he can at his task. My job as an artist is to make dreams real.

KOSTELANETZ — This suggests the question of evaluation. In what sense is one Happening "better" than another?

KAPROW — I've often wondered, because I really know that some of them flop, that some of them read better than they actually perform, that some of them that read badly turn out magnificently in enactment, and some are just as interesting when read as they were in performance. Even within those cases where there is an equal interest in both means of communication, some are better than others. I can usually seize on what was wrong in a particular piece; but as for making a generalization, I confess that I really don't know enough about the situation yet.

KOSTELANETZ — Can we say that realization of the elements is a criterion; and in this respect, can we use words like tasteful as opposed to vulgar? Can we judge that one conception is considerably more imaginative than another?

KAPROW — "Tasteful" and "vulgar" are no longer relevant evaluative terms to me. I prefer, among others, "revelatory," "appropriate," and "realized."

KOSTELANETZ — How do you evaluate your own work in retrospect?

KAPROW — I naturally think over what occurred in each piece; and I'm aware that sometimes things just don't come off right, while at other times they do. The "failures" I find more easily analyzed than the realizations. Often the former lack a sense of practicality—in other words, they are poorly prepared, which is to say that details haven't been thoroughly thought through; sometimes, however, the conceptual center of the Happening is corny or sentimental. *Tree* [1963], for example, I derived too easily from a rebirth ritual vaguely remembered from some readings in anthropology, so parts of the work felt like an illustration for a college lecture.

KOSTELANETZ — What's wrong with having too simple a ritual base?

KAPROW — Rather than having a presence that is blinding, it betrayed its source. You may later analyze and appreciate all the sources of this and that; but while it is going on and being conceived, it must seem overwhelmingly present—be itself, not *about* something else.

KOSTELANETZ — Is your "conception-censor" more efficient today?

KAPROW — Yes.

KOSTELANETZ — Where do you think your pieces fail nowadays?

KAPROW — They fail, if they do, in expecting too much out of people—too much devotion. For example, in allowing so much freedom and in not checking up on anybody—not even communicating with them—and in going around the world and working with groups I'll never meet again, the assumption on my part is that they are great —great with self, great with intention, with response and with responsibility. The fact is that they are lazy, just like me and everybody else. Without me, very often, their devotion, which at first was genuine, flags; and the next thing you know, they forget all about it and don't show up. These are the elements which are still dissatisfying.

KOSTELANETZ — Perhaps because your script presumes too optimistic a conception of human nature. I'm struck by your insistence that people who participate in the Happening have to be really sincerely and honestly committed, or else it doesn't work.

KAPROW — I think they should be, but sometimes they're not. If they find themselves caught up in something which then turns them on, then they really go at it, so I'm told. I don't check up, because I'm just another participant. This has happened, as it does in many other things. The reverse, however, is sometimes the case. Participants will develop a great idea of what it is going to be, and then when they find out what degree of commitment is required, they turn off, because they find it too much work, or have something better to do, or they think it is embarrassing when they finally get into it.

KOSTELANETZ — What are your politics?

KAPROW — They are, I guess, a little bit of a hold-over from the old days—somewhat apolitical, essentially anarchistic in leaning rather than in action. I see the irony in politics too much; politics is all a matter of ambition and, yet, terribly necessary. There are no new great ideologies today, as far as I can see. Surely you have local causes, such as civil rights and peace movements and things like that; but these are not essential philosophical problems, it seems to me. I will support, in whatever way I can, local causes. I once considered doing a "sit-in" as a Happening; but I decided not to, because I thought it would be bad politics, if it were good art. I believe educational and

economic reforms—sometimes even guns—to be a lot more effective.

KOSTELANETZ — Would you like to see more Happenings in America?

KAPROW — No, I think there are just enough—sufficient opportunity for everyone interested to work when he wants.

KOSTELANETZ — Do you think the movement might become too much of a fad, as they say?

KAPROW — It's possible.

KOSTELANETZ — Does this frighten you?

KAPROW — Yes, because I'd just have to run faster away from it. That's all. I'd have to think of new ways to obscure my presence and yet make it felt.

KOSTELANETZ — Why obscure yourself?

KAPROW — For the sake of the freedom to work as playfully as possible. Public attention makes one too "serious"—creates a false sense of public responsibility.

KOSTELANETZ — Do you now think of yourself as too famous?

KAPROW — No. There's just enough ambiguity and nonsense written about me. It's the kind of "fame" I can endure, because I can't recognize myself in it.

KOSTELANETZ — Does the impetus of the Happenings movement lie in America?

KAPROW — I'm not sure that it does. According to writings I've read from overseas, they are probably more active there than here, because there is much more support for them there and publicity about them. I'm not quite sure whether it is true, but I think the best works, to my knowledge, are being done in this country. Aggregately, there is more talent here—more adventurous work; the real vitality of the movement seems to be here.

KOSTELANETZ — What characteristic would you describe as peculiar to the American stream of the movement?

KAPROW — Its lack of theatricality, in the traditional sense. It's free-wheeling, like hot-rod races. That's perhaps overly simple. The explosion of shopping centers seems to me very characteristically American —that sense of big space, of the time that is involved in getting from one place to another (that we don't seem to pay any attention to), and the sense of vast scale, to me, is a very American experience.

KOSTELANETZ — That sense of unbounded space.

KAPROW — Now some of my colleagues—in South America and Germany and elsewhere—are very interested in the possibility of what would be a world-wide Happening; yet I'm almost positive that the idea was stimulated here.

KOSTELANETZ — Aren't you now involved in a smaller version of this—a Happening to take place in three countries?

KAPROW — This one will be, unlike my *Self-Service,* so coordinated that we will actually synchronize our watches. We will each prepare one activity, a copy of which will be sent to the other two; so that each of us will perform three activities by clockwork. Hopefully, we'll be joined by Telstar and other such media so that we can be at once in touch with one another.

KOSTELANETZ — If Telstar has the power to make a historical event happen at once around the world, so you want to create an artistic event that can happen simultaneously around the world.

KAPROW — Right. We don't think of California as impossibly far away, and the fact that, in *Self-Service,* prescribed events happen in three cities brings our distances closer; yet of course we are actually far away. So we experience at once the paradox of separation—the fact that people are not in literal touch with one another—and the fact that we are all in imaginary touch.

KOSTELANETZ — Are those themes the content, as we say, of a three-city or three-country piece?

KAPROW — They are part of the content.

KOSTELANETZ — The other part being the events themselves.

KAPROW — Yes. As for the three-country Happening, so far, I haven't convinced Telstar to cooperate.

KOSTELANETZ — Does one learn anything from participating in your events?

KAPROW — One becomes more attentive.

KOSTELANETZ — Omni-attentive, as Cage says.

KAPROW — Oh, no. This is impossible; that is presumptuous. Besides, you'd go crazy paying attention to everything. One becomes more attentive to the things that might engage one thereafter. So many things we don't pay attention to just go on. As such, both you and the world are better for it.

# 6

**Poets have such a great advantage because they don't have to construct their dreams, whereas I have to come down to earth and make them happen in my theatre.**

## —Claes Oldenburg

Claes Oldenburg is primarily known for his imaginative sculptural distortions of popular iconography—a crushed toothpaste tube six feet long, a hamburger of stuffed canvas several feet in diameter, a limp toilet bowl made of vinyl—which the artist divides into "hard" and "soft" categories, depending upon the construction material used. Oldenburg has exhibited these works in one-man shows in New York, London, and Stockholm (at the Moderna Musset) and at the 1964 Venice Biennale.

Born in Stockholm in 1929, Oldenburg grew up in New York, Oslo, and Chicago, where his father was the Swedish Consul General, and later attended Yale University, graduating in 1950. After spending the following two years as an apprentice reporter on a Chicago newspaper, he decided to study at the Chicago Art Institute. He came to New York in 1956 and three years later had his first exhibition of sculpture. In December, 1961, he filled his storefront studio with an assortment of objects, creating an environment which he entitled *The*

*Store*, and in his subsequent one-man shows, the gallery itself has usually assumed environmental qualities. In fact, Oldenburg regards his theatrical activities as extensions of his sculptural concerns, and he often exploits an exhibition of his work as a setting for a theatre piece.

His first theatrical venture was a short work, *Snapshots from the City*, performed in 1960 in an environment he was showing at the Judson Memorial Church in Greenwich Village. Subsequent performance pieces include *Blackouts* (1961), *Fotodeath/Ironworks* (1961), *Injun* (1962), *Stars* (1963), *Gayety* (1963), *Autobodys* (1963), *Washes* (1965), and *Moviehouse* (1965). In the spring of 1962, he also produced a series of works on ten successive weekends for his Lower East Side storefront studio, which he christened The Ray Gun Theatre—a period remembered in Oldenburg's book *Store Days* (1967). Where the earlier performance pieces occurred in settings especially constructed for artistic occasions, Oldenburg's more recent theatre works explore such "found," yet spatially closed, locations as an indoor swimming pool or the seats of a moviehouse. Although his preparations for a theatrical piece tend to be rather informal, if not haphazard, the resulting work is invariably extremely deft; and through each one runs a distinctly personal style that is consistently achieved.

Oldenburg himself is a blond, balding, blue-eyed man over six feet in height, with a bearish physical demeanor. He is extremely gregarious, quite blunt in his talk, and cantankerously charming to his friends. Despite the acclaim his sculptural works have recently received, he exhibits considerable introspection and self-honesty as well as old-fashioned Bohemian cussedness. He lives with his quiet, petite wife, Pat, in a block-long fourth floor loft in New York's East Village. The front half of the floor is used as living quarters; Oldenburg's working space in the back includes an alcove with a desk, where he does occasional writing. During both our interviews, the first in midsummer, the second in winter, we talked most of the time over a large kitchen table. Our constant companion was a turned-on television set with its sound extinguished. Like his sculpture, Oldenburg's conversation exhibits such a pronounced love of irony that often his comments seem designed as much to stimulate his audience's thinking as to define the matters at hand. He edited, rearranged, and expanded the

original transcript considerably more than anyone else interviewed here.

KOSTELANETZ — What kind of theatrical awareness did you have when you presented your first theatre piece, *Snapshots from the City?* OLDENBURG — Since that was as late as March, 1960, I had by then seen everyone give performances, except Jimmy Dine, who gave his first at that time too. That is, I had seen pieces by Robert Whitman, Red Grooms, Allan Kaprow, Dick Higgins, and perhaps George Brecht. I was aware of a tradition called "happenings" and also the experiments lumped with happenings although they had a different sort of inspiration, such as Red Grooms's *The Burning Building.* I had also seen the productions at The Living Theatre. I was influenced of course by all these things, but since my purpose was making all this useful to myself, I wasn't trying to be the first one to do anything.

At the time, I made an analysis of what was going on. I felt that there were two possible choices whose differences then looked very clear to me. There were people, both performers and spectators, who would go to one kind of theatre and ignore the other. I remember very well that the late Bob Thompson said he would not see a Kaprow, for example, because he was in the Red Grooms piece. I remember that when a Red Grooms piece and a Kaprow were put on together at the Reuben Gallery, in January of 1960, there was really a lack of communication between the two groups; they divided between an emotional and a rational expression. The latter had come out of Cage's ideas and what Kaprow had done with the *18 Happenings.*
KOSTELANETZ — Was Cage known to be anti-expression—against the conspicuous display of personal emotion or even individual taste? OLDENBURG — At that time, he appeared to be. I remember how clearly his put-down of [Edgard] Varese stuck in my mind. In "The History of Experimental Music in the U.S.," in *Silence,* page 69, Cage wrote, "It is clear that ways must be discovered to allow noises and tones to be just noises and tones, not exponents subservient to Varese's imagination."
KOSTELANETZ — Cage objected to Varese's desire to create something out of himself and of his own, rather than accept the surprises his environment created for him.
OLDENBURG — On the other hand, there existed at that time a strong

influence from both Artaud and certain people who just went that way, like Red Grooms and The Living Theatre and Dick Tyler. Tyler, who was and is a print-maker, introduced me to Artaud's text, *The Theatre and Its Double*. He was my "super" at 330 East Fourth Street, between Avenues C and D, where he lived in the basement. He had his print-maker's press there and I saw him almost every day. The assistant minister at Judson [Memorial Church] at that time, Bud Scott, appreciated him very much. Tyler had a cart, which he kept in the Judson backyard and from which he sold his "magic" pamphlets. They were about such things as salvation through schizophrenia—all kinds of mind-breakers, that were then revolutionary but have now become commonplace. He was very interested in theatre and he also had a little group that was among the first to play music at Judson. It was an anti-music that I used to call "no-music." They would use various instruments in all the "wrong" ways and play them for hours. Anyway, the story of Dick Tyler is a long one that has not been written. Now he has taken a lighthouse in Nova Scotia, and he commutes from there.

KOSTELANETZ — How was Tyler Artaudian?

OLDENBURG — I've never absorbed Artaud very thoroughly. His theatre was, as you say, an expressionist theatre, which I tended to lump with all the expressionist theatre I could think of, as well as certain German films like [*The Cabinet of Dr.*] *Caligari* [1919] and *M* [1931]—things with a terrifying mood and horrible experiences. Of the things that were revolutionary at the time, that direction posed one possibility.

KOSTELANETZ — This was opposed to the Cagean stream . . .

OLDENBURG — . . . which was a revolution too. It consisted of silence—in accepting the world . . .

KOSTELANETZ — . . . and in being able to perform anything.

OLDENBURG — At this time, this separation seemed extremely clear. Now, it is different, as the two streams have sort of run together. Cage turned out to be a more complex person than he seemed at that time, and his influence has become so mixed up with other things. For instance, as Kaprow is now much less dependent upon chance procedures, he has become more of an expressionist.

KOSTELANETZ — He expects his pieces to create some emotional in-

volvement, and to fulfill this purpose he generally inserts a degree of physical danger; and this is very much in the Artaud tradition.

ÓLDENBURG — The fact that these traditions flow together and that people who do happenings can draw upon one or the other is one reason why happenings are confusing to an audience. When I did happenings at The Ray Gun Theatre, I drew upon both streams. I would make a very engaging and emotional sequence which I would suddenly stop and drop, to start something entirely different.

I remember very well a Tyler piece, that was never put on, in which the audience at the Judson was to be gathered into a pit. There was supposed to be a stage at one end; and on it Tyler planned to put a friend of his who had a steel plate in his head from a war injury. He was to sit there, tied up; and I had the part of hitting him in the head with a baseball bat. There were other details I can't remember; but that one stays with me very clearly, because I didn't feel like doing that. At the climax of the piece, bombs would be thrown down at the audience, who would be so terrified and wounded that Tyler expected they would panic. He wanted to do it in the chapel of the Church, which at that time was not used for performances; so this was one among the reasons why it was never performed.

KOSTELANETZ — Did his Artaudian conception win much discussion?

OLDENBURG — I don't think this piece had much circulation, but it had a great influence on me. I think you can see in the photographs of *Snapshots* that there is a great element of cruelty and suffering which may be theatrical. I wasn't really suffering at that point, but I looked as though I were suffering. Just before the performance, I accidentally cut my finger rather deeply, went over to St. Vincent's Hospital, where I sat around for a long time; and I think that experience directly contributed to the choices of costume and so on that I made for the piece.

KOSTELANETZ — Wasn't there an element of cruelty in keeping the audience in the dark for fifteen minutes?

OLDENBURG — Not only were they in the dark, but they had a great deal of difficulty seeing, because of the small opening to the room in which it was performed. The audience was in another room, and they had to look through a doorway. So, there were many people in a dark room, and only a few of them could see. There was a lot of jostling

around. Often, too, the unpredictable and unprofessional surroundings of the performances produced suffering, simply by lack of foresight or sufficient provision for the audience. One must admit, though, that such indifference is a form of cruelty. Here was this mixture of my acting out suffering and forcing the audience to undergo suffering; yet the whole idea of the piece was rather objective—I was going to translate myself analytically from an inanimate object to an animate one.

I suspect that *Snapshots* had more of an expressionist effect than later pieces; it was partly because of the tremendous involvement which anything at the Judson at that time inspired. There was a great sense of crisis constantly; that was the style of the time and the place. They were starting to reach out into the community, and the community was flowing in there. The place had a lot of action then.

What I'm trying to get at is that I tried to make an analysis at this time of the theatre that could be done, and then I decided what *I* wanted to do; and I was very selective about what I took; I think I came out with a synthesis that was something quite personal.

KOSTELANETZ — Where did you stand at this time, around 1960, in relation to Bob Whitman?

OLDENBURG — Well, the two things about Whitman then that interested me most were his use of material—stuff like clothing; he had a deep feeling for any kind of fabric—and his sense of time, that was the second thing. He has spoken about his pieces being sculpture in time.

KOSTELANETZ — As you were extremely interested in both time and material in *Snapshots*, wasn't his position then very close to yours?

OLDENBURG — Absolutely. His style was also very personal and highly aesthetic. His things were so beautiful and lyrical they were almost precious.

KOSTELANETZ — How did, say, Kaprow's example work upon you?

OLDENBURG — My position, you must understand, has always been on the outside. I didn't live in New Jersey, and I wasn't part of the New Jersey school, of which Kaprow was the leader. I didn't study with Cage. I discovered this whole area when I was looking for a gallery in 1958 and came across Red Grooms, who had started the City Gallery, which was the prototype of the Judson and many other informal artist-run places which also housed performances. Another

later stopping-place of Red's perambulating was, for instance, the Delancey Street Museum, a loft which has recently been the home of Peter Schumann's Bread and Puppet Theatre.

At the same time, I found Jim Dine, who had also found Red. The City Gallery was a splinter from the Hansa Gallery, and we formed the younger generation. After having my first one-man show at the Judson, I went away for the summer; and when I came back I saw Kaprow open the Reuben Gallery with his *18 Happenings in 6 Parts*. It wasn't until then that I gradually came to realize the existence of this New Jersey group. It included Whitman and Lucas Samaras, who both had been students of Kaprow's and were very much influenced by him, at the same time that they had their own entirely different ideas. Also through Kaprow, I met George Segal and Roy Lichtenstein. That year, of course, I had started the Judson Gallery with Jim Dine, Dick Tyler, and Phyllis Yampolsky. Although I had seen Kaprow at a Hansa picnic at George Segal's farm in 1958, the Reuben performance was my first meaningful point of contact with him. I had earlier read his piece on Jackson Pollock, which impressed me.

KOSTELANETZ — How did you do your first piece?

OLDENBURG — *Snapshots* was done in the beginning of March, 1960. I had created a "street" inside the Judson Gallery; a metamorphic "street" constructed out of paper and street materials; and it had a "floor collage" with all kinds of found objects on it—a "landscape" of the street; and the white walls showing through the construction were to be taken as open space.

KOSTELANETZ — Would you have preferred to have done this on a real street?

OLDENBURG — The original performance was supposed to take place in front of the Judson on Thompson Street. It was called *Post No Bills*. We had planned to block the street at the moment of performance by stalling a car, but the more I thought about the piece, the more I felt it was very closely connected with the construction I had made. I decided that I wanted to show my construction at the same time that I presented a performance. When people eventually came into the Judson Gallery, they saw me on the street as an object. So, from my first performance, my theatre work was linked to my sculpture or my construction. I was literally *in* my construction. Otherwise, I was try-

ing to work from the inanimate situation to an animate one, from no-motion into motion.

KOSTELANETZ — To what does the title refer?

OLDENBURG — They were snapshots in the sense that flashes of light froze the action. I was obsessed at the time with something that lay between action and stillness; freezing the motion was a painterly and a theatrical idea. Originally, I had wanted to bring things from a very still state to a very slow state to a very fast state; but I settled for the snapshot device, which made the effect of the thing really painterly. You can see that in the photographs of it. As the people came in, for fifteen minutes Pat and I were on the stage not moving—bodies that were not exactly buried but part of the landscape; it was a three-dimensional panorama like the things you see in museums. There were thirty-two flickers; and as Lucas is rather perverse, he once or twice waited a long time before he put the lights on. Otherwise, you couldn't see a damn thing, and we were doing all these things in total darkness.

My piece was the beginning of the night's performances. The audience left that little place, which was also the gallery, and went into the anteroom of the gymnasium, where Al Hansen had his piece for W. C. Fields. They went from there into the main gym where Kaprow did his piece with the boot [*Coca Cola, Shirley Cannonball?*] and from there back to the anteroom where Whitman did his piece. The evening closed with Higgins' piece, which is in fact interminable—counting in German until everybody left. The idea was to give a spectrum of what was going on. I organized the show.

KOSTELANETZ — How large was the audience?

OLDENBURG — About two hundred; and we gave it for three nights. Most of the faces there were familiar.

KOSTELANETZ — Did any newspapers cover it?

OLDENBURG — In those days, the *Voice* was very excited about off-Broadway. They were creating off-Broadway, and they had just invented the Obie Award. But they were only interested in theatre as they understood it. Jerry Tallmer did a put-down review of happenings at the Reuben Gallery in the early sixties, and that was supposed to seal the fate of happenings. Things have changed a lot. Now almost anything you care to do they will cover and cerebrate. Happenings are news.

KOSTELANETZ — Did you create a tradition as a result of your own performance?

OLDENBURG — The understanding of what we all have done is still not cleared up. Everything that everyone has done seems to have flowed together, as far as historical criticism is concerned. The necessary distinctions have not been made. Perhaps it's a good thing—that the word "happening" has reached a status of one of those words that mean everything and nothing. It's a word for artists, non-artists, fashion, revolution, politics, pop, and who knows what else. I have poured a lot of innovations into the tradition, but the critic is yet to come who will bother to sort out individual contributions. Michael Kirby was fanatically devoted to letting things speak for themselves.

KOSTELANETZ — Would you say, then, that the notion of "painter's theatre" is not very useful, because even among the painters exist not only different styles but different artistic traditions and different artistic ancestors?

OLDENBURG — Yet something you could say about my performances to individualize them is that as they are very much connected with my work as a painter and sculptor, they correspond to certain periods of my work. For example, the first three pieces—*Snapshots, Blackouts* [December, 1960], and *Fotodeath/Ironworks* [February, 1961]— are limited in color to black and white, and they have a great deal to do with darkness. This would also describe my work at that time, when I worked entirely with materials from the street and paper, as well as used no color. These three pieces also have a quality of desperation and misery about them; they deal with events of the street and its inhabitants, beggars and cripples. The sculptural pieces from *The Store* [December, 1961] and Ray Gun Theatre [1962], by contrast, are very colorful and warmly lighted—intimate.

After that, starting with *Sports* [October, 1962], which followed The Ray Gun Theatre, you get a group of performances where the place, the actual place, becomes very important. Examples include *Moviehouse* [New York City, December, 1965], the automobile parking lot of *Autobodys* [Los Angeles, December, 1963], and the farmhouse in Dallas for *Injun* [Dallas, 1962], and the swimming pool of *Washes* [New York City, 1965]. *The Store* was a store of course; but it was used very metamorphically—every week the mood and set were changed—whereas the later pieces always take into ac-

count a particular place. *Washes* deals with what you can do in a swimming pool. There is a limit to how big a thing I can make; but if I go out and find a place like a swimming pool—which was one of the most marvelous settings I've discovered—then I can use it for my own purposes. Now, the difference between *Snapshots* and *Washes* is that in the earlier piece I attempted to construct a street; but as I was unable to construct an actual street, I did an "art" version of the typical street. In *Washes*, I simply went out and found a swimming pool. I had the feeling, while I did the piece, that I had really taken possession of nature for my own purposes. Similarly, my sculpture after *The Store* tends to be rather objective.

In the recent pieces, the biggest object is the place itself, and the people in it tend less to be stereotypes or symbols, but just people moving naturally and doing unaffected things. The parallel in my sculpture is the period I call "The Home," where I made toasters, chairs, ironing boards, plugs. This was the period after the food sculpture, which is connected with *The Store*. In "The Home" period, which started toward the end of 1963, the colors are limited not to drab black and white but to rich textures of those colors with one other color, blue. A washstand, for instance, is black, white, and blue, as is the bedroom. The pieces here are very neat and clear. That expressionist element becomes entirely the action of the material; my choice of soft material, not my manipulation of it, makes the pieces "expressive."

KOSTELANETZ — Do you have any desire to duplicate any of your own performances in a new setting?

OLDENBURG — I never could. They are too dependent upon just those little things—the place, the time, the condition of the audience and the players. Everything is immediate. It becomes harder and harder to do a happening. You use up everything that you have. That's why you have to find new places. One reason that I have done fewer things in New York recently is that I used up New York, particularly the Lower East Side. Last year [1965], I found a little piece of New York I hadn't seen before, which was Al Roon's pool. I suppose I could find other parts of New York. In 1963, I went to Chicago, Los Angeles, and Washington. Every place has something fresh.

KOSTELANETZ — So, most of the time you start with a situation. . . .

OLDENBURG — . . . the preconceptions are really first.

KOSTELANETZ — Preconceptions about what—form, content?

OLDENBURG — If you go, say, to Dallas, they're what you think about Dallas in advance and what happens to me when I arrive in Dallas—all that before I find something concrete to hang on to and before I meet the people I am going to use. Then, there's the matter of place. I was supposed to do it in this auditorium, but it didn't work at all. . . .

KOSTELANETZ — In what sense didn't the auditorium work? Was it too uncomfortable a situation? Was the lighting bad?

OLDENBURG — It was a neutral auditorium, which meant nothing to me. It didn't give me anything.

KOSTELANETZ — In one of your pieces, however, you did use an auditorium—*Moviehouse*, done at the Film-Makers' Cinematheque in 1965.

OLDENBURG — Yes. That was a very special auditorium. This is the room in the Wurlitzer building, where the Wurlitzers used to promote the sales of their violins and things by giving recitals. My friend, Rudy Wurlitzer, can remember having a recital in there. That's why its walls are all done up with scenes of Europe, pillars along the side, and all that kind of stuff gives it a certain identity. Also, right now, as the Forty-first Street Theatre, it *is* a moviehouse, you know, and that fact gives it additional character.

I didn't accept an invitation to do *Moviehouse* in Hartford, because I knew the auditorium there was so neutral that the piece would have lost all its effect—the backlighting on the landscape, and the pillars and so on. The [Wurlitzer] auditorium is something like the late Paramount; there's enough to look at, if you don't want to look at the screen or the stage.

KOSTELANETZ — Your own preference is for theatres which have something else to see.

OLDENBURG — I very seldom go to theatres or go to the movies; but when I do, I like to be able to look in all directions. I like to look at people. At Lincoln Center, for instance, there is a fascinating thing, which is very important in all theatres—something you can count when you're bored. They have these things on the ceilings which are almost uncountable, because by the time you get up to 175 you've lost track of where you began and you have to start over. That's a good thing, because it keeps your eye engaged in the theatre.

KOSTELANETZ — In *Moviehouse,* before you started to compose the piece, you knew only the environment.

OLDENBURG — I didn't say "yes" to John Brockman [the producer] until I had visited the place. Once I decided something could be done there, then I got together the people, something which has over the years become increasingly difficult in New York. The people that I used in 1962 by now all have their private lives, and things are not the same. Lucas Samaras became a busy artist in his own right. Maria Irene Fornes became a playwright. So I have to go to a younger group of people. Anyway, as I had a show coming up [in February, 1966], I didn't want to go to too much trouble; so I went to people that I knew, such at Letty Eisenhauer and Freddie Mueller.

KOSTELANETZ — Then, your situation in life, in relation to your sculptural work and the people you knew, joined the setting in determining what kind of piece you would do.

OLDENBERG — As far as I'm concerned, when I decide to do something, it's like throwing a switch, and everything that happens from that moment is a contribution to what finally takes place. A happening isn't always successful; and when people ask me whether one was or not, I don't know how to answer.

KOSTELANETZ — Would you know if it were unsuccessful?

OLDENBURG — I would know it when all the factors don't work in performance. The first performance night in Dallas was unsuccessful in one way and yet successful in another. The audience created a sort of bedlam, which was their idea of what a happening was. I'm always running into situations where the audience defines what I'm doing. What I did in rehearsal in Dallas was a very quiet, beautiful, musical thing, where the flow was very quick through the house, where one incident came after another. When the audience arrived, they were difficult to manipulate; so it became a kind of riot. As they were grouped in this house, they were even more angry.

KOSTELANETZ — Does this bother you?

OLDENBURG — It changes the definition that I would prefer, and it has led to a lot of misunderstanding. A lot of people think of "happenings" as an excuse for some kind of orgy. The best happening, I feel, might be a very quiet, more contemplative situation.

KOSTELANETZ — Isn't there, however, in much of your work a tendency to brutalize the audience—to make it feel uncomfortable?

OLDENBURG — It's really not to hurt them but to make them feel their bodies more.

KOSTELANETZ — In *Moviehouse*, for instance, everyone became aware of his body because, as you performed the piece in the theatre's seats, you insisted that we had to stand crowded in the aisles. As the crowd flowed above capacity, the situation became nearly intolerable.

OLDENBURG — There were too many people there. If there had been half the number, the piece would have come off very differently; there wouldn't have been this effect of brutalizing them, which was brought home to me in a subtle way when Marcel Duchamp apologized for sitting down in a seat because he was tired. Instead, the piece would have created the effect of standing when you should be sitting, but I guess it was *more* of a bodily feeling—to be pressed in there.

KOSTELANETZ — Have you always had such large audiences for your theatre pieces?

OLDENBURG — In the store, we used to have about thirty for each performance; so that no more than 150 people saw my happenings there. Things are different now.

KOSTELANETZ — Does this bother you?

OLDENBURG — There is the problem, you see, that the thing is a relatively intimate experience, and it is difficult to accommodate everyone who wants to have it, especially in New York. It was fine in the early days, because very few people came to the performances. Just enough came. After a while, it got bad; so you had to turn people away.

I think Whitman was wrong to do what he did in 1966 at Circle-in-the-Square; for a repeatable performance over so long a period, with sucker advertising, is against anything we've done before. It promises you'll see vinyl and naked girls, pandering to curiosity which the practitioners of new theatre have avoided up to this point.

Also, when you get bigger and bigger audiences, what can you do with them? How can you handle two hundred people as well as you can handle thirty-five. It was so beautiful in the store because you could touch every one of those thirty-five people in some way—touch them with your hand, and put something in front of their eyes or behind them. If you get spectator sports, then you're having baseball games or something. I don't like spectator sports.

KOSTELANETZ — Are you always a participant in your pieces?

CLAES OLDENBURG — **145**

OLDENBURG — I'm not always in them. I prefer to be around the corner. I don't like to see them. If I'm in them, it's because I could not find anyone else to do what I want, as in *Injun*. Sometimes I'm in the audience, but I prefer not to see them.

KOSTELANETZ — Do you supervise the actual performance in any way?

OLDENBURG — I supervise the rehearsal very strictly until the last minute; then I like to withdraw and let the thing handle itself and find its own way. After about four performances, the piece starts getting very loose.

KOSTELANETZ — After you agreed to work in the Cinematheque, you contacted new people.

OLDENBURG — Who got other people, who wanted to give me the time. I don't pay, you understand, nor did I get paid. All I got for that performance was an old film-projector. If someone needs money, to eat or take a cab home, I'll give him some. In the case of the Cinematheque piece, it all came out of my own pocket—I may have spent a hundred dollars on the piece. In *Autobodys*, in L.A., I spent about $600, and I got about $250 back from the tickets. Sometimes a piece is commissioned. The Washington Gallery of Modern Art in 1963 put up $850 for a happening, but that included traveling to the place and living there. Performances are not a profitable thing.

KOSTELANETZ — Would you prefer to do theatre to sculpture?

OLDENBURG — I love to do sculpture too; but I would love to do less sculpture and more theatre. As you get better prices for your sculpture, you can afford to do less of it, but I like to do sculpture so much that I wish I could have two existences.

KOSTELANETZ — Why don't you do more theatre pieces now?

OLDENBURG — I've done nineteen by my count, since 1960, but at the moment my life is set up for doing sculpture.

KOSTELANETZ — Would you like to have a performance company?

OLDENBURG — The ideal set-up would be to have a number of students available at certain times during the year with a reasonable allowance of money. This work could be presented as a formal course, because the act of participating in the piece is definitely instructive. Right now, what is most likely to frighten me out of starting a piece is the looking forward to phoning and interrupting people's lives.

KOSTELANETZ — Your own work has a more distinct sense of rhythm than most examples of painter's theatre. Do you conceive it this way?

OLDENBURG — In *Moviehouse* I was very aware of the extension of time. It was my job to determine how long anything would last. I chose a tune which was extremely simple and which set the rhythm; this elementary tune provided a great deal of time sense. The piece had a tension of time in it.

Bob's piece [Rauschenberg's *Map Room II*, on the same program at the Cinematheque] was much slacker. His performers went on as if, say, you could be having dinner while you were watching them. They are very eye-directed.

KOSTELANETZ — Let me go back to *Moviehouse*. You have the space; you have the people. Then, what's on your mind?

OLDENBURG — In this case, there's always a tremendous amount of danger involved in doing a happening, because it is impossible to tell how it is going to come out. You leave yourself entirely to good luck or what may come your way and your ability to take advantage of whatever comes along, as you would depend upon your ability to take advantage of, say, running plaster or paint.

You get these people together as if you knew exactly what you are going to do, because unless they think you know, you can't get them together. There's this deception. No matter how sympathetic people are to happenings, they are terribly disturbed when they come together in a place and there is nothing for them to do.

KOSTELANETZ — Do they want very precise programing?

OLDENBURG — Yes, especially in New York, as they are very busy. They want to know what they should do so that they can fit it into their schedules. Even in places where they aren't very busy, they are still kind of frightened, because they don't want to appear on a stage. There's that dream I have myself—where I come onstage and I've forgotten the lines.

I would love to do a happening based on another dream, where I say to myself, "On the 24th of January I'm going to do a happening," and my entire preparation consists of forgetting that I had promised to do this piece on the 24th of January. When the time comes, I get into a cab and I go to the theatre and there I am with the audience before me. Whatever I did would be the piece. I haven't had the

nerve to do it but in a way all pieces are like this. I always have a date; so I'm always working against or with time from the very beginning.

KOSTELANETZ — Why do you create your pieces, both theatrical and sculptural, against a deadline?

OLDENBURG — I have read somewhere, probably in some pop psychology, that if you put in your mind a date for a task and are not afraid then when that date comes all the things will be ready. That's the way I operate in my theatre. Here are these people, my players, and the first thing that happens is that I am overwhelmed by the presence of so many people. As I spend most of my time alone, happenings become a way of meeting people—of getting out into the world. It's like coming back to New York after you've been away for a month; when you take your first ride in the subway, you can hardly get out of the car, because there is so much going on there.

First thing, I have to give my people something to do. After the first rehearsal, or the second rehearsal (if I have an exceptionally large cast), something begins to emerge—and much of it, a great deal, is made by the people themselves. Some of the best parts of a happening occur in the "rehearsals" when the piece takes shape. That thing with the bicycle [one of the last sequences in *Moviehouse*], which really made the whole piece, was a complete improvisation by Domenick Capobianco, who carried the bicycle . . .

KOSTELANETZ — . . . from the front of the theatre to the back, stepping over the rows of seats. Some people thought it stood out too much from the piece—it was so eccentric it was affected.

OLDENBURG — I don't agree with them. I know it stuck out awkwardly, but I liked it for that reason. For me, that was an important thing. It was a kind of ripping of the fabric of the setting.

KOSTELANETZ — In another sense, it was also too climactic a conclusion for a consistently flat structure. After you see several incidents that are faintly odd, then you see something that is really odd or odder; for that reason it is somewhat painful.

OLDENBURG — I am not a purist. However, the fact that Domenick, motivated by who knows what, went down and grabbed the bicycle and started climbing over the seats all by himself is sufficiently factual for me to use it in the piece, to find it irresistible. I think that I was seduced by a visual notion there too; I got so carried away by the correspondence of fans, wheels, and film reels that the bicycle seemed

like the proper climax. If the elements of a happening can be wrenched out and classified, this could be called a "dance." I often hand a person an obstacle and supply him only with a terrain and a direction. The resulting dance creates itself, as a sculpture takes its own shape when I substitute a soft material for a hard one. Domenick took a bike and crossed the terrain of the seats, which was very difficult and likely to hurt him. In one performance his foot stuck in a seat and I had to come along the floor and free him.

KOSTELANETZ — Once you assembled your cast at your first rehearsal, what did you do or tell them?

OLDENBURG — The first night I got up on the stage and I put them in the seats and I told them to do the things that they would do in a moviehouse. Then I went home and I wrote out on cards things that I can remember people doing in moviehouses; and in some cases, I made duplicates of certain actions like sneezing. The next night, which was the final rehearsal—we had only two nights—I gave them the cards, which had simple directions and time intervals. There were two sets of cards—one for the usherettes and one for the fictional audience. In the actual performance, the usherettes handed them out like tickets.

KOSTELANETZ — Let me just reconstruct the situation. At the start of the piece, you've invited the audience to stand in the aisles on both sides of a single block of seats; in the seats are about a dozen people. A beam of flickering light passes overhead, as though a movie were showing; but there is no screen in the place. Standing outside the block of seats, in the aisles, are two girls in red usherette uniforms; and in their hands are thick packs of cards. What kind of instructions are on them?

OLDENBURG — Well, there were several things, like, "Say: 'Get your hands off me.' " or "Blow your nose," "Laugh," "Cry," "Eat Popcorn." Each person carried a bag with about six different props, and the cards referred to props. There was a Coke, and one card said, "Open a bottle of Coke, pour it into a cup." This sound event made a little concert. There were all kinds of other typical things in the bags, such as a mirror. Using the mirror, the performers could reflect the light from the projector. Other cards were simply instructions such as, "Climb over the seat in front of you" or "Put your legs up" or "Move to the nearest person and put your arms around him." As

everyone was getting cards all the time, somebody could be, say, eating popcorn when another person came up and put their arm around him and someone would say, "Get your hands off me," while another person was sneezing. Nobody knew what cards the other people were getting. Then, there were also characters in costume in the piece, such as "Santa Claus," who is factually the sort of Salvation Army Santa who might drop in to the local moviehouse for a drink from his bottle or a nap. Then there were the white masks of the "Strange Mickey Mouse." A theme of the piece was disks—the movie camera, the fan, the bicycle, and also the disk on the head of the "Doctor in the House." There were certain general directions that *everyone* was told to repeat, if they came up. If laughter came up for one person, everyone was supposed to laugh. If one person put on a Mickey Mouse hat, everyone was supposed to put on a Mickey Mouse hat.

KOSTELANETZ — Then, you had the usherettes walking through the rows.

OLDENBURG — From time to time, they too would get a pink card that said, "Cross from one aisle to the other."

KOSTELANETZ — And as they went through, they would hand out cards to the performers.

OLDENBURG — The cueing was as follows: A person would get a card from the usherette, and the card would say, "Sneeze," and then there would be a number on it, say, five; whenever you got to the end of the count, you would stop doing whatever you were doing and hail the usherette who came over and gave you a new card. If she didn't come over, you simply repeated the old card or you improvised. Everyone was familiar with the cards, and they were all quite simple. The whole thing was just a device to keep the action going.

KOSTELANETZ — So, within your basic vocabulary, you used chance techniques?

OLDENBURG — The important thing was to get the place moving. The structure, as far as I'm concerned, always has to be tied to some factual situation, like the usherettes giving the cards, which is like showing people their seats.

KOSTELANETZ — All these images, then, are to you "found images," so to speak—things that you've seen in a moviehouse that you wanted

to duplicate here. Why didn't you show an actual movie instead of creating its semblance in flickering lights?

OLDENBURG — Because everybody would be looking at the picture. I didn't want people to look at the film. Originally the idea was to have the audience onstage looking at the players, but the stage was too small so I had to put them in the aisles. The idea was to see the movement in the theatre.

KOSTELANETZ — If the film were there, why would everybody be looking at the film?

OLDENBURG — Because it is a hypnotic image.

KOSTELANETZ — Right now, as I'm sitting next to you, I find that too often I'm watching the TV there. It's hard to resist, although I don't have one myself. It's very distracting; I wish you'd turn it off.

OLDENBURG — That's the way the TV is. [He turns it off.] Now— this is the way the world was before, because we weren't using that abstract over there.

KOSTELANETZ — As soon as I see one of your sculptures, I want to touch it, to identify its material and sense its texture. Do you think that desire is present in your theatre pieces too?

OLDENBURG — Yes. They're *sensuous* theatre.

KOSTELANETZ — To go back to *Moviehouse*. How did you choose the piece of music you used?

OLDENBURG — This was an example of good luck. I had a girl working for me, a very good seamstress; but she didn't understand what I was doing in the happening. She was just the person I wanted; in every town you find someone who is sort of a ringer—who is really perfect, although they don't know what they are doing. You want to use them in some way. I got her to play this music only by paying her money; otherwise, she'd go home and watch TV or something. In fact, after she played this thing, she did go home; she wasn't the least bit interested in the rest of the performance. She could only play simple pieces, which was very important; if I had had a very good pianist, the music probably wouldn't have come off as well as it did. To find a piece that she could play, I went to those stores along Fourth Avenue, but I couldn't get anything I wanted. Then I passed a garbage barrel outside one of the bookstores—they had just thrown out a lot of music. One was a little book, which looked very simple.

I picked it up on a hunch, not being able to read music myself. I brought it home to her and asked her to play these things. The best one was "Oats, Peas, Beans and Barley." It was musically perfect. And it was tangible; it brought to mind these particular things: oats, peas, beans, barley. She played it very well; she was perfect. She wore a long gown, like a soloist in a Christian Science Church.

There was a glass of milk on the piano. I don't know if you noticed it; many things are never visible in happenings now, because there are too many people. I wanted a moon somewhere; I had this image of someone playing with the moon gliding across. Liz asked for a glass of milk. We got her one. This became the moon. When she sipped it, the moon waned—the emptying of the glass being the curve of the moon.

KOSTELANETZ — You created certain visual illusions in *Moviehouse*. To convey the illusion of a movie projector flickering, I remember that you put a slow fan in front of the light from the empty projector.

OLDENBURG — I was trying to make the movement of this machine more feelable; to call attention to the character of the machinery.

KOSTELANETZ — It also established a ground bass rhythm for the piece. The second more various bass rhythm came from the usherettes moving back and forth across the rows, even though, as you say, their actions were not precisely timed. The third source of rhythm was, of course, the thumpety-thump of the piano. At the same time that the rhythms of *Moviehouse* were always present and identifiable, its visual sense was at once everywhere and nowhere—there was always something to see, and there was nowhere special to look, except at the end when Domenick carried his bicycle across the rows to the back of the theatre.

OLDENBURG — Everybody looked at him; he riveted attention. The event was unique in the desert of ordinary action—the sort of fantastic event you might find only in a movie, but here it was climbing out into real space. The silhouette of the bicycle moved and got bigger as he got closer to the projector; his image resembled film action in the lighted rectangle. When he got to the end, he put the bicycle down, and once he walked out the door, light came into the theatre. The lighted door in the darkness resembled the screen. As the theatre was drawn inside out, the piece ended.

It's characteristic of all my pieces to want to put the responsibility

upon the individual eye. You see whatever you choose to see. People are always saying, "Look over there," while someone else is looking somewhere else. In photos taken of the audience during my performances, everyone is usually looking in different directions.

KOSTELANETZ — Isn't individualized response also an effect of your sculpture?

OLDENBURG — Yes. With the soft sculpture, for instance, the collector must arrange the piece himself.

KOSTELANETZ — In this sense, your work demands perceptions similar to those demanded by life. On Fourteenth Street, there's nowhere special to look. As our individual responses to such unpatterned activity are subjective and various, any meanings we attribute to such perceptions are apt to be personal and ambiguous.

OLDENBURG — Right. You have to make up your own mind.

By the time I had decided that theatre was, from my point of view, as well as that of the performers and the spectators, a choice of what kind of emotion or attitude to feel toward something, my attempt was to make the actions deliberately ambiguous whenever possible; so that you could either get terribly involved with them or you could be rather indifferent to them.

KOSTELANETZ — You wanted actions to be ambiguous in the sense that they could suggest several directions at once. For instance, my picking up a spoon could be interpreted as meaning that I wanted to bring it to my mouth, that I wanted to throw it at somebody, or that I wanted to measure out some salt.

OLDENBURG — I had the benefit of working with the sculptor Lucas Samaras at that time [Ray Gun Theatre, 1962], who was, as a performer, able to make a very simple action extremely suggestive. In one performance, he buttered about fifty slices of bread very slowly; and this could be taken either as a very sinister obsessive activity or simply a preparation of bread to be eaten.

KOSTELANETZ — Your pieces often exhibit the strategy of repeating something until its repetitiousness assumes either an obsessive quality which instills emotional responses, or a formal interest where one simply enjoys seeing something appealing repeated.

OLDENBURG — Each time a thing comes back, perhaps it means something different. You mentioned the different interpretations of lifting the spoon. In the other example, Lucas might butter one slice,

and you wouldn't feel either one way or another. By the next slice, you might feel either he or I were trying to say something, but that feeling may have been influenced by something else that was happening. In my performances, there are always many things happening at once, so while there is repetition, there is also a perpendicular relationship which is unpredictable. Lucas may be buttering the bread in one case against this girl taking fish out of a basket; as your eye glances back to the bread a second time, you'll pass another guy smashing a box.

KOSTELANETZ — The repeated action becomes a ground bass, upon which you impose more various action.

OLDENBURG — Well, one action has neither more importance than another, nor a longer duration. I am trying to create a sense of simultaneous activity, as if you could see in one glance all that was going on in a building.

The people in my audience are like spectators at an anatomy—a medical theatre. I throw up images one after another or on top of one another and repeat them until it is evident I am asking, "What are they, or what do you think you are watching?" My theatre is therefore undetermined as to meaning.

Of course, my theatre can also be seen and enjoyed as purely a physical spectacle. My theatre is a painter's theatre for the reason that the values involved are those you would expect of a painter or sculptor. It is a theatre of physical effects; water, for example, is used a great deal, as are food and natural substitutes for paint, like dirt. There is a lot of ripping and tearing and squeezing and crushing and, also, falling "bodies" which exhibit a sculptor's attraction for the effect of gravity. It is also a way to make objects of the players. My instructions to them have always been not to display emotion or attitudes. They behave like machines—either their bodies are inert or, when they are moving, they behave unreflectively and mechanically, repeating a simple action. It is their bodies that are used, their movements more than anything. Yet the movements are not abstract or refined. They are always movements in response to an object, a simple task, or a kind of terrain.

KOSTELANETZ — Your sculpture has often been viewed as very literary.

OLDENBURG — By "literary," what do you mean?

KOSTELANETZ — I mean it in the sense of a paraphrasable theme similar in kind to what I might use to characterize a work of literature. For instance, I might paraphrase a theme in *Moviehouse* as suggesting that the activity in the seats can often be as interesting as the movie on the screen.

OLDENBURG — You could put it that way. That reflects my preference for the thing rather than the picture of the thing and for uninteresting ordinary activity in preference to organized activity, round *vs.* flat, etc. It became my attitude or critique of film.

KOSTELANETZ — Are your theatre pieces also literary in their use of symbolism? Is the situation in *Moviehouse* regarded as a microcosm of the larger world?

OLDENBURG — I have the intention usually of presenting fragments of everything. My performances are more epical than lyrical. The aim is panoramic, spatial—as if one could see both past and present, inside and outside, the whole nation and the whole world, now and in history. I use stereotypes, pictorial clichés, for literary reasons, though what the performing figures do or what they wear may also be important for formal or color reasons—Santa has on red, of course. The literary residue is felt—Santa may also be read as a discarded magic figure. There are, in addition, distinct female types. I categorize my players, sometimes unfairly, and I imagine them in advance often as types—elements in the composition I have in mind.

KOSTELANETZ — Do you tell them their identities you imagine for them?

OLDENBURG — No. They are not actors and actresses. I imagine they know about themselves and, I hope, feel right about the way they are used in the composition.

There are other literary interpretations which I am not responsible for and which surprise me. In theatre this is bound to happen and I don't object. Purity or singleness of interpretation is not my intention, though I want to present the material (however obscure or suggestive it might be) very clearly. Another type of symbolism is the illogical, or anti-idea. It consists of a visual resemblance which may or may not correspond to an intellectual resemblance. For example, cap equals pie, as well as hamburger or gun, as I draw them, that is. These associations make a chain of resemblances within my work against which every new formal suggestion is tested. They are my "forms" or my

"alphabet," and occur in my theatre as well as in my sculpture. For example: An obelisk equals an ironing board; you can see a simple formal relation there.

In a happening at Washington, these relations were used as follows: There was a girl ironing obelisks that were made of stuffed waxcloth. Of course, there's sexual symbolism there; but my main interest was the resemblance of the forms.

KOSTELANETZ — Are your master forms extended to archetypal definition? For example, the archetypal dimension for an obelisk is a penis.

OLDENBURG — Well, you can use that, if you want to. One thing about my alphabet is that I try to have everything equal a "Ray Gun," which is a phallic form; and the Ray Gun Manufacturing Company, as I officially entitled my store, is, of course, a place where Ray Guns are manufactured. One interpretation, then, is the phallus manufacturing company, with CO also being my own initials. And "manufacturing" originally meant—if you look it up in the dictionary —things done by hand, as was really the case; and it can also mean "mother-fucking." On the Lower East Side, "mfg" means precisely that. Anyway, these are all literary possibilities.

KOSTELANETZ — Then, the underlying strategy behind your pieces is to work from a mundane image to hidden archetypal materials.

OLDENBURG — It's there, but the situation is open and the interpretations are various. I don't insist on any particular interpretation, but I demand of myself that I make the thing as suggestive as possible.

KOSTELANETZ — Would you say that if someone saw only the moviehouse dimension of that theatre piece, he observed only the surface, missing the more mythic and ritualistic dimensions; and in this respect, your theatre and sculpture are more or less similar in strategy?

OLDENBURG — I don't want to limit myself because I don't think it's possible. No matter what you do, you're saying much more than you think you are saying. So I take the opposite view from the purists— they cannot succeed—and I try to let in as much as possible, now and tomorrow.

KOSTELANETZ — Is your bathtub sculpture erotic?

OLDENBURG — If it's erotic, it's because man has spun his erotic fantasies around it—made an erotic object out of it. Many body associ-

ations about it are sexual (such as the umbilical cord suggestion of the hose) which didn't occur to me when I made it, not consciously. The more clinical looking of the bathtubs, the one of canvas, is owned by a doctor who specializes in obstetrics. A recent reviewer in a Toronto newspaper quite surprisingly wrote, ". . . [the] bathtub hangs, begging for re-excitement after the orgasm." I don't object to this interpretation, but I didn't have such specific thoughts when constructing the tub.

KOSTELANETZ — Is your theatre erotic?

OLDENBURG — The fact that theatre deals with human beings makes it potentially erotic. In my theatre, however, the emphasis is more on the object, so one could perhaps speak of the sexuality of an object. Bathtubs have appeared in my theatre not just as bathtubs but as centers of interest with the players servicing them in a subordinate way as they might an auto in a garage. The awareness of the power of the object (or rather the ordinary versions of an object) is necessary for understanding my theatre. A model of my style in writing scripts is the clinical description of case-history details such as this one in [Wilhelm] Steckel:

If Doctor Biswanger even placed a finger on the patient's heel, she would become upset and threaten to drop into a faint. It was also a feeling as if someone had pressed a button, as if a stroke of lightning had passed through her body. . . .

The surface is cold and the content is hot. I like that. It describes a certain kind of activity whose particular quality Lucas especially can bring off.

KOSTELANETZ — As an actor?

OLDENBURG — Well, it is not only acting. You see, when I use people, I use them for what they are. I wouldn't use everyone that way, but Lucas is a natural.

KOSTELANETZ — Do you think your exploration of psychological dimensions separates you from other creators of mixed-means theatre?

OLDENBURG — I think you probably could make it an individualizing characteristic. I may be wrong, but I feel that the intimate supersensitivity I have about my subject matter may be unique among the people we've been discussing, with the possible exception of Jim Dine.

KOSTELANETZ — In some of your pieces there is a clear preoccupation with American history, both the facts and the myth; how would you define your attitude toward the American past?

OLDENBURG — In *The Store* you have a hamburger and baked potato; these are stereotyped objects. The equivalent in theatre would be stereotyped figures and stereotyped events. A hamburger would be similar to an "Injun."

I value stereotypes, conventions, because they are "frozen" in time, objectified. All my objects are typical; that is, they are antiques, situated a bit back in time, so that while you observe what I do to them you have a clear idea of the original model. It's not a matter of nostalgia. I am not sentimental about America, or nationalistic. If, in painting, you take a familiar subject, that gives you a certain freedom. Nonetheless, the stereotypes of every nation creep into the minds and imagination of its citizens, but what they mean once they get there may be very personal. They may be masks, externalizations of personal dramas. In the period when I used historical figures, my theatre, I think, was too personal to be considered a conscious play with U.S. history. Though I did refer to the Ray Gun Theatre series as a "history of the U.S. consciousness," I think now it might have been more a history of *my* consciousness. Where I started with an outside idea, as with *Injun*, to represent "man's savagery" in the "pop" conventional way, the contact with actual materials turned the spectacle into an intimate personal account, maybe too much so.

KOSTELANETZ — You write scripts for both your pieces and studio notes, and have published some of each. Why do you feel a need to do this?

OLDENBURG — Well, first I do a sort of daily writing. From time to time in the course of working in the studio I attack the typewriter with bits of scenario or notes on work I've done or want to do. Sometimes I write a letter. There are all kinds of different reasons for going to the typewriter. It's a very physical ancient typewriter, which I find pleasurable merely to pound on. It's so eccentric that it's almost like a musical instrument—you have to use it in a certain way. That's the way I like to write. Rather than use a pencil or dictate, I prefer to use all my fingers; and often I write a lot of nonsense because it feels good.

KOSTELANETZ — It becomes an extension of your sculptural impulse.

OLDENBURG — That was the idea behind its use in *Massage* [Stockholm, 1966].

KOSTELANETZ — Isn't your working environment when you're typing different from when you're sculpturing?

OLDENBURG — The typewriter stands in the studio, placed up on a chair on top of a table; so I never sit down while I type. If I'm doing a concentrated kind of writing for a catalogue or a request for a statement about my work, I require absolute silence; and that's not necessary when I'm working in the studio on other things, such as what is called sculpture, when I can listen to the radio.

KOSTELANETZ — When you get an idea for a sculptural piece, do you type it out first?

OLDENBURG — Yes. The conception usually comes first in a written form.

KOSTELANETZ — Is that another way of explaining why your work is "literary"—that you deal with written-out conceptions?

OLDENBURG — I don't think that necessarily makes it literary, because the description can be nothing more than a type of material or a certain use of material. Often, instead of writing out a note, I will draw a picture of it or I will tear something out of a magazine that looks like it, to remind myself of it.

KOSTELANETZ — Do you keep files?

OLDENBURG — Yes, I have lots of files.

KOSTELANETZ — When you have to do a theatre piece, in what form does it first come to you?

OLDENBURG — I don't always write scenarios for pieces. Sometimes parts of them will develop in action; some scripts are fragmentary. If I did a maximum amount of scriptwriting for a piece, the first draft would be a poetic script—all kinds of impossible activities that I feel like jotting down. That lays the groundwork or sets the mood for something more practical. The second draft would come after these poetic ideas come into contact with the realities, such as who's going to play what. Poets have such a great advantage because they don't have to construct their dreams, whereas I have to come down to earth and make them happen in my theatre.

In *Blackouts*, in 1960, I was determined to have a dog in a cage with water pouring on him. At first, I tried to get a real dog in a cage, but I couldn't find the right-looking kind of shaggy dog. Then, I

built a fake dog and put it in a cage and poured water on it and had a device to make the head move so that it looked like a real dog; but that wasn't very satisfying either. So I went outside, found a bundle of newspapers, put them on a chair, and then poured water on that; and this seemed to solve the problem for me. That kind of change goes on all the time.

KOSTELANETZ — It's a symbolic transposition—the paper becomes your version of the dog.

OLDENBURG — My *Store Days* book contains some poetic pre-scripts; and you can see how the realities of making a performance change the conception. The second script is more practical, and then there is a third script which is for the individual performers; so that they know when to enter and what to do. That is a very elementary script.

KOSTELANETZ — Is that usually written out?

OLDENBURG — I've done both. Many effective pieces I've done have had no preliminary script. They developed in rehearsal as pure action. If the piece develops without words, I may still go home and write it up as a scheme; so that, if the players get nervous at the time of the performance, they can refer back to it. I usually post some rudimentary script backstage where they can refer to it. In the case of *Washes*, I wrote out an elaborate script which nobody could understand; and then I lost it or somebody hid it. We continued developing the performance without it, and it proved to be no loss.

KOSTELANETZ — What terms do you use in a pre-script?

OLDENBURG — I write out images and ideas in relation to the place of the performance.

KOSTELANETZ — What were your ideas in, say, *Moviehouse*?

OLDENBURG — I had a clear recollection of a pickpocket working in a theatre late at night in Milwaukee years ago, among the people who were sleeping. I was interested in watching him work. In *Moviehouse*, Domenick, the fellow who carries the bicycle at the end of the piece, is known in the script as "the pickpocket," and his actions consist of going through the rows from back to front, looking under the seats. He's the timer of the piece; when he reaches the front of the theatre and picks up the bicycle, he signals that the piece is entering its last stages. He times the piece by how quickly he moves among the aisles; thus, it is he who actually decides how long the piece will be.

KOSTELANETZ — Speaking of *Moviehouse*, do you ever plan to work film into your pieces?

OLDENBURG — What I've been looking for in film I haven't yet found. All the films I have made have been very unsatisfying. Lately, I have begun to believe that in working with the visual image I started at the wrong end. I feel that sound is comparable to sculpture; it touches me. Sound is an invisible sculpture—think of thunder. It is possible that I'd have better luck if I started a film with the sound.

KOSTELANETZ — How, specifically, would you do that?

OLDENBURG — In my Stockholm performance of *Massage*, the base was a recording I made of myself typing the notes to the catalogue. I became aware of how spatial and physical the sound of a simple thing like that could be, and I used it in the performance, highly amplified. The sound really took possession of the space. That was the first time I ever used tape. Up to now, I've avoided tape-recordings to rely on a phonograph, because the tangibility of putting a record on and taking it off is more of a sculptural feeling.

KOSTELANETZ — How did this sound influence your use of space?

OLDENBURG — The space was a room of the museum; and in that situation, the sound, highly amplified, produced an effect something like that of a battlefield, creating a great deal of expectation about when the next sound would come. You had an almost visual picture of some kind of control of the sound; if you could recognize the sound as a typewriter, you would imagine a man typing. It produced a sense of large scale. I knew it was a typewriter, and I think most people did. One reviewer referred to it as a giant typewriter, which suggested that I was using sound to represent a sculptural object— a visually giant typewriter—I'd previously made. It fascinates me that he felt I was evoking through sound a giant image. What added to the effect was the fact that the sound was coming from a structure, inside the museum, where I had my studio; so the actual location of the typewriter was precisely where the sound was coming from. Also, this structure in the museum had the appearance of a giant typewriter.

KOSTELANETZ — What kind of structure was it?

OLDENBURG — You would need to see the thing to know exactly what I'm talking about. The structure was placed in one corner of a large room inside the museum, so that it appeared to be a big block

inside another room; with a little imagination, you could read this as a typewriter.

What might happen is that I could get so involved with the sound that I might eliminate the film. Or I might wind up using a very weak image and let the thing come through as sound.

KOSTELANETZ — Or, you might make a film about something because you liked the way it sounded.

OLDENBURG — That way the image would be rather inert; yet there would be an image. Or I might let your own eyes provide the images and take over your ears with sound, in a transistor sculpture, say, to be worn around town.

# 7

**The fox knows many things,
but the hedgehog knows one big thing.
—Archilochus**

# Ken Dewey

Ken Dewey is the only artist interviewed here whose original training was predominantly in the theatre, where he worked for several years as a director and technician; and he is probably the most versatile of the mixed-means practitioners. Where most others have concentrated upon developing one type of piece, he has been an adventurer, creating works in all four genres, as well as collaborating with artists from fields as various as architecture, music, film, painting, and landscape design.

Born in Chicago in 1934 and raised in Somerville, New Jersey, Dewey attended a succession of preparatory schools. Before entering college, he chose to work for two years as a uranium prospector in the West; during this period he wrote his first play. He then returned east to enroll at Columbia University's School of General Studies, where at first he divided his attention between sculpture and playwriting. He later decided to major in drama, receiving his B.F.A. in 1959. Dewey's post-graduate education was an apprenticeship at the San Francisco Actors' Workshop Company. While on the West Coast, he also studied dance with Ann Halprin and mime with R. G. Davis,

both of whom later joined him in forming the short-lived A.C.T. Company (which has no relation to a current group of the same initials).

In Los Angeles, in 1962, Dewey directed and produced Jack Gelber's *The Apple*. In the same year, he gave his first public quasi-mixed-means performance—*The Gift*, based on his own script and presented both indoors and on the street in San Francisco. Since then he has presented nearly twenty more mixed-means pieces, in all forms, all over Europe and America. The most famous was undoubtedly *In Memory of Big Ed*, a staged happening which shocked the International Writers' Conference at Edinburgh in 1963. His more recent staged performances include *Vaxlinger* (1964), which ran for fourteen evenings at Stockholm's Pistol Theatre, and *Sames* (1965), on which he collaborated with the composer Terry Riley. His best-known kinetic environments are *Selma Last Year* (1966), displayed at the Fourth Annual New York Film Festival and elsewhere; and the *Entrance Environment* (1966) to a production of Molière's *The Misanthrope* at Chicago's Goodman Theatre. *Without and Within* (1965) was largely a staged happening, and his five-hour audience tours, *City Scale* (1963) and *Cincinnati Journey* (1965) were closer to pure happenings than anything else. Currently Dewey lives in New York City, where he is head of Action Theatre, Inc. and Special Projects Director for the New York Council on the Arts.

Dewey's demeanor is quiet, considerate, introspective. Unlike most other mixed-means practitioners, he attends all kinds of theatre quite often; and he learns from observing the work of others. Behind all his remarks, therefore, is an understanding of the various strains of the new theatre as well as a sophisticated awareness of theatrical possibility. He gives one the clear impression that he expects to consolidate his diverse forays into a more sharply defined and consistent approach and style.

KOSTELANETZ — How did you first become involved with making theatre?
DEWEY — All that solitude out in the West, before college, made me bored and tired; so I began fiddling around with a play. It was about prospecting and trailer-camp life. I brought it back to New York and showed it to a friend who was stage-manager at the Circle-in-the-

Square. He was remarkably kind about it: "Well, it must have been a lot of work to write that much." When I took it back, I did six or seven rewrites. Then, I decided I wanted to take some courses at Columbia. I started out unsure of whether I wanted to go into sculpture or playwriting; so I took courses in both. By the second year, I became a drama major.

The best courses I had were historical, taught by a Doctor Pinthus, I believe. He dealt very much with origins, like cave paintings and ritual; but he tied everything to theatre, and really gave you a sense of how theatre evolved, accommodating to different societies. He also covered the various periods of architecture; and although I haven't thought about it much, I suspect he laid down the groundwork for my present activity. Everything else about theatre I studied there— playwriting, acting, direction, speech for the actor (which I failed) —was too empty and academic.

I'd heard of the reputation of the San Francisco Actors' Workshop, so, when I graduated, I went out there and presented myself, to pay my dues as an apprentice. I concentrated upon stage-managing and technical work, and was particularly involved with lighting and sound. It was damn good experience. I developed such a craftsman's pride that I began to see the striking of the set as a kind of dance. The stage had these big tall flats, which one person could carry like a sail. There's a whole artistry to taking a set and programing—that's what it really is, programing—the movements of people's time and energy. That's the level at which I got terrifically involved—how to program time in that kind of way.

The next step at the Workshop was assistant directing, particularly working with Glynne Wickham of the Bristol Old Vic. He had a beautiful system of phasing rehearsals—no one in this country does it—which was a deliberate attempt to exploit the fact that when people first confront something, their intuitions work. That's why your first impression is so very often accurate. He would set up a situation where the actors would display their first impressions. Then, he would respond to what they had come up with and record it. Then, he would tear the play apart and break it down and eventually bring it back.

For instance, at the first reading, he asked me to record the running times of each of the acts. Toward the end of the rehearsal period,

just as the opening approached, he asked me for the original times; we saw that the times kept on coming down until on the opening nights, the running times for the whole play were within ten to fifteen seconds of the original times.

KOSTELANETZ — Was this intended to be an experiment?

DEWEY — No, it stemmed from a realization that there exists this initial form which reveals itself once and then is found again—that makes the process of producing a play almost a symmetry. Children have this fantastic instinctive perception, which in adolescence is all shot apart and broken down into categories. This is what Wickham did in rehearsal—he broke the play down; and then he put it back together again. This incredible trust in people's intuitions was an important experience, because I have used it countless times no matter how absurd the process. I've phased my own preparation for pieces.

Before I started writing my own scripts again, I began, back in 1960, to take a script that I liked, such as Camus's *The Misunderstanding*, and working with Yvette Nachmias, who was also at the Workshop, I would use it in new terms. I would break the dialogue open. That is, I took out the speeches of one character and wove together a single monologue which I gave to Yvette. I took all the other people she was talking to and replaced them with either sounds or lights or objects or the environment itself in some kind of way. We used Varese's music—*Poème électronique, Density, Hypertism*— and as it has its own rhythm, we dropped her speeches into its rhythm. It ended up as a very complex experiment—an attempt to set up a dialogue between her and this music. There are three people she talks to in the play—her mother, her brother whom she doesn't know is her brother and whom she conspires to kill with her mother, and the wife of her brother. She is telling these people something; so she declaims at them as though she were talking into a crowd.

KOSTELANETZ — It seems you were using words in a mixed-means format.

DEWEY — What I was doing at that time, in working with Sartre and Camus, was running down the director's process for myself. For one thing, I felt it was terribly necessary to know the philosophical background in which the playwright had conceived his play. As it was existentialism that I fell into, I went all the way back to Kierkegaard and read all the Sartre and Camus philosophy I could get my hands on.

This was good background, because when I finally came to do *No Exit*, which, in translation, is terrifically wordy and overdone, I had his style down so clearly that I could see the play as a rope, where Sartre would go over one thing and then come back to it later and a third time. This technique might have been effective in French, but in English the result was simply overweight. I went through it and cut out the repetition and then pieced the whole thing together so that it actually flowed better. What resulted hit all his points, but I dumped out his redundancy. What I wanted to do was strengthen the dramatic action. For me, this was an experience in discovering the essential form.

In the other play, the Camus, I began to get preoccupied with the content. There were certain forces—the environment and all the characters. Each had an outlet, a voice. Yet what would happen if one assigned different voices to those forces? If one gave them different outlets? The environment was a force. Its voice was the setting and the constant references to it. We replaced that with the Varese. We took other voices assigned to each of the other forces—the mother, the wife, the brother—and found new voices for them within the music. We left only one character, the sister. She spoke her lines, which were the play's lines, but the answers and responses came back at her from the music. We were in this way resurfacing the forces which the mother, wife, brother, and environment had represented but in the different medium of music and, therefore, as different voices.

KOSTELANETZ — Elements other than words become the materials of your dialogues.

DEWEY — I would say that my training had convinced me that in order to get the play on right, you had almost to forget about the text to get at whatever it is underneath there—the organic thing that unfolds itself and follows a progression. Stanislavsky referred to it as the sub-text, and other people have other words for it.

KOSTELANETZ — Bob Whitman called it "the image."

DEWEY — Yes. I feel it more as a gesture.

KOSTELANETZ — Did you consider this a breakthrough?

DEWEY — I wasn't terribly well-read in theory; so it was more or less an instinctive thing. In retrospect, I'd say yes, but it was another year before I was able to work with it again deliberately.

KOSTELANETZ — Were your activities honored?

DEWEY — The Workshop was preoccupied with its national image; consequently, response to root-level experimentation was slack. Lord knows, I didn't really know what the hell I was doing. The best I could have hoped for was that somebody would come on with a straight response to the whole thing. Then, I could have grown more quickly from it.

KOSTELANETZ — What happened to your career in the Workshop?

DEWEY — At a certain point I had to leave because I couldn't progress in my explorations any more.

I stayed in San Francisco and began to work on my own. I formed the A.C.T., the American Cooperative Theatre, which was composed of Ann Halprin, Ronnie Davis, Lee Brewer, and myself. The intention was to form a cooperative which would pool our resources of personnel and would raise money collectively. In its original form, it never got off the ground; so Lee Brewer and I kept it together. He did Jean Genet's *The Maids*, and I did a play of my own called *The Gift*, which I also directed. By then I had written seven or eight plays for a bare stage or for no stage. I realized that if I could not get sets and things, I should write plays that needed nothing. *The Gift*, therefore, was made to go into the street. Two of Ann Halprin's dancers—John Graham and Lynn Palmer—approached the text in a completely non-literary way. They used the sound of the words to provide movement. As we got into the production, I felt that it violated everything I knew about directing, because we had abandoned the meaning—the content of the words and even the recognition of the text. Underneath, however, it felt right; so little by little it came together. We created it to adapt to various kinds of space. I thought of the setting as a mobile medieval form, where the performers take with them what they are going to use. With *The Gift*, in some strange way, the earlier exploration with resurfacing forces in other forms paid off as Lynn resurfaced the gesture under the play as movement and John resurfaced his aspect of the gesture in a movement-dialogue with the environment.

KOSTELANETZ — How many times did you do this?

DEWEY — We did it in about five or six different places—in a church, on a stage, on Ann Halprin's deck, in the center of the city.

KOSTELANETZ — When did you get involved with theatre in Los Angeles?

DEWEY — I kept A.C.T. going myself. Down in L.A., I did Jack Gelber's *The Apple*.

KOSTELANETZ — Why did you choose a play whose New York production almost everyone found disappointing?

DEWEY — It's a fantastically deep play. He's talking about democracy as opposed to dictatorships. This is the point. You have to go through the play to get into the ground underneath it. Gelber missed in the couple of key places, and that's why it's such a difficult play. When I saw it, the opening of preview week, it was going down exactly as he had written the play. It was a group coming together. Judith Malina was going up the wall over details, the set was falling down, the whole production was so outside the play that it was all sort of a big staged happening. I went back three times to see it, and it got tighter and tighter and duller and more awful. By the time it opened, it was just a ghost of what it had been. So, in my own production, I really tried to set up a situation in which we could get at whatever it was that had been so alive, and I would say the result was pretty close to what I had seen the first night.

KOSTELANETZ — Once you had recognized what the sub-text of *The Apple* was, how did you go about staging it?

DEWEY — The first phase was an extremely prolonged research into the play; it went on for a couple of months. I worked primarily with Anne Horton, a painter who was the set-designer. I began by doing a traditional kind of breakdown in which I divided the play into its beats or action units, whatever you want to say. Then, I sought the underlying gesture for each of these beats and the underlying gesture for different characters—what they really wanted, as opposed to what they were saying. Then we started on our own journeys. I went to an astrologer, and we picked planets for each of the characters.

KOSTELANETZ — How did you do that?

DEWEY — Well, it is a play that, symbolically, holds up on a lot of different levels, and I found it necessary to draw back from these characters in order to get a different kind of a depth, a different context for them. The use of planets fit, because each planet does have a particular character or identity.

KOSTELANETZ — With it, then, you created a kind of symbolic network to hold the disordered surface together, one character being like Mars, another Venus.

DEWEY — I used them not so much to hold the play together but to probe further the individual characters. For instance, the Negro character represents Mars, as he comes on signifying Change.

KOSTELANETZ — Once you had these symbolic equivalences clear in your mind, what happened?

DEWEY — We abstracted from the planets, selected things that we could turn into alchemical symbols and medieval symbols. In making a list of possibilities that related to each character, we used a kind of Cagean technique to make us aware of things we might not have thought of ourselves. This was a deliberate use of chance. It was a way of bringing out meanings. All this information provided a guide.

I gathered a number of people—the composer Bill Spencer, whose music is beautifully distinctive; and the sculptor Helen Burke, who created several polyester animal masks for the dream sequence. The four of us went down to L.A. and put together an Equity company, mostly of New York actors—people trained, to a certain extent, in Method. Instinctive though it was, the actors' perception of the sub-text, or underlying confrontation, became so acute and dependable that they challenged a number of times my own preconceptions of the text and the action; and these had to be abandoned in favor of what developed out of the rehearsals.

KOSTELANETZ — So, instead of acting out roles, the actors were performing the underlying rituals of the play, as they sensed them. Metaphorically, you were not telling them to go onstage and be soldiers; you were instructing them to enact a war. To this instruction, they responded not as role-players, but human beings.

DEWEY — Once the actors made contact with the core, they had a strong hand in the composition of the performance. My problem was really to handle their introduction to the core.

The situation I tried to set up in rehearsals was like a studio, and I used my own preconsiderations about the play to get us by periods in which nothing was happening, or to provoke the cast. Then, we just invented; and if something better came out of the rehearsals, we used it. The actors were contributing.

KOSTELANETZ — What was the over-all sub-text here?

DEWEY — A collision of forces. You had this quasi-democracy, where everybody is free to do what he wants. Then, the group gets introverted and incestuous and ingrown; then it begins to disintegrate. What Gelber does is pick the point at which such a group is falling apart because of incoherence at its center. Then, he introduces the traditional fascistic individual, who is falling apart the other way— he has too much of the control and self-discipline that they need. So, these two forces interact with each other in various ways. Initially, they attack each other. In the second section, however, almost by accident, they improvise together. This takes the form of an incredible dream sequence which is both horrible and moving. The improvisation becomes such an explosive trip that this fascist-type goes off the deep end, and the scene falls to pieces. They ask themselves who's going to help this man—to take responsibility for him. Two political systems have collided; and since that social theme was sufficiently there, I pushed the human terms—the interrelationships between the characters, trying to evolve a collaborative, rather than hierarchical, system.

KOSTELANETZ — When did you first witness an example of new theatre?

DEWEY — In 1961, I saw Bob Whitman's *The American Moon* at the Reuben Gallery. When I lived in California, I came back once a year to New York and saw as many plays as I could, and that same time I saw Bertolt Brecht's play, *The Jungle of Cities*, at The Living Theatre. When I got back to California, these two things were really weighing on me.

KOSTELANETZ — How did you respond to your first encounter with mixed-means theatre?

DEWEY — It had a terrific impact, by being first of all unexpected and then by working with a whole vocabulary with which I wasn't familiar. By "vocabulary," I mean a textural vocabulary of shapes, sounds, spaces, and sizes.

KOSTELANETZ — Did it seem radically different?

DEWEY — To me it was. We went into Bob's place. It was dark, and we sat in little caves and looked out and saw other little caves, with other people sitting in them. Screens went up and down in front of our cave. Things bubbled up until they filled up the opening. It was obviously theatrical—it progressed, it moved, it went from this to

that, the emphasis changed. I was terrifically disarmed by the things being done around me, and I began to think that the whole possibility of disarming people was very important. I had become so used to seeing predictability in theatre. Even the productions I had seen of Ionesco and Beckett had, in comparison, a safeness about them in the relationships of both the actors to their roles and the audience to the stage. You could go along with them and be moved within them, but still Bob's piece was different. It's the difference between watching a game from above in a stadium seat and being down on the playing field, in the game or on the sidelines among the players. It's a difference in both distance and scale; Bob's piece was physically *around* you.

KOSTELANETZ — This raises the question of when you read Artaud and what *The Theatre and Its Double* meant to you.

DEWEY — Before *The Apple*, or after, I don't remember. At the time I hardly understood what I was reading. The experience confirms Cage's suggestion that something you at first only absorb can become a great influence; it goes off later in you like a time-bomb. The demands Artaud made on theatre impressed me. He called for an emotional and physical scale that is so totally involving it would have an impact beyond that of a lecture situation, which is really what Western theatre traditionally is.

KOSTELANETZ — What happened after the Gelber thing?

DEWEY — I went back to San Francisco early in 1963; and with Ramon Sender and Anthony Martin, I did *City Scale*, which was my first conscious and deliberate happening, composed of existing elements. We probably had twenty people, and the audience was maybe seventy.

KOSTELANETZ — What was your purpose here, and how did you coordinate with your two co-authors?

DEWEY — We tended to work in a way that I have worked often since then. Tony Martin did the visual aspects—projections and things of that sort; Ramon was involved with sound. I functioned as a catalyst. I made a score that located all the events—a blueprint similar to what we later used in *In Memory of Big Ed*. It plotted time and space throughout the evening. We worked from it, but somehow it got lost in the end.

KOSTELANETZ — So what was in your mind here?

DEWEY — To take *The Gift* further. When we went into the street

Robert Rauschenberg, *Map Room II*, 1965.

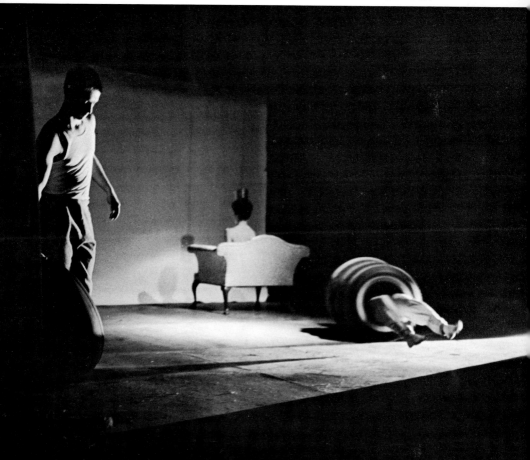

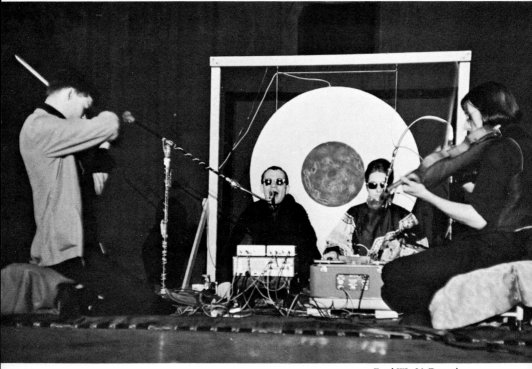

*Fred W. McDarrah*

La Monte Young, *The Tortoise, His Dreams and Journeys*, 1964 —.
Left to right: Tony Conrad, La Monte Young, Marian Zazeela, and
John Cale.

*Fred W. McDarrah*

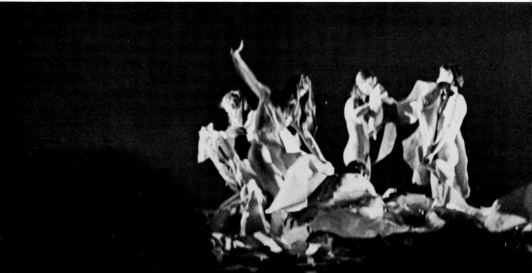

John Cage (center), *Variations VII*, 1967.

Ann Halprin, *Parades &
Changes*, New York, 1967.

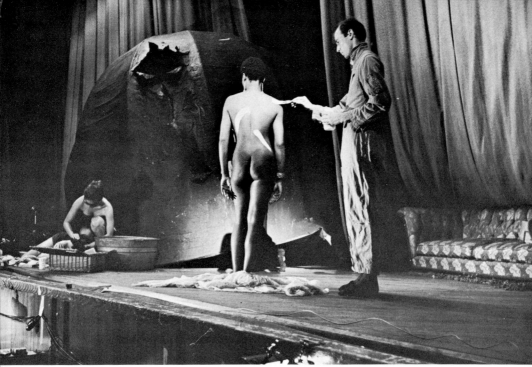

Ken Dewey (right), *Without and Within*, 1965.

Robert Whitman, *Prune. Flat.*, 1965.

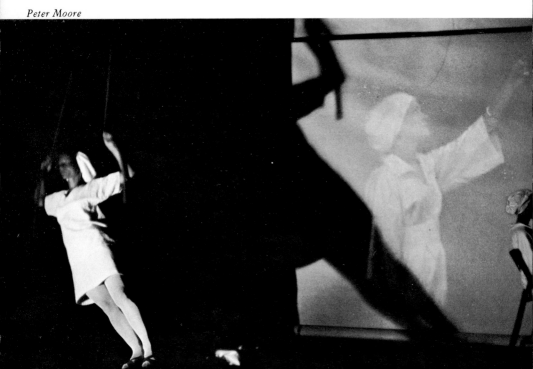

USCO, trademark. From left to right around centerpiece: Michael Callahan, Steve Der Key, and Gerd Stern.

THE BROTHERHOOD OF LIGHT

THE UNOBSTRUCTED UNIVERSE

Guidance counselling navigation and control

is our business

Ann Halprin, Automobile Event, Dancers' Workshop of San Francisco.

*Rudy Bender*

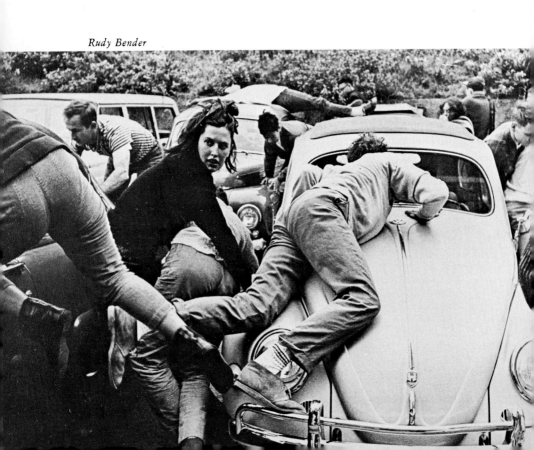

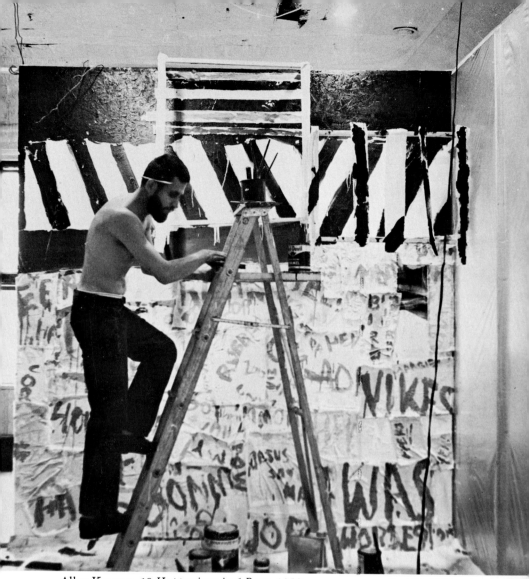

Allan Kaprow, *18 Happenings in 6 Parts*, 1958.

Fred W. McDarrah

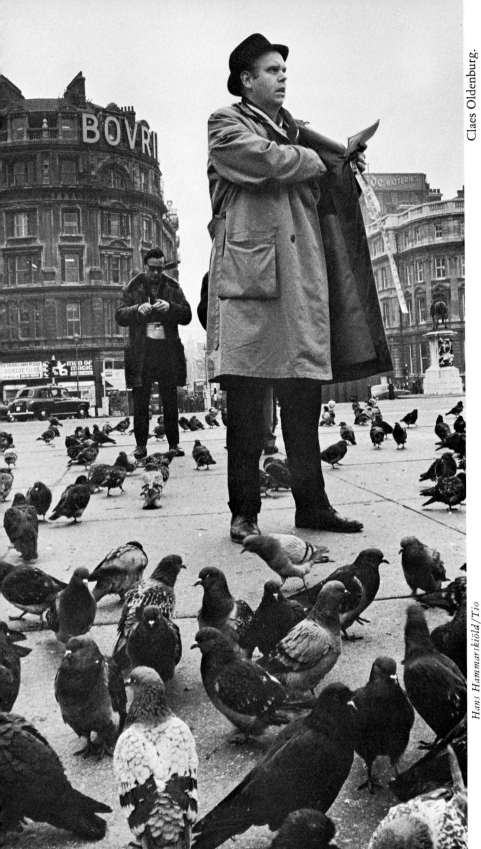

Claes Oldenburg.

Hans Hammarskjöld/Tio

with *The Gift*, the thing that bothered me most was its inflexibility. It was as open as we could make it—it could adjust, but it was still taking a play into the street, whereas what was incredibly fascinating was the street itself. With *City Scale*, we made the break and composed with the street. My purpose was to deal with the city in these terms— to make familiar places unfamiliar, to take the audience to places with which they weren't familiar. We took a familiar bank there, for instance, and projected blue color on the side of it, to introduce surprises into a stable situation.

KOSTELANETZ — How long a piece was this?

DEWEY — It started around eight-thirty or nine o'clock and went until three or four the next morning.

KOSTELANETZ — With this piece, you established a genre within which you have since worked.

DEWEY — The next time I got back to it was the *Helsinki Street Piece*, which I did with Terry Riley, in 1963.

KOSTELANETZ — Let me go to your famous Edinburgh piece, *In Memory of Big Ed* [1963], which I would call a staged happening in that it had a partially fixed script and closed space, even though it stimulated a lot of unplanned activities within that space. How did the piece come to you?

DEWEY — I was asked to do a demonstration at the Conference. Everyone agreed that we couldn't talk about happenings on the last day of the Conference, which was devoted to "theatre of the future," because nobody had seen one. So the organizers—Kenneth Tynan and John Calder—asked Kaprow and me to do happenings so that everybody could then talk about what we did.

KOSTELANETZ — Where did the piece's title come from?

DEWEY — The hall we used was part of the University. When the assemblagist Mark Boyle and the playwright Tom Lewsen and I started exploring this hall, we came across a whole collection of phrenologist's head studies. In the middle of this big hall was a head of David, as in David and Goliath; the statue was about three feet tall. On the bottom somebody had written in lipstick, "Big Ed." For the happening, we arranged to lower this head from the roof by rope so that he would be looking in the window just behind the speaker's stand. In rehearsal, the rope slipped, and most of Ed landed in the courtyard; so we entitled the piece in memory of the statue. Of course,

the title then fit with Edinburgh and with the notion of the Conference as a memory of the old theatre.

KOSTELANETZ — Didn't it open with Charles Marowitz parodying the Conference by proposing that the audience vote on a definitive interpretation of the symbolism of *Waiting for Godot*?

DEWEY — Charles wrote that. What we wanted was something that would little by little become more absurd; we worked out of the form of a conference into our kind of piece.

One thing you must remember is the scale of the space. It is a tremendously large hall, with a great dome at the top and three large balconies. It was filled with fifteen hundred to two thousand people. A number of the elements in the piece were intended to distract from the primary focus which had been on the podium. We had people come to the windows of the place and an electrician with a pipe walk along a ledge way above the audience. From down at the bottom it looked about six inches wide; actually, it was a few feet. We were cueing this by remote control. The Conference had a simultaneous translation system with four or five different channels; and since they were using only three of them, we used the fourth channel for communications in our piece.

Charles's bit broke up the logic of the Conference. We broke up the tone or sound-structure of the Conference by introducing low notes on the organ in the hall; then, these tapes came on, which first contained noises that sounded like they came from outside, and later contained voices of the participants. Then, we started breaking up the activities by having Carroll Baker, who was sitting on the podium, take off her coat, begin a staring dance with Allan Kaprow in the back of the audience, and then crawl right through the audience on the tops of the seats. She looked very beautiful in her long gold pants, stretched out across three or four rows. She met Allan in the middle, and they just went out.

We were gradually stacking up elements; so that each new one added to those already going on. By the time we finished, we had eight elements operating at once.

KOSTELANETZ — Were you attempting to satirize the Conference?

DEWEY — If satire is based upon exaggeration, you could say we did satirize. I was rather attempting to pull things out of their context and

reintroduce them in another context, so that people could respond to them.

KOSTELANETZ — This kind of purpose presumes a great deal of selection; and in constructing the tape you played, for instance, you chose certain words rather than others.

DEWEY — What I did was scramble passages, and then I took all the "uhs" and "ahs" of the Conference, many of them from my own contributions, and made them into a piece that was almost musical.

KOSTELANETZ — What was your purpose in that sequence with the nude girl going across a choir loft over the speaker's stand?

DEWEY — I don't know. It just seemed the right thing to do at that point.

KOSTELANETZ — If you couldn't have used a nude girl, what might you have done instead that would have been equally right?

DEWEY — I don't know. Since then, I came across a speech by a South African novelist named Laurens Van Der Post on "Intellect, Intuition and the Race Question." He was talking about the gap that exists between the consciousness of civilized man and that of certain tribes in Africa. He had seen the Edinburgh happening, which he described as an example of a primitive form of communication. He saw that the forms were movements and sounds, as opposed to words. As for the nude, he said that the artist has always used the female figure to represent his soul—he cited Dante and Beatrice; so the nude had been introduced to show where the soul was at, at that Conference—it whisked by, overhead. I wasn't plotting any of that, but in retrospect his interpretation held up so well that, when we introduced his speech at the girl's subsequent trial, we won the case.

KOSTELANETZ — Haven't you also done kinetic environments which have a closed space and an open time, so that certain actions are continually repeated?

DEWEY — It's curious, but I found that I've crossed into other areas. Where Allan Kaprow, say, came from painting and environments into theatre, I came from theatre, we met at happenings, and then I went from them into environments. The kinetic environment is really the most recent area that I've worked in.

In *Breathing Piece Lund*, which I did for a university in southern Sweden, there was a section in which we programed the entrance to

the hall as a recollection of all the other entrances they had made to this assembly hall. It became a kinetic environment which was an introduction to the piece. I did another piece like that in Chicago for a production of *Misanthrope*. We found that the theatre's building, an ultra-modern law school, was all wrong for the play; so there was a problem of transition—of getting people in the mood for a play which was out of their time. I've often used techniques to collect people. I'm particularly aware, since I am susceptible to it myself, that most of us are in three or four places at one time. I may be doing something, while my mind is someplace else and I may be emotionally involved with another thing. To overcome this, a musical comedy hits you with a strong overture that presumably gets you into involvement with the theatre. The problem in Chicago, given the play, was collecting people into the seventeenth century.

I'd heard of Jerzy Grotowski's work in Poland, where he costumes the audience and deals with classics in an unusual fashion; so I suggested that we program the corridors leading into the play in such a way that they prepared the people for the play. In the nearby art institute, I selected a number of engravings of the period and made slides of them. Then, we made little clocks, where I selected slides from the early part of the seventeenth century and then worked up to 1666, when the scenes in the play take place. The arrangement showed how the engravings changed from being very realistic and earthy, until they became more precise, rarefied, and distilled. Then, to create a Frenchman's view of the world, we projected a parade of flags; and from the red, white, and blue bunting of the American flag we progressively made a transition into the tricolor. They were like Burma Shave signs; so that each one was a little bit different from the one before. The eagle on the top of the flags progressively starts to fold up its wings until it becomes a *fleur-de-lis*. Then we had music on three tape-loops, each of which created a pool of seventeenth-century music; so when you walked through, you would hear them one after the other.

First of all, people were so surprised when they walked into the corridors, to find the slides here and the music there. Also, we had changed the color of the lights in the halls. By the time they got into the theatre and saw the set, they were really keyed up. They could expect anything. In theory and in practice, the environment worked

as a bridge into the place. This got me into the idea of programing spaces in order to accomplish certain things.

KOSTELANETZ — How have you been able to direct plays in languages other than in English? How do you develop a feeling for the text?

DEWEY — This gets back to that earlier point—the play really isn't in the words but underneath it. What I would do, again and again, was sit down with the playwright, the actors, anybody else I could find, and just go over the play until I understood what was underneath. Obviously, it was clear to the cast that they had to control themselves with regard to specific meanings. You would be amazed how much is communicated in the gesture and the tone of people's voices.

KOSTELANETZ — However, in foreign cultures, not only is the language of words different but the language of gestures is often also different. For instance, two men talking with their faces a foot apart means something quite different in America than it does in Italy.

DEWEY — In these different situations I get immediately involved in understanding that language of gesture. It may not be useful for ordering lunch but it is good for communicating feelings. You can learn to read what feelings are being communicated—it's a study of vibrations. I find that if I really need to understand these vibrations, I get them. Not knowing the language becomes an advantage, because the words aren't in the way. When we talk together, we are compelled to maintain our primary focus upon the meaning of words; but when you are freed of that, as children free themselves all the time, you stop listening to what a person says and get involved with how they are saying it. What happens is that the meaning inevitably takes care of itself.

KOSTELANETZ — Unlike most of the people included in this book, you have worked extensively abroad. How would you characterize the major differences between European and American mixed-means theatre?

DEWEY — There are problems and advantages on both sides. One of the advantages abroad is extremely strong response to almost everything that is done; and an artist at work there can count on really penetrating criticism by people who relate to a performance in depth. Here that just isn't the case yet. For instance, the major papers, with-

KEN DEWEY — 177

out shame seemingly, send critics, if they send anyone at all, who have absolutely no background in this field and are not prepared to push themselves to find out what really goes on and what it really means. Very often, highly exploratory pieces may hit their aim in only one of two fragmentary elements; and the artist himself may not realize what has worked and what hasn't. If the critic's response to the piece is a generalized one, these successful dimensions will be missed.

KOSTELANETZ — The crushing paradox is that although America has thriving avant-garde art, it has a small avant-garde audience and practically no avant-garde press; in Europe, today, the proportions for art and press are almost reversed. There, the cultural audience considers the avant-garde as an integral phenomenon.

DEWEY — The disadvantage abroad is that all experimental activity is overshadowed by this Dada heritage of destroying in order to rebuild. Therefore, in Europe there is a terrific concern with sequence. People continually ask if this threatens to supplant that. Will this piece overtake that? Is this better than that? They love evaluative judgments.

KOSTELANETZ — In relation to abstractions, such as who embraces history now?

DEWEY — Right. Who's king, who's threatening the king, and who was king. This tends to inhibit the relationship that the audience can take to the experience before them. In America, there doesn't seem so much preoccupation with whether one piece will bury another.

KOSTELANETZ — The scene here, like American politics, is more pluralistic.

DEWEY — On the other hand, abroad you have more opportunity to function as an artist. Within a given year I made a film for Swedish National Television, worked in the traditional theatre, did a piece in a major museum, lectured at a couple of universities, and did happenings both indoors and out; and no one there saw any inconsistency in such variety. I wasn't bagged as a "happenings-person" or forced into another specialization. Here I have such a reputation for happenings that I'm lucky if I get to work in the legitimate theatre again. I haven't directed a play since I returned here in 1965.

KOSTELANETZ — Would you like to do so?

DEWEY — Sure. Actually, I'm going to help in the staging of an opera this year [early 1967].

KOSTELANETZ — How, in general, are the European mixed-means pieces different in character from American work?

DEWEY — It is hard to decide who has done what in this whole area. Certainly the European Dada artists initiated a lot of new theatre; but my judgment is that they did not commit themselves to it. Instead, they were pitting the mixed-means form against previous art—more interested in attacking painting and sculpture than in taking off from it; so they never really gave it the independence of being a separate form. In America, when Allan Kaprow says, "It's not painting or sculpture but something different," he is giving the form an independent identity.

KOSTELANETZ — Have you been influenced by European theatre?

DEWEY — One of the things that has preoccupied me has been the confluence in our time of Artaud and Brecht. Brecht called for the capacity to emotionally disassociate yourself from what you were seeing, or being involved in, so that you could intellectually reflect upon it. Artaud called for an emotional impact that would all but make it impossible to do that. On one side is Brecht with his thoughts; on the other, Artaud with his feelings. Right now, we have a theatre emerging which is really trying to do both—to set up a situation in which people can reflect if they want to think about it or be involved with it totally if they want to engage their emotions.

I've also wanted, for instance, to know whether or not it is possible to achieve something similar to the so-called psychedelic experience without chemicals—to push your concentration so that you get into a situation of compounded awareness or provoked imagination.

KOSTELANETZ — You have employed all four of the genres I've identified in new theatre. What factors determine why you use one genre and not another?

DEWEY — To some extent, the factors include the materials, the situation and the people involved; however, I notice the distinct progression out of plays into other forms of composition, as well as the almost methodical exposure to time, space, and motion, focusing upon them successively. Then, there is another progression from sculpture into architecture and from architecture into landscape architecture; and from an involvement with the static aspects of a building to an interest in the kinesthetic ones. These things happen seemingly without direction; but there is a logic prevailing underneath all of this; so

far I've been putting together the missing pieces of what I feel is necessary for a theatre in our time.

KOSTELANETZ — Is this kind of theatre better for our time than conventional theatre?

DEWEY — I have a very strong feeling that each society or social group abstracts its values through its art; and a society does not cohere until it has accomplished that. I feel that in America today we have yet to achieve an appropriate theatre.

KOSTELANETZ — What kind of relation do you see between values in society and values in the mixed-means theatre?

DEWEY — A quality common to both is a pragmatic attitude toward forms and materials. Our theatre will bring exposure to new phenomena. It will insist on dispelling or dismissing materials which are no longer useful. For instance, one genre that I would like to do is the departure piece. To make it easier to dispose of buildings that no longer serve a function, I would do a public funeral, which would permit them to be torn down gracefully. I like the continuity of recognitions—both arrivals and departures. I think that if a society is functioning effectively it can assimilate new things and dismiss others without trying to sneak them out the back door. I think there is a need for some continuity, because our roots lie in the past; on the other hand, you don't want to restrict your movement today. The most desirable attitude is the organic one that recognizes the inevitability of birth and death. There is no reason why you shouldn't take, say, the Metropolitan Opera House and do an event or a series of events which would sum up what that building had meant to the city and America. Then, if everyone feels there is sufficient reason to tear it down, so it should go.

KOSTELANETZ — Would you want to burn down every theatre on Broadway?

DEWEY — No, that's part of the problem. True, the Broadway theatres have in many ways become unworkable; that's why they fall away to become parking lots and other things. Before they are all gone, it would be interesting to get in there and do performances to explore whether or not these things should be saved—how they could be made workable. That is, I would figure out what these theatres are supposed to do as spaces and what people are trying to do with them and what it is that they could do.

KOSTELANETZ — Do you consider yourself part of a theatrical tradition?

DEWEY — Yes, by this time I do, now that I've recognized my continuity within theatre. I feel, first, related to this juncture where Brecht and Artaud come together. Going further back, I feel related to medieval times more than Shakespeare or Restoration. I feel more closely related to the primitive than the Greek or Roman. The primitive and medieval periods are root times. I have a theory that Greek theatre had its roots in primitive dance and that the chorus maintains in a complete way the kinaesthetic contact between the purpose of a primitive ritual and the people who play it. I understand that in a Greek performance the chorus, by exaggeratedly reacting to what takes place on the stage, sets up a response for the audience; in this sense, the chorus forms a tangible bridge, like cheerleaders in a football game. This relationship is broken in the Roman theatre, which drew a line across the middle of the circle. My theory is that Shakespearean theatre had its roots in medieval theatre, particularly the mobile theatre that set itself up in the village square or on the church square. The Shakespearean theatre is constructed as the street folded in; so that you have nobility in the box looking out and the poor people in the pit. In Shakespearean theatre, the pit becomes the Greek chorus—if the action onstage held their attention, their favorable responses would galvanize the other people. I think that right now we are in a transitional time, back in something corresponding to the primitive or medieval periods; and what we are doing now will in the future produce a theatre yet to arrive. Anthropomorphically, I'm inclined to regard Greek theatre as the childhood and the Shakespearean and Renaissance theatre as the narcissistic adolescent period. Right now, we are turning the corner to an adulthood in which all these pieces will be put back together.

KOSTELANETZ — How does the fact that your original training was in theatre distinguish you from others in the mixed-means movement?

DEWEY — First of all, I've developed in an opposite direction. Whereas I've done environments just recently, most of the others started in environments and went into working with people. Second, most of them don't have my commitment to collaboration. The painters and sculptors come from an individual image-art; so they ask people to come in and participate with them. Bob Whitman will

tell performers his image and then instruct their movements. Now, theatre has been a collective form from the beginning; and to stabilize various interests, it seeks out a common denominator; and then somebody gradually assumes leadership in a situation.

Theatre forms a community in the way that society forms a community and the organization that theatre creates is, as I said, appropriate to its society. If the society has a king, then in the theatre a dictatorial form will arise. I am particularly concerned with defining the theatre form for a democracy; and in answering the question of how to apply its ideals to theatre, I've been very much involved with collaboration and the distribution of responsibility.

KOSTELANETZ — What kind of audiences do you prefer?

DEWEY — Obivously I'm attracted to the idea of the broadest possible audience—of reaching people not accustomed to theatre, who are not of the elite to which theatre has currently tended to appeal. As I like a homogeneity in my company—to get together with people of diverse backgrounds—so I prefer the same diversity in the audience.

KOSTELANETZ — Do you make critical evaluations of your own work; and if so, what criteria do you use?

DEWEY — More than that, you must ask whether or not a rapport has been created between the materials of the piece and the situation in which it existed, between the performers and the people who came to join it. Now, rapport is not just a relationship of benign happiness; it could be very aggressive, or even delayed. It must have enough impact, so that contact of some kind takes place. The root of the theatrical experience is, in addition to the integration of the elements involved, the bringing together of people for the purpose of articulating a mutual concern.

# 8

My own feeling is
that if people aren't carried away to heaven
I'm failing.

## —La Monte Young

In less than a decade, La Monte Young has established himself as one of the most imaginative young composers in America by offering a succession of pieces which, while valid extensions of certain current practices, were absolutely novel. In 1960, at Berkeley, he presented a composition which consisted of turning loose a jar full of butterflies (they made a sound, however inaudible); the score of Composition 1960 #7 consists of an open-fifth chord (B and F♯) followed by the hand-written instructions: "To be held for a long time." At a New York concert, some years later, he set fire to a violin; another time he performed a suggestive abstract design by Toshi Ichiyanagi by counting a bag-full of beans. Many of these early pieces are collected in *An Anthology* (1963), which he edited. In 1964, Young publicly initiated *The Tortoise, His Dreams and Journeys*, a mixed-means theatrical piece which is currently the only work he performs; with new sections introduced on each of many occasions, it is among the most admired works in the new theatre.

Young was born in a log cabin in 1935, in Bern, Idaho, where his father herded sheep; he lived in Idaho until the age of four, in Los

Angeles through the sixth grade, in Utah through junior-high school, and then his family settled permanently in the Los Angeles area. He attended John Marshall High School, Los Angeles City College, Los Angeles State College, and the University of California at Los Angeles, where he majored in music and received his B.A. in 1958. Throughout his youth, Young studied the saxophone, which he calls "my instrument of virtuosity," and he later studied composition with Leonard Stein (once an assistant to Arnold Schoenberg), as well as attended Karlheinz Stockhausen's seminar at Darmstadt in the summer of 1959. After graduating from U.C.L.A., he studied at Berkeley under a Woodrow Wilson Fellowship and served for two semesters as a Teaching Assistant in the Music Department. In 1960, he won the Alfred Hertz Memorial Traveling Scholarship, which took him to New York where he studied electronic music with Richard Maxfield; and he has lived there ever since. In 1966, he received grants from both the Foundation for Contemporary Performance Arts and the John Simon Guggenheim Memorial Foundation.

Although Young's earliest work as a serious composer was in the Schoenberg twelve-tone tradition, his use of sustained notes, sparse textures, and the exclusion of certain combinations of pitches suggested directions he has since pursued. His interest in classical Indian and Japanese Gagaku music, combined with his exposure to the work of Karlheinz Stockhausen, Richard Maxfield, and John Cage helped produce even more radical changes. Following his return from Darmstadt where he "discovered" Cage, he created numerous audacious performances which demonstrated the effects of his "discovery," and his work since has been increasingly original and idiosyncratic. In *The Tortoise, His Dreams and Journeys*, Young and three associates chant an open chord of intrinsically infinite duration, amplified to the threshold of aural pain. Public performances usually consist of two sessions, each nearly two hours in length, within a darkened room illuminated only by projections of pattern-art. Although music is the predominant force, the entire setting induces a multi-sensory involvement, and as the piece's time is open and its space is closed, I classify it as a kinetic environment.

Young is a small and slender man, strong in physique, who speaks with a decidedly far-western accent. He possesses the ability to talk

forever, in a tone at once passionate and professional, and he likes to laugh at his cleverness. He carries himself in an eccentric and commanding manner similar to that of his music. Disdainful of worldly realities, he once subscribed to a twenty-seven-hour day around the clock—eight for work, eight for play, eleven for sleeping—a regime that meshed with the rest of the world only a fraction of the time. He insists that other people who perform his work must pay in inverse proportion to a piece's length—three hundred dollars for seven minutes, twenty-five dollars for twenty-four hours.

Young lives with his wife, Marian Zazeela (a painter noted for her objectivist contemplative patterns, such as those used in the *Tortoise* piece), in a large loft filled with desks, boxes, tape and electronic apparatus. Here, his group, The Theatre of Eternal Music, rehearses every night for at least a month before a performance. Its membership consists of Young, Marian, Tony Conrad, Terry Riley, and, at different times, John Cale, Angus MacLise, Terry Jennings, and Dennis Johnson. Married in 1963, the Youngs share such common enthusiasms as turtle-keeping, yogurt-making, Far and Middle Eastern cooking, and organic vitamins. During the interview, conducted on a hot summer night in 1966, they often spoke simultaneously.

KOSTELANETZ — What was your first instrument?

YOUNG — The very first I ever played was the harmonica; however, at the age of two, this was soon followed by singing and guitar lessons from my Aunt Norma, who sang in the local high-school operettas. The songs I learned to sing at that time were cowboy songs.

KOSTELANETZ — Did you learn to read music then?

YOUNG — No, I did not learn to read music until I was seven. During that period, around the age of three, I also had tap-dancing lessons, and I developed a tap-dancing routine which was among my earlier stage experiences. I had also played my grandparents' piano a little bit and looked through the sheet music of cowboy songs that they had there, but I didn't have lessons in reading music at that time. When we moved to Los Angeles, my father one day brought home for me this old gray saxophone; he was my first saxophone teacher and he taught me to read music.

KOSTELANETZ — What do you consider your most important early experiences?

YOUNG — The very first sound that I recall hearing was the sound of the wind going through the chinks in the log cabin, and I've always considered this among my most important early experiences. It was very awesome and beautiful and mysterious; as I couldn't see it and didn't know what it was, I questioned my mother about it for long hours.

KOSTELANETZ — Do you remember this now?

YOUNG — Yes, quite vividly.

KOSTELANETZ — Were there any important high-school experiences?

YOUNG — The best thing about high school was the small intellectual community I fell into—artists, poets, philosophers, as well as other musicians. There was a boy, Gordo, who was the leader of the gangs in Toonerville at that time; but he was also a prize-winning trombonist of the Philharmonic and had already been on the road with Perez Prado's band. He came upon me one day practicing Charlie Parker's *Donna Lee* at a furious tempo and after that we often had jazz sessions together after school. In the first or second year of high school I began taking private saxophone lessons with William Green at the L.A. Conservatory. He is really a saxophonist's saxophonist, and put the finishing polish on my technique. I also enjoyed my high-school harmony classes. Otherwise, I did not like the social situation of high school. I thought it was fairly juvenile.

KOSTELANETZ — What would you rather have been doing?

YOUNG — Playing music all the time and associating with the people I liked. I didn't like being regimented. For instance, when I was chosen to play the saxophone solo at graduation I had to shave off my goatee and sideburns.

KOSTELANETZ — Where did you go to college?

YOUNG — I began at Los Angeles City College where I first studied with Leonard Stein, the pianist and theorist who was Schoenberg's assistant. I later studied counterpoint and composition privately with Stein. Then I went on to U.C.L.A., where the main influence upon my actual writing style was Dr. Robert Stevenson, with whom I studied both baroque and sixteenth-century counterpoint as well as keyboard harmony. Lukas Foss was very important in encouraging me to talk about my work at the various composers' symposia held at that time.

KOSTELANETZ — The earliest piece in your list of compositions is

dated 1955. Were you already a functioning composer at that time?

YOUNG — Oh yes. Of course, I had already started playing jazz in high school.

KOSTELANETZ — Professionally?

YOUNG — As professionally as I could play the kind that I was interested in playing. I never recorded, but I always went to the best and most exciting sessions at the clubs. When I got a few jobs at dances and so on, I used to hire all my friends, like Billy Higgins, Don Cherry, Dennis Budimir, and Tiger Echols. We rarely got hired back to those jobs, because we played jazz all night long. Billy and I had a group at Studio One, as it was called, downtown in L.A.

KOSTELANETZ — Are you still interested in jazz?

YOUNG — Only from a listening and speaking point of view.

KOSTELANETZ — Was it your original ambition to do something in jazz?

YOUNG — Yes, in high school, it was. The reason I discontinued my work in jazz was to progress into more serious composition. I found that I got into far-out areas that were not being appreciated except by a very small group. Most were complaining that my rhythmic style didn't out-and-out swing, because I used rhythmic configurations that weren't always right on the beat in the most obvious way. They confused the drummer. I was also interested in harmonic patterns that were beyond what the ordinary jazz musician was using. Jazz is a form, and I was interested in other forms.

KOSTELANETZ — Did you object to the repetitiousness that tends to plague even the best jazz?

YOUNG — No, that wasn't it. I'm very interested in repetition, which is why I prefer the style of John Coltrane or Indian music. I am wildly interested in repetition, because I think it demonstrates control.

KOSTELANETZ — However, there are different kinds of repetition— repetition because the musician can't do anything else, and repetition as a very objective strategy to produce a subjective effect. Your own recent music exemplifies the second kind.

You told me once before that at college you knew the late Eric Dolphy, the jazz saxophonist.

YOUNG — He was at L.A. City College at the same time, and his playing was an example of repetition used in yet another inventive way. While John Coltrane constructed modes or sets of fixed fre-

quencies upon which he performed endlessly beautiful permutations, Eric Dolphy had an incredible set of licks—melodic fragments—that he would repeat in the most various and happy combinations at any frequency transposition that sounded right to him at the time.

KOSTELANETZ — After you gave up your jazz career, what was your next step?

YOUNG — While I was at City College, studying with Leonard Stein, I became quite interested in the work of Anton Webern. In fact, to this day his work stands out among my influences as one of the most important examples of clarity, which is a value of great interest to me.

KOSTELANETZ — What kind of clarity—his uncompromising precision in the use and extension of serial principles?

YOUNG — I think the clarity in every dimension of his work may be unprecedented in Western music. Schoenberg used row technique in a far more naive way—it was not as strictly, in an audible way, related to the musical result, as it is in the work of Webern. In Schoenberg's music, theme and content are separated from row technique, whereas in Webern row technique is very strictly coordinated with thematic and motivic materials.

Some of my favorite Schoenberg pieces are the Five Pieces for Orchestra, Opus 16, and of particular interest to me among these are the second, *Yesteryears*, and the third, *The Changing Chord—Summer Morning by a Lake—Colors*, which is a very static piece with extraordinarily subtle and delicate changes. It goes on and on with mirage-like motifs disappearing and reappearing over recurrent droning textures that are among the most gorgeous in orchestral sound. The *Summer Morning by a Lake* piece interests me because it involves stasis in contrast to climax.

I feel that in most music peculiar to the Western hemisphere since the thirteenth century, climax and directionality have been among the most important guiding factors, whereas music before that time, from the chants through organum and Machaut, used stasis as a point of structure a little bit more the way certain Eastern musical systems have. In *Summer Morning by a Lake*, as I say, stasis is used, although it wasn't as much in Schoenberg's other work. In Webern, however, stasis was very important, because not only was he involved with row technique but he also developed a technique for the repetition of pitches at the same octave placements throughout a section of a movement.

That is, each time C, A, or E♭ comes back in the section of the movement, it is at the same octave placement. So, as you hear the movement through, you find this static concept of a small number of large chords reappearing throughout the entire movement.

KOSTELANETZ — Were you interested more in this static dimension than the serial language?

YOUNG — I was interested in both elements; for even though we can define serial technique as constant variation, we can also redefine it as stasis, because it uses the same form throughout the length of the piece.

KOSTELANETZ — How can the row be a static element if its manipulations are so various?

YOUNG — We have the same information repeated over and over and over again, in strictly permuted transpositions and forms, which recalls the thirteenth-century use of *cantus firmus*. The theme-and-variations technique depends as much upon the static repetition of the theme as upon its variations.

KOSTELANETZ — Of course, the theme or information of the piece is the row, which informs all the structures of notes; however, as the row is manipulated, we hear the row in continually different ways.

YOUNG — The "continually different ways" are so precisely related to the "original" form of the row that any one of the permutations is simply an aspect of the basic shape of the row which includes all of the permutations. Schoenberg based row technique on the belief that these "continually different ways" were related in such a way that they could be the unifying structure of a composition.

KOSTELANETZ — What you are saying, then, is that as the row informs every aspect in a controlling fashion, a serial piece therefore acquires, as information, an ultimately static quality.

YOUNG — Also, I might point out that I was predisposed to the twelve-tone technique, because my high-school harmony teacher had studied at U.C.L.A. with Schoenberg. Beginning in 1956 I enjoyed writing with serial technique for about three years, but by 1957–58 I was beginning to discover reasons for moving beyond the twelve-tone system. I felt that it was by no means the final word as far as structure is concerned. There are so many forms that structure can take, and so many structures that form can take—so many possible forms in art. In my Octet for Brass [1957], I began to introduce,

within the serial style, very long notes. In the middle section, there were notes sustained easily for three or four minutes, where nothing else would happen except other occasional long notes overlapping in time, and there would be rests for a minute or, at any rate, a few beats, and then another long note or chord would come in. This technique became more refined and perfected in the Trio for Strings [1958] which has pitches of longer duration and greater emphasis on harmony to the exclusion of almost any semblance of what had been generally known as melody. The permutations of serial technique imply possibilities of ordinal organization only. Ordinal organization applies to line or melody, whereas the increasing emphasis on concurrent frequencies or harmony in my work implied the possibility of the organization of the cardinal values both in regard to how many frequencies are concurrent and the relationships of the frequencies to each other.

KOSTELANETZ — Do you still listen to serial music?

YOUNG — If I happen to hear it. When I did work in it I listened to some pieces over a hundred times; nothing else would be going through my head. Now I listen to it if a composer brings a piece by or sends one to me. But otherwise I spend almost all my time working on my own music, as I have found other organizing factors which I feel are more interesting and pertinent to it.

KOSTELANETZ — How are these factors more interesting?

YOUNG — The longer notes make harmonic analysis by ear a reality and these integral relationships soon sound much more beautiful and harmonious and correct than their irrational equal-tempered approximations.

KOSTELANETZ — What else initiated your turning away from serial composition?

YOUNG — In the late fifties I had more opportunities to hear Indian classical and Japanese Gagaku music, partly because of the outstanding ethnomusic department at U.C.L.A., which had its own student Gagaku orchestra and Japanese instructors, and partly because of that famous early recording by Ali Akbar Khân and the late Chatur Lal of Râgas *Sind Bhairavi* and *Piloo* which essentially introduced the longest example then available of masterfully played Indian music. I literally flew to the record store when I first heard it on the radio.

I was also hearing recordings of plain chant and organum, and while at Berkeley I had the privilege of visiting a nearby Dominican monastery where I heard the monks sing plain chant. That was a beautiful experience. These examples of modal music, and particularly the systems of harmonic frequencies required by the continuous frequency drone of Indian music and the sustained harmonics of the *sho* in Gagaku, seemed to move me much more deeply than anything else I was hearing.

In contemporary European music after Webern, the work of Karlheinz Stockhausen had made a very powerful impression on me. In the summer of 1959 I traveled to the Darmstadt Festival for New Music to take his composition seminar. On my way there from Berkeley I met Richard Maxfield in New York, and heard his new electronic music for magnetic tape. I liked it so much that a year later I took his class in electronic music at the New School for Social Research.

In the seminar at Darmstadt, Stockhausen devoted much time to his own work in sound, and to the work of John Cage. The events at the festival also provided my first exposure to John Cage's lectures and the concert presentation of the recording of the David Tudor performance of the Concert for Piano and Orchestra played on an impressive sound system. After this sequence of refreshing experiences, meeting composers and hearing new work, I returned to Berkeley even more inspired to further explore extensions of the ideas related to the sustained frequencies I had presented in my Trio for Strings. The relevance of this work as a synthesis of particular Eastern and Western musical systems and a new point of departure for my work had become strikingly clear to me, and the cumulative effects of all of my exposures to music were at this point providing enough information that I began to think of serial technique as only one of many possible methods applicable to music composition.

KOSTELANETZ — Why had you not been exposed to John Cage's ideas previously?

YOUNG — In those days, there was no Cage on the West Coast, except on records. Dennis Johnson had played the recording of the Sonatas and Interludes for Prepared Piano for me maybe once, and Terry Jennings had a record of the String Quartet which we used to listen to, but I had to go to Europe to really discover Cage. When I got back

to Berkeley and started to perform Cage, everybody there still considered him an out-and-out charlatan. I really had to fight to get him on programs.

KOSTELANETZ — What were your purposes in the pieces of your second year at Berkeley, the compositions of 1960, written after your encounter with Cage?

YOUNG — I was on my way to Mount Tamalpais, the biggest mountain in the Marin County area, and I started thinking about the butterfly. Alone, it made a very beautiful piece. Being very young, I could still take something so highly poetic and use it without the fear I would have now—that it would be trampled on. Now, I would offer something quite a bit more substantial than a butterfly or a fire— something that can't be so easily walked on. After all, a butterfly is only a butterfly. No matter how much I write about the fact that a butterfly does make a sound—that it is potentially a composition— anyone that wants to can say, "Well, it's only a butterfly."

KOSTELANETZ — Your point, then, in bringing into the concert situation a jar of butterflies and then releasing them, was that a butterfly makes a sound.

YOUNG — True. Another important point was that a person should listen to what he ordinarily just looks at, or look at things he would ordinarily just hear. In the fire piece, I definitely considered the sounds, although a fire is, to me, one of the outstanding visual images. I'm very fascinated by the form of fires, as I am fascinated by the form of the wind. In fact, during my entire Berkeley period, I was constantly talking to people about the form of the wind and the form of fires. Also, I was talking at that time about the sound of telephone poles, and I liked to quote these words from Debussy:

> Listen to the words of no man,
> Listen only to the sound of the winds and the waves of the sea.

I feel, in fact, that Debussy is among my most important influences.

KOSTELANETZ — What else were you doing at that time?

YOUNG — Some of the other important pieces involved the audience. Those grew out of a performance of *Vision* [1959], which I wrote immediately after my return from Darmstadt and the exposure to chance music and so on. I took thirteen minutes of time and organized that period with eleven sounds, the longest of which was over four

minutes. During the first performance, the audience carried on at such a rate of speed—at such a level—simply because I turned out the lights for the duration of the performance and they were involved with these weird sounds coming from strange spacings. In that period, I was really intrigued with the audience as a social situation.

KOSTELANETZ — Were the sounds in *Vision* constant in pitch and amplitude?

YOUNG — No. However, textures and methods of performance were sometimes constant. The sounds were complex and changing. There was, for instance, a sound we called "Herd of Elephants" which was made by two or three bassoons playing a series of notes up in the falsetto range of the instrument at a rapid rate of speed. That would go on for the specified duration of a few minutes or less. These sounds were ancestors of the wild sounds—natural sounds, abstract sounds, interesting material juxtapositions such as metal on glass, metal on metal—that I later worked with extensively in 1959–60 when Terry Riley and I were doing the music for Ann Halprin. Terry and I started making incredible sounds; they were very long and very live, and we'd really go inside of them, because they filled up the entire room of the studio. However, we were working with very irrational timbres.

KOSTELANETZ — Were any of these sounds tape loops?

YOUNG — No, it was all live. I've released very few tape pieces for public performance. I did record and preserve three of the sounds from that period, two of which I have released as the tape composition 2 Sounds [1960], which Merce Cunningham uses in his *Winterbranch*.

KOSTELANETZ — In *Vision*, were your musicians all in one place?

YOUNG — No, I had grouped them around the audience—up in the balcony, in the aisles, and all over the place. I never saw an audience carry on that way, except at some of my subsequent performances at which they sang *The Star Spangled Banner* and stood up and swore.

KOSTELANETZ — Did you mind this?

YOUNG — Well, at that time I felt it was the best they were capable of. I didn't see what I could do about it, although I was quite upset that they did not sit and listen. I just hoped that in the future they would. Finally, now I think they do listen, as when Merce does the piece. Here's the difference: With Merce they are also given something

to watch. I've noticed that a much greater part of the world is visually oriented and more capable of concentrating on visual stimuli than aural. Only a small percentage have learned how to concentrate on sound.

Some of the pieces of this period, then, were specifically related to the social situation. In one, someone announced the duration and told the audience that the lights would be out for the entire composition and that was all. Sure enough, plenty of people tore up their programs, and a few made other noises. Everybody thought I had programed these events into the composition but I hadn't.

KOSTELANETZ — So it was, as a silent piece, very much like John Cage's *4' 33''*.

YOUNG — They are related, except that in John's you have a classic setting in which one sits at the piano and turns the pages for each movement—going through the motions of a classical form. In my piece, I just announced a block of time, which may be of any length. In the original manuscript, I said that, "When the lights are turned back on, the announcer may tell the audience that their activities have been the composition." This is not at all necessary, and I have never done it in that form.

KOSTELANETZ — Are these theatre pieces or music pieces?

YOUNG — Both categories apply. I divide my works into music pieces, and musical-theatre pieces. All my pieces, I feel, deal with music, even the butterflies and the fire. In every case, I was writing them as musical compositions to be played at musical performances. In fact, a certain amount of their impact relates to the fact that they are performed in a classical concert situation. Although there is no question but that my exposure to John Cage's work had an immediate impact on aspects of my Fall, 1959, and 1960 work, such as the use of random digits as a method for determining the inception and termination of the sounds in *Vision* and *Poem for Chairs, Tables, and Benches, Etc., or Other Sound Sources* [1960] and the presentation of what traditionally would have been considered a non- or semi-musical event in a classical concert setting, I felt that I was taking these ideas a step further. Since most of his pieces up to that time, like the early Futurist and Dadaist concerts and events which I became aware of shortly after my exposure to John's work, were generally realized as a complex of programed sounds and activities over a prolonged period of time with

events coming and going, I was perhaps the first to concentrate on and delimit the work to be a single event or object in these less traditionally musical areas. This was a direct development of my application of the technique in my earlier, more strictly sound, compositions.

KOSTELANETZ — At this point, too, you developed that composition where you instruct the performer to hold an open fifth "for a long time."

YOUNG — Another related to it was Composition 1960 #9 . . .

KOSTELANETZ — . . . which you published as a straight line on a three-by-five file card.

YOUNG — I have performed this work at one sustained pitch.

KOSTELANETZ — What is your purpose here?

YOUNG — This leads us from the old area of the Octet for Brass and the Trio for Strings, where I had sustained pitches in the context of other pitches, into the new area. I noticed about 1956 that I really seemed more interested in listening to chords than in listening to melodies. In other words, I was more interested in concurrency or simultaneity than in sequence.

KOSTELANETZ — That was your radical step.

YOUNG — Yes, that separated me from the rest of the world. I was really interested not only in a single note, but in chords, while other musical systems have placed great emphasis on melody and line or sequence.

KOSTELANETZ — Because the wind is a single note or chord.

YOUNG — The wind is a constant sound, the frequency of which at any given time is dependent on its surroundings or location, and therefore not always constant. Sometimes the frequency was fairly constant, during blizzards as the wind blew through the chinks in the log cabin, although even at those times the sound was characterized by that kind of increase and decrease in frequency with which we all associate the sound of a wind storm as the gusts would become stronger and then weaker. I really enjoyed it. I found it fantastic. It sounded great coming in like that—very calm, very peaceful, very meditative. During my childhood there were four different sound experiences of constant frequency that have influenced my musical ideas and development: the sounds of insects; the sounds of telephone poles and motors; sounds produced by steam escaping from such as my mother's tea-kettle or train whistles; and resonation from the

natural characteristics of particular geographic areas such as valleys, lakes, and plains. Actually, the first sustained single note at a constant pitch, without a beginning or end, that I heard as a child that did not have a beginning or ending was the sound of telephone poles—the hum of the wires. This was a very important auditory influence upon the sparse sustained style of work of the genre of the Trio for Strings and Composition 1960 #7 (B and F♯ "To be held for a long time").

KOSTELANETZ — At this time, did you go back and listen to telephone poles?

YOUNG — I did—and to this day, I'm also very fond of power plants. For instance, the step-down transformer up there on the telephone pole probably contributes to the hum. As the power hits intermediary stages, it has to go through transformations, and hums of various frequencies are generated. A great deal of electronics and machinery seems to generate series of partials. The partials of many of these series are related to each other as positive integers, and what is interesting is that the partials in the series produced by strings and pipes are also related in this way. When my refrigerator goes on again, or if I happen to turn on my little turtle motor, I can sing a few of the earlier harmonics for you.

KOSTELANETZ — So, you observed that nature is full of constant sounds?

YOUNG — Actually, aside from the sound of groups of insects and natural geographic resonators, sounds of constant frequency are not easily found in nature before mechanization and electronics.

KOSTELANETZ — What about a waterfall?

YOUNG — That's pretty constant. If it's a large waterfall, it's a pretty noisy sound, similar to white noise. It is very full—it has so many frequencies in it that one tends to hear it as a complex of sounds. Theoretically, white noise has every frequency within a given band, although a particular waterfall may or may not have all of these.

One place where we find a constant sound that has been with us for a few thousand years is the drone used in certain musical systems, such as those of India, Scotland, and Spain. The constant sound is also in organum, a form that grew out of chant, used in the ninth-century Catholic Church; in one style of organum various pitches were sustained, and a melody woven over them. After the first plain chant (which was just melody alone and very static, as I hear it and

analyze it), the next stage was parallel fifths and fourths. After that, a musician started holding one of these notes for a long time, while another one moved around over it.

KOSTELANETZ — Once you observed this tradition, did you want to recreate it?

YOUNG — I wanted to do more of it, because I felt there was all too little around. It made me feel very good to hear it, so I really wanted to hear a lot of it. In fact, my ideal is to have a number of machines playing a constant sound around the house.

KOSTELANETZ — You spoke once of "trying to get inside a sound." How does this process work?

YOUNG — There are several ways you can approach it. One is that someone concentrates so heavily upon a given sound—he gives himself over to it to such a degree—that what's happening is the sound. Even though I could be sitting here, all I am is an element of the sound. Another approach is to walk into an area in which the sound is so abundant that you actually are in a physical sound environment. This happens when someone walks into one of my concerts.

KOSTELANETZ — It's the same thing as walking into a noisy generator room.

YOUNG — Yes, it depends upon the level. If it were high enough, you could be enveloped.

KOSTELANETZ — Is this a valuable process?

YOUNG — I find that it does things to me unlike anything else.

KOSTELANETZ — If you walk into Grand Central Station, you're also enveloped by sound, but it consists of a different, dissonant quality.

YOUNG — The difference in which sound you would want to be enveloped depends upon whether you are John Cage or La Monte Young.

The harmonically related frequencies I'm interested in have so much to do with the way we hear and the way so many sounds are structured. These common characteristics reinforce each other. Alain Danielou points out in an article on sound in the *Psychedelic Review* #7 that he feels the mental mechanism permits us to analyze and recognize only those musical intervals which are harmonically related. This is an area in which I plan to do more work—what happens after the information carried by the sound passes the reception stage at the ear. It is highly likely, as I hear it, that what makes me like this sound

is more than just the way the ear receives information; the brain finds this kind of information congenial.

KOSTELANETZ — Let me go back to that earlier point. Why do you prefer the constant sound of the generator to the sound of Grand Central Station that Cage has always treasured so much?

YOUNG — I think it has more to do with how human beings have related to sound from history on end. Not only do the ears receive information this way, but the vocal chords are strings. The sound with which we are most familiar, the voice, is structured according to these principles.

KOSTELANETZ — So, in retrospect, we may trace two long-standing preoccupations that are reflected in your present work—the *Tortoise* piece—one was creating a social situation or environment in which all kinds of elements were used, another was the interest in the constant sound.

YOUNG — My recent work has led me away from the twelve-note equal-tempered system, which is necessarily a compromise of music and musical structure, if we are going to consider how sound is organized and how the ear hears. The twelve-note system divides the octave into twelve equal-tempered intervals, equidistant pitches. The interval between each consecutive frequency is an equal irrational proportion. An accepted standard allots one hundred cents to the distance between each consecutive semitone; so there are twelve hundred cents to the octave.

If we take the major scale, which is the Ur-scale, or scale of origin for many musical systems, we find that this scale is most rationally and musically represented in the octave 24 to 48 in the overtone series. The overtone series—the system of partials arising within a given sound—is one basic aspect of the area of music I'm involved with today. If we assume a fundamental, which can be a random note of any pitch, and subject it to the analysis which twentieth-century electronic instrumentation allows us, we find that most sounds consist of more than one frequency. These many other pitches are partials, also known as harmonics or overtones. In many sounds these partials exist in whole-number relationship to the fundamental. The frequencies of these partials relate to each other as integers. For example, if we have the fundamental one, which we will call the first partial, the

wave pattern of the second partial completes two cycles to each cycle of the fundamental.

KOSTELANETZ — Which is to say, the second partial has twice as many frequencies as the original; it is the octave.

YOUNG — Right. These partials exist in the frequency ratios of 2:1, 3:2, 3:1, 4:3, 4:2, 4:1, 5:4, 5:3, 5:2, and so on.

We distinguish the timbre, or characteristic sound, of one instrument from another by which overtones are present, which ones are louder and softer, and their phase relationships.

If we take the major scale as represented in the octave 24 to 48, the scale of frequency proportions is 24, 27, 30, 32, 36, 40, 48. Many cultures have been hearing and playing this scale. The twelve-note system of equal-temperament was a simplification developed to approximate the integral relationships found in the major scale, but since none of the adjacent rational intervals in the harmonic series (by which the major scale is represented) are equal, we are confronted with a compromise.

KOSTELANETZ — What kind of relationships does the serial scale have then—24, 26, 28, etc.?

YOUNG — No, it's just a division of the octave, the ratio of two to one, into twelve equal irrational fractions or intervals, each of which is separated from the other by an interval designated as the twelfth root of two over one ($\sqrt[12]{2/1}$) which, when written as a proportion, is an infinite non-repeating decimal, approximately 1.0594631/1. An array of composers, theoreticians, and scientists have been aware of, or written about, the problems of twelve-note equal-temperament; Helmholtz, Alain Danielou, Harry Partch. Lou Harrison, Narendra Kumar Bose, and C. Subrahmanya Ayyar are just a few of the investigators in the field. Some have recommended a division of the octave into the larger number of 53 equal-tempered intervals which allows a smallest interval that is very nearly the same size as 81/80 for the basic unit, and a lesser compromise for limited musical systems composed only of intervals expressible as powers of this smallest unit interval, whereas others have accepted no compromises whatsoever. But with our present system of tuning the piano, the only intervals that are rationally in tune are the octaves. None of the other intervals are harmonically in tune. If you play these other intervals for a long

time at a loud enough volume, there is no problem hearing how un-harmonious they sound. In practice most of the time, however, they are underemphasized and rushed over. To compare some harmonic and inharmonic intervals, just listen to any piano quintet, any piano concerto with orchestra, any choral work in which the piano is out part of the time. Whenever the piano is not around, instrumentalists tend to play in tune with exact harmonic proportions. This is called "just intonation." There are two factors which lead musicians to do this if their instruments do not have equal-tempered limitations.

The first factor is that the frequencies of the harmonic components of the timbres of the classical instruments of the string and pipe families are defined by the multiplication operation. This means that these frequencies will all be integral multiples of the fundamental and that the performer, who is near the instrument is hearing these in-tegral harmonic relationships or being influenced by them whenever the instrument is sounding.

The second factor is that the ear's characteristics as a non-linear receptor and transmitter of sound also include this operation of multi-plication, as well as the operations of addition, and subtraction, in that it generates its own harmonics at integral multiples of the funda-mental even when presented with sine waves which have no harmonic content, and sum and difference combination frequencies when at least two frequencies are present, if in each case the information is presented at a loud enough volume. It is a characteristic of the opera-tions of multiplication, addition, and subtraction that as long as they are performed on integers they will always produce integers, and these of course will correspond to the integral structure of the har-monic components of the instrumental timbre.

KOSTELANETZ — Would I be able to hear this difference between harmonic and dissonant intervals?

YOUNG — If I put one against the other, you'd have no problem. The rational intervals sound beautiful and harmonic, as when the best string quartet plays a Beethoven quartet. The twelve-note system, in contrast, sounds like the piano that comes in out of tune in a Brahms concerto after the orchestra has been playing for so long. When Peter Yates gives his lecture on tuning, he'll play first an equal-tempered example and then one in just-intonation; an equal-tempered and then a Pythagorean; an equal-tempered and then one in mean-tone

tuning. I find it myself quite easy to hear the difference, as I think the audience does. On the simplest level, all you have to hear is whether or not it sounds like what we conventional people have always called harmonized, in-tune, beautiful, rather than just grinding and gratey.

KOSTELANETZ — What you are saying, then, is that nature sounds in "just intonation."

YOUNG — This is an example of a harmonic system that occurs naturally in the world of sound.

KOSTELANETZ — Aren't there some cultures that don't use this harmony?

YOUNG — Some cultures have very interesting different systems. In the music of Java, for instance, we know about *pelok* and *salendro*, which are scales of irrational intervals. The seven-note, heptatonic scale is also used in Cambodia. There is evidence for another kind of harmonic hearing, however, when we consider the fact that in Java they use plates and bells as resonating bodies. Plates and bells have irrational harmonic systems, whereas here and in Europe, as well as in India, China, and Japan, we use strings and pipes as our primary resonating bodies, and as the bases for determining the frequencies of our musical system.

One factor that shapes the use of the system of just-intonation and what the audience hears at my concerts is amplification. It happens that the audibility of harmonics can be a function of amplification—the louder a sound is, the more likely you are to hear the harmonics that sound makes, which is to say that they increase as the amplitude goes higher. At ordinary volumes they are so soft that you don't even hear most of the higher partials. In fact, if you listen closely to my singing voice without amplification, you will hear perhaps up to three. With amplification, the seventh harmonic in my voice and often the ninth harmonic in Marian's voice become clear and audible for everyone. That's only one reason we play the *Tortoise* piece so loud.

An important step in the history of just-intonation is the use of relationships that are multiples of integers greater than the number 5. That is, the entire major scale can be derived from proportions which are multiples of the integers 2, 3, and 5 only by themselves. Let me reduce the proportions: 27/24 is a 9/8 interval; 30/27 is 10/9; 32/30 is 16/15; 36/32 is 9/8; 40/36 is 10/9; 45/40 is 9/8;

48/45 is 16/15. There are only three kinds of consecutive intervals, each of which reduces to factors of 2, 3, and 5: 9 is 3 times 3; 8 is 2 times 2 times 2; 10 is 2 times 5; 16 is 2 times 2 times 2 times 2; 15 is 3 times 5. The music of South India forms an important basis of the theoretical work I have done. Not only do they use the number 7 but they also employ the numbers 11, 13, and simple multiples of these and, perhaps most important, these intervals are considered harmonically over the drone rather than only melodically. I refer to the book by the Indian theorist and violinist, C. Subrahmanya Ayyar, *The Grammar of South Indian (or Karnatic) Music*.

KOSTELANETZ — What does this give you?

YOUNG — An expanded vocabulary. It means that you are using pitch relationships which are not available in the Western system by any means, because of the fact that this system uses numbers only up to five.

KOSTELANETZ — How are you able to hear them, or even create them?

YOUNG — Very easily. That has a great deal to do with my work in long durations and the fact that I'm interested in harmony, not melody.

KOSTELANETZ — Some of your first pieces in New York were more or less theatrical events, such as counting the string beans.

YOUNG — I did that at my first performance of Toshi Ichiyanagi's *Mudai Number One*, during a series of concerts at Yoko Ono's loft that I directed. He had given me the score, which has been published since in my *Anthology*. It is an abstract pattern—a few calligraphic brush strokes on a white field—which give the impression of a half-dozen images. It is very sparse, very pretty—a few inkdrops, John Cage style, or, more appropriately, in the style of the Zen abstract calligraphers. This was given to me with no instructions, and *Mudai* means untitled. I had been thinking about the piece up to the moment of the concert, and I really hadn't come up with anything that was appropriate. Finally, when I passed a vegetable stand on the way to the concert, I decided I would buy thirty cents' worth of string beans. When I got there, I counted them. Most people who mention it never point out that I timed the counting with a stopwatch, so that I would find out how long it took me.

KOSTELANETZ — How long did it take you?

YOUNG — I forget.

KOSTELANETZ — Did you write it down?

YOUNG — I'm not even sure about that.

KOSTELANETZ — What good then did it do to time it?

YOUNG — The timing interested me then.

KOSTELANETZ — Was that "music"?

YOUNG — I think so. There was a score, and certainly it involved a duration of time, an element with which music has always been involved. Certainly, picking the pods out of the bag made a little rustle here and there. People were sitting and listening, and I was definitely performing. According to the definitions that I had exposed in my earlier 1960 pieces, I'd say it was certainly music.

KOSTELANETZ — Music being anything that makes a sound. Is anything not "music"?

YOUNG — There probably are very still things that do not make any sound. "Music" might also be defined as anything one listens to.

KOSTELANETZ — What happened in the piece where you burned a violin?

YOUNG — That was in a piece by Richard Maxfield performed at the Y.M.H.A. in New York. Even though it was Richard's piece, he gave me free rein, as he did in all his pieces; and this was one of the general conditions I often asked for my performance of the works of other composers and artists during that period. The piece was his Concert Suite from *Dromenon*, I believe. It involved a small orchestra, most of whom had far more rigid instructions than I did. I had my violin and my music stand, and I had carefully stuffed the violin with matches and lighter fluid ahead of time. I didn't tell anybody except Richard, who I thought should know, because I felt certain that they would not allow me to do it. Fortunately, they did not stop the performance; the instruments were playing, while the violin went blazing away.

KOSTELANETZ — Was this a theatre piece?

YOUNG — Both theatre and music. The definition of theatre can be expanded in much the same way we expanded the definition of music, and in many cases the two areas overlap.

KOSTELANETZ — Do you consider yourself the author of the visual element?

YOUNG — In this piece, yes. Particularly so, perhaps, because I was

performing an aspect of my Composition 1960 #2, which calls for a performer to build a fire where the audience can see it. Here the emphasis was displaced from the fire alone to the violin as combustible fuel for the fire.

KOSTELANETZ — Where does the piece in which you drew a line for an entire evening belong in your development?

YOUNG — As we have observed, I have been interested in the study of a singular event, in terms of both pitch and other kinds of sensory situations. I felt that a line was one of the more sparse, singular expressions of oneness, although it is certainly not the final expression. Somebody might choose a point. However, the line was interesting because it was continuous—it existed in time. A line is a potential of existing time. In graphs and scores one designates time as one dimension. Nonetheless, the actual drawing of the line did involve time, and it did involve a singular event—"Draw a straight line and follow it."

In 1961, I became more and more interested in the idea of this sort of singular event, and I decided to polish off my entire output for 1961 in a singular manner. My book, *LY 1961*, published by Fluxus, reads Composition 1961 #1 (January 1), "Draw a straight line and follow it"; Composition 1961 #2 (January 14), "Draw a straight line and follow it"; Composition 1961 #3 (January 27), "Draw a straight line and follow it."

KOSTELANETZ — Did you do that same piece on all those nights?

YOUNG — No, what I did was this. On January 6, 1961, I determined the concept. Then I took a yearly average of the number of pieces I had completed over a given period of time, and spaced that number equally throughout 1961, with one composition on the first day of the year, and one on the last day. It came out to one every thirteen days, and that night I quite coldly wrote out the dates.

KOSTELANETZ — Were they the 1960 pieces written over and over again?

YOUNG — It was Composition 1960 #10 written over and over again. What is also important historically is that I performed all of them in March, long before many of them had ever been written according to their dates of composition. I think that was interesting.

KOSTELANETZ — How did you actually perform it?

YOUNG — Well, it can be performed in many ways. At that time, I employed a style in which we used plumb lines. I sighted with them, and then drew along the floor with chalk.

KOSTELANETZ — As you were performing, did you announce each piece—to separate one from the other?

YOUNG — No, I distributed programs in which each one was listed, and it was up to the audience to keep track of which one I was doing.

KOSTELANETZ — Did you erase each line after you drew it?

YOUNG — No, I didn't erase. I drew over the same line each time, and each time it invariably came out differently. The technique I was using at the time was not good enough.

KOSTELANETZ — Did you fix duration at the commencement of the piece?

YOUNG — No.

KOSTELANETZ — How, then, did you decide to terminate it?

YOUNG — After I had completed the last line, which was Composition 1961 #29 (December 31).

KOSTELANETZ — How long did it take to draw each line?

YOUNG — It must have been a few minutes—I forget exactly; but a whole performance must have taken a few hours.

KOSTELANETZ — Weren't there times when nobody was in the audience—you and your assistant were performing merely for yourselves?

YOUNG — That's very possible. People came and went and came back again.

KOSTELANETZ — Would you call this a successful piece?

YOUNG — I did enjoy it very much, because I like becoming involved in a singular event.

KOSTELANETZ — Is your desire to concentrate upon one thing influenced by Eastern philosophy?

YOUNG — It's both an influence and a parallel, because at the time I started to do this I was becoming aware of various concepts of mysticism. I've been interested in Taoism since the time I became acquainted with it, which was about the same time I began to become aware of these areas of my experience. I had already started reading *haiku* in high school, for instance.

KOSTELANETZ — What other steps did you take before the *Tortoise* piece?

YOUNG — There is the "dream chord," which I used to hear in the telephone poles, which is the basis for the Trio for Strings. It is, for instance, G, C, C-sharp, D.

KOSTELANETZ — Which is one to four, to four-sharp to five.

YOUNG — Let's think of it in the key of C, in which case it is five, to one, to two-flat or one-sharp, to two. The entire work, *The Second Dream of the High-Tension Line Step-Down Transformer* (1962), which Lukas Foss's group from Buffalo played at Carnegie Recital Hall in January, 1965, consists of this chord. It is one of the few pieces of the genre notated in frequency ratios that I have released in score form. In the most primitive form, I think of the ratios as 12, 16, 17, 18, which represent the intervals for G, C, C-sharp, D. However, in the version I gave them, I suggested 24, 32, 35, 36, because I was interested in the smaller interval of 35/36, which I felt was a ratio I may have been hearing all along.

This then leads us to the fact that in the *Tortoise* we have an incredibly large vocabulary of pitches available to us, each of which is related by very simple mathematical proportions.

KOSTELANETZ — This increase occurs basically because, whereas your ratios are fixed, your pitches aren't.

YOUNG — You mean, whereas the ratios are fixed, the number of notes is infinite. I haven't taken a count; but just glancing over at Tony Conrad's chart on the wall here, I can see, roughly, in *O*-tonalities we have used about twenty-seven frequencies to the octave, which is more than double the number used in the twelve-note system. Of course, there is no limit upon the number we can eventually squeeze into an octave, because we don't necessarily hear them as one coming after another, filling up an octave. We hear them as various relationships to a pitch we have established very clearly in our ears and minds. We approach each new pitch, which then provides another identification point in an octave, from some very simply established interval. That is, every new pitch very simply relates to the previous point of departure. Let's say that we begin with one, which will be the fundamental; and let's say that we put a drone sound on one.

KOSTELANETZ — Can one be arbitrarily established?

YOUNG — It can be any frequency. Given a fundamental, which we call one, only the frequencies thereafter must be precisely derived—

must be in precise relationship to the fundamental. In theory, however, these other pitches can exist at any frequency.

KOSTELANETZ — Therefore, as soon as you establish a fundamental pitch, you thereby also establish, metaphorically, a row of possibilities for the entire piece.

YOUNG — If we establish a fundamental frequency represented by the number one, all of the other frequencies considered for use are related to this fundamental as positive integers, exactly as established in the overtone series of strings, pipes, and certain electronic instruments. From one we proceed to two, which is twice as great a frequency, or twice as many impulses per unit of time; this is perceived by the ear as what we call an octave.

KOSTELANETZ — Can the human ear hear an octave of notes which are not duplicable on a piano?

YOUNG — Yes, the octave consists of frequencies in the relationship of two to one, and it doesn't matter where the one is.

Then in going up to three we have the simple relationships of three to two and three to one. If we call the fundamental one C, then two is C an octave higher, and three is G a perfect fifth above two. Four, a C, is a perfect fourth above three; five is a major third above four; six is the octave above three, or two times three. Then, with seven, we introduce a new frequency which is not a factor of the C-major scale, and consequently has no name in the European classical system. It is not the same B-flat found on the piano, but lower, some 31. odd cents lower, or 231. odd cents below eight, which is two to the third power ($2^3$) or C again. Nine is three times three, and is a major second above eight, of the type represented by the interval between D and C in a C-major scale; it is called a major tone in just-intonation. Ten is two times five, and is a major second above nine of the type represented by the interval between E and D in a C-major scale; it is called a minor tone in just-intonation. Eleven is another new frequency that is not a factor of the C-major scale as it would fall between F and F-sharp; it is approximately 150 cents below twelve, which is three times two to the second power ($3 \times 2^2$), or two octaves above our first G. Thirteen, like seven and eleven, is not a factor of the C-major scale, as it would fall between A-flat and A at 138. odd cents above G, and 128. odd cents below fourteen, which

is two times seven. Fifteen is five times three, or B a major third above G. Sixteen is two to the fourth power ($2^4$) or C. Seventeen is very close to the equal-tempered C-sharp on the piano. We can go on infinitely in one dimension with these numbers.

KOSTELANETZ — Won't you go out of the range of hearing?

YOUNG — How quickly we go out of the range of hearing depends upon where we start, but we will eventually go out of the range of hearing. Theoretically, you can still plot where all these other notes are; this is demonstrated in Alain Danielou's book *Tableau Comparatif des Intervalles Musicaux*.

KOSTELANETZ — Haven't we always been conscious of these harmonic relationships?

YOUNG — I do think that certain instrumentalists and singers have. These pitches are available to the singer and the violin player, because the latter has no frets to predetermine his frequencies. He doesn't have to put his finger down on either five or six, because he can play any of the points between. That's one of the reasons I stopped playing saxophone and began singing. The blues singer does use flat sevens, which are real seventh harmonics, occasionally. I referred to the use of harmonic intervals in South Indian music earlier. Also, many reputable Western classical musicians play their major thirds beautifully in tune, whereas on the piano they are, as I said, very seriously out of tune. If you sustain these on a piano or particularly on an equal-tempered organ, they sound terrible.

One of the structural bases I have established for the *Tortoise* is that the most frequently used numbers are one, two, three, and seven, and certain other prime numbers, and multiples of these numbers by two, three, and seven, and the chosen primes. By the mathematical processes I have outlined, then, we get to a larger number like 63, and we can have a relationship of 63 to 64. 63 is a very interesting pitch; it is just below 64 by 27.27 cents, which is a very small interval, just a little larger than an eighth of a tone. 64 is the fifth power of two, and 63 is achieved in several ways: as nine times seven, and as three times 21.

KOSTELANETZ — Is this an *a priori* system?

YOUNG — No, I determined all of this by ear, before I decided I would use certain numbers. In fact, I always work by ear first, and later, by number, I analyze what I've done. Of course, as I become

more sophisticated about what I'm doing, I start plotting and making devious schemes and plans.

KOSTELANETZ — In sum, then, how do the musical elements of the *Tortoise* piece function?

YOUNG — In advance, we determine which frequencies we are going to use and which combinations of frequencies we are going to allow. At this point enters the only element of improvisation in the work we are doing right now.

KOSTELANETZ — How do your musicians divide the task?

YOUNG — In the past, we were using one viola, one violin, and two voices. The violist, John Cale, used a flat bridge that he had especially designed to allow three strings to be bowed simultaneously. Tony Conrad used double-stop technique on the violin, giving us five pitches. Each of the voices, of course, can sing only one note at a time; in sum, we had seven frequencies. Right now, The Theatre of Eternal Music consists of three voices—Terry Riley, Marian, and myself. Tony has two pitches, which makes five. We now use an audio-frequency generator at one pitch (210 Hertz *), and a turtle motor, which also has a pitch. Again we have seven. The motor is now the primary drone at 120 Hertz, which is twice the 60 Hertz we get off the house current.

KOSTELANETZ — Do you make the turtle motor the fundamental, or one?

YOUNG — These days, we are interpreting the drone as three, or the dominant, and playing in the mode of the dominant much of the time, and occasionally modulating back to the real fundamental.

KOSTELANETZ — What you have then, in the metaphor of the Western scale, are the notes C and G playing constantly.

YOUNG — If we call the fundamental, one C, then the notes you are referring to are G and D in the dominant, or six and nine. In the most recent concert you heard [the Midsummer concert in Amagansett, N.Y.] the only pitch that was being sustained at all times during the music was six, played by the motor. Other pitches were used as drones above the G in addition to D, but no one of them was sounding at all times.

KOSTELANETZ — What is the turtle motor?

YOUNG — It's just a little tiny vibrator which is used to run an

* Cycles per second.

aquarium filter. I started using this motor because it was conveniently around the house and I knew it sounded pretty good as a constant frequency source.

KOSTELANETZ — What do the rest of the people do?

YOUNG — They play frequencies in agreed-upon combinations.

KOSTELANETZ — Such as?

YOUNG — Eight, seven, six, four.

KOSTELANETZ — In relation to one, by the system we outlined before.

YOUNG — Right. If we happen to play it over the drone three and transpose it . . .

KOSTELANETZ — How do you transpose?

YOUNG — Very easily. It's just by multiplying by the number of the key or frequency to which we wish to transpose. If we've already established that the turtle motor sings on three, I can either sustain this chord, for instance, by going eight, seven, six, four, while the turtle motor is a drone on three. Or, if we modulate temporarily to the key of three, which is to say the key of the dominant, we can have the same complex at 24, 21, 18, 12.

KOSTELANETZ — If you arbitrarily decide to make the turtle motor not one but three, then you can use these arrangements of multiples. What does that sound like?

YOUNG — In this case it sounds like a modulation to the dominant.

KOSTELANETZ — On the piano, the equivalent is the shift from a C-chord to a G-chord.

YOUNG — Or, on the piano, the equivalent of going from C, G, (B-flat), C, to G, D, (F), G—from a C-seventh chord with no third to a G-seventh chord with no third.

If we have already determined in advance the frequencies that we are going to use and we allow only certain frequency combinations—certain chords which we have determined are harmonious to our ears —then we find that as soon as one or two people have started playing, the choices left are greatly reduced and limited; so that each performer must be extremely responsible. He must know exactly what everyone else is playing; he must hear at all times every other frequency that is being played and know what it is. This is the assumption on which we perform. That's why we rehearse every day.

KOSTELANETZ — In what terms do you hear so exactly?

YOUNG — Familiar frequency-pitch-interval relationships.

KOSTELANETZ — If you sang a note now and I sang a note in relation to yours, you could tell at once the frequency relationship.

YOUNG — Yes. That's what I've spent my life learning to do. Even though Marian had no previous musical training, in the last year she has learned to hear and sing two new pitches, giving her a total of three pitches.

KOSTELANETZ — That makes Marian basically a drone voice, while you, Terry, and Tony shift tones.

YOUNG — Right. We move quite a bit. In our present format, the turtle motor and the generator are constant, and Marian is fairly constant in that she moves around only in three notes. We've given her a little ostinato that, over a long period of time, she goes over and over again.

KOSTELANETZ — In terms of timbre, what kinds of sounds do you make?

YOUNG — We make throat tones and nose tones.

KOSTELANETZ — The latter is a kind of humming.

YOUNG — Well, nose tones are humming, but they become more interesting when you use a microphone. You can direct a more concise and, consequently, louder stream of air at the microphone, because the air comes from a smaller enclosure than a throat tone. However, you get a different timbre, because whereas the throat tone resonates harmonics, the nose tones are much closer to a simple wave structure that has less harmonics. When you use the mouth, you have a resonating chamber which, like that of violins and guitars, can emphasize a tone. For instance, we've developed a technique through which we can emphasize the seventh harmonic by using a certain syllable, "uh."

KOSTELANETZ — When I hear the *Tortoise* piece, the timbre of the sound continually changes, and I notice that certain timbral textures seem to go and return. Is this because one voice is dominant?

YOUNG — One voice or another might predominate at different times. Basically, we are interested in the blend, as we are working with timbre at many levels. The whole complex is a form of timbre, from its definition, which is various emphases of phase relationships, number, and amplitude of the different harmonics. Not only do we have individual timbres, but we also have a cumulative timbre, which cor-

responds to the component partials of an assumed lowest fundamental frequency one.

KOSTELANETZ — Then you send out the blend at an extremely loud amplitude, almost at the pitch of aural pain.

YOUNG — It's getting up there. To me it is not painful, but to a newcomer it often is. This is a threshold of sensitivity that is developed. One learns, I believe, to hear loud sounds without feeling pain. I don't think that I have lost much hearing over the past few years. When I worked with Ann Halprin and heard loud sounds from close up, I often did not regain my normal hearing until a few hours later. Currently, I don't get that effect. I find that I can still hear up to 17,500 Hertz, which is probably as high as I've ever been able to hear. Although I have no way of proving that I can hear something very soft as easily as I used to be able to, my assumption is that my ears are not deteriorating.

There are two very important reasons for my interest in sounds at levels of 120 and 130 decibels. One, we know from studies of the Fletcher-Munson curve that the ear does not hear bass at lower amplitude as loudly in proportion to treble. In other words, if we take a given sound situation that has basses and highs and middle-range tones and it's not too loud, the ear really doesn't perceive all the bass that is there. It can't pick it up as easily. We find, however, that at louder amplitudes the ear hears bass more in proportion to the way it is actually being produced. This gives you a fuller chord. Secondly, combination-tones, particularly difference-tones, are more audible. The least frequent, or lowest of these at frequencies below 15 Hertz, are called beats and can be very valuable in helping the musician tune intervals to a very fine tolerance, and they only become audible at the loudest levels.

KOSTELANETZ — The louder the volume is, the more difference-tones you can hear.

YOUNG — And the greater the intonation-precision potential, as well as the richer the complex.

KOSTELANETZ — What do these difference-tones sound like?

YOUNG — Well, they add these tubas, trombones, double basses, and cellos that, you notice, we don't have in the group but whose sounds are apparent on the speakers.

KOSTELANETZ — How would you characterize the result I hear?

YOUNG — By the time someone walks into our environment, the sound is extremely complex. We've got seven fundamentals going. This means a large number of combination-tones.

KOSTELANETZ — Why isn't there any dissonance?

YOUNG — Everything functions in whole-number relationships. There can never be any dissonance in this system, unless things get out of hand—somebody wavers, somebody misses his pitch, the machinery goes haywire. If one or another of the fundamentals are off pitch from the established drone, then the difference-tone will not appear in tune. Therefore, if you have two fundamentals, there is no way in the world to know, except by what your ear tells you, if they are in any particular ratio to each other; but if you have a third sound—a third point on your plumb line—then you can talk about a fixed series of ratios.

KOSTELANETZ — Thus, because the fundamental one is constant, if you deviate from the correct seventh, you can hear the difference-tone out of tune.

The sound I used to hear in your piece was absolutely unfluctuating —it wasn't interrupted by any beats or rhythms; but now that you've introduced the generator, there is a kind of beat.

YOUNG — One of the things happening now is that we get the piece going with such precise synchronization at such a high level, that we hear every little impulse more clearly, because we are really concentrating on them. When you get down into the bass range, these impulses are slowed down to such a rate of speed that one starts to hear them as rhythms. Once you get down to 30 Hertz, you can almost distinguish individual sounds; and by the time you get down to 10 Hertz, or three, you don't hear a constant pitch any longer but a rapid succession of pulses or rhythms, which are precisely related to the over-all complex. The other pulse situation comes from beats, which occur when you play closely related intervals. If the pitches are up high, the difference-tone will be so low that you will hear little pulses instead of a resonating tone. This relates rhythm to frequencies, because the frequencies are actually in positive integral relationship to the rhythms.

KOSTELANETZ — How do you use your electronic apparatus?

YOUNG — Much time and care have gone into the selection of what we feel is some of the best equipment available for our purposes.

Each of the performers' sounds is picked up with a microphone. The violin uses a magnetic pick-up which Tony has installed himself, and the voices use two Sennheiser MKH 405 and one PML EC 61 condensor microphones. These connect to custom mixing equipment which directs the information through the Marantz 7T stereo pre-amp and through the Futterman Model H, 100 watts RMS at 16 ohms per channel, power amplifier which drives four Argus-X Custom 450 speaker systems on one channel and six Leak Mark II Sandwich speaker systems on the other. We use a large number of speakers now because at the levels we are interested in, a lesser number will break down. Even so, we drive our speakers at peak power.

KOSTELANETZ — Why does *The Tortoise, His Dreams and Journeys* have a different title each time I hear it?

YOUNG — Each section has its own title, which is a way of characterizing one particular area of time, in which we are doing one kind of work, in the over-all duration of the piece. Although the piece may sound pretty much the same each time, each performance is basically quite different.

KOSTELANETZ — Recently, you've substituted Terry Riley's voice for John Cale's three-string drone and, after that, added the turtle motor and the generator. Aside from this change in instrumentation, how is the piece different?

YOUNG — It's partly timbral, partly a difference in the availability of other types of pitches. With generators and motors, I have the most sustained pitches I've had to date. Also, a third voice offers a less sustained pitch than John Cale could produce with a bow on his three-string drone. With two male voices, I can produce certain timbral blends impossible with one male and one female voice. Similarly, Tony Conrad on the violin doesn't have as much to relate to, now that John Cale has gone.

Also, at the Film-Makers' Cinematheque, in December of 1965, we were using 80 Hertz as a constant drone; at a recent concert, we put our primary drone on 120 Hertz, which put the concert in the mode of the dominant.

KOSTELANETZ — Why give each concert a different subtitle?

YOUNG — I feel that since each concert does represent work in different areas it is very important to have a method of categorizing each concert. A library likes to have a name or a number for some-

thing. This becomes a means for referring to an area of work I did at a particular time.

KOSTELANETZ — Do you expect to devote your whole life to this piece?

YOUNG — I suspect that I might easily, because it seems to become more and more inclusive. I'm trying to include many of the areas I'm interested in, and the steps from one area to another seem to be gradual, as I gradually leave one emphasis and move on to another.

KOSTELANETZ — Such as . . .

YOUNG — Now I've become more interested in controlling which harmonics are present at any given time. This is not easy to do with conventional instruments and voices, but I have developed a technique that allows me to emphasize, for instance, the seventh harmonic or the third harmonic, or, quite possibly, some other harmonics. With the use of electronic equipment, I should be able to set up situations in which I can have precisely, and only, the seventh harmonic or the ninth harmonic as they are required. In other words I'm really interested in a very precisely articulated situation—I always have been. I'm interested in the most clear and sparse sounds—in control and in knowing what I'm doing.

KOSTELANETZ — In traditional terms, how do you classify *The Tortoise, His Dreams and Journeys?*

YOUNG — Music and theatre. The music might dominate, but it does so in a theatrical situation.

KOSTELANETZ — What is the design you project on yourselves and the wall behind you?

MARIAN ZAZEELA — I designed it as a cut-out which, although it exists originally on cut paper, was intended to have light either behind it, or projected through it. Then the slides were made from the design. There are two patterns; one is a development of the other. They are both used in their negative and positive forms, and there is some variation within the negative form itself. The black-and-white patterns have been treated with colored theatrical gells. The colors are in ranges of either pink or green, as are the lights that project upon us. I have found that my interest in these particular colors has extended into my work in light, which is natural as they are two of the three primaries of the light media. In different superimpositions they produce or suggest nearly every other color.

The designs themselves are symmetrical, derived from calligraphic forms. Part of the projection falls upon us as we play and re-programs us, or actually re-costumes us visually into the larger pattern, which is intended as a mode for visual concentration—as votive image.

KOSTELANETZ — Objective elements intended to inspire subjective responses—this is a strategy aesthetically similar to your music.

YOUNG — The areas we are working with in light are the earlier stages of development toward directions that may relate to some of the things we're trying with the music. I feel there are parallels already. This concentration on the light images does not distract the mind from the music but rather gives the eyes something to rest on and become absorbed in, as the ears have the sound to become absorbed in.

KOSTELANETZ — What theatre tradition do you consider yourself in, if any?

YOUNG — Although my present work with The Theatre of Eternal Music is establishing a tradition of its own, just as did my earlier work in The Theatre of the Singular Event, it will be informative to consider some of the kinds of theatre I have been aware of over the years: Theatre as Ritual; Theatre as Ceremony; Theatre as Trance (such as Temiar Dream Music); Gagaku; Bugaku; Chinese Opera; Classical Indian Dancing; Indonesian Theatre; Total Awareness; Cage accepting as theatrical whatever occurs; Audience Participation; Dada; Futurism; Surrealism; Artaud; Total Theatre; Theatre as Environment. It is interesting to note that although the scope of the two periods, that of The Theatre of Eternal Music and that of The Theatre of the Singular Event appears divergent, they both relate to some of the same theatre traditions. For instance, *The Tortoise, His Dreams and Journeys* and my Compositions 1961 have some relation to Theatre as Ritual.

KOSTELANETZ — Do you like to work as theatre?

YOUNG — Yes, but I would prefer Dreamhouses or truly Eternal Theatres with a more permanent installation, which would allow us to perform in one location for longer periods—weeks, months, and hopefully, in time, years—without having to move on like traveling musicians to the next concert site. Constant moving about interrupts the continuity of the work and prevents the realization of its full potential as a living organism with a life and tradition of its own.

KOSTELANETZ — That remark about life and tradition applies to your audience as well. Why did you choose the title *The Tortoise, His Dreams and Journeys?*

YOUNG — "Tortoises have been tortoises for two hundred million years, which is 199 million years longer than people have been people." I refer you to a very nice book on turtles by Robert J. Church, which I'm very fond of not only because he treats the subject with love and precision, but also because each line of every caption is precisely centered under the picture. He points out that while other creatures over the years have been changing, tortoises and turtles remain essentially the same. I'm interested in this, because I'm interested in long durations. I'm interested in stasis, and in things that stay the same although they change in detail.

KOSTELANETZ — Are you perhaps developing a turtle aesthetic for human art?

YOUNG — I'm going in this direction because of my own natural tendencies. There still is considerable variation in the piece, because variation is such an unavoidable factor of life that nothing exists without it. No matter how exact you try to be, no matter how many times you try to draw the line exactly the same, things will always be different. This is one of the inherent characteristics of my work.

KOSTELANETZ — What kind of time does the *Tortoise* piece create?

YOUNG — Its own time, which is determined by and measured in terms of the frequencies we are sustaining.

KOSTELANETZ — Could someone find the *Tortoise* piece boring?

YOUNG — Somebody certainly could. I feel that the audience must be free to come and go as they choose. I do not like to impose limitations on people, but I am interested in organization and precision—in controlling a situation to a considerable degree.

KOSTELANETZ — Should the piece induce in the audience a particular psychological state?

YOUNG — The tradition of modal music has always been concerned with the repetition of limited groups of specific frequencies called modes throughout a single work and, as a rule, the assignation of a particular mood or psychological state to each of the modes. There is evidence that each time a particular frequency is repeated it is transmitted through the same parts of our auditory system. When these frequencies are continuous, as in my music, we can conceive even

more easily how, if part of our circuitry is performing the same operation continuously, this could be considered to be or to simulate a psychological state. My own feeling has always been that if people just aren't carried away to heaven I'm failing. They should be moved to strong spiritual feeling.

KOSTELANETZ — Does your theatre have a therapeutic value?

YOUNG — I suppose it could. People have said that they have come in depressed and left fantastically elated.

# 9

Forms, colors, densities, odors—what
is it in me that corresponds
with them?—Walt Whitman, *Leaves of Grass*

That's what I mean by plastic empathy;
you become involved
with the image.

## —Robert Whitman

In the summer of 1966, Robert Whitman's "Theatre Happenings"
ran off-Broadway for several weekends, and Whitman thus became
the first major creator of mixed-means theatre to allow his work to be
commercially produced. Like his previous pieces, *Prune. Flat.* [1965]
and the untitled work [1966] that accompanied it were eminently
painterly in Whitman's heightened concern with the evocativeness of
images and the textures of shapes and colors. In a theatrical art where
sloppiness is too often a failing, they also demonstrated the neat pre-
cision and realized complexity characteristic of Whitman's earlier
work.

Whitman was born in New York City in 1935. After graduating
from Rutgers University where he majored in English literature and
also studied art with Allan Kaprow, he registered for graduate work
in art history at Columbia, but never completed a degree. He had

one-man shows of his paintings and sculpture, and his work in these media are frequently included in group shows. He has since abandoned the creation of objects, not out of artistic principle but merely because his theatrical interests currently consume all his time..

Originally a member of the painter's wing of the mixed-means theatre, Whitman now thinks of himself primarily as a creator of theatre, having paid his dues, so to speak, with numerous works. *American Moon* (1960), which had ten performances at New York's Reuben Gallery, *Mouth* (1961), *Water* (1963), and *Flower* (1963) were among the more significant. *Prune. Flat.* drew not only larger audiences than his previous pieces but also a series of critical articles on his work—indeed, perhaps the first body of serious critical literature on an individual artist working in mixed-means theatre. Another 1966 piece, *Two Holes of Water*, was presented in different versions in a swamp near Sag Harbor, Long Island; in a small auditorium at the Fourth New York Film Festival; and in the 69th Regiment Armory, for the Theatre and Engineering Festival.

Whitman lives with his wife, Simone, in a smallish top-floor loft near Canal Street in New York City. On the hot summer day when I visited him, all sorts of materials were strewn around the working area of his studio, and he was experimenting with special filters and pliable plastic mirrors as supplements to his motion-picture camera. We talked over the kitchen table, just after lunch. Simone, a dancer of note and a performer in his pieces, moved in and out of the conversation.

Unlike most of his peers, Whitman resists offering precise definitions of either his work or his processes of creation. Because of this prejudice, he often seemed at odds with the purposes of the interview; however, his natural articulateness, as well as his serious commitment to his work, invariably overcame his resistance. Intense in demeanor and slightly self-conscious, Whitman speaks with enormously fluctuating speed, as though he wants to inform his listeners subliminally that his slow answers are more considered than his fast ones.

KOSTELANETZ — Why did you drop out of graduate school at Columbia?
WHITMAN — I just couldn't do it. I found myself too bored. I'd go there every morning and then go to the movies and then go home at

night. Going to graduate school was something I did because I hadn't made up my mind about where to go. I was doing my work, I was having a show. I had some vague notion that as artists don't make any money, they might get jobs teaching. That was my excuse. Really, I suppose it was marking time.

KOSTELANETZ — What were your early paintings like?

WHITMAN — I honestly don't know. I did a lot of different things— some drawings, some sculpture. I did a lot of things with scribble drawings. Not much of it is left; most of it was destroyed.

I had a show at the Hansa Gallery of sculpture and collage things, and I had a show at the Reuben Gallery of sculpture and some drawings. I was in a few group shows at the Martha Jackson that were kind of interesting. She had three of those—the two versions of "New Forms, New Media," and an environment show with Claes [Oldenburg] and Jimmy [Dine] and George Brecht and Allan [Kaprow].

KOSTELANETZ — Was your evolution as a painter, then, from drawings to collage to sculpture to environments?

WHITMAN — Well, a lot of the sculpture was sort of large, but that last term is really another one of those words.

KOSTELANETZ — Because it isn't a valid characterization of what it describes?

WHITMAN — It connotes a lot of stuff, a lot of other kinds of stuff. I can't tell you how difficult it is to talk about those things I did. It was a long time ago, and they're all gone. Thinking back, I don't know what I'd make of them if I saw them now.

KOSTELANETZ — Still, why do you object to that word "environment"?

WHITMAN — It connotes an awful lot more than sculpture. It has to do with where people live. I haven't heard of any people who live in their sculpture. "Environment" has to do with all kinds of sociological situations and laws and all that. A work can imply all those things; so that even a little work can be environmental, whatever that means.

KOSTELANETZ — I use it to describe a work that fills or surrounds a space with a multiplicity of communicating forces.

WHITMAN — Sure, but you can do that with a little tiny drawing. If a work is a good work, it is environmental. The idea of environmental sculpture meant a giant work that was supposed to envelop you physically, but very little of it did anything more than that. It

was just very big, and you could walk around in it. It didn't have much to do with what was going on in the world.

KOSTELANETZ — So you think a painting can become an environment, if it envelops your attention.

WHITMAN — Sure. We are all trained to look at things that are small and big and let them be the world, like TV for example. When you look at a television screen, it may be very tiny, but it is a world; everything else is destroyed when you are watching it. A news broadcast is probably as environmental as you can get.

KOSTELANETZ — But then you place the source of a definition of "environment" upon human attention, rather than upon the communicating field. You are saying this: "It is an environment if it totally engages me."

WHITMAN — But that has to do with you, and it has to do with the world. Some things are environmental to some people and not to others. Harlem isn't very environmental to me, because I don't live there. It sure as hell is for people who do.

KOSTELANETZ — What kinds of artworks do you find environmental?

WHITMAN — Good ones. Ones that move me.

KOSTELANETZ — Of all periods?

WHITMAN — Yes, but I have a few favorites.

KOSTELANETZ — I find Pollock in your sense very environmental.

WHITMAN — I have a lot of funny feelings about Pollock, because I'm not sure about him. The first time I saw those big paintings I absolutely couldn't believe it. I thought they were the most incredible things I had ever seen. Now that I think about them for a while, I wonder why in hell he kept on doing them. It doesn't seem very interesting to do a whole lot of those, after you do one of them or ten of them. It's a question of what he would have done, I suppose, if he just kept going—of what would have happened.

KOSTELANETZ — Do you find an artist more interesting if he has a succession of styles?

WHITMAN — I wouldn't say "styles," because style, I think, is consistent in all a man's work. I think it is a succession of ambitions maybe or an increase of scope. Maybe it's having the ability to continue forward without ever settling upon something that he thinks works. The nice thing about Bob [Rauschenberg] is that he goes right

on not caring if the new thing is going to work. His theatre work seems to me much less defined than his visual work—it's far more dangerous for him personally to do that.

A personal artist's problem that I have relates a little bit to this. When you're doing a work, part of that means that you're engaged in examining the interior of yourself—a part of your experience that is not the world you find walking on the streets. It's a world of loaded things, where things have content. When you have to produce a work, you have to deal with people. I have to come out of that interior world and tell them what I've seen there in such a way that they are interested enough in it to want to participate in it—in helping to reproduce the world.

KOSTELANETZ — When you compose a piece, then, you have certain images in your mind. Do you have a whole situation in your mind as well?

WHITMAN — I would say "image" is a good word for it. Let's say I have a sense of an image and a form. That thing could be very local. It could relate to something that has happened in the last six months of my life. Supposing I detect an image, whatever that is. It means basically a coherence in the ways that things have happened. The image is perceived in a lot of different ways by me—sometimes sounds suggest themselves. Sometimes something suggests itself that is interesting in itself for no reason. I have to accept that. I see someone behave in a certain way, and I'll know that I want that in the piece.

KOSTELANETZ — So anything then can be a component of an image.

WHITMAN — The image is like an iceberg, and these different things that I'm mentioning are like different things that are sticking up out of the water. It might be a particular kind of sound, or it might be a material. The basic image is still that thing underneath; and all you can do, to show it, is go around it and describe it by rhythms you sense about it, by the way things behave that you can see. If you pick a material and look at the material, the material starts behaving in a certain way. One way is to make that material do what you want it to do, and the other way is to look at the material and try to figure out why you picked it in the first place—what's that material trying to do for itself? If something has a certain spirit, be sympathetic to that and let it function the way it wants to function. All these are ways to talk about what that image was; that's the vocabulary.

KOSTELANETZ — I get your process, but I'm not quite sure what the content of the image can be.

WHITMAN — Your experience. It's as simple as that. Whatever is that order or perception I was talking about.

KOSTELANETZ — Can you give me an example?

WHITMAN — The work is an example—whatever comes out at the end is your story about that image. What that lump is made up of is all the experiences you've had and the kind of perceptions and awarenesses you've had of those experiences; also, the relationships you've had and the things that are suggested to you when you're walking around.

KOSTELANETZ — So the image is what you've perceived in a special way, and the content of that image, in theory, could be anything.

WHITMAN — Well, it's the story of all those perceptions and awarenesses you get just from being a person.

KOSTELANETZ — Then, you as an artist find this image in your experience. You retain it in your mind and then you use it in a piece.

WHITMAN — Right.

KOSTELANETZ — Let's take *Prune. Flat.* [1965]. How did the image function there?

WHITMAN — Well, I didn't start out with anything specific, like an idea or anything else. I went to the space. I got interested in the idea of a proscenium stage because of its very peculiar arbitrary nature.

KOSTELANETZ — You mean arbitrary in the sense that space doesn't have to be organized like that.

WHITMAN — Right. It's a block, usually in the shape of a cube in space. That particular case was shaped like a cube cut in half so that it wasn't as deep as it was wide and high. It had a certain square and flat shape from the front. I said, okay, that's kind of nice, so I got involved with certain flatnesses—with certain movie ideas, in the way that I think about movies. Movies are fantasies. They do things to the space. They flatten it out. When you project on people, you flatten them out. People who have a movie projected on them are like Jolly Jump-Ups. They can disappear and reappear. I suggested in the piece itself that it was about movies. I think that's very clear. It opens with a picture of a movie-projector. That's the first image. I use it as a reference point—to tell people that this is a movie.

KOSTELANETZ — Curiously, although I saw *Prune. Flat.* several

times, I forgot it was there. Only last time did I see it, and even then it did not mean much to me. Does that matter?

WHITMAN — I don't think it matters at all, for a lot of times if you ask people if they saw something, they'll say "What?" But you know they were reached by it, anyway. If you describe something and ask if they saw it, they'll say, "Something funny was going on, but I didn't know that's what it was." Also, in *Prune. Flat.* I was interested in the separation between the audience and the stage, which I tried to keep and make even stronger.

KOSTELANETZ — This is in contrast with your earlier pieces.

WHITMAN — It's in contrast with traditional theatre, where they try to suck you up onto the stage, to get you to believe in that world. I'm not interested in that. I want people to understand that world was manufactured. It is an object world. There are a lot of funny things that happen between what's going on onstage and what's going on in the back where the projectors are. It's very important for me to have people know that those are projectors back there and that they're making noise and shooting light out.

KOSTELANETZ — As the filmed image of a knife cutting through fruit is also projected upon live girls, there is a suggestion of sexual violation.

WHITMAN — I don't always think of it as sex. I always like to leave these equations open, though I know if something will have a lot of psychological meanings, I'll leave them in anyway.

KOSTELANETZ — But are these your intentions?

WHITMAN — They are not all my intentions. I like them because it's very easy to talk about a piece in those terms to people who ask me what it's about. They say, "I didn't see anything." Then I ask if they saw this and this and this, and they say, "Oh . . ."

KOSTELANETZ — Let me go back to origins—how did you compose *Prune. Flat.?*

WHITMAN — I saw that space, with its flatness. Then I started doing things I was interested in. Then I thought it would be interesting to project an image of somebody on themselves and see what that was like. Then, I tried to work with that. I just assumed that because I'd had enough experience taking movies and projecting them on different situations in different ways that although I didn't really know what it would be like, I did know. You have to trust your intuition.

KOSTELANETZ — So that was an idea that came to you—projecting an image of a person upon a person.

WHITMAN — Right. I don't remember much about it. I just decided to do it.

Then, the ultra-violet light changes the space in a different way. It keeps the people flat, but it makes them come away from the screen a little bit. It also defines them in terms other than the movies being projected on them. It takes them out of the movie. They are not part of the background images any more.

KOSTELANETZ — The blue light makes their edges darker.

WHITMAN — It washes out the movie on them. It also makes them strange and fantastic.

KOSTELANETZ — Did this come to you in composing the piece? Did you want this kind of light on people because it had this kind of effect?

WHITMAN — Actually, I didn't know what that light was going to do, because I had never seen it before. I just had an idea about ultra-violet light.

I don't think it's a good idea to be too knowledgeable about what you're doing. I prefer a situation where I make something that I'm interested in, and I'll see what it tells me. For one thing, it tells me a lot about me.

The other thing I'm involved in very consciously is time. When I first started doing things, I thought of time as a material that these works were made out of, as a sculptor might make something out of a rock. I thought of time as real and substantial. What you do is structure it in a way that has coherence in terms of that image we were talking about. There are ways you can do this. One is to let the image structure the time, which is a nice way to do it. All my work has a kind of rhythmic structure. I've been used to using time that is very measured, very articulate, and very organized.

KOSTELANETZ — In *Prune. Flat.*, are things timed to happen at certain moments?

WHITMAN — They happen in a certain time that has to do with the piece. The nature of that time sets up a certain kind of structure. There is one series of images that happens in the background film. There is another series that happens on the film that is projected on the person.

There is another time-structure for the three live people on the stage. Then, there are major things that happen, like the light bulb going on.

KOSTELANETZ—I notice that in the script of *Prune. Flat.* you are sending to Argentina, you list cues and action. Is this how you conceive it now or is it a way of translating your scheme into print?

WHITMAN — No, it's just a way of telling somebody how to do it.

KOSTELANETZ — But isn't it timed that way? When something happens, somebody has to do something.

WHITMAN — That's usually the way it works out for me.

KOSTELANETZ — Perhaps that's what your rhythm is—when a mechanical operation changes, then your people do something. When a certain image of feathers goes on the screen, for instance, the two girls shake their bodies.

WHITMAN — It's very hard to talk about those things until you have a lot of time between you and the piece. A lot of those things had to do with directing and presentation. Some of them are essential to the piece, and some of them aren't.

Recently, I went over an old piece, and I noticed that a lot of things I wrote into the first score had to do with direction; but they weren't necessary for the score. Why hamper somebody who can do it better than you?

KOSTELANETZ — Do you conceive of time as a material?

WHITMAN — That's the way I used to look at it. Now I prefer to approach the question of when things happen with a kind of personal understanding and intuition about what works and what doesn't work.

KOSTELANETZ — Is the stopwatch on your wrist for your theatre work?

WHITMAN — It started out to be for timing movie shots. I used it three times and then decided that I was much better than it was. Now my approach is a little different. If something has to be timed by somebody else, I will make a time for them to do it.

KOSTELANETZ — Let me return to *Prune. Flat.* for the moment. So you had these images, a rhythmic sense you wanted in the piece, and a sense of the space. Then did you go out and shoot the filmed sections?

WHITMAN — To break it down that way is hard, and I don't like to work that way.

KOSTELANETZ — You do everything all at once.

**ROBERT WHITMAN — 227**

WHITMAN — Right. When we went out and shot the movies, I had it in my mind that I would time it very rigidly—that I would do thirty seconds of this shot and ten of that; so that I'd be able to block out the area of the screen where the second movie would be and so that I'd know where the other person would be when I shot that movie. But all that planning wasn't necessary, for I just shot the images the way I felt them—for whatever lengths of time they wanted to be. I thought it would carry.

KOSTELANETZ — Did you edit the film?

WHITMAN — Very little. I don't do much editing.

KOSTELANETZ — Let me take the sequence of the two girls walking across the screen, which is usually followed by the same two girls walking across the stage at a different angle. Did this image come to you as a whole or did you first take shots of people walking down the street and then say wouldn't it be nice to have this also happen on the stage?

WHITMAN — Either that, or I had the possibility vaguely in my mind. I can see how you might think this is important, but it is an effort for me to think of it as being really significant. When one works, one tries desperately not to approach it like that. I try to be sensitive to that inner coherence that is suggested by the things I am doing. Nice things can happen. For example, when we were shooting the film in the City, there was a blinking Con Edison warning light that happened to be on the street where we were shooting the film. Then, it was nice to have someone on the stage go in front of the light and have it blinking on them. It became part of the film and part of the piece.

KOSTELANETZ — Something haunts me about that sequence in *Prune. Flat.* in which the filmed image of a nude figure is projected upon a white-smocked girl. Is this image supposed to match the dimensions of her body precisely? In the several times I've seen it, sometimes it fits precisely, and other times it doesn't.

WHITMAN — No, only occasionally precisely.

KOSTELANETZ — Are those occasions programed in advance?

WHITMAN — No. Not at all.

KOSTELANETZ — As I get it, the girl places herself in front of the filmed image by looking in the mirror at the back of the theatre.

WHITMAN — No, she can't see herself in that mirror. That's there for another piece. We originally rehearsed the girls with mirrors, and

then we took them away. For a while, we had a mirror partially on the stage so that the lead girl could place herself, but it worked only in one small area of the stage. She did perfectly well without it.

KOSTELANETZ — To make sure that she meets the image—that she knows where to stand—does the girl then mark a specific place on the stage?

WHITMAN — No, she can figure it out by looking at the projector. She can cheat by looking at herself or by looking at the screen behind her to see whether her shadow is blocking the image or not. There are the two dots of light where her feet are supposed to be.

KOSTELANETZ — Then, she is trying to meet her image as exactly as possible, even though you have set it up so that she can't always succeed.

The first time I saw *Prune. Flat.*, at its second performance at the Cinematheque, the nude image fit so precisely on the real girl that the illusion of her nakedness became persuasive. When the image flashed off the audience gasped. I thought this was a marvelous sign of the effectiveness of your deception, but it never happened again— such a complete mesh of illusion and reality. Wouldn't this be worth attempting to realize every night?

WHITMAN — I think that is nice, but it isn't that crucial. I don't think that's what the piece is about.

In the new version of the piece—what we've been doing at Circle-in-the-Square—the movie we've been using is a different movie, and two other girls do the piece. The scale of the nude figure is different; when she stands there, her rear end is around her chest somewhere. She can't be in sync with that image at all. Also, in the earlier version, you noticed that the girl stood still during that section; in the second one, there's a lot of movement.

KOSTELANETZ — Are these changes intentional?

WHITMAN — No, when you're working with a particular girl, you try to respond to what she is about and how she can function in terms of the piece; that's how the piece changes.

KOSTELANETZ — Does this change in detail change anything important in the piece?

WHITMAN — No.

KOSTELANETZ — Let me identify certain strategies that I've observed. One is the repetition of an image. When this happens in different

media, the result is a constant interplay between, say, a filmed image of something and the same image live. The piece introduces, for instance, the kinetic image of the light-bulb explosion on film and then duplicates it in live action; and the two images seem extremely different. Otherwise, the piece repeats an image in the same medium; an example is the flower image which you introduce on film in the last major sequence and then repeat, again on film, at the very end of the piece.

WHITMAN — Yes, that image runs all through the last section.

KOSTELANETZ — Does the piece have sections?

WHITMAN — Yes, it has a lot of sections. You mentioned earlier in the film where the people walk across the street and then they walk across the stage—that becomes something of its own. It's like playing the same note an octave apart maybe.

KOSTELANETZ — Then you have a chord, consonant rather than dissonant. When an image is projected on the girl and it doesn't fit her body, the visual disjunction strikes me as dissonant.

The other theme that comes to me is this: Kinetic motion is more real—it makes a stronger impact upon our senses—than static images. The filmed image of the girl moving, as it is projected on the still girl, appears more real than the girl herself. I assume this happens because on film she is kinetic, rather than static. However, at the very end, the girl extinguishing the real light bulb is more real than the girl extinguishing the light bulb on film. In this sense, the piece is about movies, which is a more kinetic medium than photography. Is all that there?

WHITMAN — I think that's fantastic—I don't understand it. The problem is that one could talk about these works endlessly and find those things there, but I find it hard to do. I would much rather be aware of these things in another language.

KOSTELANETZ — In a more specific language.

WHITMAN — No. In just some language where I know that it's happening—it's in my head and all that.

If you start thinking about these things, you might try to make them.

KOSTELANETZ — You'd work too hard to realize them, rather than just play with the images as they came to you.

WHITMAN — Yes. That's the kind of interior rhythm I was talking about before—those relationships that keep coming up and changing.

When one thing happens before the next, it changes the emphasis of the film and the live action. If something happens on the movie that's stronger than that thing live, then the weights might be reversed. The movie is the dominant thing for a while, then the live action, then the movie.

KOSTELANETZ — Another thing that happens very strongly is that one's sense of space is continually changing. Also, how your eye should look is constantly changing—where it should be focused. Sometimes it's looking very precisely at a small detail; other times it must pull back and look at the whole thing. This change in spatial perceptions occurs most strongly at the end, with the light-bulb sequence. Your eye is riveted on the light bulb, until it goes off. At that point, your spatial conceptions figuratively explode—you see the whole stage again. Therefore, much of the piece is about space.

WHITMAN — Yes, that happens. A lot of it is about relationships— about the relationship between the audience and the people on the stage. It's about how available they are—how you relate to them— and how abstract they are.

You mentioned that when the light bulb comes on, those people are more real than when they are stuck in a movie. They are functioning as human beings. Just another point: Very rarely do the people function in my pieces as characters in the usual sense, yet the performance has a lot to do with the personalities of the performers.

KOSTELANETZ — I find that is more or less true of all the new theatre. People are neither dramatic characters nor abstract personalities—they don't stand for anything in particular. In *Prune. Flat.*, the image of the girl flying, which might at first seem an abstract or symbolic personality, is not at all realized in those ways; it turns out to be just an image of a girl flying.

May I ask what kind of purposes you have in your theatre work? WHITMAN — I think there are a lot of ways to answer that. I happen to believe that there's a great purpose in doing work; what that importance is could be anything.

KOSTELANETZ — Do you think of your own pieces as having a classic Greek form?

WHITMAN — That's a way to look at them.

KOSTELANETZ — I find that in *Prune. Flat.* the second light-bulb sequence serves as a climax to the piece, as it culminates a significant

theme; and because it is a climax, it releases the tension the piece establishes and gives us in the audience a kind of cathartic exhaustion.

WHITMAN — That's a possibility, and it's something I'm aware of—that most of my work is resolved. Anything that functions, even if it appears open-ended, which is a way of identifying a certain kind of form, still has a resolution or some kind of coherence; and it's understood.

KOSTELANETZ — The fact that *Prune. Flat.* is closed-ended doesn't necessarily imply that it has a plot, or at least any more of a plot than a succession of related images which are, I think, strung along a theme, although this may not have been your purpose.

WHITMAN — Right.

KOSTELANETZ — Is it among your intentions to instill in the audience a kind of cathartic experience?

WHITMAN — I don't know. Like I say, you make available to them the same kind of perception you think you've seen somewhere.

KOSTELANETZ — What kind of perception is that?

WHITMAN — It's a perception in terms of that image we were talking about before—that thing that exists that you really can't define in any other way except through the piece. You're asking about the difference between an artistic experience and something you can talk about; and the last has to do with philosophers and critics and people like that.

KOSTELANETZ — Nonetheless, can't I identify components of this image—one component being your attitude toward the movies? However, I realize that's only part of the image, and it would be impossible for me to list all the aspects because there are always several more beyond my perception.

WHITMAN — Yes, that would be true.

KOSTELANETZ — How would you define "theatre"?

WHITMAN — I think of theatre as anything where you can get people to agree to experience something that has a word or definition. Theatre could be a sports event; it happens on television, because everybody understands together that they are going through a similar experience or an experience that relates. A business could be a theatre, but it would have to have some sort of artistic aim or intention.

KOSTELANETZ — Nonetheless, your notion of a theatrical experience

implies an enhancement of experience that is above the normal run of things.

WHITMAN — Right, it's that kind of awareness—where people agree that they are participants in a particularly unique experience. In a work that I think of as truly theatre there is an audience and some performers; the audience agrees to observe and to be sensitive and aware, and the performers agree to produce something to be seen and observed. Still, there doesn't have to be a separation between the audience and the performers.

KOSTELANETZ — Could the paying audience become performers?

WHITMAN — I think they could be. If you ask an audience to go from one place to another place in groups of three or four, let's say, and all the other people watch them go, then the people walking across somehow become part of the performance.

KOSTELANETZ — What kind of theatre do you admire?

WHITMAN — If you're thinking of theatre with what we call "artistic intentions," there's not a lot. I like what I do, I like what Rauschenberg does, what Cage does . . . I think I like what Claes [Oldenburg] does, Kaprow—a few others. I like in particular Oldenburg's sculpture, which could be theatrical as well.

KOSTELANETZ — Can you have theatre without a kinetic dimension?

WHITMAN — I think so.

KOSTELANETZ — So a museum can be theatre.

WHITMAN — I think so. I don't want to put any limitations on it. I don't see why anybody should think that anything couldn't be theatre.

KOSTELANETZ — You use the word "theatre" honorifically—where a space or a situation attains the quality of enhancement; even a living room could be theatre.

WHITMAN — It could be theatre if you made it with that artistic intention we talked about. A Claes Oldenburg living room would be very theatrical.

KOSTELANETZ — Does theatre imply three-dimensionality?

WHITMAN — No. Movies are flat. I don't see why a TV program couldn't have some artistic validity.

KOSTELANETZ — Have you seen one recently that did?

WHITMAN — No. I don't think I ever have.

**ROBERT WHITMAN — 233**

KOSTELANETZ — But it's possible. Would you like to work in TV?

WHITMAN — I'd like to work *with* TV. I've been thinking about using TV as part of a piece.

KOSTELANETZ — How would you like to create a TV show?

WHITMAN — I wouldn't, because that thing is too small. I don't usually think like that. But I'll tell you honestly that if someone asked me to do a television program, I'd say, "Sure."

KOSTELANETZ — In that list of theatre authors you liked, all of them, except for Cage, were originally painters. Why do you prefer this to other kinds of theatre?

WHITMAN — Because I've seen it all before. I haven't read a modern play that has anything to do with what I think is interesting, exciting, or meaningful in my life. They just haven't been very pertinent to the problems I face.

KOSTELANETZ — What about classic plays?

WHITMAN — I think that there are a lot of classic plays which are kind of interesting and pertinent—Greek theatre and Shakespeare.

KOSTELANETZ — Would you like to direct a Shakespeare production?

WHITMAN — I don't think I'd be very good at it. I don't know enough about speaking that language.

KOSTELANETZ — Do you see much conventional theatre?

WHITMAN — God knows that the plays that I've seen have been so few and far between—two Broadway plays, since being born.

KOSTELANETZ — When you were young, what kind of theatre did you see?

WHITMAN — I went to the movies. I like almost all movies, except as a rule I don't like so-called "art" or serious movies. I find them pretentious and boring; they say, "This is an art movie," and then do something that is not very interesting, usually.

KOSTELANETZ — What have been your favorite movies or your really great experiences in the movies, or is the medium itself your great experience?

WHITMAN — Good movies I remember have been things like [Fernand Léger's] *Ballet Mécanique* [1928], which I thought was interesting the first time I saw it because I'd never seen anything like it. Hollywood movies sometimes produce images that are interesting.

KOSTELANETZ — Since the recent theatre pieces you like are mostly

authored by painters, do you consider the idea of "painter's theatre" a valid concept?

WHITMAN — Not particularly. I'll tell you what I think that's all about, for me anyway. At the time that I started working [in the late 1950's], all the action was in painting and in sculpture. The New York art world was an exploding dynamic situation, and naturally it was a lot more attractive than anything happening in the theatre.

At that time, in painting and sculpture, there were a whole lot of other things we were interested in—hence, all that talk about "environment" and "motion." This led to "kinetic sculpture" and all this interest in things that move and are live. It was just a natural step for people to realize that they were really interested in creating a theatre. People tend to overlook the literary value of the kind of theatre we've been doing. Nobody seems to be very interested in talking about it, partly because it is a little more difficult.

KOSTELANETZ — So literary content has to do with . . .

WHITMAN — . . . certain kinds of images and kinds of relationships. Part of the literary content in a Rauschenberg painting is a certain kind of imagery that is very charged and loaded.

KOSTELANETZ — Such as pictures of John F. Kennedy.

WHITMAN — That's what I call a part of literary content, and that's what people tend not to look at—not to be aware of.

KOSTELANETZ — Such as the facts that in *Prune. Flat.* you used girls rather than boys, or that an image of a flower ends the piece, or that one of the opening images portrays a knife cutting across women— these decisions are all meaningful to you as content.

WHITMAN — Right.

KOSTELANETZ — As is the suggestion of something faintly sexual emerging from the pieces of vegetable and fruit as the knife cuts across them.

WHITMAN — Well, there's glitter, there's ball-bearings, feathers, and white liquid detergent.

KOSTELANETZ — Do you think of painter's theatre as different from composer's theatre, in turn, as different from . . .

WHITMAN — Listen, I think of myself as a just-ordinary dramatist. If I were to say I am anything, I might also talk of myself as an "artist," if I have to put that word down on an income-tax return; but basically, for me this is plain theatre.

**ROBERT WHITMAN — 235**

KOSTELANETZ — Do you still paint?

WHITMAN — No. It doesn't interest me. It's very hard—a full-time professional occupation.

KOSTELANETZ — In most of the pieces you've done, you were the author, the director, and sometimes the performer. Do you envision the possibility of splitting these functions?

WHITMAN — Yes.

KOSTELANETZ — Would you like to direct another man's mixed-means piece?

WHITMAN — No.

KOSTELANETZ — But you would still let someone direct one of yours?

WHITMAN — Yes.

KOSTELANETZ — What kind of script would you give them?

WHITMAN — We've been trying to figure this problem out. One way to do it would be in terms of the images that are presented and then trust the director to be sensitive.

KOSTELANETZ — In which case, you would write the thing out as a sequence of events—this happened and then this happened and then this—and then rely on him to make his own timing.

WHITMAN — Almost like that, but I think what's happening is that as the work is receiving more and more attention—more and more people are becoming sensitive to it—the kind of person capable of directing these things will appear; and he'll be able to be sensitive to the values of what you want. I think that after seeing one of my things, someone who is sensitive and aware could direct it . . .

KOSTELANETZ — . . . as well as duplicate a reasonable facsimile elsewhere. It would be more difficult if you had to write the piece down.

WHITMAN — Right now it would be, but I think in a time to come, somebody will be able to take a script and bring it off.

KOSTELANETZ — How else would you preserve a piece so that another person can do it?

WHITMAN — Another way would involve photographs and drawings and suggestions and a score.

KOSTELANETZ — Why not give someone a film made of your piece?

WHITMAN — That's an idea also. One of the problems then is that films lie. If you did an actual film of a piece, it would be an unending bore. It would require almost as much training to watch that movie as it would to figure out the piece from the script, because film time is

so different from theatre time. I couldn't imagine anyone doing that, really.

KOSTELANETZ — How is film time different from theatre time?

WHITMAN — A ten-second shot on a film is a long time; thirty seconds or a minute is fantastically long in a movie. In the theatre, you have a range because you can watch something and then watch something else; you're always looking around and changing your attention.

KOSTELANETZ — How has your work developed from *American Moon* [1960] to the present? How are things different now from before?

WHITMAN — Everything is more clear. I have more experience; I know more about what I'm doing. What I really mean is to have the image or the thing I'm after articulated more clearly.

KOSTELANETZ — In general, are people understanding your pieces better now than they used to?

WHITMAN — I think that one does work and keeps doing work; and as a few people become more aware of what you're doing and more receptive to it, they acquire a certain familiarity with the language. People in general, like that audience now at Circle-in-the-Square, couldn't be more confused.

KOSTELANETZ — Why, because their expectations are all wrong?

WHITMAN — It's not so much their expectations. They are so unfamiliar with the language—with the vocabulary of what I'm doing. They are not used to observing the kinds of things that are going on. They expect to hear talk, and there's no talk. They get a little annoyed that they are not going to hear talk. All of a sudden they are expected to understand something, and they get too nervous and tight to be responsive to the images and things that are going on.

SIMONE WHITMAN — In regular theatre, you have to learn, as an audience member, not to see what the stage is looking like; and when people come to Bob's piece, a lot of them don't see what anything looks like; so they think they haven't seen anything, and they haven't.

KOSTELANETZ — In other words, they are not using all their inborn senses to perceive what's in front of their eyes.

WHITMAN — It's like those natives who can't "read" movies, because they can't *see* them.

KOSTELANETZ — Weren't you the first of the creators of new theatre to go into a regular commercial situation? Your piece has been run-

ning at an off-Broadway theatre for ten weeks now; it's been publicly advertised. What does this mean to you?

WHITMAN — What is most important is that maybe ten people in the audience a night will want to see something else. After that, it means learning about certain kinds of dealings, relationships, business. It has to do with a participation in a real world.

KOSTELANETZ — You're encountering things as a theatre man you're going to encounter the rest of your life.

WHITMAN — I'm not going to invent something and keep it a secret. If I think that what I'm doing is important, I have to get it out there, where it can do whatever good it is supposed to be able to do.

KOSTELANETZ — Would you like to communicate your work to an even much larger audience?

WHITMAN — Oh, absolutely.

KOSTELANETZ — Do you consider that they are acquiring a kind of education in seeing your work?

WHITMAN — You could talk about education or you could talk about what happens when some person doesn't know what in the hell he's seen, but is excited by it. He doesn't know what it means, but he really doesn't find that important. Something has happened; he's had an experience that's different. He's discovered a world that he didn't know existed before. That's a good thing. Of course, a lot of people discover a world they didn't know existed before, and they aren't at all happy or excited about it. I think that they still get the message. It's there, and they've been moved. I think that sooner or later somebody will see something else and say, "Oh yeah, I saw something like that." They'll talk about it, and they'll say, "Let's go and see this other one."

KOSTELANETZ — You envision that in the near future there will be a larger number of pieces in regular performance?

WHITMAN — I think, yes. Also, the audience will expand.

KOSTELANETZ — You don't mind, I gather, repeating the same piece in different situations?

WHITMAN — Part of that has to do with a personal thing—my own making a decision to say "yes" to anything that arose during the course of a year.

KOSTELANETZ — And then try to adjust or impose your work upon the space at hand.

WHITMAN — A little of both. You try to work out a truce. The *Prune. Flat.* piece is the kind that can fit most anywhere, as long as you have a flat wall and can make some wings. You don't even need wings, actually.

KOSTELANETZ — Will you continue this piece much longer?

WHITMAN — It will be retired shortly, I'm sure. For me it is a piece that I can do almost anywhere. It was the first piece that I was able to do in more than one place.

KOSTELANETZ — What do you think of most of the critical writings on mixed-means theatre?

WHITMAN — The stuff suggests that most of the writing is done by people who have little experience in seeing things or in bothering to talk to anybody about it, if only to find out what the new theatre is about. Michael Kirby's book is the biggest exception I can think of, off-hand. His book is interesting, because it comes from a very specific point of view; it is located in Michael's mind, in what he's seen and tried to find out about. He goes to see everything, and he takes very seriously the responsibility of having written the book.

One of the criticisms I hear has to do with how inhuman or non-humanistic the so-called new theatre is, and that sort of statement reveals that some critics just don't know what we're doing. They don't understand the values with which we are concerned. You get hit with people who say that we should be concerned with Vietnam or civil rights, and all that means is that these guys, too, aren't watching. They don't know what they are seeing. Take Rauschenberg as an example. Most of his visual work is loaded with imagery that is very pertinent and current.

KOSTELANETZ — That criticism of the new theatre as anti-humanistic is based largely upon the avoidance of speech; but this strikes me as a terribly narrow notion of the human function, where the example of human experience would be disembodied voices on the telephone. No, you're talking about how people move, how we see, how we assimilate our environment, how we experience space and kinetic activity; these purposes are eminently humanistic.

WHITMAN — It is much easier to lie with words than any other way, I think. Also, they want theatre to be propagandistic.

KOSTELANETZ — I suspect that the fact that these moralists have attacked you proves that you are getting famous.

WHITMAN — I don't know about myself, because mainly I've been sort of in the background. I haven't been related to anybody else in particular. The work that I've been doing has been mainly by myself. I don't do visual work; I don't have shows. Occasionally, I have works in galleries, but it's very occasional. It's nothing that I'm known for, and theatre people don't know what I'm doing, because they are not interested in the new theatre, except to be scared a little.

KOSTELANETZ — Why was *Prune. Flat.* originally subtitled a "film-stage event"?

WHITMAN — It wasn't. I think of all my work as "theatre work" and leave it at that. Most of the old words are used, because of a peculiar notion of how you tell people what they are going to see. The idea of "theatre happenings" in the advertisement for *Prune. Flat.* has a lot to do with my compulsion to talk about it as theatre work and the producer's interest in using the word "happenings" for its commercial value.

I wanted to talk a little about the so-called new theatre. I think the most obvious thing is dispensing with words—with dialogue; that's one thing. Another thing is dispensing with the idea that people in the audience have to be seduced into being on the stage; there's nothing about empathy, except in terms of plastic empathy, which has to do with image—seducing somebody into your world in terms of rhythms and colors and images that are pictorial or audio or . . .

KOSTELANETZ — When is plastic empathy achieved—when an image is relevant to me?

WHITMAN — Or when you enter the rhythm of the piece—when you start relating to it. For instance, in doing *Prune. Flat.*, I've seen audiences respond in many different ways, in almost as many different ways as we've had performances. There are noisy, ugly, aggressive audiences sometimes; they are bent upon being destructive. What's interesting is that they start out noisy in that piece, and halfway through you notice that you're not hearing things any more. What happens to them, I don't know; all I know is that we've got them somehow. I don't think that they're bored to death, because they're not leaving.

When we did some current pieces at the University of Massachusetts summer art program, in a big field house, there were kids who came in very noisily, because they didn't know what they were going to see. They were exhilarated by the idea, I think, that they were going

to see something they hadn't seen before—that it would be new or far out or wild. We had worked so hard to put it on that we weren't paying much attention to the response until the whole evening was over. I had told the guy to turn the house lights on at the end of the last piece, as soon as the movie was over; about a minute after it was over, he hadn't realized that it was. During that time, there was complete silence; it was the first time that we knew that we got them. What we got I don't know. They weren't identifying with any character. They were identifying with something else; they were involved with the form of the piece, the structure, with what actually happened. They were into it. A lot of people talk about the work as having an hypnotic effect.

KOSTELANETZ — Certainly *Prune. Flat.* had a great hypnotic effect on me—and I've seen it enough times to know this effect is consistent —especially when that real light bulb comes down, near the end of the piece.

Aren't you describing painterly values in a theatrical situation?

WHITMAN — No, I wouldn't say that. I would prefer to say that I'm concerned with values that have in the last few years been thought of as values that were only in the province of the visual artist. There's a language of metaphor that comes from the pure physical things possible in theatre that's much stronger than words spoken by actors.

KOSTELANETZ — What are you working on right now?

WHITMAN — It is a piece where I hope to have about ten different basic events. They may move from one place to another; they may be more intermingled with each other. They'll be in different places. People will walk along a path, and they'll have to choose to go one way or another. If they go one way, they'll know that they are not going to see what happens if they go the other way; so that a person will take a left at a fork, see something at the end of that trail, and then go on to another choice somewhere. Maybe they'll get to see everything in wandering through this labyrinth and maybe they won't. They might decide they like something enough to stay a long time; so that they won't get to see everything available to them.

KOSTELANETZ — So the piece will have ten parts; and although the time of the entire piece will be fixed, each part will be indefinite.

WHITMAN — Right, that's why I'm in a big sweat right now. I don't like to work this way; it's not comfortable working this way; but I find

that it is fruitful to have a deadline, to stall to the last minute until you're good and scared and panic-stricken, and to precipitate the kind of presence that might help you get something that is important.

KOSTELANETZ — How quickly did you create *Prune. Flat.* for the Cinematheque?

WHITMAN — In about a month of manual labor and six months of living before that.

# 10

The artist is the man
in any field, scientific or humanistic,
who grasps the implications of
his actions and of new knowledge
in his own time.
He is the man of integral awareness.
—Marshall McLuhan

## USCO

USCO (or Us Company) is the taken name of a group of artists who have established a small communal settlement in an abandoned church in Garnerville, New York, a small town about fifty miles north of New York City. Consciously returning to the pre-Gutenberg idea of anonymous art, they divide the labor of creating environments, theatre pieces, and miscellaneous objects; and the signature on all they produce is, like the insignia above, collective and anonymous, rather than individual. The composition of the USCO community continually changes as numerous people move in and out, contributing to the group's activities and yet retaining their personal identities for private affairs; but the three founding members, Michael Callahan, Steve Der Key, and Gerd Stern, comprise its core. Although these three had all known of each other for several years before, not until late 1963 did

their friendships jell into a group identity; together they have since offered many performances at museums and universities in addition to constructing machines, printing posters, and building a mixed-media discotheque called "The World." Most of their pieces are kinetic environments in which they create a field of various and simultaneous aural, visual, and sometimes olfactory stimuli, all of which usually evoke an archetypal theme. The motif of the Quest, for instance, ran through much of *Hubbub* performed at the Film-Makers' Cinematheque early in 1966, and their exhibition at the Riverside Museum in May of the same year offered several meditation rooms. Informing their work is a supra-political or -religious creed, whose basic tenet is, "We Are All One"; and like most political artists, they presume that a change in a society's consciousness precedes a shift in its politics.

The oldest of the three, Gerd Stern, was born in 1928 in the Saarbasin. As refugees from Hitler in 1936, his family came to America, where Gerd attended the Bronx High School of Science and several colleges. His interests and competences are as various as the jobs he has held: carpenter, mucker in a gold mine, galley-boy, public-relations executive, travel writer for *Playboy*, manager for the West Coast micro-tonal composer Harry Partch. Originally known as a poet, the author of *First Poems and Others* (1952) and *Afterimage* (1966), he discovered around 1961 that his poems "started running off the paper into collage and lights and sounds." Greatly influenced by the ideas of Marshall McLuhan, he believes the contemporary poet should return to his traditional bardic role; and for this reason, like Allen Ginsberg, he regards spokesmanship and publicity as the most natural extensions of his poetic activities. He lives with his wife Judi at USCO's "country place" in nearby Woodstock, New York.

Steve Der Key (né Durkee) comes from Warwick, New York, about fifteen miles from Garnerville. Born in 1938, he grew up in New York City, quit high school at the age of fifteen, and soon after embarked on a career as a painter. Once critics started to place him among the early pop artists, he vacated that scene. Nowadays, he creates what some would call objective art—large pattern-paintings intended to induce contemplation. He considers himself a follower of the mute Indian prophet Meher Baba, whom he calls "The Avatar of the Age"; yet the patterns his ideas take—both associational and ana-

gogical—reveal his Catholic upbringing. He purchased the abandoned church that now houses USCO in 1962, just after he married; and he still considers it his home base, although he spent several months in 1965–66 on the West Coast, lecturing with Richard Alpert on LSD and most of 1966–67 exploring the Southwest for a new USCO retreat—"Solux, our spiritual tribal center."

Michael Callahan, born in 1944 in San Francisco, joined Der Key and Stern at Garnerville just before his twentieth birthday. Prior to that, he attended San Francisco City College for nearly two years, and during that period helped construct the local Tape Music Center. Self-educated in electronics, he builds most of USCO's machinery. As he is shyer than his partners and considerably less accustomed to public speaking, he was hesitant about contributing to the following conversation.

The first interview took place in the early afternoon around the commons room table of USCO's church. The adjacent main room, which was formerly the chapel, houses a rich array of electronic apparatus and other construction materials, all of which make it seem more an electronics factory than an artists' studio. Within it, USCO has recently constructed a kinetic tabernacle, which they open to the public every Sunday afternoon. Barbara Der Key woke her husband up to keep the appointment, and he came down in dungarees. Within minutes of sipping his coffee, he became enormously fluent, speaking with the frenetic confidence of a prophet, stopping only to answer the telephone, which rang often, or to attend to his three-year-old daughter. An hour or so later, Michael Callahan woke up to join the interview. Gerd Stern, away in California at that time, was interviewed at a later date; and his more leisurely comments have been spliced into the text. All remarks representing the collective's opinion are attributed to "USCO"; otherwise the speakers are individually identified.

The conversation opens with Der Key commenting on the tape-recorder's voice-operated microphone.

DER KEY — Beautiful; that's beautiful.
KOSTELANETZ — If it rattles you, I can cut out that voice-sensitized device.
DER KEY — No, that's really fantastic.
KOSTELANETZ — Why do you call yourselves USCO, or Us Com-

pany, and then insist that in USCO's work your individual identities remain anonymous?

STERN — The idea of anonymity came from two sources, [Ananda K.] Coomaraswamy, and McLuhan. When I read Coomaraswamy, say a dozen years ago, one of the things that came through to me was the discussion of the traditional society and the role of the artist within that society—the builders of castles and cathedrals, the craftsmen, the statue-makers, the writers of songs. The word and the image were passed around without any signature of status; and their authors didn't suffer feelings of alienation. Now, I was a poet, and I still think of myself as a poet. I was never successful in this chosen profession, because I always felt a tremendous frustration over getting my poems through to people. A lot of it resulted from my alienation from the literary world. I just couldn't make it with Kenneth Rexroth, Allen Ginsberg, or Allen Tate. Coomaraswamy's ideas about the artist's possible role in a different kind of society hit me very strongly; and when I came around to reading McLuhan and recognizing the trend society was taking—back to electronic tribalism as distinct from Renaissance individualism—I immediately connected it to Coomaraswamy's idea of traditional society, where the artist could assume a different kind of role.

USCO — Anonymity is an integral part of our whole situation, because that is how we got to work together. We all came out of individual bags, as it were; and the thing that appealed to us was a rejection of the conventional concept of the artist—the-agony-and-the-ecstasy-type scene—to get into the twentieth century or back into a traditional concept of the artist. It isn't the person but the work which is important. Our whole motivation is to reintegrate into a traditional society, because that's what we see is happening. We're going forward to where we were in the beginning; in the re-tribalization of the world, as it were, the circle is coming full around.

Now there is a big difference between the work being anonymous and the people being anonymous. The work we do is USCO. If someone came to Chartres Cathedral and asked to talk with the guy who made the gargoyles, he'd be told to find Joe up there on the scaffold.

KOSTELANETZ — In other words, even though Joe hadn't signed his

name to the gargoyles, he was known as the craftsman who executed that dimension of the total task.

USCO — With us, Steve's the painter, Gerd's the poet and the carpenter, Michael makes the machines.

KOSTELANETZ — That word before, "re-tribalization," echoes McLuhan. When did you have contact with him?

USCO — We've had two shows with McLuhan—one in Rochester, where he spoke before and after the performance; and the second show we ever did was in conjunction with McLuhan at the University of British Columbia in Vancouver back in January, 1964.

KOSTELANETZ — That was before *Understanding Media* was published.

USCO — Well, you see, *Media* came out initially in a typescript published by the National Association of Educational Broadcasters back in 1959. We had that, and it was one of the first things that turned us on. We got a lot of our initial ideas out of that, particularly that whole electrical sense.

KOSTELANETZ — Your work would seem to illustrate McLuhan's idea that, through electronic machinery, you can create a field of artistic activity—a kinetic environment—which has numerous foci of communication.

USCO — Right. Focus-locus, locus being the area of focus and focus being the locus of whatever you pick up out of the gamut of what is happening. We live in a world where everything is happening simultaneously, right here and now we're always in that movement; and what distinguishes you from me is where my focus is, or where my locus or direction of focus is. The whole thing about getting people together is having them focus at the same locus at the same time.

KOSTELANETZ — Are you omni-attentive?

USCO — Pretty much so, after having done this for a long time. We lived in a twenty-four-channel system, day in and day out when we were doing our things at home, running them for twenty-four hours a day almost. In the house here, there were about eight different types of projectors in eight millimeter; another eight projectors in sixteen millimeter. Film and slides and tapes were going all the time because we were constantly working on this thing. When all this was happening, plus our lives going on, plus people from the outside coming

in, the whole thing was just running all the time. It was like being on a ship; since we had a lot of work to do, we had shifts over a twenty-four-hour day. Even right now, at twelve-thirty P.M., somebody's still sleeping, because Michael was out running "The World" last night and he didn't get back until four in the morning. In an environment like that, you can become pretty omni-attentive.

\* \* \*

KOSTELANETZ — Have you had much contact with Buckminster Fuller?

DER KEY — During that time I spent last year in California, we came into contact with Fuller and spent a long time talking to him, because it was obvious that he is really among the great minds of our time.

KOSTELANETZ — Had you read him before?

USCO — We were very well acquainted with his ideas and integrities, as it were; but contact is the only love. In talking with him, there is no superfluous conversation. If you have a problem, you tell it to him; and he says, "If you want to do this, you have to do . . ." He gives you the next thing you have to do. It's really beautiful—complete contact communication; for there's no talking about the weather or the sun.

KOSTELANETZ — Didn't he take from USCO his observation that we have no picture of the world?

USCO — Stewart Brand turned him onto that. McLuhan said, "We do not meet any more. We merely cross one another's territories." Stewart's territory at that time was why haven't we seen a photograph of the whole earth yet; and when they crossed territories, Bucky picked up on that. It became part of his territory.

KOSTELANETZ — Do you mind this talking without credit?

USCO — No. All the time we've given away our schematics of anything we've ever built; as soon as we can give something to somebody else, it means that we don't have to do it any more. Fuller said, "Whenever I had a business, the first thing I designed was how I was going to get out of it." That's exactly our attitude too. If somebody else wants to paint these paintings or to build this console, that relieves me of having to do it. I want to work on what I don't know.

\* \* \*

KOSTELANETZ — Let me try to organize this material in a chronological order.

USCO — It's not linear; but you can, if you want to. Actually, it's all associational.

KOSTELANETZ — Haven't you, Gerd, recently published a collection of poems under your own name?

STERN — In fact, those poems in *Afterimage* [1966] were written between 1952 and '62; so not only are they thoroughly my poems, but the work pre-dates USCO. Now, if you take the more recent verbal manifestations such as "Take the No out of Now, then take the Ow out of Now," it would make no sense at all to call it a "poem by Gerd Stern." I don't consider that my poem; it's as much Steve's as mine, because Steve and I were together when it was made.

Even earlier, when I wrote poems out of other people's mouths, I would call them my own. For instance, I would go to a party, listen or even make notes; and then write it out. My poem "Thank You for Bodhi Day" was written that way.

KOSTELANETZ — Would you define your evolution as a poet as literally working yourself out of the poem? That is, where your early writing is very expressionist, your recent verbal constructions are anonymously objective.

STERN — I would rather say that where poetry was very simple in those days, now we're into cathode-ray tubes, stored images, which actually duplicate an earlier preoccupation in my poetry of holding an image in time—reflection and focus and perspective—as well as multiplying the image. Although I was talking about visuals then, I really didn't understand them at all. I'd never worked with film, for instance; and when you start working with film, all of a sudden you have this little strip in front of your eyes—there's *time* and an experience of time that has nothing to do with verbalizing about it. You don't know what it is until you start cutting film and see it pass through a projector and realize that this much film is that much time.

I think of our tape-collage, "Billymaster," which is a thirty-two-minute history running from F.D.R. through James Joyce to McLuhan, as one of the best permanent things we've ever done. I used to record a lot of stuff for KPFA, the Pacifica station in Berkeley; and years after, I went back to get some tape which was, in effect, part of my history—Ted Roethke reading his poems, Allen Ginsberg doing *Howl*, and Lord Buckley blowing a riff. That tape is a poem—a thirty-two-minute poem. That's where my "poetry" went.

KOSTELANETZ — As in one of your earlier poems, you here took "found words" and put them in your own order; and where you once used words spoken at a party, now you used words on tape.

STERN — The next step was using a number of slides with words on them, creating a *Verbal American Landscape* [1964]. The words fit themselves into little patterns, and they read and they pun. In sum, they give us some idea of what our associational universe is really like. For the next step with words, which I haven't accomplished and which may not even get done, I started by working with a computer man, Bill Siler. The idea was to take a New York City block and to store in the computer's digital memory all the words in that block. Then, we would simulate walking trips that a person would make, and the machine would read out as poems the succession of words that would appear before his eyes.

A project submitted to the Guggenheim foundation a few years ago was for a vast instrument with which you could throw audio and visual material on a screen or a dome; it was designed to provide information. I wasn't thinking at that time of what we got into later —quasi-entertainment.

KOSTELANETZ — Does that machine presume that a series of pictures can teach you more in one hour than you would otherwise learn in a week?

STERN — I think that idea is really an illusion. A picture is not worth however many words that proverb says. Let's face the fact that it simply is not. You can't transform picture values into word values.

KOSTELANETZ — While McLuhan may in his own life practice a print bias, he sometimes seems to say that young people today can receive more education from television than from print. But although television may provide a certain kind of information you may find lacking in print, literary critics for some fifty years now have found the electronic media deficient in the sorts of information and experience they value. The real point, I think, is that print and television are different and yet complementary; and a truly literate person should be able to appreciate both media and confront experiences on each one intelligently.

STERN — In the end, the way you best get both education and information is from one human being to another.

KOSTELANETZ — However, even that medium has its positives and

its negatives. If I were to depend solely on all the people I personally knew for my education, there would be a lot of things I wouldn't learn about. That's why I read a lot of books. On the other hand, a book or a work of art I once didn't understand is now more familiar because of a friendship I have made.

STERN — The last time McLuhan and I crossed, when I drove him to the airport in Rochester, I complained to him that we never have any time to talk at length together. We are either going to the airport or having coffee before confronting a hundred people. Marshall said, "These days, you must remember, we cross one another's fields; and what you get from me and what I get from you isn't what we're trying to give each other at all."

Three or four years ago, I recognized the necessity of forming something like USCO. When you're dealing with technology or multi-media, after a while you see that you've got to have more people. It's no longer just a question of wielding a brush or a typewriter; you can't do it all yourself.

*　　*　　*

KOSTELANETZ — What is your own background, Michael?

CALLAHAN — My father was an electrician, so I inherited an interest in electricity. He says that I dragged a lamp around everywhere just like the guy in the comic strip who is attached to his blanket. I got hooked on switches—I turned off the lights in the ladies' room while the train passed through a tunnel and things like that. Also, I've always been interested in law. I would ultimately like to get a degree in it and practice; however, it is easier to practice electronics without a license than law. I went to public schools in San Francisco, and around 1960 I got involved with the Tape Music Center. Once it got going, I worked there pretty heavily; and Gerd at that time was working on an octagon called "Contact Is the Only Love." He needed a sound tape made for it; so he came to the Tape Center, which was where I met him. Then, in August, 1964, I came here.

KOSTELANETZ — How would you define your own contribution to USCO's creations?

CALLAHAN — I have a background in hardware and electronics. Although I've never studied it and I don't have a degree, I've always known people who have needed something electronic done. To get a degree, you have to spend four or five years in an industrially oriented

situation. I don't have any desire to design conventional machinery; so I'm probably a natural for this work here.

We do a lot of funky stuff, particularly with electronics; so we started using this word "funktional" to describe what we do. Since it hasn't been printed and we'd like to get it out into the world, if you could get that in, it might help people.

KOSTELANETZ — I notice the phone rings all the time here.

USCO — We are a control post; we love transcontinental calls several times a night. It's a big habit and our biggest expense. What we'd really like to do is find a way to get around Ma Bell by going into our own radio transmission.

\*     \*     \*

KOSTELANETZ — Weren't you, Steve, included in G. R. Swenson's original survey of pop art [*Art News*, September, 1963]?

DER KEY — Well, I lived in an area in downtown New York where Jim Rosenquist, Bob Indiana, Larry Poons, and Bob Rauschenberg were all living; and we were all interconnected, as it were, or related to one another. When Swenson wrote his initial article, I got included; but that wasn't what I was into at all. I understood that, in terms of categorization, the best thing to do was get out of there. I saw pop as a very limited type of art, and I'm not tremendously appreciative of the culture we live in. What it celebrated was something I didn't care to celebrate; I saw it as not a sensitizer but a de-sensitizer. I'm interested in sensitization—in awareness of, rather than acceptance of, the world.

KOSTELANETZ — Because, as McLuhan suggests, through awareness of hidden phenomena, you can attempt to transcend their influence upon you.

DER KEY — As I understand it, what happens is that the entire phi-logeny or the entire evolution of the species is within every human being. Art is a psychic process whereby you manifest outside of yourself what is inside of yourself. The important thing is not to get stopped by categorization at any point; rather, to keep getting it out. In other words, the process of enlightenment, if you will, is a process of getting rid of or emptying, rather than filling; and to empty, you need to have scope and space to empty all this philogeny that is within you. You cannot evolve, in terms of the over-all evolution, until you have completely recapitulated the philogeny which is

**252 — CONVERSATIONS**

within you. You have to go exactly to the point where the entire culture is—to the edge; and once you are at that edge, you are at the point where you don't know. Right? Then, there is a possibility of growth. If you stop short before that edge, then the edge immediately is growing...

KOSTELANETZ — ... and you are left behind. Have you hit your edge?

DER KEY — Well, I live on it. Here was this whole thing we had going, and the money was coming in so that everything was cool. It was a good time to end it, obviously. Where would we have been? Among those guys who run around doing performances. Everybody knows that bag—where are you? As I see the society, everybody has a role within it; and as soon as you begin to discriminate the pattern (and the only way you can do that is by having a Gestalt view of total history), you begin to see that the roles are always repeated. The duty of any explorer, who is someone always on the edge, is to report back.

KOSTELANETZ — So, you as an artist are reporting back. . . .

USCO — Right now, because this conversation will be reported out to another thing. It drops down that pyramid.

KOSTELANETZ — Do you define the artist as a kind of seer?

USCO — A visionary seer.

KOSTELANETZ — A visionary into what?

USCO — Into precisely that—what's unknown.

KOSTELANETZ — What's the difference between you and McLuhan?

USCO — McLuhan is a critic or a see-er of present patterning. He looks at the present situation, and he gives you his print-out. The real difference is between Fuller and McLuhan. Obviously Fuller sees everything McLuhan sees but he says, if that's the trending, then we should do this. He takes the next jump all the time. That's the beauty of him—the ability of seeing, as a result of an initial understanding of the patterns, what the next step is. What I think McLuhan has done is brought everybody up to date, very rapidly. This was all happening —the electrical thing and the total tribalization of the world and he just brought it into the public consciousness.

He has also this thing about content and environment. At a certain time, the environment was the atomic bomb; everybody lived in that environment; and the content was warfare of some sort. Then, we got to the point where the space race became the dominant thing; well,

automatically the space race became the environment and atomic energy became the content of the environment.

KOSTELANETZ — The old form becomes the archetype, which is to say, the content of the new form.

DER KEY — The way to change the thing is to see what the next environment is going to be. I just was thinking of this whole Vietnam crisis, which is obviously the meeting of East and West, which is happening in many, many ways. The United States Government is unable to meet East and West, except in an aggressive way; whereas various artists, particularly those in the psychedelic movement, are all into that. Well, they are just a part of the same thing that the United States Government and everybody is part of, which is East and West getting together. It's going to happen in many different levels. That's what's happening. Okay, then you have to say, "If that happens, then what is the next jump?"

What is important is that process—that people are getting together, even if they may have to kill one another to get together. It's like America and Germany; now I have a Volkswagen and we work together. Today the problem is how are we going to work with this gigantic country called China. We'll have these scenes; we'll keep fighting it out and fighting it out.

KOSTELANETZ — In how many years will we achieve universal peace?

DER KEY — Universal peace is right now. That's a very funny thing. As I look out the window, there are no planes in the sky.

\*     \*     \*

KOSTELANETZ — Very often what you see is determined by where you stand and how far you are willing to look.

USCO — The main thing that really hangs people up about that is precisely the fear of death. This causes people's views to be very shortsighted, because they identify themselves with their own bag, which is to say their own body or envelope. They say, "This is I, and this is very threatening to I."

KOSTELANETZ — One of McLuhan's implicit themes is that the further we move into the electronic age, the less aware we become of durational time and therefore, the less fear we will have of death.

USCO — I suppose that the people who have really turned us ahead have been McLuhan, Fuller, and Meher Baba, who is the avatar in the

world at the present time. He is the one who gave us, "We are all one." In a pamphlet called "The New Humanity," he completely clarified for us that competition is the root cause of all wars, whether they be physical or material or spiritual. That's what helped us to get out of the competition bag. We decided to end competition here and now, not when we have peace.

KOSTELANETZ — USCO still has division of labor.

USCO — That's basically an understanding of roles or of service to one another or the entire body. We are one body. Here we are on this space ship, and the crew keeps squabbling among themselves about the food and how much land they have to sleep on and so forth. It's obvious that it's just one thing—this earth; and we're all in it together. The only way it operates is efficiently. Fuller says that once he recognized that fifty-four percent of the population in the United States at the present time is under twenty-five and, secondly, that their attitude toward the world is not how can we get something but how can we make it work, he decided to talk only to people under twenty-five. That last is precisely our attitude. How can we make it work? I know that I was born, and I know that I shall die. As soon as I can understand that we all are performing functions or roles that are of service to one another, I know that in living I have to live with everybody here.

KOSTELANETZ — In your community here, do you divide the labor and split the fees?

USCO — Nobody has ever made any money, because we put everything right back into the situation. There's enough to eat every day, a place to sleep, and a chance to do your work. There is a fellow here who is our mechanic, the person who operates the heavy machinery. He wanted to work on his car; well, as that's part of his thing, enough money had to be found so that he could do what he wanted to do to his car.

KOSTELANETZ — Is someone in particular the treasurer?

USCO — That role has gone through three or four people. That's the way it runs. There is no spending money; we all live very simply; we have very few possessions.

\*    \*    \*

KOSTELANETZ — Let me go back to 1962 when you bought the church.

DER KEY — Gerd was living near here, and he was just turning his poetry into on-the-wall objects. As I had been making objects on the wall for a long time, I helped him. Since I understood that very thoroughly, he was able to say, X, Y, and A, and I was able to say A, B, and Z. That was how the relationship started. We made some pieces together, and then Gerd had a show at the gallery in New York I was connected with. He went to California late in 1961, where he met Michael, who was then working at the Tape Center, building components. Gerd recognized he was not a technician but a creative person, and they got together. Basically, USCO was just the three of us for a long time. Recently, it's been just Gerd and Michael, really, because what I've been seeing all along was the next step. That was my role for the group.

KOSTELANETZ — What was the first step together as USCO?

USCO — The first step was putting together all these things—sounds and light. It all goes back to light and images. We had to begin to see that the three of us, in looking at the world, all had different images.

KOSTELANETZ — Shaped by three different backgrounds and three environments.

USCO — So we were three projectors. That becomes clear. So, when you get three or four things and start filling them in with your different backgrounds, what we saw on the wall was the hybridization of media, as McLuhan talks about it. There was this cross, and in this cross something else happened. The computer people explain why a machine cannot come up with a new idea: Because each thought has a direct relationship only across this thing, it never gets anywhere. At some place in the human mind, these two things hit one another; and all of a sudden another thing arises—that's the new thought. That method becomes more possible when you have three people working together. Michael talks about crystals and the fact that crystals vibrate at a certain frequency. Steve at that time was into Richard Wilhelm's *The Secret of the Golden Flower*, which is a metaphysical work; it talks about the adamantine body of the crystal—the perfect body. It's all the same vibrations. His understanding of the crystal out of this electronic thing, Steve's understanding of the crystal out of a spiritual thing, and Gerd's understanding of the crystal out of the fact that he used to grow them. . . . All of a sudden, there you go.

KOSTELANETZ — You believe there are similar forms in all your various areas.

USCO — Completely. It is all the same thing, in the end.

KOSTELANETZ — And that one thing has different symbolic manifestations.

USCO — Right. The problem in communication is this: If one of us goes to communicate with a group of people, someone in the audience will get exactly what I'm saying; but the next person may not get it. With three or four of us working together, the amount of people with whom we can communicate becomes much larger.

KOSTELANETZ — What are you trying to communicate?

USCO — The basic thing is that we are all one; that is the root. Once we can have the understanding that you're not threatening to me and I'm not threatening to you—in other words, that you are myself outside of myself, so to speak—then we can begin to work together. When you pare it all down, what determines that we are all one, is service. I can be a Hindu or a Catholic, a man or a woman, or any one of a number of things; but the only thing which is common to all of us is service. We all serve one another; it's a mutual symbiotic relationship, if you will, which the whole world has with itself. If we can communicate that, then we have the basis for going on to what we don't know.

KOSTELANETZ — If we're sitting together in an USCO environment and all the channels are functioning, then what's being communicated?

USCO — Let me give you a sample program. On one screen is a baby being born; on another screen a man is dying in a room. On a third is a child going through a garden picking flowers. On another is a picture of helicopters with parachutists dropping out of the sky. In one channel of sound is a space ship lifting off. In another channel is a baby crying, and so on and so forth. These are all experiences and perceptions which we all have in common. You are born and you shall die; I am born and I die. I pick flowers, and you pick flowers. We can all agree upon these things. They are common to all of us, and they are happening all at the same time. If we all can agree upon that, we have the basis. . . . We can't really talk until we can agree upon something, and the first thing that we have to find out is what we can agree upon. You assume that in the audience are people who will be comparing their responses.

USCO — 257

We once had this scene where a war sequence was on one channel. On another channel was a simple, naive, soft, sweet thing. So A and B go into this show together, and A comes out and says, "Gee, that was really beautiful." B says it was horrible—"All I saw was people killing one another." Okay, where are they at?

KOSTELANETZ — If we all subject ourselves to these experiences for a long time, will we all eventually see the same thing?

USCO — We'll see facets of the same thing. The question that you really have to ask is, "What is the whole thing, for these are only facets?" The whole thing, as far as I understand it, is the life experience.

KOSTELANETZ — Have you seen more of life, having been with this so long, than the next man?

USCO — By being able to see all things as happening at the same time and being able to accept the fact that as soon as one thing is born, another dies. . . . In the world of duality, the only way that one gets to unity is not by saying "I want the good" or "I want the bad," but by seeing that good and bad are part of the whole and you are then able to say "yes" to the entire situation, even though it is trying and painful. If you say "no," that's not going to change it.

KOSTELANETZ — Isn't that mysticism?

DER KEY — Well, that's my bag. Michael and Gerd will, no doubt, discuss it from another viewpoint; but there are certain ideas we share. What is it Gerd says about Michael—he would rather switch than fight. That's a twentieth-century thing. You turn on your television; and if you don't like the channel, you switch it. Why be on that trip, when there are a vast gamut of experiences to choose from.

KOSTELANETZ — This explains why you and Fuller feel that the younger generation in America is more communitarian in spirit.

USCO — Well, they've been looking at TV more. They didn't grow up with radio and TV being novel things.

KOSTELANETZ — How does TV make us communitarian?

USCO — Yes, first of all, because of the fact that millions of people are on the same trip at the same time; that's sharing an awful lot of awareness and time. All those people are being stimulated in precisely the same way; the same information is going into millions of human heads at one time.

KOSTELANETZ — So at the time of the Kennedy assassination . . .

USCO — . . . everybody got a similar picture. The information fed into their heads was all of a similar nature. I'm sure that if you lived in Russia, the information about the same experience would be much different. What TV is doing is programing millions of people simultaneously. Since you base your view of life upon what comes in, everybody is going around with the same input in their heads; that's why I don't watch TV. Once I understand the nature of the programing and the trip that everybody's on, then I can do the next thing.

KOSTELANETZ— Yet, USCO has used television in environments.

USCO — Yes, but it's how to be in it, not of it.

KOSTELANETZ — What has been your relationship with LSD?

DER KEY — I took an awful lot of LSD, but I don't take it any more and I don't smoke pot. I don't have a need for them now. Those things took me a certain step, and I've assimilated that electro-chemical information they gave to me, once I understood these things in terms of my own chemical and electrical network, as it were. The physiological reality of LSD is that at each one of the synapses of the brain there is a deposit of a chemical called Serotonin which activates the firing of the synapses. When you take LSD, all these synapses start firing simultaneously, all over the place; and where you once heard a baby cry before, now you hear five hundred different things.

KOSTELANETZ — It produces a crossing of wires, so to speak.

USCO — Right. In the breaking down of conditioned responses, your habitual patterns of association no longer operate.

KOSTELANETZ — So, LSD's effect is very much of a piece with the responses USCO's environments create, and both in turn contribute to a greater tendency.

USCO — Teilhard de Chardin talks, metaphorically, of a blanket of ideas in the world, and people pick up on them. There is no cause and effect; it just happens that five hundred people pick up on the same idea at the same time. What caused them to do that?

KOSTELANETZ — What new ideas?

USCO — Just think of your parents and how they look at the world and take how you think of the world; then, you'll see what I mean by new ideas. It's obvious that this new generation is different. One of the reasons, as I understand it, why the Food and Drug Administration has clamped down so hard on drugs has nothing to do with the drugs. What happened was that many people began changing their

reality. Now, reality is a very tricky situation, because it means that when we all agree on a certain thing we call that "reality." There is no reality. The only thing that is really real is that It is—you can call it God or what you want—Life is. Now, we agree to share a reality, and one form of this reality is the United States of America. That's an idea that we all have together, and it has certain rules. It's a game; Russia's a game. The whole scene is a game which everybody can agree upon; that's the reality of the situation. What happened because of LSD is that many people said, "Well, nationalism is sort of a corny game. Let's play something else." That's a big threat to any government or organized reality, as it were; so that's why I say the F.D.A. isn't interested in what happens to a person physiologically, because they permit all sorts of horrible chemicals in the world anyway and cigarettes and other things which are known to be deleterious to health. The thing that bugs them is that all these people are changing their reality.

KOSTELANETZ — "Realities" such as national boundaries. . . .

USCO — Right. When you get up in the air far enough, there are no little lines on the maps; it's all part of a whole thing. The U.S. Government is paying money to disprove itself, because as people get further out in these rocketships, Shepard and these guys will see just beautiful pieces of land surrounded by water. We are all together, and we have a choice. We can persist in this outmoded idea that since you have slanted eyes or that I have straight eyes, then we are different; or we can see what we have in common, that's what we are trying to do with these shows. At least we'll agree upon one thing—that we are stuck with one another; and although I may not like you and you may not like me, we'll have to live together.

KOSTELANETZ — You alluded before to religion; may I follow it up?

USCO — Let us say all religion is sham except for the religion of the heart. It doesn't need any rituals or any dogmas. What it needs is heart to heart; that is what religion is. There is no need to establish any new religion. All that is necessary is that people get into their hearts. That is the medium; love is the medium between us. If I love you, and if you love me, in the truest sense, that's all the religion we need.

*    *    *

KOSTELANETZ — How did you construct the environment at the Riverside Museum.

USCO — "System" is better. Lily Ente, who lives in Woodstock and teaches at the Master Institute, said it would be possible for us to have a show there. We didn't actually build anything new for it; it was a kind of retrospective in which we used things we had lying around.

KOSTELANETZ — Someone said, "Here is this space," and you decided to fill it to your taste.

USCO — Right. That's how God created the universe. He filled a space. The invitation was particularly attractive because "Contact Is the Only Love," the big octagon, had just been sitting in the basement of the San Francisco Museum for a couple of years. This show became a good reason to bring it here.

KOSTELANETZ — So you have your space and you have your elements, then what do you do?

USCO — That is the creation of the world, in effect. You have the materials; and the point is to fill the space, to turn people on, to turn yourself on.

KOSTELANETZ — Let's take the back room, where you had a tent with a chair in the middle. How was that made and how did it function?

USCO — Bob Dacey had paintings he did a year ago, and suddenly he had the idea of stringing them all together and making them into a cave. There was a space, into which his paintings fitted. Owen Jones built the mechanical turning hassock in the center, which is five above ten.

KOSTELANETZ — What does that mean?

DER KEY — All things that grow are basically five-sided, like a starfish or a human being. Things that are crystallized have six sides. That's the nature of numbers. As you call me a mystic, I am also a scientist. I only make something if I know that it is absolutely correct. This is what objective art is. Not only is the wheel five over ten, but it turns counter-clockwise. All things that turn counter-clockwise are involution. All spiral shells, if you look at them, turn clockwise, because they are growing out. Now, that tent or cave was something that was growing in; on all these walls were things like fetuses and everything —the total blur of being—that were turning people back into unconsciousness; that's why it was the way it was. The cave is where we

first lived, and we were trying to go back into that place where all these things were blurred together.

KOSTELANETZ — Was the purpose, then, the recreation of the sensory reality of the cave?

USCO — Well, to turn people back into their subconscious—into non-discrimination—where everything is just stuff.

KOSTELANETZ — What's the relevance of the number ten?

DER KEY — Ten is five and five. Ten is the number of completions, because once you have ten you have to start at one again, or eleven which is the second time you go through the number one. As eleven looks like two ones, you've started the cycle again. You've got to understand cycles. Everything is circular. There are 365 days in a year; and when you get to the end, you start with one and two again.

KOSTELANETZ — Is this a symbol or a concept?

DER KEY — It is a reality. The world makes a cycle; and when it gets through the cycle, it spirals in another cycle. Ten is the number of completion. You've finished your cycle, and you must start over again. In other words, you have five, which is the symbol of growth, over something which has ten sides. You were sitting on top of the thing of growth on top of a thing of completion; and that's the way life proceeds.

KOSTELANETZ — Is it a coincidence that ten is twice five?

DER KEY — Nothing is coincidental; everything operates under laws not made by you or me but of the universe. Nothing is real that any of us will invent; there are just given factors that you've got to work with. One of the factors is that all crystalline structures are six-sided. All energy forms are eight-sided. All growing things are five-sided. People will say this is mysticism; but it's not mysticism. What is mystical is that if you can understand these things, then you can apply them to your life. It's simply a science—a discipline of understanding.

KOSTELANETZ — How many elements were there in the big room at the Riverside Museum?

USCO — Well, there were paintings; some were Steve Der Key's and others were Dion Wright's. Another element was the sandbox which has the rotating column with a fulcrum at the base, and on top of the column were four colored lights which revolved at about one and three-quarter revolutions per minute. They illuminated the paintings.

This light system had a dimmer circuit on it, which every minute dimmed the lights out for a minute period; and then they would come back on. So, you would have two timed variables in the illumination—the color and the intensity; and as these weren't synchronized, there was an element of variability. Also, all the other lights in the place were flashing; and the thing that caused the flashing also fed back across the circuitry of the building until, at one point, we were pulsing lights in the whole building.

We also had the five elements. We had sand in the box in the middle; fire in the candles; we had air; we had water in the fountain around the periphery of the column, which was also the lingam inside the yoni—a psycho-sexual situation. There was an "om" tape loop playing on a stereo tape-recorder. Have you heard of "om"? Dome, home, womb, tomb, mom, bomb; the "om" is in a lot of important things. "Om" was the original sound of the universe.

KOSTELANETZ — I remember in particular the constant sound of a heartbeat.

USCO — There were also a lot of other things on the collage tape; we do a lot of tape work. Then, in the paintings, we had a man and a woman. The male is radiant, with all the lines going out; and with the female, all the lines go in. Up above are the seven spheres, which represent the seven planets in their orbits. "The Creation," which is Dion Wright's painting, had everything from the protozoa in the early murky swamps to the man and woman standing at the top and the DNA and RNA codes. What we had in that room, in short, was everything that is. The basic facts of existence, which are man, woman, man and woman and child, spheres, the stars, all create a meditation room. That's what it was.

KOSTELANETZ — Why fill it with all the basics of life?

USCO — That's the only thing you could fill a meditation room with. What else would you want? That's what is. What we wanted to do was give people all the elements of being; so that when they were there, they would be centered—they would have everything that is. When you came up the stairs, the first thing you saw was the tiger at the gates. It was all constructed symbolically and metaphysically on every level.

KOSTELANETZ — Could you have stayed in that room all day?

USCO — We were there every day for six weeks.

The relationship we're interested in, one which is really basic to the last decade, is between digital and analog—between the discrete particle and the continuous process, as personified by the hybrid computer with its digital storage and its analog capability. Applying a digital method to a constant process is very much related to mirrors and seeing an image of yourself between two mirrors, and also very much related to the medium-message, content-effect relationship. That brings you to poetry. Now, isn't it indicative that someone with McLuhan's background in medieval manuscripts and Joyce should construct a system where the only reality has to do with metaphor.

KOSTELANETZ — Or that everything has a metaphoric relation to something else and that there exists no ultimate reality to which all metaphors relate except the system itself—the metaphoric resonance of any dimension. This is also Joyce's theme in *Finnegans Wake*.

USCO — Whether you are dealing these days with the simulations of weaponry or with the simulations of the structure of protein molecules, the technology is basically a very poetic and metaphorical application of the human mind to making things in man's own image in matter.

KOSTELANETZ — What you are creating in your environments, in parallel, is often a symbolic image of man—or images that represent symbolic extensions of aspects of being. For instance, in the tabernacle here, you have six paintings on the wall—one is man, another is woman, and so on.

STERN — As for those paintings, Steve is the only artist I've ever known who handles the real and the symbolic so well that he makes the symbolic real in his paintings. Take that painting of the male or the shiva. If you understand the male force, as distinct from the picture of a man or the symbol of man, you can really feel it when the work is laid out before you. The painting creates in matter an image of man—of the necessity of making a one-to-one correlation. Steve's work has nothing to do with process—with the aesthetics of Expressionism or Action Painting; to him, painting is a ritual directed to a certain end.

KOSTELANETZ — The result is a very objective pattern which can in itself inspire processes of all sorts in each of us.

USCO — The process into creating environments out of individual

work was at first a difficult one that took a long time. Gerd was working in verbal collage—putting words together in various ways; in the meantime, Steve was putting words as images into his paintings—"Jesus Saves" and "A Man with a Camera"—as well as numbers, as in "Small Canticle" [1962].

We insisted upon making a fantastic jump. Remember the image of the tiger at the Riverside show and the word "Entrance"? It was that kind of a jump from the visual to the word; and in between something else comes into existence—something that has nothing to do with either the image or the word.

KOSTELANETZ — The jump in the image, then, is a symbolic reflection of the jumps each of you had to make to achieve such an image.

USCO — It's more than a symbolic reflection. You get into the whole question of the reality of the word and the image and what the relationship is between them.

KOSTELANETZ — You also have the simultaneous perception of both, even when they are not congruent.

USCO — That's the experience of an environment. What happens is that you get out of the belief that you can hang a painting on the wall and expect somebody to *spend* time relating to that painting. After you've been painting things for a while and hanging them in galleries and museums, you know that nobody is going to stand in front of that painting and spend a lot of time with it. Then, if you're thinking about consciousness and wanting people to make jumps, you wonder how to do it. You have to provide a different *métier*.

KOSTELANETZ — What happened then was that Steve's frustration as a painter paralleled Gerd's frustration as a poet—how can you reach people in this world today.

USCO — The environmental circumstance is beautifully suited to communication. You take a space and an open-ended piece of time, and you see what you can make it do to people. Can it change them? What's the effect? In environmental art, the content is more easily subordinated than in easel painting or kinetic sculpture. You're inviting someone to live in your room, in your time; and if the situation doesn't engage him, he's liable to leave.

*　　*　　*

KOSTELANETZ — I've noticed that USCO's pieces are either synchronous—basically a mesh of things in phase with each other, like

the meditation room at the Riverside Museum and the tabernacle here—or non-synchronous—a mess of things out of phase, such as *Hubbub* at the Cinematheque. Is this a central distinction in your own minds?

USCO — What you are counterposing here is organization against randomness. Actually, the apparent randomness and the appearance of unison activity are simply different forms of the same kind of ideas of order. When you're working in a multi-channel system, there are various considerations. In the tabernacle here or the Riverside Museum, the space is a conditioning factor which produces a certain kind of order. When you're in a theatre situation working with just a screen and your images are changing very rapidly, even though you're using the same amount of channels, the result is the appearance of greater randomness, although this is not necessarily so.

We're dealing with questions of how you can get into the mind with information and images and whether literary, sequential ordering is really a decent, rational, and reasonable input. Also, if you project twenty images simultaneously, does the receptive system take them in and retain them. That's the kind of thing we're testing. We've discovered certain things. For instance, until you get above seven images or so, a lot of people can still just hold on to one of them. Past that point, people either let go or suffer pain.

What we really prefer to do now is work environmentally—to set a thing up which would just keep running and let people go through it at their own will; however, there are still a lot of places that want you to set up something before an audience which comes at a specific time and is charged a specific admission, and so forth.

For another thing, we discovered not to forget about re-entry. That's something we learned from psychedelics. The important thing in a chemical trip is bringing people down. Anybody can go up, but it is very hard to bring people down safely. The same thing is true of an audio-visual trip. It's easy to overload people; but it's hard to bring them down to the point where they'll leave the theatre peacefully.

KOSTELANETZ — In the past year, you earned a lot of public attention. What's this doing to you?

USCO — It crystallizes. A guy wrote us from England the other day, "How long do you think you'll be able to maintain the image?" When

does the image get out of hand? we ask ourselves; when do you cease creating the image, and it creates you? It's getting to that point.

One thing we've noticed is that when we first started giving performances, a good half of the people would walk out; and among those remaining, about a quarter would be terribly irritated and come up and snarl. Reviews would say, "Landmark of a Flop." That doesn't happen any more; now they all stay. It means that they are at the same level we are at. It's getting basically mechanical.

Once we got the show on at the Riverside Museum, we really began to discuss the next step. We got a lot of offers, but everything seemed a continuation of the steps we were already taking. The only way we could take a next step would be going back to nothing and starting again.

KOSTELANETZ — Will you continue in mixed media?

USCO — Well, mixed media have now become a separate medium. With someone like Jackie Cassen, the mixed media becomes an art form, which is great and beautiful; but it's absurd for us. We have communicated to our fellow artists, and they can take it from here. If somebody else is doing it, then we don't have to. . . .

CALLAHAN — I'm going to Philadelphia on Tuesday to Albert Einstein Medical College, where they want to talk to us about building a funny room to test people's reactions to over-stimulation and understimulation.

KOSTELANETZ — That too is the creation of an environment, which is the same purpose you've had from the start.

USCO — I don't think that anybody who creates can ever get out of creating an environment. It's just a question of the content of the environment. Remember before, when we were talking of McLuhan's distinction between content and environment? Well, the environments we were creating have become content.

<p align="center">*   *   *</p>

KOSTELANETZ — How did you make "The World"?

USCO — A producer named Michael Myerberg had these three aircraft hangars out on Long Island, and he hired John Brockman to help him make a discotheque. Myerberg also produced the movie *Fantasia*, which I mention because like "The World," it used a new technology. *Fantasia*, you know, had the first multi-channel stereo

<p align="center">USCO — 267</p>

sound system, and "The World" is the first multi-channel night club; there's a strong connection.

We first got invited to do the control equipment—there's a big console that controls the tape and modifies the slide projectors. Originally, Myerberg planned to rely heavily on "the underground" for his films and slides; but as these arrangements fell through, he asked us to do them all. We turned out thousands of slides and two-and-one-half hours of sixteen-millimeter film.

KOSTELANETZ — What kind of subjects were on the slides?

USCO — All and everything. Each projector has eighty-one slides, and there are twenty-one slide-projectors. Chris George did a lot of the photography, along with Charles Rotmil. Judd Yalkut did most of the films. Originally there was a closed-circuit TV, but it turned out to be too expensive.

All of this, I should add, was planned during August and September of the year before. We began trying to assess ways in which the community, which is what USCO is, could provide for itself. The prime idea we had was discotheques, but we never got started on them. You know the law of opposite effects—it never turns out to be how you originally thought, but it always happens. In order to make the word flesh, you have to say the word; and in order to say the word, you have to be able to see—vision. What you have to do is get it out; and as soon as you get it out and on, it will happen.

CALLAHAN — I've wanted a good oscilloscope for over eight years, and I've wanted it in the worst way. About a month ago, I got a brand new oscilloscope on a long-term loan.

DER KEY — You remember what Jesus said, as he was talking to his disciples by the field: "Consider the lilies. Neither do they reap nor do they sow; yet Solomon in all his glory was not arrayed as these." Now, I gave up working when I was nineteen years old, because I decided to put my trust in God; and God's been good. It's an absolute trust. As soon as you go out to gig, you are cut off from that, and you are into this fantastic thing of where is it going to come from. If you can just have enough faith, everything comes—the commissions come, the oscilloscope comes.

KOSTELANETZ — This kind of attitude presumes precisely the sense of time, as I said before, your environments create—a sense of time

that makes it unlikely that you'll worry about tomorrow or even next year.

DER KEY — There is only now, after all.

USCO — One thing we're worried about is the school here—the Collaberg School that comes out of Summerhill tradition. A couple of weeks ago the main building burned down; so we've been involved with designing the new building. A lot of kids there are bored; what are we to do about them? That's one area we're particularly interested in working with.

KOSTELANETZ — What kind of education would you like for your kids?

DER KEY — They are being educated now. It's hard to understand any more what education is; but the basic question is how can a child become an adult living in the world with a sense of something to do. I don't think they have to know A to Z or anything like that. They have to find what's inside of them—what their role is and then perform upon it satisfactorily, rather than being oriented toward any accumulation or achievement.

If I wanted anything in the world, I would apply myself to how you get that. That's all that's necessary. Everything is possible, and all you have to do is want something. "Knock and it shall be open unto you. Ask and you shall receive." That's the way it is.

KOSTELANETZ — What kind of future do you see for USCO?

USCO — We've recently built an environment here and opened it to the public every Sunday, providing a situation in which people can have a contemplative or meditational experience. The religious content of that experience, it seems to me, is overt and apparent; that's why we call the environment, "The Tabernacle." Now, there's a category in New York State known as "free church," which means that you have a number of trustees, most of whom are not ministers of the church, and that you have to keep your pews open to the public at least one day a week, which we do. The thing almost seemed designed for us; next year we'll be tax-exempt.

Right now, there are several levels of USCO activity—our performances, the things that we make, like environments; then there are our cottage industries of work we do for money, such as silkscreening, electronic audio-visual pieces, a counting-unit for a the-

atrical production. As for the future, we know that we like the idea of involving a lot of people in working together; but such a system didn't work when we all lived here in the church. We recognized that this building was not designed for people to live and work together. If we are environmental artists, we should be able to conceive, design, and plan a structure which would lend itself to this kind of living activity. Another problem is that as we are so close to New York City, its high-energy center keeps us going all the time. Paradoxically, though we're providing a place for people to meditate and contemplate, we don't get much of that opportunity for ourselves.

Over the last six or seven years we have lived in a variety of different communities that were set up in different ways, and we've seen all the different problems that arose from such arrangements. There are tremendous difficulties that ensue—kitchens, looms, areas of work. Basically, if we are going to work together, living together makes a lot of sense. What we conceive, finally, is a return to the wilderness— going away from high-energy centers like New York or L. A. or San Francisco or London and getting out in the middle—because everything is connected now or will be in a short period of time—and providing, in the initial plan, for a large geodesic central dome surrounded by these smaller domes in which each family can live as they choose to display themselves as a family. In other words, if some people want to live nude and want everybody to ball everybody else, why they will have one dome and live that way in that building.

KOSTELANETZ — Your families would be established not by ancestry but by sympathy; so you could switch from one family to the other, so to speak.

USCO — You could live in any dome you chose. We found that if all these things try to live under one roof, tremendous problems arise. Some people like to flake out all the time; so we would have the flake-out dome. That's their trip. Then, we would have a work dome for everybody on that trip. The one dome in the center is the one reality that everybody can agree upon; and that's the first thing that is created. It will be a universal spiritual center—an entire re-creation of the universe in one place. It will be a 48¾-foot dome sitting on a 24-sided base, upon which will be portrayed all the possibilities of existence. There will be nothing in the dome except a matted floor; but we will paint on the walls of the base, which will also be all

electrified. The walls will be translucent. We've secured the land and about fifteen thousand dollars as the initial money to start this thing. There won't be any roads leading into it. The only way will be through the air. We are living in the twentieth century; and once you get into the air, you begin to understand that all roads go nowhere.

critical values
and the theatre
of mixed means

1

When a new or familiar work is accepted
as beautiful on its first hearing,
its fundamental quality
is one that tends to put the mind to sleep.
—Charles Ives, *Essays Before a Sonata* (1920)

The main cause for disappointment
in and for criticism of television
is the failure on the part of its critics
to view it as a totally new technology
which demands different sensory responses.
—Marshall McLuhan, *The Medium
Is the Massage* (1967)

Charles Ives's words are particularly relevant to an age such as ours in which the more imposing artists have rejected traditional notions of beauty as too sentimental and quaint, and, in contrast, audiences and critics would sooner acknowledge the familiar than explore works of art they cannot immediately comprehend. Ives's remark implies a converse—that a truly original, truly awakening piece of art will not, at first, be accepted as beautiful; indeed, negative judgments greeted even the best of Ives's own musical compositions, most of which were not performed until many years after he finished them. This converse

is also relevant to a new theatre that nearly everyone except the artists involved at first dismissed as ugly and chaotic. Not until the middle sixties did it start to receive a respectful, though skeptical, criticism from outside its immediate circle. Nonetheless, where Ives's original statement is more valid than not, its converse is not at all as generally correct. Most art that at first strikes us as ugly and chaotic seems doomed to remain so forever.

That last truth still does not deny the relevance of Ives's bitter words to criticism of the Theatre of Mixed Means; for a particular performance, like the entire movement itself, is likely to be too hastily dismissed, by audience and critic alike, long before its dimensions are confronted. Not only do inexperienced spectators generally fail to discern what purposes and forms the new theatre presents, but they also approach it with expectations that are irrelevant or peripheral to the scene before them. A major problem stems from the fact that as the new theatre descends from several arts, so it defies and transcends the necessities of each of these arts, as well as a sensibility honed primarily upon a single art. Therefore, at a mixed-means performance, such a monoliterate spectator is sensorily bound to assimilate only those stimuli that assume a familiar form. For example, where a theatre critic is predictably responsive to such theatrical dimensions as the demeanor of the performers and the piece's over-all form, so the dance critic is attuned to its choreography. Invariably, a connoisseur so specialized finds the mixed-means theatre deficient—to a theatre critic most performances will lack the dramatic vibrancy of an Albee play; to a dance critic, the choreography as such is not likely to compare favorably with Martha Graham's. Moreover, the specialized critic is likely to discuss a mixed-means piece primarily within the terms and conceptions that his field prepares him to perceive and explain; thus, a theatre critic ascribes to every piece a plot, while the dance critic evokes a succession of movements. Instead, I think that to treat a mixed-means piece as existing within any of these standard categories is to miss its essentially hybrid quality; and precisely because the new theatre incorporates elements from so many specialties, it demands critics, as well as audiences, possessed of a polyliterate and generalized sensibility which is responsive to dance, speech, sound, image, setting, and space, as well as overarching thematic statements. "All minds should contain several vocabularies," R. P. Blackmur once

wrote, and the new theatre demands an audience that has sloughed off a commitment to a particular artistic category in order to remain wholly open to the total field of impressions that a multiply communicating mixed-means theatrical performance offers.

Once we realize what identity the Theatre of Mixed Means has, and what values it cherishes, we can recognize how conservative attackers of the new theatre fail to understand how a radical art transforms and redirects traditional impulses and purposes. The conservative charge I most often hear states that the new theatre rejects both reason and feeling and that it therefore exhibits, as the critic John Simon asserts, "total dehumanization." In a superficial respect, this charge exploits its evidence, for in abandoning language the new theatre eschews the central characteristic that separates man from the animals; and without speech, literate man lacks his most convenient medium for channeling his capacities for reason and feeling. On a more profound level, however, we can see that the de-emphasis of a single aspect of human endeavor hardly affords sufficient evidence for such a derogatory generalization—indeed, a definition of human essence based on speech is ludicrously limited; for reason and emotion are not necessarily expressed in words. Reason is often revealed, if not discovered, in action; many of us often realize how we can most effectively do something only after we move to do it. Also, in expressing our deepest feelings, many of us are mute, if not paralyzed; and indicatively, in some of the most moving and resonant theatrical pieces of recent years—for instance, Kenneth H. Brown's *The Brig* (1963) and Eugene Ionesco's *The Chairs* (1952)—the language is, by conventional standards, inexpressive.

What the conservative critic fails to consider is that the new theatre, precisely through its de-emphasis of speech, can be devoted to eminently humanistic purposes. The literary theatre has by now become so encrusted with clichés that the words and movements of staged emotion more closely resemble archaic conventions than the immediate and intimate realities we know. How often have we heard onstage a fictional husband and wife claw at each other with lines so supremely elegant only a poet could write them; or how many times have we seen a character stage-left scream he is a failure, stumble toward the table at the center, fall into a chair, throw his head into his arms, and sob onto the table? As any sensitive theatre-goer must surely recognize by

now, the expression of emotion, along with the words for love, has become so thoroughly debased through indiscriminate repetition that the more tasteful among us reserve it for the most private occasions. However, the fact that the new theatre eschews such conspicuous displays of emotion does not at all mean that emotional qualities are absent; in fact, nearly every piece I have ever seen expresses and evokes a range of feelings, usually in the most subtle of ways. Where La Monte Young's *Tortoise* piece and John Cage's *Variations VII* created in me feelings of exhilaration comparable to those inspired by a great performance of Shakespeare, so Ken Dewey's and Terry Riley's *Sames* and Merce Cunningham's *Winterbranch* instilled in me emotions of terror similar to those I experienced after Harold Pinter's *The Homecoming*. The power to elicit strong emotion is clearly present in mixed-means theatre; but the audience must be attentive to its symbols and stimuli.

Windy discourse is the most traditional style that reason takes in the theatre. However, the major movements in post-Shavian theatre, even the philosophically inclined "existentialist" dramatists, scrupulously reject such an emphasis upon expository language, which has by now become the most popular medium for the pieties of reason and feeling, for a more elliptical, poetic, or simplistic use of words; and many of the great moments in contemporary theatre, such as the end of Samuel Beckett's *Waiting for Godot* (1952), exploit gesture (or the lack of it), rather than words. Nonetheless, this two-fold rejection does not mean that the new theatre is opposed to reason or even that it is incapable of instilling reasonable thoughts. In many pieces a sensitive spectator can find the same sort of statements he respects in literature; and if he wishes, these can be translated into critical prose. Merce Cunningham's *Place* (1966) evokes a bleak vision of human life, Ken Dewey's *Without and Within* (1965) assumes a concern with political conflict in both Vietnam and the American South; and Meredith Monk's *16 Millimeter Earrings* (1966) can be interpreted as a symbolic autobiography. The new theatre also disposes of all those falsely "human" conventions that separate a professional actor from his natural behavior. As the emphasis is more upon execution of a prescribed task than the advertisement of a "personality," the mixed-means performer in enacting nothing but himself cannot be anything but himself; only by "acting," which is to say projecting

himself above the throng, can he be false to his role. The trouble with most "humanist's" critiques of contemporary art lies in their expectation that new works should resemble the old—the touchstones of Shakespeare and Rembrandt are invariably tossed; but as such a critique usually depends upon a superficial examination of the actual matter at hand, the humanist critic feels more comfortable in reading from the past into the present, rather than, as he should, the art of the present back into its tradition. Instead, in the reasons I mentioned before, as well as the artists' statements throughout this book, I think we shall find why the new theatre can be, for our time, a more humanistic medium than the standard theatre—more demanding of our deepest capacities for reason and feeling.

**2**

Thus "art" in the general sense
which I require is any selection
by which the concrete facts are
so arranged as to elicit attention
to particular values
which are realisable by them.
For example, the mere disposing
of the human body and the eyesight
so as to get a good view of a sunset
is a simple form of artistic selection.
—A. N. Whitehead,
*Science and the Modern World* (1925)

Americans may realize
that scrambling after the obvious in art
is a losing game.
—Manny Farber,
"Underground Films" (1957)

Many a critic has stated that, by traditional standards, none of the new theatrical art is truly "great"; but such a remark, while more or less valid by itself, strikes me as whipping the wagon rather than the

horse. The real question is whether or not the new art makes old standards irrelevant and erects new ones in their stead, for like all truly avant-garde arts, the Theatre of Mixed Means measures its distance from the old arts by the new critical problems it raises; and nothing more conclusively confirms how unprecedented the new theatre is than its defiance of existing patterns of comprehension and, it follows, current forms of criticism. First, in its abandonment of the conventions of literary drama, the new theatre also abolishes such traditional guides to appreciation (and criticism) as plot, development, climax, characterization, and thematic explicitness. Once those old vehicles for holding the audience's interest are discarded, the theatrical situation reverts to its barest essentials, time and space; and the creator's primary problem becomes animating the space and time he allots for himself.

Such a radical restatement of theatrical purpose is not as revolutionary as it may at first seem; for the modernist strain of literary theatre has, over the years, been approaching a similarly basic situation. That is, where we once judged a play by how well it exploited and tempered the established conventions, praising the most effective ones as "well-made," we now defend, say, Samuel Beckett's *Happy Days* (1961) as excellent primarily because Beckett creates supremely brilliant theatre out of such slender basic materials—a woman immersed in a mound (space), prattling for about ninety minutes (time). The woman's language continually impresses our ear and the pathos of the situation evokes our compassion, all of which is to say that the sound-image complex achieves a constant intensity and originality several levels higher than the usual run of theatre. Such a revolution in definition implies a shift in theatrical structure. *Happy Days* achieves its tone and scale, and presents its themes as well, through repetition of image and word—filling in time and space, rather than developing action through plot. By accepting the implications of this shift in emphasis—from the efficacy of the whole to the sustained excellence of its parts—we can effectively approach the problem of critical discriminations in the new theatre.

Historically, all the arts have witnessed in the twentieth century the breaking-up of old forms, and each truly contemporary artist must face the problems and possibilities that the situation of formal freedom offers. The most successful recent works of imaginative art, I

find, either parody old forms, create entirely new forms, or accept the condition of formal chaos and work within it. For example, John Barth's great novel, *The Sot-Weed Factor* (1960), successfully parodies the conventions of eighteenth-century English fiction, the language of seventeenth-century England, certain myths of American history, the aims of historiography, existential philosophy, and the academic's love of pedantry, among other intellectual pieties; and although the novel initially takes its structure from a variety of familiar forms, Barth so distorts and transcends these conventions that the result is a distinctly original literary concoction. In contemporary music, the twelve-tone method represents the creation of an entirely new musical language with its own grammar and syntaxes—a wholly different system for coherently organizing musical sound; and the best examples of serial technique—the pieces, say, of Schoenberg, Webern, and Babbitt—achieve, indicatively, a much higher intensity of significant musical activity within the time and space a single piece allots for itself than traditional music.

If the artist accepts the condition of absolute formal anarchy, then he must decide how to distinguish his work from the chaos; and the artist who most successfully copes with this absolute freedom, my experience as a spectator tells me, concentrates his attention upon the smallest parts of his work, to make every dimension as rich and suggestive as possible. Jackson Pollock, I believe, accepted such a situation, and his greatest works create an over-all field that is, inch by inch, intensely interesting. John Cage's pieces, thanks to his cleverness in assembling their elements, are as aural experiences invariably more involving from moment to moment than, say, Morton Feldman's. Most of Allen Ginsberg's *Howl* (1956) thrives brilliantly within formal anarchy; but its third section simply does not, line for line, achieve the intensity and consistency, which is to say the excellence, of the other two. That is, Ginsberg's use of time and space in this last section is considerably flabbier. Similar criteria are relevant to contemporary fiction; for as William Burroughs' *Naked Lunch* (1958) is, page for page, a more successful book than, say, his *The Nova Express* (1963), so perhaps the most essential laudatory comment we can make about James Joyce's *Finnegans Wake* (actually an example of a wholly new form) is that ten pages of it are denser in linguistic texture, more allusive to significant experience, more suggestive of

meaningful themes and interpretations—contain more of the stuff of great fiction—than ten pages of nearly all prose in literary history.

Not only does the Theatre of Mixed Means descend from the formally chaotic tendencies in the arts it encompasses—aleatoric music, rather than serial; free-form dance, rather than ballet; assemblage, rather than primary art—so it also contributes to that great modern tendency that would blur the traditional lines separating one art from another, in order to synthesize means from all the arts, as well as non-artistic technologies and materials, into a single, great, catholic super-art. Part of this development involves merely a series of redefinitions and, concomitantly, a readjustment in consciousness. Once John Cage says a concert of his music is also "theatre," then the audience can take another step and learn to appreciate the performance as a kinetic sculpture with live parts, and the entire situation, which includes the audience, as a spectacular dance. Nonetheless, in rejecting the traditional methods of putting theatrical activity together, as well as the conventional forms for representing reason and feeling, the Theatre of Mixed Means likewise pares the theatrical situation down to its absolute essentials—the choice of space in which the activity shall take place; the marking off of a segment of time, which may literally be of any length; and the selection of elements, which is to say props and people, to be employed. Upon these basic decisions every mixed-means piece is built.

Therefore, our primary judgment in critically approaching an example of mixed-means theatre stems from how well a particular piece articulates and enhances the situation—time, space, and elements—it chooses for itself; for even if "life" is, as Kaprow says, the model for a chaotic event, the evidence of art is still that heightened quality that distinguishes a certain situation from its usual level. Once this basic dimension of a piece is evaluated, then we can critically confront other questions about its forms and meanings, its use of individual media, and its over-all meaning. For instance, Robert Whitman's *Prune. Flat.* (1965), which I consider among the best pieces, presents a fairly swift succession of images on film and of live action, sometimes separate and at other times combined. Often, the action on the screen is matched by an action on the stage, or the stage action sharply contrasts with what we remember of a similar image on film; occasionally, what is actually a filmed image deceives the audience into

believing it is a staged activity. In *Prune. Flat.*, significant events are continually occurring and relating to earlier events; and through the strategies of repetition and variation, the piece establishes a major theme—the unusual nature and inherent deceptiveness of filmed images. Moreover, *Prune. Flat.* achieves a sustained tone and a consistently appropriate scale, as well as an articulated rhythm and a highly distinctive "feel." To my mind, its use of space and time is as intensely and continually interesting as the best example of literary theatre; and perhaps the most basic compliment I could extend is that, after seeing it several times (itself another compliment), I sensed not a dull sequence in the piece.

This emphasis upon formal qualities does not discount the relevance of humanistic criteria in an evaluation; but because these have their root in more extrinsic and more subjective concerns, any evaluations based primarily upon such values are false to the intrinsic purposes of the art. For instance, as much as I find the ultimate philosophical message of an USCO environment highly estimable, that bias should not lead me to excuse certain aesthetic deficiencies in a particular piece. Robert Rauschenberg's cordial attitude to his performers, a quality quite evident in all his pieces, can sometimes compensate for his sloppy use of time. Conversely, although I enjoy La Monte Young's *Tortoise* piece immensely, I am intellectually disturbed by the incipiently totalitarian situation the piece creates—where the input so overwhelms the senses that the mind cannot think about anything else; and although it teaches the spectator to appreciate gradations of change in what at first seems a constant sound, *The Tortoise* reveals, for me at least, little about anything else. At any rate, if the over-all purpose of the Theatre of Mixed Means is perceptual enhancement, as I think it is, then the movement itself is, for its "content," nothing but praiseworthy.

In my own theatre-going of the past few years, I have, as I said before, been moved and impressed more by mixed-means performances than by literary drama; and in general, I have suffered less boredom at mixed-means pieces, although some of them contained repetitive, which is to say boring, activities. One reason, I suspect, is that as New York City offers far less mixed-means theatre than literary work, only the best or most persistent artists can field productions. (This, in turn, can be attributed to the fact that mixed-means theatre

lacks the established production and publicity machinery that literary theatre has.) Second, I have noticed that just as contemporary twelve-tone music makes nineteenth-century pieces seem unnecessarily slow and flaccid, so my experience with the new theatre leads me to find conventional theatre and movies needlessly confined in space; and because the miniscule space allows so little to happen, the action in these old media also seems rather slow. (Personally, I would probably find greater enjoyment in movie-going if I could watch simultaneously two different films on adjacent screens, with one earphone for each film.)

A more conclusive reason behind my preference for mixed-means work, may I suggest unfashionably, is that the new theatre is interesting and important to us precisely because it *is* new—because I am nearly sure to see images and actions I have not seen before, and because I am intrigued to see how adventurous artists explore the unfamiliar possibilities afforded by absolute formal freedom and the use of new materials. In sum, all the mixed-means performances I have seen contribute to my concern with discerning and defining the most viable media for artistic expression in our time. Perhaps the developing nature of the art, as well as the scarcity of performances, make going to mixed-means events more of the heightened, exciting occasion that theatre-going should be. In short, although I personally received far more education in literature than art, I am today more anxious to see Claes Oldenburg's next theatrical piece than Edward Albee's or Arthur Miller's, if only because at Oldenburg's work I am more likely to be challenged and surprised. In this respect, the most satisfactory answer to the query about the "greatness" of mixed-means theatre is that in its contemporary relevance, not only to the arts it encompasses but to our actual lives, we can locate the new art's ultimate significance.

Along with other avant-garde tendencies in contemporary art, the Theatre of Mixed Means infers, as I said before, that traditional question of whether something is or is not "art." In practice, that condescending epithet of "it isn't art" formerly expressed the opinion (rather, escalated an opinion into a pseudo-reality) that a work had not satisfied the prerequisites for form and content that critics, up to that time, had associated with the best examples of a particular art. Nonetheless, I would say that the word "art" still has a meaning and

a use, as it refers to dimensions of life, whether produced by human intention or not, that are superior to the normal run, because they are unusual, capable of involving attention, or shaped in a pattern that instills recognition or pleasure. Therefore, it follows that if I should find more essential art in an eccentrically clothed chick than a plainly dressed girl, I might, sometimes, find more art in an unusually ugly woman than a conventionally beautiful one. Formations of clouds are more interesting than empty sky; a forest of trees is invariably more engaging than a bare horizon; but a richly colored sunset is, perhaps because its image is faintly kinetic, usually more attractive than both. Most films are better than an empty screen; a piece of carved ivory is usually more desirable than a rough slab; and if it is not, then its carver has failed the essential purpose of his task. Similarly, a piece of new theatre must, as a basic test, be more interesting than the life outside on the street; therefore, the act of walking out implicitly expresses one man's considered judgment (reasoned action) that the activity on the street is more interesting than the show in the theatre. (I should add, however, that an abrupt, if not peremptory, exit may also be too easy an escape from the problems a piece may offer.) That is, although art may literally be everywhere, the most successful aesthetic creations, whether designed to be art or not (say, a space shot), invariably stem from intelligent, original, and premeditated programing. More specifically, if a mixed-means piece uses actions or syntaxes patently derived from elsewhere, if its activities are too ordinary to hold one's interest, if its materials are hackneyed, if its juxtapositions are too obvious, if its pace is too slow for its materials—all of which are stimuli that could in sum compel a sensitive viewer to leave—then the piece fails, to some degree, the situation it defines for itself.

This brings us to the question of boredom in the new theatre. Some artists, particularly those of the Cagean persuasion, will attempt to defend essentially boring activity as a viable strategy for contemporary art; and Cage even suggests that any activity, regardless of its purposes or quality, cannot help but be interesting—pieces are not boring, only the spectator is bored. In one sense, this position has its merit in suggesting that the spectator is ultimately as responsible for finding something interesting as the performers are for creating it. Since art exists wherever one wants to find it, a certain activity will

be interesting only to the extent that the spectator is prepared to be interested. However, most of us are liable to find some scenes more interesting than others, some arrangements of shape and color more involving than others; indeed, such judgments lie behind many of the discriminations we make about the most mundane activities of the day, if only because, as the anthropologist Weston LaBarre points out, "The whole phenomenon of language testifies eloquently to this factor of preference and choice in man's dealings with the universe."

Indeed, for similar reasons, I cannot accede to the idea I often hear that the medium is the entire message—or the entire art; for although I recognize that the technique of expression may often be as important as what the expression contains, I also regard some assortments of mixed-media as more satisfying than others. That is, the medium needs the enhancement we associate with art, and the degree to which the marks of a distinctive style transcend the mixed-means medium is a clear measure of the considered artistic intention of a particular piece. To put it another way, whereas watching a mélange of simultaneous events may by itself be a pleasurable experience (I personally enjoy Times Square), the medium of multiple communication is more affective, as well as attractive, if the individual elements are uncommon, their juxtapositions striking and memorable, and their scale and tone both distinct and coherent. For instance, Times Square, as a stylistically distinctive work of art whose author is collective, is more interesting than Herald Square, just as New York's Wall Street is more remarkable than West End Avenue. In mixed-means theatre, perhaps the surest way of recognizing the difference between art and not-art comes from noticing that some moments of a piece are more extraordinary than others; indeed, a powerful memory of a certain moment of a particular piece is generally a conclusive, albeit subjective, sign that it had more to offer than another. (For this reason, perhaps, all reviews of unfamiliar art should be written long after the performance takes place.) At less impressive performances, in contrast, one senses that elements the author chose could have been more imaginatively used. Wholly aleatoric methods, my experience tells me, generally produce less interesting pieces than tastefully conceived instructions, even if these prescriptions are, like Kaprow's, merely approximate; and even Cage's best pieces owe their success, I suspect, to his conscious selection of what elements to use and how they shall

function—decisions he usually makes before aleatoric processes influence his manipulation of his materials. In short, although the new theatre implies a lessening of the distance between art and not-art and between "good" art and "bad," evaluative distinctions are still viable; and upon the most elementary discriminations about the artist's use of time, space, and materials we can build a consistent critical vocabulary.

Since the primary purpose of the Theatre of Mixed Means is perceptual education, a critical attitude that blocks perception rather than opening the sensibility defeats its own purpose. No one should consider himself qualified to make an authoritative judgment until he is thoroughly educated, and acquiring the requisite familiarity means not only seeing all the performances one possibly can but also perceiving how one man's work differs from another's and how the potentialities of one genre of new theatre contrast with the necessities of the others. As only an innocent dance critic would publicly write that Claes Oldenburg's *Moviehouse* is deficient as dance, so a passionate devotee of Kaprow's happenings is mistaken if he dismisses an USCO kinetic environment as being too precisely planned and executed. Just as an educated reader should not expect *Finnegans Wake* to have the melodramatic suspense of a mystery story, so a primary mark of an educated mixed-means spectator is that he does not expect a particular piece to be other than what it intends. For most of us, then, the Theatre of Mixed Means offers an education; and even the most bookish of us critics (let me include myself) can only, before the new theatre, be humbled by our perceptual illiteracy. What I shall now write may not be the usual way to end or the conventional thing to assert, but I believe that my own enjoyment of the new theatre, as well as the experience of doing this book, has made me a more attentive and perhaps wiser man.

Reference
Matter

# Bibliography

*The following bibliography lists writings about the new theatre that I found useful. This is by no pretense comprehensive, nor do my listings exhibit the professional bibliographer's scrupulous consistency. The material is divided into four sections; and certain items I list in one place could have also been marked under another heading. The first section refers the reader to statements, scripts, and essays by the various practitioners interviewed in this book; and where the second section itemizes general critical articles about the new theatre, the third lists reviews of particular performances and each individual's work. The fourth section presents background materials relevant not only to sources quoted in my introduction and conclusion but also to the numerous references scattered throughout the text.*

*First of all, there exist several anthologies containing diverse materials about the Theatre of Mixed Means. The most important is Michael Kirby's* Happenings *(N.Y.: Dutton, 1965), which includes scripts and remarks by Allan Kaprow, Robert Whitman, Claes Oldenburg, Jim Dine, and Red Grooms, as well as the editor's scholarly introduction. Issue Number 30 of the* Tulane Drama Review *(Winter, 1965), edited by Kirby and Richard Schechner, contains scripts and statements by La Monte Young, Oldenburg, Kaprow, Whitman, Ken Dewey, Yvonne Rainer, Robert Morris, Dick Higgins, and Jackson MacLow, in addition to interviews with Ann Halprin and John Cage.* Happenings *(Hamburg: Rowohlt, 1965), edited by Jurgen Becker and Wolf Vostell, has pictures of mixed-means theatrical events around the world and miscellaneous texts, published in German, by Kirby, Kaprow, Cage, George Brecht, George Maciunas, and many others. Allan Kaprow's book,* Assemblage, Environments, & Happenings *(N.Y.: Abrams, 1966), has an appendix of scripts by Kaprow, Dewey, Brecht, and several*

European practitioners, as well as large pictures of their work. Other anthologies encompassing American phenomena include: Alison Knowles, et al., Four Suits ( N.Y.: Something Else, 1965) and Ay-o et al., Manifestos (N.Y.: Something Else, 1966).

## I. BOOKS AND ARTICLES BY PRACTITIONERS

Cage, John. *Silence*. Middletown, Conn.: Wesleyan University Press, 1961.

———. *John Cage*. [Catalogue of Compositions, etc.] N.Y.: Henmar Press, 1962.

———. *A Year from Monday*. Middletown, Conn.: Wesleyan University Press, 1967.

Dewey, Ken. "One Take for a Bare Stage," *Contact*, 10 (1961).

———. "Act of San Francisco at Edinburgh," *Encore*, X, 6 (November–December, 1963).

———. "Lunda-duetten II: Regissören vittnar," *Stockholm-Tidningen* (July 18, 1964).

———. "Score for Readers," *Art Voices*, V, 3 (Summer, 1966).

Halprin, Ann. "It's All the Fault of Christopher Columbus," *Dance Magazine* (August, 1963).

———. "An Interview with Renée Renouf," *Genesis West*, I, 4 (Summer, 1963).

———. "Film and the New Dance," *Bolex Reporter*, XVI, 3 (1966).

Kaprow, Allan. *Piet Mondrian: A Study in Seeing*. N.Y.: Columbia University (M.A. Thesis), 1952.

———. "The Legacy of Jackson Pollock," *Art News* (October, 1958).

———. "Notes on the Creation of a Total Art," in catalogue. N.Y.: Hansa Gallery, 1958.

———. "The Demiurge," *Anthologist*, XXX, 4 (1959).

———. "The Principles of Modern Art," *It Is*, 4 (Autumn, 1959).

———. "Some Observations on Contemporary Art," *New Media–New Forms*. N.Y.: Martha Jackson Gallery, 1960.

———. "Happenings on the New York Scene," *Art News* (May, 1961).

———. "A Service for the Dead," *Art International* (January, 1963).

———. "An Artist's Story of a Happening," *New York Times* (October 6, 1963).

———. *Assemblage, Environments, & Happenings*. N.Y.: Abrams, 1966.

———. "Experimental Art," *Art News* (March, 1966).

———. "The Happenings Are Dead, Long Live the Happenings," *Artforum*, IV, 7 (March, 1966).

———. *Some Recent Happenings*. N.Y.: Something Else, 1966.

Oldenburg, Claes. *Spicy Ray Gun, Ray Gun Poems,* and *More Ray Gun Poems.* N.Y.: Judson Gallery, 1960.

———. "Extracts from the Studio Notes (1962–64)," *Artforum,* IV, 6 (January, 1966).

———. *Injun and Other Histories.* N.Y.: Something Else, 1966.

———. *Store Days.* N.Y.: Something Else, 1967.

Rauschenberg, Robert. "The Artist Speaks." *Art in America,* LIV (May–June, 1966).

USCO. "Our Time Base Is Real," *Tulane Drama Review,* 33 (Fall, 1966).

[Gerd Stern. *Afterimage.* Woodstock, N.Y.: Maverick, 1965.]

Young, La Monte. "Death Chant," *Genesis West,* I (September, 1962).

———, ed. *An Anthology.* N.Y.: Fluxus Editions, 1963. [Also contains Compositions, 1960: 2–7, 9–10, 13, 15, and other works.]

———. *Compositions, 1961.* N.Y.: Fluxus Editions, 1963.

———. "Lecture, 1960," *Kulchur,* 10 (1963).

———. "Compositions, 1960: 3, 6, 7, 10." *New Departures,* 4 (1964).

## II. MACRO-CRITICISM

Baxandall, Lee. "Bertolt Brecht: The Happenings," *Studies on the Left,* VI, 1 (January–February, 1966).

Esslin, Martin. "What Will Happen Next?" *New York Times Magazine* (September 11, 1966).

Geldzahler, Henry. "Happenings: Theatre by Painters," *Hudson Review,* XVIII, 4 (Winter, 1965–66).

Hansen, Al. *A Primer of Happenings and Space/Time Art.* N.Y.: Something Else, 1966.

Higgins, Dick. *Postface.* N.Y.: Something Else, 1964.

Johnston, Jill. "Happenings," *The Encore Reader,* Charles Marowitz *et al.,* eds. London: Methuen, 1965.

———. Review of *Happenings,* Michael Kirby, ed., *Artforum,* IV, 2 (October, 1965).

———. "Post-Mortem," *Village Voice* (December 15, 1966).

King, Kenneth. "Toward a Trans-Literal and Trans-Technical Dance-Theatre," *The New Art,* Gregory Battcock, ed. N.Y.: Dutton, 1966.

Lebel, Jean-Jacques, *Le Happening.* Paris: Denoel, 1966.

———. "Lettre *ouverte* au regardeur," *Les Lettres Nouvelles* (June, 1966).

Robbins, Eugenia S. "Performing Art," *Art in America,* LIV (July–August, 1966).

Schechner, Richard. "Is It What's Happening, Baby?" *New York Times* (June 12, 1966).

Simon, John. "What Can I Do in the Water?" *New York Times* (June 19, 1966).

Sontag, Susan. "The Art of Radical Juxtaposition," *Against Interpretation.* N.Y.: Farrar, Straus & Giroux, 1966.

Tallmer, Jerry. "Rebellion in the Arts," *New York Post* (August 1–6, 1966).

## III. MICRO-CRITICISM

JOHN CAGE

Kostelanetz, Richard. "The Two Extremes of Avant-Garde Music," *New York Times Magazine* (January 15, 1967).

Yates, Peter. "After Modern Music," *Location,* I, 1 (Spring, 1963).

KEN DEWEY

Bourdon, David. "Friends with Bail Money Should Be Watching," *Village Voice* (December 30, 1965).

Esslin, Martin. "Event or Happening?" *Encounter,* XXI, 6 (December, 1963).

Gelber, Jack. "Edinburgh Happenings," *Evergreen Review,* VII, 31 (October–November, 1963).

Magnusson, Magnus. "Full of Fury—And Ideas," *The Scotsman* (September 9, 1963).

Marowitz, Charles. "Happenings at Edinburgh." *Encore,* X, 6 (November–December, 1963).

Mekas, Jonas. "Movie Journal," *Village Voice* (December 2, 1965).

Stevens, Dale. "Our First Happening Happens," *The Post & Times-Star* [Cincinnati], (September 20, 1965).

Tynan, Kenneth. "Dramatists in Perspective," *The Observer* (September 15, 1963).

Van Der Post, Laurens. *Intuition, Intellect, and the Racial Question.* N.Y.: Adelphi University, 1964.

Williams, Michaela. "What Is a Happening?" *Panorama—Chicago Daily News* (April 16, 1966).

ANN HALPRIN

Anderson, Jack. "San Francisco," *Ballet Today,* XIII, 9 (November, 1961).
———. "Manifold Implications: Ann Halprin," *Dance Magazine* (April, 1963).

———. "Dancers and Architects Build Kinetic Environments," *Dance Magazine* (November, 1966).

H'Doubler, Margaret N. *Dance: A Creative Art Experience*. Madison: University of Wisconsin Press, 1957.

Peterson, Sidney. "An Historical Note on the Far Out West," *Contact*, III, 3 (August, 1962).

Seymour, Richard. "San Francisco Dance Beat," *Dance Digest*, X, 40 (December, 1960).

Stuckenschmidt, H. H. Review of Halprin performance in *Theatre heute* [Hanover, Germany], (1963).

Yates, Peter. "Visions of the Dance," *Arts and Architecture* (February–March, 1965).

ALLAN KAPROW

Agnello, Michael. "The Art of Nothing—Self-Service in Three Cities," *Los Angeles Free Press* (August 19, 1966).

Bourdon, David, "Books," *Village Voice* (August 3, 1967).

Hahn, Otto. "Pop Art and Happenings," *Les Temps Modernes* (January, 1964).

Ichyanagi, Toshi. "Allan Kaprow," *Bijutzu-Techo* [Tokyo] (Fall, 1965).

Johnston, Jill. "Ingenious Womb," *Village Voice* (January 12, 1961).

Livingston, J. H. "Mr. Kaprow's 18 Happenings," *Village Voice* (October 7, 1959).

Restany, Pierre. "Happenings," *Planète*, 21 (Autumn, 1965).

Seckler, Dorothy. "The Audience Is His Medium," *Art in America*, LI, 2 (1963).

Tucker, Theodore. "Kaprow's Apple Shrine," *Village Voice* (January 12, 1961).

CLAES OLDENBURG

Bourdon, David. "Claes Oldenburg," *Konstrevy* [Sweden], XL, 5/6 (1964).

Glazer, Bruce, ed. "Oldenburg, Lichtenstein, Warhol: A Discussion," *Artforum*, IV, 6 (February, 1966).

Johnson, Ellen J. "The Living Object," *Art International*, 7 (Winter, 1963–64).

———. "Claes Oldenburg," *Painting/Sculpture—Dine, Oldenburg, Segal*. Toronto: Art Gallery of Ontario, 1967.

Johnston, Jill. "Three Theatre Events," *Village Voice* (December 23, 1965).

Pincus-Witten, Robert. "The Transformations of Daddy Warbucks," *Chicago Scene* (April, 1963).

Rosenstein, Harris. "Climbing Mt. Oldenburg," *Art News* (February, 1966).

ROBERT RAUSCHENBERG

Johnston, Jill. "Three Theatre Events," *Village Voice* (December 23, 1965).

Klüver, Billy, *et al.*, "Nine Evenings of Theatre and Engineering," *Artforum*, V, 6 (February, 1967).

Kostelanetz, Richard. "The Artist as Playwright and Engineer," *New York Times Magazine* (October 9, 1966).

Perreault, John. "No Boundaries," *Village Voice* (March 16, 1967).

Solomon, Alan. *Robert Rauschenberg.* N.Y.: Jewish Museum, 1963.

Wulp, John. "Happening," *Esquire,* LX, 5 (November, 1963).

USCO

Glueck, Grace. "Multi-Media: Massaging the Senses for the Message," *New York Times* (September 16, 1967).

Kempton, Sally. "Electronic Generation Goes Totally Kinetic," *Village Voice* (April 7, 1966).

Mekas, Jonas. "Movie Journal," *Village Voice* (December 2, 1965).

———. "Interview with Gerd Stern," *Film Culture,* 43 (Winter, 1966–67).

ROBERT WHITMAN

Anon. "Jammed Doors," *Newsweek* (October 31, 1966).

Cintoli, Claudio. "Robert Whitman o delle Performing Arts," *Cinema 2* (1966).

Johnston, Jill. "Theatre: Night Time Sky," *Village Voice* (May 27, 1965).

———. "Robert Whitman," *Village Voice* (September 8, 1966).

Junker, Howard. "The Underground Renaissance," *The Nation,* CCI, 22 (December 27, 1965).

Mekas, Jonas. "Movie Journal," *Village Voice* (June 3, 1963).

———. "Movie Journal," *Village Voice* (September 15, 1966).

Mussman, Toby. "The Images of Robert Whitman," *Film Culture,* 43 (Winter, 1966–67).

LA MONTE YOUNG

Cardew, Cornelius. "In re La Monte Young," *New Departures,* 4 (1964).

———. "One Sound: La Monte Young," *Musical Times* (November, 1966).

Johnston, Jill. "Music: La Monte Young," *Village Voice* (November 19, 1964).

Kostelanetz, Richard. "Theatre: A Manner of Mixed Means," *Art Voices,*
V, 4 (Fall, 1966).
Vanden Heuvel, Jean. "The Fantastic Sounds of La Monte Young," *Vogue*
(May, 1966).
Yates, Peter. *Twentieth Century Music.* N.Y.: Pantheon, 1967.

IV. RELEVANT BACKGROUND MATERIALS

Alloway, Lawrence. *Pop Art.* N.Y.: Abrams, 1967.
Amaya, Mario. *Pop Art—and After.* N.Y.: Viking, 1966.
Anon. *I Ching, Or the Book of Changes.* N.Y.: Pantheon, 1961.
————. "Sarodist [Ali Akbar Khân]," *The New Yorker* (August 27,
1966).
Apollinaire, Guillaume. *The Cubist Painters.* N.Y.: Wittenborn, 1949.
Appleyard, Donald; Lynch, Kevin; and Myer, John R. *The View from the
Road.* Cambridge: M.I.T., 1964.
Artaud, Antonin. *The Theatre and Its Double.* N.Y:. Grove, 1958.
Battcock, Gregory, ed. *The New Art.* N.Y.: Dutton, 1966.
Benedikt, Michael, and Wellwarth, George, eds. *Modern French Theatre.*
N.Y.: Dutton, 1964.
Biederman, Charles. *Art as the Evolution of Visual Knowledge.* Red Wing,
Minn.: Biederman, 1948.
————. *The New Cézanne: From Monet to Mondriaan.* Red Wing, Minn.:
Biederman, 1958.
Blackmur, R. P. *A Primer of Ignorance,* Joseph Frank, ed. N.Y.: Har-
court, Brace & World, 1967.
Boas, Franz. *Primitive Art.* N.Y.: Dover, 1955.
Boulding, Kenneth. *The Image.* Ann Arbor: University of Michigan Press,
1961.
Bowers, Faubion. *Enigma of Scriabin.* Tokyo: Kodansha, 1968.
Brant, Henry. "Space as an Essential Aspect of Musical Composition,"
*Contemporary Composers on Their Music,* Barney Childs and Elliott
Schwartz, eds. N.Y.: Holt, Rinehart & Winston, 1967.
Brecht, Bertolt. *On Theatre,* John Willett, ed. N.Y.: Hill & Wang,
1964.
Brown, Norman O. *Life Against Death.* Middletown, Conn.: Wesleyan
University Press, 1959.
————. *Love's Body.* N.Y.: Random House, 1966.
Burke, Kenneth. *Philosophy of Literary Form.* N.Y.: Vintage, 1957.
Capek, Milic. *The Philosophical Impact of Contemporary Physics.* Prince-
ton: Van Nostrand, 1961.

Carpenter, E. S. and McLuhan, Marshall, eds. *Explorations in Communications*. Boston: Beacon, 1960.

————; Flaherty, Robert; and Varley, Frederick. *Eskimo*. Toronto: University of Toronto Press, 1959.

Coomaraswamy, Ananda K. *The Transformation of Nature in Art*. N.Y.: Dover, 1956.

Denby, Edwin. *Dancers, Buildings, and People in the Streets*. N.Y.: Horizon, 1965.

Denney, Reuel. *The Astonished Muse*. Chicago: University of Chicago Press, 1957.

Eisenstein, Sergei. *Film Form, and The Film Sense,* Jay Leyda, ed. N.Y.: Meridian, 1957.

Ernst, Earle. *The Kabuki Theatre*. N.Y.: Oxford, 1956.

Esslin, Martin. *The Theatre of the Absurd*. Garden City: Doubleday Anchor, 1961.

Fowlie, Wallace. *Age of Surrealism*. Bloomington: Indiana University Press, 1960.

Fuller, R. Buckminster. *Education Automation*. Carbondale: Southern Illinois University Press, 1962.

————. *Ideas and Integrities*. Englewood Cliffs, N.J.: Prentice-Hall, 1963.

————. *Nine Chains to the Moon*. Carbondale: Southern Illinois University Press, 1963.

————. *No More Secondhand God*. Carbondale: Southern Illinois University Press, 1963.

Gascoyne, David. *A Short Survey of Surrealism*. London: Cobden-Sanderson, 1935.

Giedion, Sigfried. *Space, Time and Architecture*. Cambridge: Harvard University Press, 1941.

————. *The Eternal Present I: The Beginnings of Art*. N.Y.: Bollingen, 1962.

————. *The Eternal Present II: The Beginnings of Architecture*. N.Y.: Pantheon, 1964.

————. "Symbolic Expression in Prehistory and the First High Civilizations," *Sign, Image, Symbol,* Gyorgy Kepes, ed. N.Y.: Braziller, 1966.

Giedion-Welcker, Carola. *Contemporary Sculpture: An Evolution in Volume and Space*. N.Y.: Wittenborn, 1960.

Gilbert, Douglas. *American Vaudeville*. N.Y.: Dover, 1963.

Gorelik, Mordecai. *New Theatres for Old*. N.Y.: Dutton, 1962.

Greenberg, Clement. *Art and Culture*. Boston: Beacon, 1961.

Gregoriev, S. L. *The Diaghilev Ballet, 1909–29*. London: Constable, 1953.

Gropius, Walter. *The New Architecture and the Bauhaus*. Cambridge: M.I.T., 1965.

Gruen, John. *The New Bohemia.* N.Y.: Shorewood, 1966.

Hall, Edward T. *The Silent Language.* Garden City, N.Y.: Doubleday, 1959.

———. *The Hidden Dimension.* Garden City, N.Y.: Doubleday, 1966.

Harrison, Jane Ellen. *Themis.* N.Y.: Meridian, 1962.

Heisenberg, Werner, *et al. On Modern Physics.* N.Y.: Potter, 1961.

Hoffmann, Banesh. *The Strange Story of Quantum.* N.Y.: Dover, 1959.

Huizinga, Johan. *Homo Ludens.* Boston: Beacon, 1955.

Ives, Charles. *Essays Before a Sonata.* Howard Boatwright, ed. N.Y.: Norton, 1961.

Jammer, Max. *Concepts of Space.* N.Y.: Harper Torchbook, 1960.

Junker, Howard. "The New Silver Screen," *Esquire, LXVI,* 5 (November, 1966).

Kenny, Sean. "The Shape of the Theatre," *Actor and Architect,* Stephen Joseph, ed. Manchester, Eng.: Manchester University Press, 1964.

Kepes, Gyorgy. *Language of Vision.* Chicago: Paul Theobald, 1944.

King, Kenneth, "SuperLecture," *The Young American Writers,* Richard Kostelanetz, ed. N.Y.: Funk and Wagnalls, 1967.

Kirby, Michael. "Films in the New Theatre," *Tulane Drama Review,* XI, 33 (Autumn, 1966).

Kostelanetz, Richard, ed. *The New American Arts.* N.Y.: Horizon, 1965.

Kouwenhoven, John A. *The Beer Can on the Highway.* Garden City, N.Y.: Doubleday, 1961.

———. *Made in America.* Garden City, N.Y.: Doubleday Anchor, 1962.

Kubler, George. *The Shape of Time.* New Haven: Yale University Press, 1962.

LaBarre, Weston. *The Human Animal.* Chicago: University of Chicago Press, 1954.

Lewis, Wyndham. *Time and Western Man.* London: Chatto & Windus, 1927.

———. *The Demon of Progress in the Arts.* Chicago: Regnery, 1955.

Lippard, Lucy R. *Pop Art.* With Lawrence Alloway, Nicolas Calas, and Nancy Marmer. N.Y.: Praeger, 1967.

McLean, Albert F., Jr. *American Vaudeville as Ritual.* Lexington: University of Kentucky Press, 1965.

McLuhan, Marshall. *The Gutenberg Galaxy.* Toronto: University of Toronto Press, 1962.

———. *Understanding Media.* N.Y.: McGraw-Hill, 1964.

———, and Fiore, Quentin. *The Medium Is the Massage.* N.Y.: Random House, 1967.

Malcolm, Norman. *Ludwig Wittgenstein: A Memoir.* N.Y.: Oxford, 1958.

Martin, John. *The Modern Dance.* Brooklyn: Dance Horizons, 1965.

Mead, Margaret. "Art and Reality," *College Art Journal,* IV (May, 1943).

Mekas, Jonas, ed. "Expanded Arts," *Film Culture,* 43 (Winter, 1966–67).

Moholy-Nagy, Laszlo. *The New Vision.* N.Y.: Wittenborn, 1947.

———. *Vision in Motion.* Chicago: Paul Theobald, 1947.

Moholy-Nagy, Sybil. *Moholy-Nagy.* N.Y.: Harper, 1950.

Motherwell, Robert, ed. *The Dada Painters and Poets.* N.Y.: Wittenborn, 1951.

Mulas, Ugo, and Solomon, Alan. *New York: The New Art Scene.* N.Y.: Holt, Rinehart & Winston, 1967.

Mumford, Lewis. *Art and Technics.* N.Y.: Columbia University Press, 1952.

Nadeau, Maurice. *The History of Surrealism.* N.Y.: Macmillan, 1965.

Peckham, Morse. *Rage for Chaos.* Philadelphia: Chilton, 1965.

Pevsner, Nikolaus. *Pioneers of Modern Design.* Harmondsworth: Penguin, 1960.

Piscator, Erwin. *Das Politische Theatre.* Hamburg: Rowohlt, 1963.

Pound, Ezra, *The ABC of Reading.* N.Y.: New Directions, 1960.

———, and Fenollosa, Ernest. *The Classic Noh Theatre of Japan.* N.Y.: New Directions, 1959.

Read, Sir Herbert. *Education Through Art.* London: Faber, 1943.

———. *Art and Industry.* Bloomington: Indiana University Press, 1961.

———. *The Grass Roots of Art.* N.Y.: Meridian, 1961.

———. *A Concise History of Modern Sculpture.* N.Y.: Praeger, 1964.

———. *To Hell with Culture.* N.Y.: Schocken, 1964.

———. *Icon and Idea.* N.Y.: Schocken, 1965.

———. *The Origins of Form in Art.* N.Y.: Horizon, 1965.

———. *Art and Society.* N.Y.: Schocken, 1966.

Richter, Hans. *Dada: Art & Anti-Art.* N.Y.: McGraw-Hill, 1966.

Rose, Barbara. "ABC Art," *Art in America,* LIII, 5 (October–November, 1965).

Rosenberg, Harold. *The Tradition of the New.* N.Y.: Horizon, 1959.

———. *The Anxious Object.* N.Y.: Horizon, 1964.

Rosenblum, Robert. "Pop Art and Non-Pop Art," *Art and Literature,* 5 (Summer, 1965).

Rourke, Constance. *American Humor.* N.Y.: Harcourt, Brace, 1931.

———. *The Roots of American Culture.* N.Y.: Harcourt, Brace & World, 1966.

Rublowsky, John, and Heyman, Ken. *Pop Art.* N.Y.: Basic Books, 1965.

Schlemmer, O., Moholy-Nagy, L., and Molnar, F. *The Theatre of the Bauhaus.* Middletown, Conn.: Wesleyan University Press, 1961.

Seitz, William C. *The Art of Assemblage.* N.Y.: Museum of Modern Art, 1961.

Shattuck, Roger. *The Banquet Years*. Garden City, N.Y.: Doubleday Anchor, 1961.

Slonim, Marc. *Russian Theatre from the Empire to the Soviets*. N.Y.: World, 1961.

Southern, Richard. *The Seven Ages of the Theatre*. N.Y.: Hill and Wang, 1961.

Stockhausen, Karlheinz. "Music in Space," *die Riehe*, 5 (1959).

Suzuki, D. T. *Zen Buddhism*, William Barrett, ed. Garden City, N.Y.: Doubleday Anchor, 1956.

Sypher, Wylie. *Rococo to Cubism in Art and Literature*. N.Y.: Vintage, 1963.

Taylor, Joshua C. *Futurism*. N.Y.: Museum of Modern Art, 1961.

Themerson, Stefan. *Kurt Schwitters in England, 1940–48*. London: Gaberbocchus, 1958.

Tomkins, Calvin. *The Bride and the Bachelors*. N.Y.: Viking, 1965.

———. *The World of Marcel Duchamp*. N.Y.: Time-Life, 1966.

Wagner, Richard. *On Music and Drama*. Albert Goldman and Evert Sprinchorn, eds. N.Y.: Dutton, 1964.

Whitehead, A. N. *Science and the Modern World*. N.Y.: Macmillan, 1925.

Winters, Yvor. *In Defense of Reason*. Denver: Alan Swallow, 1947.

# Index

"X-ings" (Dewey), viii, 10

Yalkut, Judd, 268
Yampolsky, Phyllis, 139
Yates, Peter, 200
*Yesteryears* (Schoenberg), 188

Young, La Monte, xii, 6, 30, 46, 47, 48, 55, 65, 84–85, 183–218, 278, 284
Young, Stark, 27

Zazeela, Marian (Mrs. La Monte Young), 185, 209, 211

# About the Author

RICHARD KOSTELANETZ was born in New York City in 1940. He graduated from Brown University, and received an M.A. in American history from Columbia University. Currently a Guggenheim Fellow, he lives in New York's East Village and devotes his working time entirely to writing.

His interest in topics as various as literature and criticism, music and painting, performance arts and social thought is reflected in two collections of criticism which he edited, *On Contemporary Literature* (1964) and *The New American Arts* (1965), as well as in three anthologies of literature, *Twelve from the Sixties* (1967), *The Young American Writers* (1967), and *Piccola anthologia della nuova poesia americana* (1967); in addition to numerous articles and essays published here and abroad.